This Woman in Particular

Contexts for the Biographical Image of Emily Carr

Stephanie Kirkwood Walker

Foreword by William Closson James

Wilfrid Laurier University Press

CANADIAN CATALOGUING IN PUBLICATION DATA

Walker, Stephanie Kirkwood, date
 This woman in particular : contexts for the
biographical image of Emily Carr

Includes bibliographical references and index.
ISBN 0-88920-263-X

1. Carr, Emily, 1871-1945. 2. Biography as a
literary form. 3. Painters – Canada – Biography.
I. Title.

ND249.C3W53 1996 759.11 C95-932582-4

Copyright © 1996
WILFRID LAURIER UNIVERSITY PRESS
Waterloo, Ontario, Canada N2L 3C5

Cover design by Leslie Macredie. Photograph of the artist in her studio
courtesy of British Columbia Archives & Records Service

Printed in Canada

This Woman in Particular: Contexts for the Biographical Image of Emily Carr
has been produced from a manuscript supplied in electronic form by
the author.

With memories of
Hexham House
for
John Martin [1904-65]
and
Nancy-Lou Patterson
in whose lives and art,
like Emily Carr's,
the sacred comes to ground

"Millie Carr!" I can hear some of her fellow Victorians exclaim with a slight gesture of scornful amazement.

"Yes, Millie Carr! When the dust of your bones is confined in neglected grave plots or blown about the ways of the world forgotten, the spirit of this visionary will be fresh and living still, speaking to generations of what she saw and felt here."

— Ira Dilworth, *Saturday Night*, 8 November 1941

CONTENTS

List of Illustrations ... vii

Foreword .. ix

Acknowledgments ... xiii

Abbreviations .. xvi

**Introduction: Preliminary Thoughts
on Biography and Meaning** ... 1

CHAPTER 1
**"The Edge of Nowhere": Emily Carr
and the Limits of Autobiography** 9
 Emily and God: Creating the Modern Self 15
 In the Arena of Self-Writing .. 17
 Autobiography: An Arena for the Creation of Meaning 20

CHAPTER 2
The Enigma of Biography .. 25
 Biography and the Covenant between Word and Object 33

CHAPTER 3
**A Mirror to Culture: Moments in the
Development of the Genre** ... 41
 Enlightenment Lives ... 41
 Plus ça change, plus c'est la même chose 46
 "In or About 1910 . . ." ... 48
 The Image of Emily Carr: Early Shapes 55
 Mid-Century Spiritual Quests: Canadian Versions 62
 The 1960s: Consolidation ... 70

CHAPTER 4
**Life and Text: There Once Was an Artist
Named Emily Carr . . .** ... 77
Feminist Inversions in the Biographical Sphere 88
Portraits of the Artist as a Female
 in the (Post)Modern World .. 92
Reconstruction and Interpretation 96
Versions .. 100

CHAPTER 5
Deep Nature: Survival in a Constructed World 109
Constructing Lives and Constructed Absence 110
Sites of Meaning .. 111
Signs of Life ... 115
Lives of a Mystic ... 117
Cultural Determinants/Spiritual Imperatives 121
Definitional Elasticity and the Necessity of Improvisation ... 125
The (Im)possibility of Knowing More 130
Deep Nature: Religious and Psychological Dimensions 131
Deep Nature: Dimensions of the Primitive 138

After Life .. 145

APPENDIX A
**A Brief Chronology of Emily Carr's
Life and Writing** ... 151

APPENDIX B
Three Responses to Carr's Biographical Image 153

Notes ... 157

References and Sources Consulted 187

Index ... 207

LIST OF ILLUSTRATIONS

The Carr Home in Victoria 7

Emily in Cornwall ... 8

The Carr Sisters ... 23

Emily and Flora Burns .. 24

Carriana ... 40

The Artist in Her Studio front cover and 76

Indian Church, 1929 .. 107

Emily and the Elephant ... 108

Emily Carr with Her Monkey and Dogs 149

FOREWORD

" "Geography is about maps; biography is about chaps." One
hopes that this self-assured aphorism is not merely mnemon-
ic, but ironic: if geography can be reduced to cartography, then of
course biography is no more than the account of the external facts of a
male life. More than the obvious sexism of that statement calls for revi-
sion. (What would a "chap" be in inclusive language anyway, even
conceding the loss of the internal rhyme?) In our ambiguous, prob-
lematizing and deconstructing postmodern age nothing is what it
appears to be and every text has a subtext. Biography, then, may be
autobiography, as much "about" the biographer as about the life of the
ostensible biographical subject. But this book takes its probing of the
issues attending biography to even deeper levels.

Stephanie Kirkwood Walker has not written another biography of
Emily Carr, that great and enigmatic Canadian artist become superstar
and icon. Nor has Walker written a book examining the various biogra-
phies (or examining the biographers) of Emily Carr. Rather, as her
title indicates, her interest lies in "the biographical image of Emily
Carr" and, even more, in the various contexts where that image has
developed. Does not this seemingly centrifugal approach take us further
away from, rather than closer to, Carr? To the contrary, Walker suc-
ceeds in incorporating, and then surpassing, both biography and the
study of the making of biographies. She takes us beyond biography and
beyond "metabiographical criticism" to study the *ecology* of biography
as she explores the contexts of biographical endeavours. Along the way,
conscious of the role of her own subjectivity, Walker interpolates her
own engagement with Carr as part of this study. Knowing authorial
self-effacement to be an impossibility, she risks that self-exposure.

A few years ago I was working on a book, in part biography, about
a Canadian fur trader and photographer. At that time I believed, having
read it somewhere, that biography employs a master metaphor to com-

prehend the subject's life, providing an overarching explanatory theory for everything they thought and did. A biographer steeped in the life of the subject would know them better than they ever knew themselves, even to the extent of being able to predict what they might think or do. My quest for the material to assemble such a metaphor for the capture of my subject led me to the archives of the Hudson's Bay Company in Winnipeg. There various letters and journals seemed to put "my" photographer almost within my grasp. I was staying with a friend in Winnipeg who, every evening when I returned to his house, asked me: "Is he in the bag yet?"

Such is the biographer's hubris. More facts, further interviews, re-examining old data from a fresh perspective, sifting it all, carefully developing a new interpretive net—all this will bring the elusive subject ever closer until you finally get them in the bag. Though conscious of biographical theory, and of my own subjective engagement with my subject, I was no more aware of the "context" (in Walker's sense of the word) of my own biographical endeavour than a fish is conscious of the sea. I thought I was approaching some kind of apprehension of my subject, not unconsciously contextualizing a biographical image.

Who could not be fascinated with the life of Emily Carr? Her distinctive paintings are regularly shown and reproduced for an admiring, even idolizing, Canadian public. The haunting monumentality of her work looms large in memory, is so intrinsic to the Canadian imagination that one sees, for instance, the reconstruction of the west coast native village at Hull's Museum of Civilization almost as if through Carr's eyes. The artist herself has been re-created and presented to us variously as an iconoclast (though later installed to iconic status herself) and eccentric, an outsider to the staid conventions of the "Victorian" (in both its regal and civic senses) society in which she was raised. She was drawn to an appreciative encounter with native cultures (and today some accuse her of "appropriating" them). She was a woman struggling for recognition as an artist in a world that celebrated the achievements of men. Success came to her relatively late in life, and then as much through her writing as her painting. She was orphaned as a teenager, possibly an incest survivor, unmarried, perhaps a lesbian. She has been enthroned as a kind of proto-ecofeminist heroine who understood in advance of her time the place and importance of nature. So the facts and the appreciations and the conjectures run. What is the reality behind these images? Or more important, as Walker would have it, what are the contexts for these images?

I can summon up in my imagination her paintings with the towering totem poles whose verticality replicates the gigantic trees of the west coast forest, beckoning towards a sacrality and an otherness extrinsic to the conventional religiosity of the day. I think that I remember (though I may have imagined it) a photograph of the artist, hulking and scowling with a knitted cap on her head, pushing a monkey in a baby carriage in Victoria. Is this my own partial and fragmented biographical image of Emily Carr? What is its source and context?

In these pages Walker presents a thoroughly engaging examination of all the contextual frameworks for the various biographies of Carr. She explores the complex conflicting and converging of approaches to Carr's life: theories in the genre of biography, twentieth-century views of art and the artist, changing perceptions of Canadian identity and culture and constructions of the self in literary theory, religious studies and feminist theory, expecially with regard to the narratological basis of selfhood. On one level this work could be termed "metacriticism," that is, a study of studies (especially within the biographical genre) for the sake of charting the current status and historical development of debates within the different fields intersecting in biographical work done on Carr. The underlying thesis is that biographical studies of Carr attain maturity with the growth of feminism and in a postmodern era. One of the advances of our age is our suspicion of assured objective truths, partly derived from our consciousness of how "reality" is filtered through symbolic systems that highlight some things while muting others, and from our awareness of the role of the subjectivity of the researcher.

Walker argues for abandoning historical biography's pretence of facticity. Some will be alarmed at the threat of losing thereby a supposedly sure basis of progress toward understanding. Central to Walker's own understanding of Carr, and of the creation of Carr's biographical image, is the conviction so carefully argued for in these pages that the conception of the self in the biographical enterprise is at its very basis a religious (or spiritual) act. She believes that a closer aproach to a subjective grasp of the biographical subject can be reached through an existential awareness of the contexts of the interpreter's own situation. This book encourages such awareness as necessary for comprehending a figure like Emily Carr, and for comprehending the biographical approaches to Emily Carr. It can also help us extend our own humanity as we realize what are the contextual images underlying our own attempts to construct a self, both biographically and autobiographically.

William Closson James
Queen's University

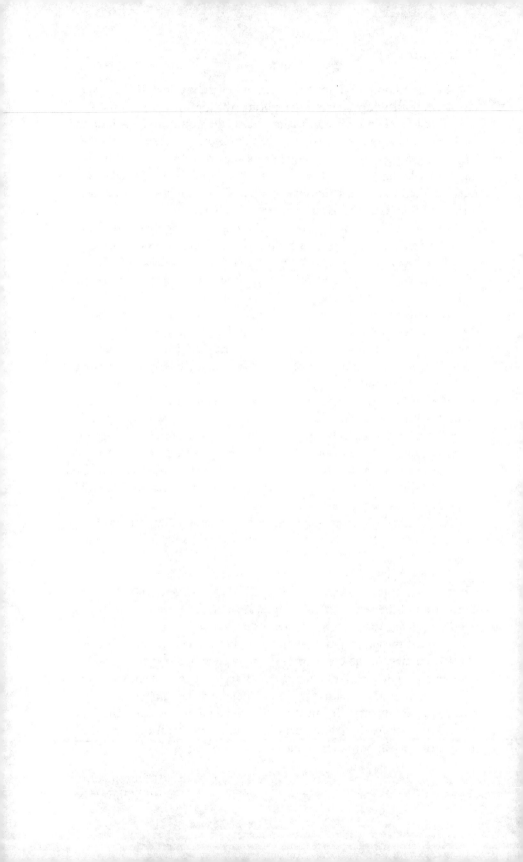

ACKNOWLEDGMENTS

My interest in the lives of artists grew, as I did, in the countryside just outside the tiny village of Blair, on the Grand River in Waterloo County, Ontario. Memory layers scenes and seasons, saturating them with music and art. Most days seem still, configured by the sound of my mother's piano. Yet often enough the atmosphere was convivial, filled with the harmonies of musicians at play; fervent conversations, stretching days far into the night, were swallowed by the hills or by dawn. To maintain a certain decorum, as I recall, religion and politics were avoided topics, but life and art were ready surrogates and argument a common pleasure. John Martin was my champion contender. He and Carl Schaefer taught at the Ontario College of Art in Toronto and, in the summers of my adolescence, came to teach up river at the Doon School of Fine Arts. They both became family friends and through them I caught a glimpse of the larger world of art in Canada. Mostly, though, there were music and musicians. Active throughout the region, many played in the Kitchener-Waterloo Symphony or sang with the Preston Operatic Society; a few jazz musicians moonlighted with the dance band at Leisure Lodge. Others were church soloists (including my grandfather, John Wildman, who had a fine tenor voice) and a few, active on farther, perhaps grander stages, were sojourners.

Maria Tippett's description of the place of the arts in English Canadian communities at mid-century, in *Making Culture*, rings true for me. Making and attending to the arts were critical activities; meaning lay in or beyond or through art. How radically artists who knew modernism conditioned my own views has become clear working through the matters of this book. Emily Carr's words and images, the details of her life and the words of those she in turn has stirred, bring my early world to mind. My principal questions were shaped there. The midnight voice of John Martin remains quintessential, as do his enthusiasms and the sweet agonies of his life—*sweet* because his art and religion

(a glorious Anglicanism) were entwined. There was always more mean-
ing and another image, more mystery, much more to living.

Coming to terms with modernism and tracing the facets of bio-
graphical writing and cultural change through the imaged life of Emily
Carr have allowed me to make connections with scholars, artists and
readers who have made the work a pleasure. In addition to those I will
name, my appreciation goes to many others for their reflections.

First I wish to thank Johan L. Aitken, my supervisor at the Univer-
sity of Toronto, whose wisdom, sensitivity and fine humour made the
dissertation process at once disciplined and enchanting. The encourage-
ment of three art historians and Carr scholars was also invaluable:
Nancy-Lou Patterson's abundant insight into the relations of art and
religion, Gerta Moray's firm and facilitating critique and Ann Davis'
generosity were truly welcomed. For their help in interpreting Cana-
dian culture, my thanks to the other members of my committee, Roger
O'Toole and Roger Hutchinson and, for their inspiration, to Phyllis
Grosskurth and John S. Moir.

In Victoria I benefited from helpful conversation and practical
advice. At the British Columbia Archives and Records Service my
thanks are due Jerry Mossop for guiding me through the collection of
Carr drawings and Brian Young for his assistance on manuscript mat-
ters. Thanks too are due John Adams from the Heritage Properties
Branch for a delightful and informative off-season tour of the Richard
Carr house. And, in Ontario, my thanks to playwright Eileen Whitfield
and poet Pam O'Rourke for sharing their own work on Emily Carr.

Links with Wilfrid Laurier University, where I first returned to
graduate school from the dominion of art and children, continue to be
a source of creative learning. For his view of the world, education in
Canada and life in the nineteenth century, all of which make differences
clearer, I am grateful to Peter Erb. To Ron Grimes, from whom I
learned skills to sustain habits of peripheral vision (akin to Carr's fresh
seeing) and tactics for sorting biographies, a very special thanks.

Many continuing conversations, a joy of friendship, have been
crucial. From Trudy Moul's views on justice and community I have
learned much about the moral ground that informs biography. Helen-
May Eaton's study of Latin American women's testimonies has added a
powerful dimension to my understanding of the genre, one not easily
seen in English biography. Becky Lee's interest in medieval women's
lives, Darlene Juschka's work on feminist theology and Pamela Klassen's
studies of Mennonite women have strengthened my sense of women's

traditions. Susan Scott's capacity to ground vision has reminded me how indispensable such skills, much like Carr's, are.

Finally I am grateful for several sources of financial support. During the days I spent in Toronto, the tranquillity of Massey College, which I enjoyed as a non-resident Junior Fellow, the sounds of water and the feel of stone kept my mind clear. For their support during my doctoral program I thank the Social Sciences and Humanities Research Council of Canada. In addition, this book has been published with the help of a grant from the Humanities and Social Sciences Federation of Canada, using funds provided by the Social Sciences and Humanities Research Council of Canada.

When all has been said, there remain two people whose patience and common sense during the hours of manuscript-making were constant. As friend and publisher Sandra Woolfrey's facilitating persistence, insight and her energy were essential and appreciated ingredients. To my husband Jim I am indebted for hours and hours of his careful reading and clear advice.

To Jim, again, and to my sons Timothy, Marcus and Julian my thanks for the preparatory training: the years of your relentless logic and the joy of your laughter. For sheer sustaining pleasure, my gratitude to Paulette and baby Nathaniel.

Abbreviations

GP Carr, Emily. 1986. *Growing Pains: The Autobiography of Emily Carr*. Toronto: Irwin.

H&T Carr, Emily. 1986. *Hundreds and Thousands: The Journals of Emily Carr*. Toronto: Irwin.

KW Carr, Emily. 1986. *Klee Wyck*. Toronto: Irwin.

Small Carr, Emily. 1986. *The Book of Small*. Toronto: Irwin.

DW Walker, Doreen, ed. 1990. *Dear Nan: Letters of Emily Carr, Nan Cheney and Humphrey Toms*. Vancouver: University of British Columbia Press.

INTRODUCTION: PRELIMINARY THOUGHTS ON BIOGRAPHY AND MEANING

> Profane is to sacred as living is to telling.
> — Stuart Charmé (1984: 98)

A deceptive genre, positioned between fact and fiction and elusive in its purposes, biography displays an individual life, an existence patterned by conventions that have also shaped the reader's experience. Biographers, for the most part self-effacing, masquerade as benign chroniclers able to mark the events and rituals of the life cycle with certitude. Birth, youth, education, career, social alliances and death exemplify familiar categories of experience. Yet beneath this blanket of narrative cohesion, the tendency of biography is to promote ambiguity. No life story is complete, nor completely explained. Like a magician, the biographer attracts attention to an individual life and allows details of collective experience to cluster at the periphery of the text; there, unexamined, they quietly convey tacit assumptions, the unconscious and habitual formulations of the meaning of life that are embedded in cultural gestures. Apparently presenting the constituent elements of a single life, the genre creates a narrative forum where, amidst its conventions and the ambiguities and complexities of existence, matters of ultimate concern can be contemplated.

My primary interest here lies in biography as a literary form able to convey or display religious matters within a milieu perceived as predominantly secular. In an age suspicious of the non-rational, one that marks the boundaries between religious life and other facets of being, biography concerns itself with addressing the central or significant dimensions of an

The note to this Introduction is on p. 157.

1

individual's existence in a manner that infers destiny, a style predicated on the meaning of life, the profundity of being. An increasing dependence on personal experience as the basis and justification for opinions and beliefs, across a broad spectrum of life's occasions, has granted this once modest genre new significance even as identity, subjectivity and self are discovered to be conditional terms, neither transparent in meaning nor inevitable as categories. Narrative accounts grant particular lives significance within larger contexts of meaning. Offering evidence and common sense, biography helps readers navigate intellectual currents that are carrying away familiar, comfortable notions.

By positioning a life, giving it context and supplying meaning, the biographer may condone or sustain some of the genre's conventions, question or reinterpret others, even invent new categories of being, in each case making decisions that qualify the nature of existence being displayed through the biographical subject. These conventions, familiar and flexible, can convey as broad a range of ideas and attitudes as the biographer deems the life to have encompassed. The biographical urge to account for life's meaning, to describe an individual's place in the scheme of things, can be explicitly or implicitly religious, even determinedly secular. Whatever the expressed sentiment toward religious matters, writing a life requires an act of imagination directed toward the order of being. It is this quality of life writing, whether in biographies, autobiographies, journals and diaries, letters, or film accounts, that attracts my interest: the intrinsic religious dimension of the genre. A definition that effectively accommodates the genre's tryst with ultimate concerns holds religion to be "the organization of life around the depth dimensions of experience" (King 1987: 286). At one level or another, in the details of life or the design behind it, the biographer is concerned with just such organization.

To assess the capacities of the genre my study focuses on one biographical subject, Emily Carr. My task here is not to interpret her life once more, to add another biographical account, but rather to examine existing interpretations as evidence of the practice of biography, to explore her *biographical image* as it emerges from the accumulation of narratives. By considering this *biographical image* to be a coalescence of texts (rather than separate and sequential versions marked by increasing accuracy or deeper insight), the details or *facts* of her life become familiar. Through repetition they establish a rhythm, an expectation, a sense of this particular woman; freed from gathering facts, the reader's attention can be directed toward variations of interpretation, form and style among the

different accounts. With several configurations of one life as a ground for study, then, and without the interruptions of factual uncertainty or the need for verification, the condition of the genre as a cultural process— one that produces a textual artifact, a biography—becomes clearer.

Emily Carr is the particular subject at the centre of this study for strategic reasons, as well as intrinsic appeal. By choosing a female life my work engages a growing body of feminist scholarship on the social construction of subjectivity, the rhetorical force of marginality and the circumstances of women artists. Carr's biographical profile—descriptive of a visual artist, a writer and a modernist woman—is sufficiently elaborate to interrogate the conjunction of religion, women and art from the late nineteenth century to the present. Full biographies, biographical essays and sketches, films, drama, archival collections and her own autobiographical writing reflect a variety of interpretive methods responsive to cultural pressures. Many significant issues of her era emerge as themes in the narratives of her life: the lineage of the female artist in Western culture; the effects of Empire, whether measured as the distance of Victoria from London or in the patriarchal behaviour of her father; the image and role of native Canadians in the culture of the Dominion; the meaning of nature as a factor in landscape painting and in the debates between science and religion; the significance of spirituality in art. Carr's religiosity, at once unique and representative, reveals a deep longing for meaning that modernism addressed through art. It emerges in her paintings and variously in the perspectives she adopted for the different forms of her autobiographical writing. In short stories, formal autobiography, journal writing and letters Carr stencilled a figure of her life for later biographers. Her story, like that of many other compelling biographical subjects, draws readers easily into a domain where clear close focus on the complexities of a particular life precludes generalization, where categories and types are empty devices and profound insight is inferential. An attraction of the genre for readers and writers alike, even in our era of suspicions and ironies, remains the garb of its conventions; their capacity to lend credibility to a lived life facilitates thoughtful explorations in both familiar and unfamiliar territory. With regard to religion and spirituality in a secular culture, Carr's story illustrates the twisting turns of discourse and its processes of redefinition throughout the second half of our century.

I have designed my text thematically in anticipation of the strength of biographical conventions to swerve attention toward accuracy of interpretation, particularly through claims to linear and chronological develop-

ment. Instead of patterning my progress according to the occasions and
concerns of Emily Carr, even of her advocates or detractors, I have drawn
this particular life into the arena of life writing.[1] Thus I write of what we
infer from encounters with the genre and the alterations in the genre's
meaning as beliefs, philosophies and creative impulses change. As much as
my concern is with how Emily Carr wrote herself, it is also with the piv-
otal place held by accounts of the lives of women artists and the manner
in which a single life—like a pebble dropped in a still pond—can affect
any number of concerns on its periphery. I begin with the form of life
writing that often seems closest to the truth, to the source of one's being.
The first chapter, "The Edge of Nowhere: Emily Carr and the Limits of
Autobiography," deals with the religious act inherent in writing the self.
The ambiguities and certainties generated by Carr's version of her life
become clearer when read against the rapidly increasing literature on
women's autobiography. In the second chapter, "The Enigma of Biogra-
phy," my attention moves away from Carr's life, from *any* particular his-
torical existence, to consider the genre as a culturally sensitive forum for
experimentation, a site of discourse, that confirms the concept and the
reality of an individual subject. An important dimension of any narrated
life is the illusion of accurate presentation. Throughout the development
of modern biography, factual accuracy, though highly valued, has been
difficult to achieve. Recently it has succumbed to an excessive accretion
of detail, especially through the growth of archival records. In addition to
a surplus of information, the deconstructive suspicions of postmodern
thought coupled with the genre's taste for fiction have put additional
pressure on its interpretive aspects. Still, regardless of assaults upon the
veracity of real experience, life stories continue to be read as written, *as if*
they reflect metaphysical assumptions while negotiating matters of per-
sonal and social concern. In the case of Emily Carr the nexus of personal,
social and metaphysical matters has generated deliberations on the status
of women as artists, in language, as political creatures, and as mediators
between this world and another accessible through nature.

 In the following chapter, "A Mirror to Culture: Moments in the
Development of the Genre," there is a double focus on the genre and
Carr's biographical image. The trajectory of biographical writing in
English, characterized by developments in the late eighteenth and early
twentieth centuries, can be usefully associated with the growth of secu-
larism. The British biographical model, specifically, has influenced the
patterns of biographical writing in English: Virginia Woolf's opinions
on biography, as an artist and a modernist in England between the wars,

sheds light on the pressures, contexts and accounts of Carr's life. Biography in English also continues gender patterns evident in earlier European hagiographical writing. In this chapter, as well, the early development of Carr's biographical image from the 1940s—when her writing first attracted national attention to the story of her life—into the 1960s is analyzed against Canada's mid-century spiritual quest, a regional version of larger debates in the postwar West on the links between religion and culture.

Chapter 4, "Life and Text: There Once was an Artist Named Emily Carr . . . ," deals with the presentation of Carr's life as a woman and an artist and engages recent feminist scholarship on gender, art and biography. Reacting to the winds of change in the late 1960s and early 1970s, biographical images of women underwent fundamental modifications and provided a forum for the recovery and invention of women's spirituality as a cultural force. The appearance of substantial Carr biographies in the 1970s and 1980s reflected those changes. An increase in the general production of biographical lives, a new awareness of the significance of female models, and critical analyses of narrative in its own terms underscored the importance of meaning extrapolated from experience as an alternative to more traditional, abstract and systematic theological thought. Biographies of Emily Carr appearing during this period fortified Canadian culture and helped fill a spiritual void created by the dearth of female narrative lives.

The final chapter, "Deep Nature: Survival in a Constructed World," examines the genre in terms of broader social and intellectual forces, particularly current political, philosophical and sociological preoccupations that fuel critical theory. The nature of inspiration and its association with divinity, set beside women's disadvantages in the art world, introduce complex assumptions characteristic of Western culture. The capacity of art to absorb the vocabulary and processes of religious experience enhances many readers' appreciation for Carr's quest for spiritual meaning. For several biographers her response to power in the natural world placed her in the company of mystics and theologians. Biography deals with general cultural concerns by drawing upon a range of contemporary ideas; biographers indicate direction and readers bring their own knowledge to the text. In this chapter I follow the lead of Carr's biographers and embellish their narratives with thoughts on landscape, art and psychoanalysis which are my own intellectual concerns in the present. In its critical guise psychoanalytic theory implicates Carr in the twentieth century's fascination with the primitive:

native art and spirituality inspired her; the boundary between her west-
ern Self and the indigenous Other offered freedoms available only at the
periphery of order. Interest in the lives of other women artists on simi-
lar margins, like Georgia O'Keeffe and Frida Kahlo, suggests a societal
urge to come to terms with the links between women, art and nature.
The images of these substantial biographical figures, like Emily Carr's
image, cast generative shadows across inchoate notions and pull them
toward the brighter light of discourse.

For the full impact of the recovery of female experience to be
appreciated, traditional definitions of religion, culture and spirituality
must be stretched, new and appropriate metaphors developed and
unsuitable biographical conventions reshaped with improvisatory skills.
Women's lives have not passed easily, if at all, within public or institu-
tional spheres devoted to progress and achievement. Metaphors that val-
idate repetition and interruption, innovation within tradition, that yield
depth and intensity, are among those likely to generate fresh categories
able to describe contemporary apprehension of female identities.

In attempting to account for the appeal of biographies of women—
narratives in a genre that has been judged a tool of patriarchy, a genre
superbly suited for heroic gestures and achievement but less viable for a
life intensely rich in meaning, quietly complicated and incised with
considerable anger—I have taken seriously the notion of scholarship as
conversation which generates knowledge. Rather than groping toward
a pragmatic truth, I imagine my voice contributing to a discursive explo-
ration of life narrative whose purpose, in constantly circling the subject, is
continuing and vital insight. The biographical subject remains, at the end,
as elusive as ever. If it is, as Carolyn Heilbrun has said, that women come
to writing simultaneously with self-creation (1988: 117), this text rests as
an analysis of the genre, an encounter with the record of another
woman's life and a robing of myself in codes of irony.

> As readers entering into the experiential world of another con-
> sciousness, we move once more within the human dimension
> where it is still possible to believe in the meaning of a personal
> identity. The impersonality, fragmentation, and alienation of
> the postmodern world seem less overwhelming as we follow the
> vicissitudes of a real person—a brother or sister creature from
> whom we grasp vicarious validation of our own lives. Perhaps
> this is one reason why autobiographies and biographies are pro-
> liferating as never before.
>
> — Susan Groag Bell and Marilyn Yallom (1990: 1)

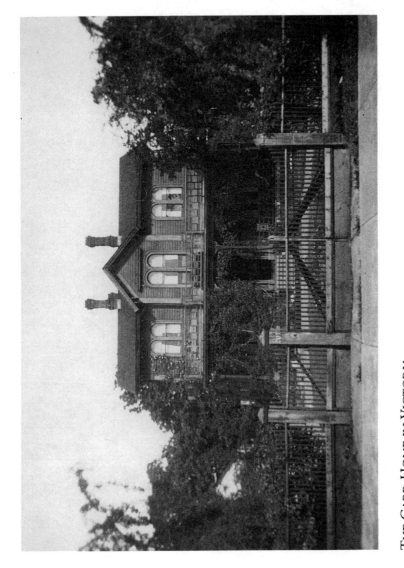

THE CARR HOME IN VICTORIA
(British Columbia Archives & Records Service HP17811, used with permission)

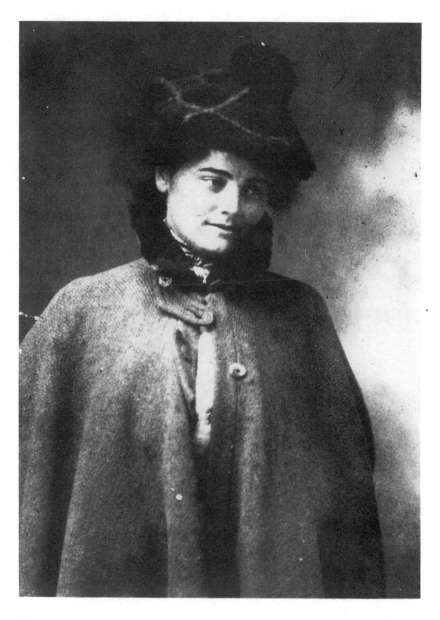

EMILY IN CORNWALL
(British Columbia Archives & Records Service HP27429, used with permission)

"The Edge of Nowhere": Emily Carr and the Limits of Autobiography

> You yourself are nothing, only a channel for the pouring through of that which is something, which is all.
>
> — Emily Carr (*H&T*: 34)

> An *Autobiog.* is the only *Biog.* that can truthfully be done, I think . . . & I'd feel a FOOL if I wasn't dead.
>
> — Emily Carr (*DW*: 307)

JANUARY 1994: THE SPECTRE of Emily Carr filters through the interstices of Canadian cultural life, a periodic manifestation affirming the strong appeal of her biographical image. As a mark of her increasingly elaborated national stature this appearance arouses both praise and suspicion. On the Canadian Broadcasting Corporation's weeknight television program, *Prime Time News*, a short documentary retells the life of this familiar British Columbia artist and writer. The details of her heroic private and professional life, religiosity and commitment to the natural world are linked through the wizardry of the medium with the romance of nature and the allure of a remembered life. The sensual visual mass of Carr's forest landscapes, hints of her voice—it moves across the treed surface of the television screen as transparent pages from her diary—and archival photographs alternate with the legitimating convention of interviewed experts. Critic Robert Fulford and Carr scholar Doris Shadbolt (whose collected edition of Carr's writing appeared in the autumn of 1993) contour Carr's appeal

Notes to this chapter are on pp. 157-61.

to our hearts and souls with explanation, interpretation and clarification. Writer Susan Crean, at work on a new life of Emily Carr, infuses the mood with thoughtful enthusiasm.

Though mention is made of Shadbolt's book in the documentary, none is heard of Fulford's feature article, "The Trouble with Emily Carr," that had just appeared in the winter issue of *Canadian Art*, adumbrated by the tantalizing comment: "How Canada's greatest woman painter ended up on the wrong side of the political correctness debate." Over the years since her death in 1945 there has been little negative criticism of Carr's intense pivotal engagement with native culture. In late-twentieth-century thought, however, questions of ethnicity and identity are characteristic. The fragmented and elliptical reasoning of postmodern thinking and the energies of postcolonial political and cultural strategies are as attracted to Carr's life as her image is augmented by them. Fulford's account, his assessment of the validity of claims of cultural appropriation, is a strong articulation of Canadian values derived from traditional Western notions of art and subjectivity. However, a new struggle for meaning, one that can be engaged through versions of Carr's life and responses to her art, is being played out in museums, galleries and publishing houses. Fulford acknowledges this with his claim that Carr's "legacy has become a battlefield in the culture wars, the subject of postmodern revisionism combined with retroactive racial justice" (Fulford 1993: 37). From the perspective of the cultural function of biography, the vitality of this particular woman's life as a source of meaning and definition for disparate points of view offers fertile material for contemplation of the genre itself. The exploration of concerns at the periphery of our understanding, as these surely are, may be the genre's signal feature. Emily Carr's experience of the world, lived on geographic and cultural boundaries, has invited interpretation. While the rich density of her biographical image created by the elaborate re-creation of her life renders her a precious specimen for a study of the genre, it also sets a formidable task before the reader. The genre is seductive. Here I am asking you, the reader, to think about the life of this particular woman as a specimen, an example of cultural practice deemed especially valuable in the present, to see *Emily Carr* as a biographical image.

Born in 1871, midway through Queen Victoria's reign, Carr spent her life circumscribed by codes of British hegemony that inferred a natural and certain order.[1] During her adult years, from the turn of the century until her death in the last months of the Second World War,

she participated in a cultural dynamic that stretched those codes to their limits, an energy in the arts that linked North America to Europe and set in motion the tensions of our own postmodern present. An unmarried female artist, determined and visionary, she challenged religious, social and artistic conventions. Marginalization by geography on the west coast of Canada had given her an exceptional view of the world. Marginalization by gender deprived her of easy access to the practices of art. Today her work, both her painting and her writing, is well known; in her lifetime, though recognized, she was never adequately rewarded.

Carr lived most of her life in Victoria, British Columbia, a small town she knew to be an outpost of Empire. To come to terms with then current attitudes and concepts in painting she left home as a young woman to study first in San Francisco (1893-95), later in England (1899-1904) and finally, when she was forty, she travelled to France (1910-11) where she found what she had been seeking. The period of her mature work—unique, powerful images of totem poles, forest and sky—from 1927 to her death in 1945, coincided with the apogee of the Group of Seven and, like them, she drew upon sentiments of nationalism linked to the northern mystique of the Canadian landscape. She felt the prodding of abstraction that came to Canada through Theosophy and in her work echoed the earthiness she found in the poetry of Walt Whitman. Her life, full and heroic in its own terms, offers biographers vibrant contrasts from which to coax evidence of dilemma and struggle. Richly linked to the cultural energies of her time and startlingly individual in her assessments of them, she attracts interpreters with promises of dense and splendid narrative.

Since the Renaissance, artistic vision in the West has been linked to glimpses of divine truth. Before the end of the nineteenth century avant-garde painters, in step with scientific innovation, found new techniques and materials to portray the world around them. The southern French landscape of Provence, a staple image for Cézanne and Van Gogh, represented a new space, an outdoor, light-filled world in whose embrace some elemental truth could be found. When this same space was blown apart by the First World War, any effortless access to certain Truth disappeared. If there was an order in the cosmos, it would not be found amidst the fragments of knowledge that remained. Carr's generation of painters continued to believe that the centre endured but in some other form, perhaps another dimension. T. S. Eliot spoke their meaning when he said: "Except for the point, the still point, / There would be no dance, and there is only the dance" (Eliot 1949: 15-16).

Similarly, a reviewer of Lawren Harris' work commented that

> the so-called natural world of which we are so cognizant is but a more
> dense and gross manifestation of that which moves at a much higher
> rate of vibration on higher planes, so it is right and natural that the
> artists of the race should be the bridge of interpretation between these
> two realms. (Reid 1985: 36)[2]

One of Canada's Group of Seven painters, Harris had a strong and
enduring influence on Carr. He wrote to encourage her to take up the
artist's task in words that reveal the power he felt lay behind the order of
things.

> Now listen again, don't you weaken or get discouraged where you
> once did. If and when that comes go right to the heart of it, that
> place, and say, I Emily Carr, command quiet here, there will be new
> growth, a new fruition, no old weeds, but the spring of a new life.
> Make everything within quieter than it has ever been before . . .—so
> that the new vision, the new life, the new conviction can arise with-
> out disturbance. It will then. (Ibid.: 11)

This notion of meaning bears traces of belief in a traditional Christian
omniscient God. Simultaneously, in England, Virginia Woolf—whose
writing would have a profound effect on the narrative shape of
women's lives and the writing of biography—was voicing a similar sen-
timent in words that make clear her separation from conventional
Christianity.

> Behind the cotton wool [her term for moments of non-being when
> life lacked clarity] is hidden a pattern; that we—I mean all human
> beings—are connected with this; that the whole world is a work of
> art; that we are parts of the work of art. *Hamlet* or a Beethoven quar-
> tet is the truth about this vast mass that we call the world. But there is
> no Shakespeare, there is no Beethoven; certainly and emphatically
> there is no God; we are the words; we are the music; we are the thing
> itself. (Woolf 1985: 72)

A widespread frustration with the inability of the institutions of lan-
guage and art to contain the energies of modernity coexisted for Carr's
generation with convictions that a profound truth was available, if not
in the world, then deep within the individual.[3] Picasso's thoughts on
the word "sacred" characterize the modernists' dilemma with old and
new forms:

We ought to be able to say that word, or something like it, but people would take it the wrong way, and give it a meaning it hasn't got. We ought to be able to say that such and such a painting is as it is, with its capacity for power, because it is "touched by God." But people would put a wrong interpretation on it. And yet it's the nearest we can get to the truth. (Lipsey 1989: 19)

Like other artists for whom the ideals of the Christian West had become restrictive, Carr rejected moribund convention. Her rebellious and determined individualism epitomized the oppositional posture of avant-garde artists as they scanned the cultural horizon for new words and images for a recovered reality, for uncommon truths suppressed in the construction of a salvific and progressive destiny.[4] A desire to revive and locate meaning suffuses Carr's writing. For her the work of the creative artist was "fresh seeing."[5]

As a modernist Carr could turn her back on institutions and convention, but as a female artist those structures were never fully accessible to her, whether they were the conspicuous ones of school, church and art academy or the less obvious ones of language, image and self.[6] In terms of the larger art world the rewards she received were small and came late; the resources she could command were few.[7] Tensions between the cultural energies of her generation and the social realities of her existence, between the centres of art and the periphery she inhabited, lie behind her observation that if her art, "the work of an isolated little old woman on the edge of nowhere, is too *modern* for the Canadian National Gallery, it seems it cannot be a very progressive institution" (*DW*: 12, n.4). Carr had been stimulated by European art to move her work toward new idioms not yet familiar in Canada. In geographic terms her "edge of nowhere" describes Victoria when it was a small British colony on the Pacific edge of western Canada. The forests at the centre of her vision marked remote margins of sea and mountain. She has been accused of exaggerating the isolation and daring of her trips to native villages.[8] Her rhetoric, however, served to pull her toward the core myths of the modern heroic artist—so much so that her "edge of nowhere" has become a centre for our gaze. Few women artists and few Canadians have received as much biographical attention as Emily Carr.[9]

In examining Carr's writing, her image of centre and periphery serves as an apt figure for her autobiographical acts: a formal autobiography, five volumes of short fiction, letters and her journal.[10] Fundamentally perilous, the process of drawing one's own life into words

generates an account in which the writing self—as narrator, subject and
reader—is both object at the centre and observer at the periphery, at
once looking out at the world from a centre of being and back, or in,
upon a life from the writing table. By adhering to generic expecta-
tions,[11] the practice of self-writing and the reception of the text create a
cultural site, an arena for experimentation with life in story. At any
moment of self-creation or reconstruction, a multiplicity of life features
can be in motion between centre and periphery. As memory shifts its
focus, they are drawn into narrative by a process whose confounding
mysteries suggest that memory "is not a collective of psychic traces, but
rather something we do with our lives" (Charmé 1984: 21).

*At this point I feel obliged to interrupt my own writing to direct attention
to the limitations of my position within this arena where, with others who may
have quite different agendas, I am at work on the biographical image of Emily
Carr, an image accessible and significant to a substantial and growing audience.
Biographers and art historians tend to dissect archival clues, sift the evidence and
forge new insights to elaborate the life of this particular woman. My questions
concern the role of Emily Carr as cultural knowledge, as a token in our economy
of meaning, in whatever shape or interpretation she reaches us. While I find
that distinguishing the historical subject from the biographical image is emotion-
ally difficult and intellectually complicated, that is the task to which I am
drawn. Nevertheless, there is something fundamentally skewed in my analysis
of Emily Carr as an autobiographical subject, a text, not myself, as if the
woman who lived and carried the name is accessible to me. Current theoretical
deconstruction of the subject could eliminate my topic, cut under my voice; how-
ever, in theory's shadow, sheltered and liberated by the power of its critical gaze,
Emily Carr can exist for me as both a repeatedly recreated biographical image
and a remembered woman.[12] The issues of voice can be extended. Although
Carr had privileged access to the story of her life, for those of us who encounter
her image half a century after her death, with only tenuous connections to her
world, her version is but one interpretation of many.[13] It is not marked by
greater factual accuracy; quite the opposite. Nor is her voice necessarily the earli-
est. She wrote late in her life; others could comment sooner or look back further.
And she continues to speak: some of her material is only now appearing. A fur-
ther complication, to be considered below, is the variety of distinctive forms in
which she created herself. The notion of autobiography as a cultural site allows
these contradictions to flourish. Within the space of the written self, by conven-
tion, there is an Emily Carr that I can know and assess and, thus, recognizing
the limitations, I can continue. . . .*

Inside the autobiographical forum, as an artist with modernist proclivities for opposition and depth, Carr did find new words and images to describe her experience.[14] By virtue of an artist's privileged vision, she observed central truths from strategic positions within or at the margins of custom. The tension between centre and periphery, inherent in the autobiographical act, was heightened by her modernist rejection of the order of things. For women like her, engaged in the modernist project, who were already systematically excluded from the institutions of art, that tension was sharpened further still (Wolff 1990: 86).[15] Suppressed energy, perhaps charged by that tension, suffuses much of Carr's writing, including this self-imperative in a journal entry from 1932: "Do not try to do extraordinary things but do ordinary things with intensity. Push your idea to the limit, distorting if necessary to drive the point home and intensify it, but stick to the one central idea, getting it across at all costs" (*H&T*: 32).

Emily and God: Creating the Modern Self

In addition to the spiritual dimension of self-creation inherent in the modernist enterprise, Emily Carr also addressed her religious life directly, most commonly in her journal. An entry from December 1940, in her sixty-ninth year, is characteristic in sentiment, insight and humour:

> To church-goers I am an outsider, but I *am* religious and I always have been. . . . Alone, I crept into many strange churches of different denominations, in San Francisco, in London, in Indian villages way up north, and was comforted by the solemnity. But at home, bribed occasionally into the Reformed Episcopal, I sat fuming. . . . I wanted to stand up and screech and fling the footstool and slap the prayer books. Why must they have one voice for God and one for us? Why be so conscious of their eyes on the prayer book and their glower on you? Why feel disapproval oozing from them and trickling over you? Why feel yourself get smaller and smaller, wilting like spinach in the process of being boiled? I longed to get out of church and crisp up in the open air. God got so stuffy squeezed into a church. Only out in the open was there room for Him. He was like a great breathing among the trees. In church he was static, a bearded image in petticoats. In the open He had no form; He just *was*, and filled all the universe. (Ibid.: 329)

She put similar ideas into story form. "Sunday" from *The Book of Small* is a wonderful depiction of her Victorian childhood: cold baths, endless

prayer and sedition. In "D'Sonoqua," a story from *Klee Wyck*, she de-
scribed the tremendous totemic power of the wild woman of the
woods:

> Sitting in front of the image, [I] gave stare for stare. But her stare so
> over-powered mine, that I could scarcely wrench my eyes away from
> the clutch of those empty sockets. The power I felt was not in the
> thing itself, but in some tremendous force behind it, that the carver
> had believed in. (*KW*: 36)

Though Carr's strong opinions on the Church and fervent desire
to locate God in the forest are clearly articulated, the central notion in
her journal, published in part as *Hundreds and Thousands* in 1966, is her
life as an artist, not as God's creature.[16] In an entry from 1931 she links
the centre of her being to the God in the forest through obligations
embedded in the artist's heroic struggle.

> I am always asking myself the question, What is it you are struggling
> for? What is that vital thing the woods contain, possess, that you
> want? Why do you go back and back to the woods unsatisfied. . . .
> This I know, I shall not find it . . . until the God quality in me is in
> tune with the God in it. Only by right living . . . intense striving . . .
> shall I find that deep thing hidden there. (*H&T*: 28-29)

Her words echo a romantic notion of divine purpose embodied in
nature. However for artists like her, alive to the fractured order of the
twentieth century, metaphysics came "indexed to a personal vision, or
refracted through a particular sensibility" (Taylor 1984: 491). Insight
embedded in nature could no longer be directly apprehended; it must
be given form by the artist. The burden of creation had shifted to this
world. In Carr's words:

> It is splendidly wonderful, the things that lie beyond, that we try to
> capture with instruments or paint or words, the same things that we
> are all trying to build, to create, the thing that our bodies are trying to
> give a spirit to and our spirits are trying to provide with a bodily
> expression. (Ibid.: 157)

She was not a systematic thinker. Emily Carr could as easily imag-
ine herself a channel to God as she could insist on the priority of form.
Still, however fluid her version of ultimate structures, she seldom lost
her direct and grounded view of things: "writing is a splendid sorter of
your good and bad feelings, better even than paint. The whole thing of
life is trying to crack the nut and get at the bitter sweetness of the ker-

nel" (ibid.: 322). A key aspect of her attempt at sorting, at cracking the nut, was the writing of her life. In his study of Sartre's existential psychoanalysis Stuart Charmé describes the biographical endeavour as a major creative act in which the self is sacralized: "The 'fundamental project' of every person becomes that of self-creation and protection of the ever-changing boundaries of the self where chaos and order meet" (Charmé 1984: 125). This "inward turn" of the twentieth century, away from epiphanic insight through nature toward meaning within the structures of the self (Taylor 1984: 461), mirrored in art, gave new impetus to autobiography. For Sartre at mid-century, according to Charmé, the goal was "to become God, divinely self-sufficient and unchanging" (Charmé 1984: 125) and, in solving questions of his own identity, to find answers of larger cultural and historical significance (ibid.: 113). The modernists' preoccupation with self, meaning and structures offered a task, an agenda that could recover reality for the individual and the community. Writing the self redeemed the world.

More recent work reflects that same strategy without theological language and moral imperatives. The task becomes one of drawing *facts* from the flow of events in our lives, of rendering life *narratable*. In that act meaning is conferred. William Epstein draws attention to "epistemological naivete" as a distinctive feature that makes life writing "one of the last strongholds of empirical knowledge" (Epstein 1983: 288),[17] "a distinct cognitive activity" (ibid.: 295) and "a powerful institutionalizing instrument" (ibid.: 298). A related point is made by Roger Lipsey in his study of the spiritual in twentieth-century art: "Metaphysical and theological maps, profound psychologies and spiritual teachings may indicate the pattern of the whole quite convincingly, but what one really knows is what one has experienced" (Lipsey 1989: 9). In narrating experience the nut is cracked, experience got at, speculation set aside.

IN THE ARENA OF SELF-WRITING

Much of Emily Carr's writing was done in the late 1930s, a decade that saw an uncommon proliferation of women's autobiography. Many of these women—Gertrude Stein and Emma Goldman are American examples; Nellie McClung, Canadian; Virginia Woolf, British—were of a generation to benefit from the insights of the women's movement at the turn of the century (Jelinek 1986: 128).[18] Strong and individualistic, often educated, like Carr they had forged public lives distinct from the private sphere more customarily described by women. Devotion to

art, however, did not exempt Carr's writing from characteristics representative of female autobiography, features that tend to prohibit the construction of a coherent self of the kind prized by Sartre: a multiplicity of narrative forms, fragmentary and disjunctive themes, an absence of chronology and the elaboration of an intimate and private world.[19] If Sartre's model and Carr's are indeed representative, they suggest that the genre supports gendered life experience.

Emily Carr's densely autobiographical writing in all of its genre forms constitutes a personal myth shaped around repeated themes, among which can be included the natural world and the world of native Canadians, childhood, family, animals, fractious tenants and the urban world of schools, galleries and hospitals. The forms Carr chose for her writing can also be distinguished by the distance they establish between the writer and the reader. She is most deliberate and formal in her autobiography, *Growing Pains*, published posthumously in 1946. Anecdotally shaped around her education in San Francisco and England, with a concluding section on her experiences as a mature artist in Canada, *Growing Pains* reveals less about life purpose and professionalism than about her relations to family and friends, and her alienation from urban society. Though it is in this work that she engages the institutions of art most directly, their effects are deflected by the necessities of charting her own course. Her growing pains are not caused so much by assembling the pieces of her career as they are by forging values in a world that does not recognize or accommodate her ambition.

In separate studies of the autobiographical writing of women on the margins of Western culture, Sidonie Smith and Françoise Lionnet delineate the exclusion of women. For Lionnet the female narrator of autobiography "gets caught in a duplicitous process" (Lionnet 1989: 93). She writes within a tradition using conventions that she intends to subvert. Smith claims that woman has no autobiographical self: the genre is "one of the forms of selfhood constituting the idea of man."[20]

> Since the ideology of gender makes of woman's life script a nonstory, a silent space, a gap in patriarchal culture, the ideal woman is self-effacing rather than self-promoting, and her "natural" story shapes itself not around the public, heroic life but around the fluid, circumstantial, contingent responsiveness to others that, according to patriarchal ideology, characterizes the life of woman but not autobiography. (Smith 1987: 50)

Reading Carr's autobiography with these ideas in mind, the tensions in her life seem inevitable, her particular strengths more evident. A claim

that she took a stand at the edge of nowhere, made that a place of power, and engaged modernism on her terms, can be made but only if her long, determined and difficult struggle is acknowledged.[21]

The misalignment of female experience and autobiographical expectation may account for Carr's interest in other prose forms. In the several volumes of her stories, which often deal with memories of the years before she gained a wide reputation, she is less aloof than in her autobiography, but similarly studied and artful. Facts are not at issue; rather, areas of her life emerge as thematic domains. She splinters into a gathering of versions of herself: an intrepid artist moving through the natural world, encountering native Canadians and their totems; a beleaguered landlady who befriends and nurtures animals; a girl called Small in an Edenic colony.

In her journal Carr frequently commented on her stories. Of "Cowyard," one of many tales of her childhood, she said:

> Mrs. Shaw doesn't like "Cow Yard" much. Says it's plotless and "maybe she could help me fix it up." . . . I just want it to be the "Cow Yard" and make people feel and smell and see and *love* it like I did as I wrote it—blessed old heaven of refuge for a troubled child and a place of bursting joy for a happy one. (*H&T*: 141)

Carolyn Heilbrun has isolated women's nostalgia for childhood as a likely "mask for unrecognized anger" (Heilbrun 1988: 15), and anger as a profound prohibition related to the desire for power and control over their lives (ibid.: 13). Valerie Sanders, in her work on Victorian women's autobiography, noticed that childhood recollections have served as a form of protest. Because children are "not yet fully absorbed into the cultural system," she claims that they are "freer to protest and more readily excused." Autobiographical emphasis on childhood drew attention to women's "emotional and intellectual needs and the meagre provision made for them by society." For Sanders "the revival of childhood frustrations . . . was the directest form of autobiographical resistance against the values and priorities of their age" (Sanders 1989: 71-72). Certainly the distinction of being outside social systems fuels Carr's stories about her child self, animals and native Canadians—most of her stories.

Against the detachment of her autobiography and the stories, both forms being repositories of her anger, Carr's journal, *Hundreds and Thousands*, presents a compelling confessional account of her mature years from 1927-41. The daily deliberate meandering of the journal form, a staple of women's life writing, evokes her private world. There

is no overt pattern; instead, the rhythms of repetition knit together the
episodic fragments. Topics occur in this personal record that might have
been expected in a more public statement of her beliefs and purpose,
but for Carr, God-talk and art-making were intense and private mat-
ters.

The final and perhaps most intimate form of Carr's self-writing is
the letter. Whereas the metaphysical situation of the artist predominates
in her journals, in the letters more mundane matters signal development
and change. Her account of the immediacy of daily living and the inex-
orability of time passing, especially as her faculties diminished and she
drew inward, epitomizes the sophisticated development of the private
sphere in women's writing.[22] In the letters the pain and limitations of
her body are clearest. We learn that she's "sick of this fat" around her
middle (*DW*: 59); that though she intended her stories of life in the
sanatorium to be uplifting (ibid.: 67), at the time she felt she had been
cut out of everything she had wanted to do (ibid.: 268); that she hated
pajamas, would rather make "any other garment in the world," but
made lots of them as part of the war effort (ibid.: 304). Letters were a
valued part of the British middle-class tradition, a genteel Tory recre-
ation.[23] Carr made an astute assessment of the significance of genre
form when she wrote of letters, in her journal, that "the absence of the
flesh in writing perhaps brings souls nearer" (*H&T*: 206).

As they appear in Doreen Walker's *Dear Nan*, Carr's letters accent
energies presently operating in the autobiographical arena. The volume
is elaborately edited, with extensive notes and material not available
elsewhere in such an organized fashion. Carr is at the centre in her
letters, speaking to one other; the editor's notes fortify the periphery,
supplying the masses of information we need in order to appreciate the
letters. That the institutions of life writing are at work here, in this most
intimate of autobiographical forms, suggests that there exists a pressure
on the self to be, to exist elaborately, within a cultural climate that is
concurrently dissolving the boundaries of the self as subject.[24]

AUTOBIOGRAPHY: AN ARENA FOR THE CREATION OF MEANING

The creation of the self can be a fundamental sacralizing act. Writing
creates meaning. Thus the literary text is an "important site for the
struggle over meaning through the formulation of narratives which
articulate women's changing concerns and self-perceptions" (Felski
1989: 78). Under these conditions Carr's myth continues to grow. In

addition to the volume of letters published in the winter of 1991, in the summer of 1990 a major retrospective of her painting at the National Gallery in Ottawa was accompanied by Doris Shadbolt's third biographical work on Carr, as well as by mugs and t-shirts; Jovette Marchessault's radio play, *Emily Carr: A Shaman's Voyage*, won a Governor General's Award. In 1993 *The Emily Carr Omnibus* edition of her writing appeared, introduced by Doris Shadbolt,[25] and 1994 opened with the CBC's short film and concerns within the art community about Carr's cultural appropriation of native motifs and beliefs. As a functioning site for social, cultural and religious exploration, the life of Emily Carr is remarkable.

Tensions between centre and periphery—characteristic of modernism, feminism and autobiography—mark the levels of activity around Carr. She read the signs of cultural stress that surfaced in her world and interpreted them for herself. We bring similar energies, with the issues of our own cultural moment, to the biographical arena when we confront *Emily Carr*. The concept of the primitive, as an instance, had a strong profile during Carr's life. It has an equally strong though quite different profile as the twentieth century winds down. For the modernists of her generation, critical of the legitimacy of the dominant culture, the primitive offered fascinating insights and alternatives.[26] Through her encounter with forest and totems, Carr explored those alternatives in her work. Jovette Marchessault, herself a Montaignais Cree and thus, in the terms of current debates on cultural appropriation, able to speak with authority, has kept the tension alive in her play *The Magnificent Voyage of Emily Carr* by portraying Carr as a shaman at the boundary between two cultures.

The modernist move toward abstraction, another site of tension, was articulated as a spiritual endeavour peripheral to conventional religious behaviour. Carr pondered it, particularly through her contact with Lawren Harris and Theosophy, but chose for herself an aesthetic language grounded in the natural world. For us abstract form is no longer avant-garde; we question its genesis and development even as we manipulate its images. Yet that Carr's language and her images resonate with current ecological concerns suggests that her grounded vision, strong in emotional and spiritual appeal, links the tensions of her era to those of our own. Associated with abstraction, experimentation in language was vital to modernism. Carr's idiosyncratic style, with its imperfect grammar and inconsistent spelling (a problem for her), is now considered central to her voice as it vibrates with the distinctive regional characteristics of "the west beyond the west."[27] Features of the life-

writing forum, these subtle blends or transformations of concern move across and link generations.

The significance of autobiography by women does not lie so much in its differences from male autobiography—both can write linear narratives, both disjunctive ones—as in what Domna Stanton has called its "essential therapeutic purpose": the constitution of the female subject (Stanton 1987: 14) and a recognition of prohibitions and of the will to succeed. In Virginia Woolf's *A Room of One's Own* the narrator, barred from the library, notes that women's history cannot be studied since the books are written about, for and by men. Instead women's history "will have to be read into the scene of its own exclusion. It has to be invented—both discovered and made up" (Kamuf 1988: 154). Emily Carr's life is a part of that process. The life she describes *is* that of an heroic modernist, an artist who challenged convention head-on. Like the ubiquitous gazing male of Parisian art in her time, the *flâneur*, she moves through her world, watching.[28] In some remarkably allegorical passages, she describes her journeys into dark, seamy quarters of San Francisco and London. With her energies focused on making art, and protected by her innocence, she walks through them unscathed, but never detached: "The little corners that I had poked into by myself interested me most. My sight-showers would have gasped had they known the variety and quality of my solitary wanderings" (*GP*: 153). Her singleness of purpose, which included rejecting intimate relationships that might stall her progress, did exact a price. As with many other women trying to move into the public sphere, that price was her health.[29] She did not, however, recount those details in her autobiography.

She tells the life of a woman without exemplars who used the materials at hand, both words and images, to forge a self—again and again. Her autobiography, in all its forms, can be read as record, in which case there will be questions of accuracy and exaggeration, of invention, issues which enliven the arena of autobiography. It can also be read as an act of self-creation, enhanced by Carr's visionary capacities as a artist and, as such, it is sacred.

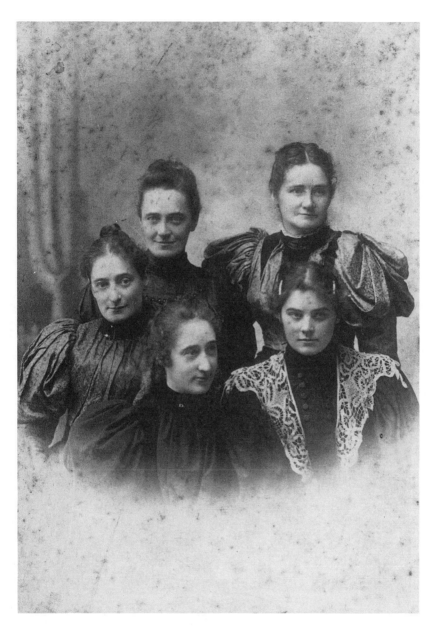

THE CARR SISTERS
(British Columbia Archives & Records Service HP5131, used with permission)

EMILY AND FLORA BURNS
(British Columbia Archives & Records Service HP51765, used with permission)

24

THE ENIGMA OF BIOGRAPHY

> Biography is the preoccupation and solace not of certainty, but
> of doubt. — Harold Nicolson (Novarr 1986: 56)

> The mysterious thing that we call a self is best understood
> exactly as a story—a story that has no point but the display of
> itself for others but especially for ourselves.
> — Stanley Hauerwas (Charmé 1984: 46)

> It's as old as human memory, the desire for story which is after
> all an attempt to put order in our lives, to understand—a need
> women certainly feel today. — Gail Scott (1989: 90)

The narration of our existence seems natural, effortless. We tell life stories, our own and others, to reveal their patterns, to show they adhere to "an order of meaning" (White 1987: 5).[1] The conventions of biography, apparently clear and direct, allow us to compare the commonalities of our existence: birth, childhood, adolescence, marriage, family and community relations, illness and tragedy, death. Yet among the assumptions challenged at the close of our century are the transparency of language and the inevitability of its meanings. We no longer suppose that we are necessarily moving toward a greater understanding and articulation of *natural* laws, themselves substitutes for earlier certitudes embedded in notions of divine will. There is much artifice in what we do. Biography is no exception: the conventions that seem irreplaceable and indispensable do, in fact, fluctuate and change.

In *Truth to Life* (1974) A. O. J. Cockshut described characteristics of nineteenth-century biography that endured for much of that century and clearly distinguish it from current work in the genre. A reliance on

Notes to this chapter are on pp. 161-67.

documentation tended to underemphasize the early stages of life, which
were rarely recorded (Cockshut 1974: 17). Thus the preoccupation
with childhood prevalent in twentieth-century Freudian-influenced
biography, and its attendant psychological explication of adult behav-
iours, was absent.[2] "The fundamental reason for writing a man's life was
that he was admirable" (ibid.: 16). High moral tones easily blended a
sense of destiny with a fondness for heroism and a proclivity for "pru-
dence and restraint" (ibid.: 32). In the interests of fine narrative style
biographers in our time employ novelistic techniques "but in the nine-
teenth century," Cockshut tells us, "another process was more com-
mon." "The biographer himself reads the *evidence* of the life as if it
were a novel, and God were the novelist. [And] the finished biography
is more accurately compared to literary criticism; it is a report upon an
obscure but momentous work of art" (ibid.: 21). In an oft-quoted
introduction to his influential, innovative and slim *Eminent Victorians*,
published in 1918, Lytton Strachey looked back on the bulk of earlier
biographies with disdain: "those two fat volumes, with which it is our
custom to commemorate the dead—who does not know them, with
their ill-digested masses of material, their slipshod style, their tone of
tedious panegyric, their lamentable lack of selection, of detachment, of
design?" (Strachey 1984: 10).

The contrasts among biographies written more than a century ago,
Strachey's small masterpieces early in this century and those being pro-
duced at present suggest that while the capacity and desire to render
lives in narrative form is persistent, the tenor and dimensions of biogra-
phies change.[3] The biographer's task, then, is to locate and sort evi-
dence within mutable cultural domains. Attitudes fluctuate; styles of
living surface and retreat. Truth, acclaim, decorum and mores are
among the many factors which, though they seem universal in applica-
tion, are measured variously across time and determine the narrative
characteristics of biography.

An American biographer, Diane Wood Middlebrook, whose life
of Anne Sexton appeared in 1991 and aroused controversy over the use
of taped psychiatric interviews, has pointed to an interesting and recent
impetus for change within the genre involving the status of the subject:
the anomaly of expanding personal archives which remain, despite their
collation in various library collections, "woefully incomplete."[4] Her
subject, the person named Anne Sexton, "exists no more."

> Now she exists as an enormous, boundless archive, some of which is
> housed in the memory of her friends and enemies, but most of which
> is located at the Humanities Research Center at the University of
> Texas at Austin, where she never set foot. This archive includes—in
> addition to a staggering quantity of paper—a film, sixty or so
> audiotape recordings of interviews and readings, four reel-to-reel
> tapes of sessions with her psychiatrist, hundreds of newspaper clip-
> pings, her typewriter, spectacles, and three teenage scrapbooks full of
> swizzle sticks from Manhattan nightclubs and rotting, worm-infested
> corsages. (Middlebrook 1990: 158-59)

Other pressures on the genre generated by the nature of the evidence
are discussed by several contemporary British biographers in *The Trou-*
bled Face of Biography (1988).[5] Hilary Spurling, like Middlebrook, notes
the imperfections of the written record: "the biographer is stuck with
such facts as he has managed to scrape together: generally a job lot,
much too full in places, hardly there at all in others, nearly always with
pitiful gaps and crucial explanations missing" (1988: 116). For Victoria
Glendinning the consequent lies and silences are an inevitable aspect of
the biographer's emphasis on a single life. She cautions against imbal-
ance. Though hoping the modern biographer will avoid "the daily
littleness of her subject's life," Glendinning is more disturbed by move-
ment in the opposite direction. "Author-theology" is her term for the
inflation of writers' lives into myth. She gives the adulation of Virginia
Woolf as an example of a "dead but immortal author" whose words
serve as transcendent truth for some who find "the traditional religious
framework useless for their purposes."

> The sanctified authors themselves become "people in books," like
> their fictional characters. Their lives are interpreted and reinterpreted
> by priests of the cult, in the way that critics interpret and reinterpret
> fictions. Virginia Woolf becomes no more and no less real than her
> fictional Mrs. Ramsay, herself a version, or vision, or Virginia
> Woolf's real mother. The mirrors reflect back and forth. There are
> heresies and orthodoxies, priests and bishops of the faith. (Glendin-
> ning 1988: 61)

For Glendinning all biographers are "in the business of ancestor-
worship, even when we demystify and demythologize" (ibid.).[6]
Though all of us, whether biographers or not, tell lives frequently,
learning to give them narrative shape, they remain mysterious. Even
expanded, corrected and revised versions written to clarify a biographi-
cal image often simply increase the ambiguities and emphasize the

opacity of existence. Those lives that interest us most and quickly attract biographers, lives that seem to promise real insight into the human condition, are often early victims of biographical inflation.

Emily Carr's autobiographical writing, in its vitality, promotes the illusion of reviewing her life as she lived it. The reflections upon her life *by others*—the biographers, film makers, playwrights, poets and curators responsible for the multiple versions of her life—generate a different kind of life-writing enterprise. Each commentary expands the image, driving it deeper within the matrix of our cultural conventions. The record of a single life, the sort that becomes an icon like Carr's life has, is never simplified. Indeed, it may not be possible to do anything but apotheosize individuals whose lives fascinate us. Leo Braudy's four components of fame are relevant to this aspect of biography. Fame, he claims, requires "a person and an accomplishment, their immediate publicity, and what posterity has thought about them ever since."

> The difficulty in writing about great figures of the past is that in every age they have been reinterpreted to demonstrate the new relevance of their greatness. The continued interest in the most famous is similar to our continued fascination with a great work of art or an important historical moment: The ability to reinterpret them fills them with constantly renewed meaning, even though that meaning might be very different from what they meant a hundred or a thousand years before. Such people are vehicles of cultural memory and cohesion. (Braudy 1986: 15)

The elements of truth in Peter L. Smith's wry characterization of Emily Carr suggest that a familiar, even conventional, process is involved in the selection and development of those lives that serve as cultural icons.[7]

> Her story was made to order for mythic exaggeration and apocryphal enlargement. She is imagined as a lonely, impoverished woman who befriended and depicted the noble savages after she had been rejected by family and genteel society; an unlettered and untutored child of nature, whose creative genius blossomed in the forest wilderness; a great artist denied all recognition and homage until her sudden discovery and salvation by keen-sighted cultural Wise Men from the East. She even has her ritual comic attendants in the form of the obtuse and outlandish philistines of Victoria, a benighted city of tweed-and-teacup mentality. (Smith 1987: 128)

Certainly, traces of Carr's life, lived on the edge of nowhere, irradiate the exemplary model she has become, but the facts of her life, the historical and empirical evidence, merge with invention as created impres-

sions multiply. A rhetoric to distinguish among the crafted images (whether mythic exaggerations or well-proportioned portraits), the figure in history and the lived life, does not exist.[8] The aggregate image, from anecdotes and entries in the historical record to elaborate interpretations, is called Emily Carr. Even when the thematic boundaries are clear—an example might be a sociological analysis of the adequacy and sources of her income—apparently relevant distinctions embedded in verifiable evidence may reflect choices based on the biographer's experience of reality rather than Carr's.[9]

The composite image of Emily Carr is large, various and increasing in vitality. There are early, middle and late biographies. Distinguished by prose style and preoccupations, they include short sketches and full portraits, dense academic works, personal reminiscences and thematic meditations. Biographical essays accompany exhibition catalogues. Carr has been the subject of several film portraits, a stage play in French that became a radio play in English, and many poems.[10] There is a civic version of her embedded in Victoria's cultural heritage: the public archives, the Carr house and the Emily Carr Gallery have contributed to her presence.[11] She also exists within the evocative spaces of her paintings, as the photographed figure—square and strangely clad—beside her caravan with her animals, and as a lingering presence on the streets of her home town. Hers is not a life occasionally narrated as a threshold figure on the edges of Empire: her biographical image comprises a profusion of familiar and available forms. Still, however large the composite image of a biographical subject, the genre appears to confirm and promote an individual and autonomous subject within the horizons of the biographer's cultural moment. Certainly the biographer's values and perspectives provide a unity that adheres to the biographical subject (Snipes 1982: 216). If the facts do not violate our understanding of the world and we are in accord with the order of things presented, a degree of "paradigmatic coincidence" is established that limits the range of alternatives (Schwalm 1980: 23). A "belief in biography, as in other things, is a common human substitute for omniscience, a necessary . . . compromise between unattainable knowledge and hopeless ignorance" (ibid.: 18).

That, until recently, biography has not been a frequent subject of literary criticism or critical theory reflects its generic conservatism which, in turn, intimates characteristics that have stimulated current interest.[12] The nucleus of the biographical account is the single life, more bold in narrative form than it was ever experienced in living.

Clustered at the tale's circumference, to explain the life and connect it to the world through which it passes, are other lives, collective experiences, tacit assumptions and, indeed, other versions of the same life. Unconscious or habitual formulations of the meaning of life cleave to the narrative structure: with attention riveted upon the exemplary life, reader and biographer can only critically examine the cultural landscape surrounding the subject with difficulty.[13] Should a biographer shift toward a depiction of *life and times*, the tight focus on an individual is lost and with it most of the genre's unique appeal. Biography posits a central core of stability—the lived life perceived as an historical actuality—whose periphery yields glimpses of the manner in which we structure our realities. This quality of biography makes it irresistible to the deconstructing mind of the late twentieth century. Emily Carr lived and died: no discursive or narrative manoeuvre can alter our cognizance of her vitality. How biographers tell her story provides evidence of changing assumptions and attitudes concerning, among other things, women, artists, modernists, British subjects on the edges of Empire, the aboriginal peoples and the natural world of British Columbia.

Frequently, when a biographical subject has evolved into legend, narrative impulses draw in, toward the centre, those cultural features that had been clustered at the subject's furthest reaches. Empirical evidence of the singular creature loses its appeal before the exuberance of imagination. The aggregate portraits of two redoubtable Canadians, William Lyon Mackenzie King and Louis Riel, illustrate a process similar to the development of the corpus of Carr images. The foundations of these two male biographical images were established with deliberate attention to empirical evidence and, as is often the case, the earliest works can be criticized for their bias and error. In King's case even though the record of his life was immense and dense at his death, since his astounding diaries were not yet accessible, the archive was egregiously incomplete. Riel, on the other hand, had been enveloped in the obfuscating robes of Empire. It took considerable time, and several biographical forays, for him to emerge as a full-scale historical figure rather than a small player in the dramatic saga of the west. Once the "facts" seemed established in historical and political terms and the biographical images outlined, subsequent narrative movement has tended to move both subjects toward heroic legend and, recently, fictionalization.[14] Both King and Riel were freed to become figures of theatre and subjects of metaphysical speculation.[15] With each version new facts can embellish the life; certainly fresh interpretations, in attempting to cor-

rect previous biases, can create new ones. And new conceptualiza-
tions—like psychobiography—reconfigure the record. As a particular
life becomes a frequent subject, idiosyncrasies grow familiar, uniqueness
seems commonplace, stereotypical, and the subject-as-individual re-
treats.[16] A consequence of the activity around a biographical subject is
that, no matter how firm the insistence on verifiable facts, how deter-
mined the urge to be free of bias, through repetition the outlines of the
legend are etched deeper into the fabric of the collective cultural mind.

Edythe Hembroff-Schleicher devotes one chapter of her *Emily
Carr: The Untold Story* to refuting characterizations of Carr as a "Peo-
ple's Artist" (1978: 267), an advocate of native peoples' social or eco-
nomic plight and a feminist (ibid.: 271).

> Many labels, big and small, have been pinned on Emily in the last few
> years, mostly by individuals and groups who have tried to use her as a
> propaganda tool for their own ends. One that is often mentioned of
> late is "environmentalist." None of us was conscious of danger to the
> environment in the twenties and thirties. The world seemed big
> enough and clean enough for all to enjoy, and the word "pollution"
> was not in current use. In the pure sea air of Victoria, no one thought
> of it at all.
>
> Emily was a naturalist, almost a nature-worshipper, and she
> instinctively respected and loved the great British Columbia forests
> and the clear-running rivers and streams. Littering, or any kind of
> destruction, was abhorrent to her and she was pained and shocked by
> the ruthless devastation caused by logging operations. But, again, she
> bemoaned this without resorting to any kind of political action. Any
> seeming protest about wanton destruction of woods in some of her
> paintings, such as *Logged Leavings, Odds and Ends* and, a favourite,
> *Scorned as Timber, Beloved of the Sky*, was quite unconscious. (Ibid.:
> 274)

The effect of Hembroff-Schleicher's remarks enriches the legend. She
makes us aware of Carr's energy, her powerful conscience, and justifies
the dreams of those inspired by Carr's insight and actions. We add her
voice to the chorus, though we are not necessarily convinced by it.

Another attempt, one that reinforces the lineaments of the legend
while apparently trying to purge it of excess, is an appendix on Carr's
use of photography in Paula Blanchard's *The Life of Emily Carr* (1987).
By summarizing a dispute among Carr's biographers Blanchard estab-
lishes the significance of photography's infringement upon the privi-
leged terrain of artistic vision and affirms the issue as a component of
Carr's legend.[17] In a review of Blanchard's biography, Douglas Cole

draws attention to another "interesting subtext" dividing recent Carr
biographers:

> Blanchard doubts, on the basis of Hembroff-Schleicher's correspond-
> ence, that Carr's 1902 breakdown in England was diagnosed as hyste-
> ria, even that diagnosis would have been recorded by the hospital.
> Such doubts are entirely unfounded. I have seen the record, even
> photographed it. (Cole 1989: 129)

Cole intimates ancillary consequences to his discovery by describing his
search in the basement of the hospital as elementary, with the help not
of "the director, but the secretaries!" (ibid.). The dynamic of this par-
ticular debate will have pointed some readers of Carr's life toward
currently lively discussions of historical attitudes toward woman's
health.[18] That Emily Carr easily exists as a sign of concerns outside the
time and place of her own reality exemplifies the genre's natural move-
ment toward complexity even as the figure of a particular subject grows
familiar.

When versions of a life, the full composite biographical image, are
considered—especially a dense image like Emily Carr's—historical and
fictional accounts coalesce. A patron could leave the National Gallery's
major 1990 retrospective exhibition of Carr's work carrying Doris
Shadbolt's third version of Carr's life, thick with new insight, and a
shopping bag filled with mugs, notepads, t-shirts and posters, all embla-
zoned with "EMILY CARR."[19] That there was not a conventional cat-
alogue of that show is significant and suggests a manner in which Carr
escapes categories. A parallel and concurrent exhibition at the Art
Gallery of Ontario of the work of another landscape painter, Lucius
O'Brien, was accompanied by a substantial, well-designed and carefully
documented catalogue.[20] Applying a Foucauldian knowledge-as-power
template to these exhibitions, O'Brien's catalogue can be termed a *dos-
sier* and its detailed record seen as evidence of a controlling scrutiny.
Carr's legend, diffuse and evocative, without similarly meticulous treat-
ment, remains *epic* (Dreyfus 1983: 159).

Biography, it appears, cannot be assessed solely on historical judg-
ment that falters when confronted by the inconsistencies of the singular
life and, as we have seen, is at the mercy of erratic archival policies. Nei-
ther is the genre's compelling use of the techniques of fiction a com-
pletely satisfactory basis for analysis or assessment. Perhaps biography's
appeal lies, simply, in the replication and re-creation of the patterns of
life, in interpretations of existence with whatever techniques are at
hand. For us, now, lives can be portrayed in an assortment of forms and

techniques; often biography challenges our assumptions about individuality even while exploring an instance of it. Though we cling to the myth of the liberal humanist self, in our demand for "definitive" biographies, we encourage versions. We favour legends. The density of interpretation spawned by repetition, instead of uncovering the essence of difference, strengthens the pattern and stimulates the growth of the legend.

BIOGRAPHY AND THE COVENANT
BETWEEN WORD AND OBJECT

Hints of a religious dimension embedded in life story become clearer in light of George Steiner's concept of a covenant between word and object. He describes this covenant as "the presumption that being is, to a workable degree, 'sayable,'" that we can mean what we say. For Steiner "the raw material of existentiality had its analogue in the structure of narrative—we recount life, we recount life to ourselves" (Steiner 1971: 90).[21] Such a covenant was essential to Carr herself. As a child called Small, a woman travelling courageously among the peoples and mountains of British Columbia, a modernist artist searching for a foundational reality and a British subject raised by codes of certainty at a remove from centres of power, Emily Carr relied on the possibility of *saying* the world and her life in it.[22] Of her "Indian stories" she wrote:

> Probably when people do not know the places or people they will be flat but they are true and I would rather they were flat than false. I tried to be plain, straight, simple and Indian. I wanted to be true to the places as well as to the people. I put my whole soul into them and tried to avoid sentimentality. I went down deep into myself and dug up. (*H&T*: 292)

The fissures in Carr's world that thwarted any easy expression of her creative genius were phenomena that paralleled the breaking of the covenant which, as Steiner claims, happened "for the first time, in any thorough and consequent sense, in European, Central European and Russian culture and speculative consciousness during the decades between the 1870s to the 1930s." Modernity issued in a suspicion that we do not, perhaps, know what we mean, that all is not as it appears to be: "*It is this break of the covenant between word and world which constitutes one of the very few genuine revolutions of spirit in Western history and which defines modernity itself*" (Steiner 1971: 93; emphasis his).[23] The decades Steiner names are the years of Emily Carr's life, from her birth till she

achieved a measure of national acclaim. His sense of a new order, a genu-
ine revolution of the spirit, can be monitored in the actual drama and in
the narrative accounts of her life. As a biographical subject she is present
to us; her life is, for the purposes of the biographer and the reader, *sayable*.
And yet this particular life contains within it many of the contradictions
of modernism that mark the break between word and world. The ground
of Carr's being, thus, might suggest the extent to which biography can be
a forum of cultural experimentation and, perhaps, the vitality or viability
of religious exploration through the genre.

The roots of biography's condition extend deep into crevices
within Western thought. Mark C. Taylor's deconstruction of concepts
currently under siege—God, Self, History and Book—supports
Steiner's analysis of change and the centrality of the biographical enter-
prise. Traditionally "history is the domain where divine guidance and
human initiative meet. The temporal course of events is not regarded as
a random sequence" (Taylor 1984: 7). Thus, by compiling the history
of a life, the biographer discerns the meaning of a self's encounter with
ultimate meaning, whether or not any theological ground is perceived.
We have not found a method of constructing a life in narrative that does
not presuppose historical development within a discernible order of
being.[24] The notion of history "stretching from a definite beginning
(creation) through an identifiable middle (incarnation) to an expected
end (kingdom or redemption)" (ibid.) may be under review, but few
biographies are written that attempt to subvert these conventions.

Since Plutarch's *Parallel Lives*, biography has been shaped around a
deference for heroic character, action and moral purity within the vary-
ing constraints of specific cultural spheres (Whittemore 1988: 5, 12).
Criticism of the genre has, until recently, been largely content to con-
sider biographical techniques that facilitate the telling: notions of time,
atmosphere, decorum, research.[25] More rigorous criticism, concerned
with the processes and effects of narration, has been stimulated by the
increase in psychological explorations of inner life, often within the
established conventions of confessional autobiography, and, more
recently, by the widespread interdisciplinary application of critical the-
ory. Though much postmodern criticism is applicable to biography,
especially regarding the validity of the individual as a discrete and self-
determining creature, the continuing and unselfconscious vitality of
the genre suggests it is strangely exempt from deconstructing urges.[26]
Though careful thought is given to the construction of biographies and
the inferences embedded in narrative portraits, the genre has not
become self-conscious in the same way that other art forms have done

so.[27] Robert Skidelsky's remark that in England "biographers write biography; they rarely spend much time thinking about how they ought to be writing it" is preliminary to his acknowledgment that the English produce "great biographers [but] no important theorists of biography" (Skidelsky 1988: 14). David Novarr's *The Lines of Life: Theories of Biography, 1880-1970* (1986) shows not that there has been an absence of important theorists but, rather, that biographical theory has tended to be ruminative rather than systematically sharp and rigorous.

In so far as it is an historical record and an empirical exercise, biography faces the difficulty of drawing events into narrative. Pondering the nature of historical writing, Hayden White has described facets of narrative in our time that locate the act of telling at the limits of our knowing. In myth, he says, there is no need to distinguish between real and imaginary events: "Narrative becomes a problem only when we wish to give to real events the form of story. It is because real events do not offer themselves as stories that their narrativization is so difficult" (White 1987: 3-4). However, the ease with which we tell our life stories, allowing them to shift and change, and the strength of the impulse to shape lives as story, are characteristics that separate biography from historical writing as surely as the assumption that the genre is grounded in factual experience separates it from fiction.[28] For White, concerned with historical representation, the distinctions in narrative that separate fact from fiction, or myth from history, are tied to fantasy, wish and desire. He goes on to ask:

> What is involved, then, in that finding of the "true story," that discovery of the "real story" within or behind the events that come to us in the chaotic form of "historical records"? What wish is enacted, what desire is gratified, by the fantasy that real events are properly represented when they can be shown to display the formal coherency of a story? In the enigma of this wish, this desire, we catch a glimpse of the cultural function of narrativizing discourse in general, an intimation of the psychological impulse behind the apparently universal need not only to narrate but to give to events an aspect of narrativity. (Ibid.: 4)

Set against this imperative to create narrative, continuing attempts to adjust the balance between fact and fiction in biography—which can reasonably raise questions concerning the motives or desires of the biographer—suggest that the enigmatic coherence of the genre, the *sayability* of life that defies any logic of chronicle and event, may be the essence of its uniqueness.

Perhaps the collapse of the Enlightenment grid, of the word/ object bond, has not so much deprived us of our conceptual tools as it has necessitated new and additional techniques. Steiner, Taylor and White are concerned with metahistory, with analysing the collapse of Reason's sway, and they rarely turn their theoretical specula on the minutiae of individual experience.[29] Gail Scott, on the other hand, who shares many of their concerns, concentrates on the intersection of personal and collective space, that place in which the desire to narrate another life is generated. A fiction writer with an interest in critical theory and the constituents of our cultural matrix, who writes as a Protestant anglophone immersed in the French culture of Quebec, she brings theoretical issues closer to the world in which we encounter the image of Emily Carr.[30] A basic concern in her essays is the diverging experiences of Anglo- and French Canadian women writers, the reality of "the ideological and symbolic heritage of growing up Catholic or Protestant," French or English (Scott 1989: 36). She notices the absence of female figures in Protestant iconography.

> Was this not symbolic of the repression of female values in Protestant society? Perhaps the culmination of a long process of cultural disembodiment of women—i.e., the refusal to recognize women as body and language incarnating another vision of life—with its roots in the tenebrous origins of "history." (Ibid.: 37)

She faces the word/object covenant directly and measures the restrictions placed upon her vision against the perspectives of francophone women writers in Quebec who have "played a vanguard role in the growing awareness of the relationship between language and struggle for change" (ibid.: 38).

> What we can learn, I think, from French-speaking feminist writers is their insistence on asserting *la différence féminine* as context. It's an assertion that rests on the confidence that the feminine exists as something culturally positive, at least potentially. But perhaps the feminine does stand as a dimmer shadow in our English-Protestant heritage. This may be another reason why English-Canadian feminist writing has tended to be content-oriented compared to the more radical contestation of language and form that has taken place in Québec. (Ibid.: 39)[31]

Though powerful in its grasp of central concerns, the alignment of word and world held less sway at the margins of culture. Like nature and magic and children, women and their lives have tended to be ill-defined and undervalued. The influence of French feminists' analyses of

language has played an enabling role in the recovery of women's experience and, thus, promoted the telling of their stories.[32] For English Protestant Canadians, extrapolating from Scott's categories, biography provides a forum for applying the linguistic manoeuvres of French critical theory to narrative biased toward content. The writing of women's lives, which has moved apace since 1970,[33] has depended on the broken covenant, the fragmentation of the Western self at the core of the French linguistic project.

> Still, the process of knocking the written word into some new shape better suited to our use goes on, it seems, with increasing insistence. A community is being formed, cutting across cultures and resistances. I know my relationship with [francophone] women writers [in Quebec] opened me early to ideas not easily accessible to most anglophones . . . [and] led me to a new vision of my own culture. . . .
> Standing on the outside—the better, perhaps, to create. (Ibid.: 41)

Though there is a generational divide separating Scott from Emily Carr, both women are Canadian artists whose abilities to navigate the conceptual gaps in mainstream culture were facilitated by associating closely with marginal groups.

Steiner's covenant, Taylor's analysis of the ideological force of deconstruction, White's sensitivity to the pressures narration places on events and Scott's awareness of writing as the particular practice of a specifically located woman, all point toward sources of biography's compelling role. In the way we tell lives, the words we choose, we draft optional realities for the construction of experience and negotiate the postmodern maze where God, History, Book and Self, all central to traditional biography, have been problematized. Steiner's concern, like Taylor's and White's, lies within the larger arena of European thought. Scott approaches that intellectual space from the margins where the energies of feminism are generated.

My analysis of Carr's autobiographical writing in the previous chapter emphasized her modernism, her life as a female artist in British Columbia, the significance of her preoccupation with childhood, and the religious act inherent in her self-creation through writing. Those topics reflect my interest in a mélange of feminist, literary and cultural theories[34] and in Canadian culture as a repository of religious attitudes and knowledge at the close of the twentieth century. I inhabit a moment as culturally bounded as those of Carr and her various biographers. My interest in Carr's life as a cultural zone, or artifact capable of generating religious speculation, can be identified as a response to

Steiner's broken covenant, to what Frederic Jameson has termed the pastiche and schizophrenia of postmodernism.[35] Jameson claims that within the intellectual horizons of the West, confronted by the dismantling of authority, the disabling of subjectivity and the exhaustion of individualism as a progressive idea,[36] we generate fragmented images, pastiche. We consume ideas but are neither nourished nor weakened. By schizophrenia Jameson means a loss of sequence as a temporal continuity that is an effect of language (Jameson 1983: 114, 119). His terms—pastiche and schizophrenia—are idiosyncratic to cultural theory, and memorable, but the notions he brings forward are common to postmodernism. Jane Flax, for example, calls the postmodern voice "nonauthoritarian, open-ended, and process-oriented" (Flax 1990: 3). Like Jameson and Steiner, she points to "a breakdown in the metanarrative of Enlightenment" apparent in "contemporary social transformations" (ibid.: 7). Her assessment has a direct bearing on biography:

> The grand ideas that structured, legitimated, and lent coherence to so much of Western science, philosophy, economics, and politics since the eighteenth century no longer appear compelling or even plausible. . . .
>
> Enlightenment ideas that now seem problematic include such interdependent concepts as the dignity and worth of the "monadic" (socially isolated and self-sufficient) individual and the interconnections between reason, knowledge, progress, freedom, and ethical action. Essential to all Enlightenment beliefs is the existence of something called a "self," a stable, reliable, integrative entity that has access to our inner states and outer reality, at least to a limited (but knowable) degree. (Ibid.: 7-8)

This self has been the biographical subject. The genre's existence must surely be in jeopardy.

Though apparently dependent on notions of self and chronology central to Enlightenment thought, biography had a substantial pre-Enlightenment existence and shows no signs of decline in the present. The biographical subject, thoroughly enmeshed in variations and sequences, appears to be thriving. The depicted life offers a pragmatic and experiential conceptual core able to thwart the pressures of pastiche and schizophrenia while sustaining a capacity to respond to critical theory's desire for a supple and deliberate use of language. That the genre's condition makes no sense in the light of contemporary critical thinking is, indeed, a sign of its strength.

CARRIANA
(William Boehlen, used with permission)

A MIRROR TO CULTURE: MOMENTS IN THE DEVELOPMENT OF THE GENRE

> I explore the lives and characters of my biographees as a traveller explores foreign countries, [and] come back from these explorations with a language learnt, something new I have seen, felt, experienced, assimilated—and can pass on to my readers.
> — Michael Holroyd (1988: 97)

> The self is not, as the nineteenth-century romanticists tended to think, opposed to culture, but . . . is a cultural achievement, that is as much outside us as inside, and . . . [it] exists outside us in the form of cultural symbols.
> — Robert Langbaum (Lyons 1978: 226)

> Just as early religious societies identify with the power of the gods in creating the world, people in modern society also seek to create a necessary order in reality.
> — Stuart Charmé (1984: 86)

ENLIGHTENMENT LIVES

Biography confounds abstruse critical thought by adhering to the ambiguities of particular embodied creatures. Its intense focus on the ellipses and elisions of the singular life evades systematic analysis of itself as a genre, as well as of its subjects. Neither history nor fiction, not strictly empirical, nor generally innovative in its use of imagination, it has, nonetheless, a remarkable capacity to monitor dispositions of the collective spirit. By employing representative aspects of style and thought, and thus mirroring the intricacies of the biographer's cultural

Notes to this chapter are on pp. 167-71.

moment, the genre displays our assumptions, habits and responses to the serious matter of existence. As a consequence the composite image of Emily Carr can serve as an instrument for examining cultural motifs during her lifetime, as her image took its initial shape. In the half-century since her death fluctuations in the style and attitudes of her biographers have reflected a variety of themes and questions, reflections, analyses, even powerful metaphors, that amplify the conditions of our times.

Though biographical narratives of artists exist from as far back as fourth-century Greece (Wittkower 1963: 3), the tradition to which the image of Emily Carr belongs is most usefully considered as having emerged with the heroic figure of the Renaissance artist. Giorgio Vasari's *Lives of the Artists*, first published in 1550 and still read, exemplifies characteristics of biography in that period. Vasari's attention, divided between the achievements of his heroic subjects and descriptions of their work, established a pattern which has remained viable as a means of "speculation on the nature and processes of aesthetic creativity in the visual arts" (Preziosi 1989: 21):

> an account of the parentage and early years of an artist, then a list of his works, and finally a description of his personality. This narrow framework is further stereotyped, for the origin of the artist is usually described either as so humble that it makes his rise to fame all the more wondrous, or as so elevated that it sheds an ennobling light on the whole profession. (Wittkower 1963: xxi)

Unlike medieval biographers whose saints' lives were envisioned within a cosmic order that was hierarchical in conception and social arrangement, Vasari's emphasis was not on the souls of artists and their lives after death. His significance, as the initiator of the tradition within which Carr's image falls, rests on his validation of the artist as a unique sort of living human whose insights and creativity bear traces of divine favour and whose life's story, therefore, deserves particular consideration. He "was not yet ready—and probably no biographer before Boswell was ready—to entertain the Boswellian notion that *anything* a really great man says is worth putting down" (Whittemore 1988: 80). Nor was his an interest in the ordinary lives of "the mundane, the troubled, and the frail"; that levelling and democratic concern would follow the Enlightenment (ibid.: 82). Indeed artists have remained privileged biographical subjects (though poets and novelists, perhaps because their medium is shared by the biographer, are more frequently subjects than visual artists). It is the relation between life and creativity that sets art-

ists' lives apart; as biographical texts they exhibit the preoccupations of the wider genre.

The cultural significance of biography in its current form becomes clearer when two decisive moments in the development of the genre are considered. The first of these, typified by James Boswell's work at the end of the eighteenth century, was a response to the consolidation of forces that marked the political and scientific revolutions in Europe and North America. The second, marked by the temerity of Lytton Strachey's *Eminent Victorians* at the beginning of the twentieth century, figured in the "complexity of modernism" which "stems from its containing both the spiritualistic, religious impulses of high romanticism and the scientific, rationalistic impulses of realism while at the same time bringing to center stage the issue of art's autonomy" (McGowan 1991: 7). Modernism and biography were well suited: idealism and fact rested easily together, supporting both the art of biography and biographies of artists. Strachey told his lives against an assumption that greatness should not only inspire, it should suffuse the detailed and observable manoeuvres of living. His insights into the human weaknesses of his subjects, sustained by the validity of his own art, proclaimed the arrival of new depth psychologies.

From the beginning of the modern era, with Vasari as a model, biographers have drawn away from the hagiographical structure of medieval lives to pursue a narrative form constructed upon a foundation of rational explanation and observation, to explore the constituents of the free, self-determining subject. According to John O. Lyons, radical change in the direction and intention of biography occurred within the decade that separated Samuel Johnson's *Lives of the Poets* (1779–81) and James Boswell's *Life of Samuel Johnson* (1791). "For Johnson a man was the leaky vessel of his soul; for Boswell he was an organic complex of the self" (6). Johnson wrote when intellectual activity no longer depended on God for coherence but before disbelief in God was plausible (Turner 1974: 3, 44). For Boswell, often cited as the first modern biographer, providence is well on the way to becoming "an automatic product of natural laws . . . bound within the physical world" (ibid.: 40). Harold Nicolson, in *The Development of English Biography* (1928), described the manner in which transitions in religious beliefs from one age to another can affect biographical perspectives. His view not only mirrors the split Lyons sees between these two great biographers, it also exemplifies a tendency among critics of the genre to move easily from stylistic rhetorical patterns toward metaphysical speculation.[1]

> In periods when the reading public believe in God and in the life after
> death, their interest centres on what they would call the eternal veri-
> ties, their interest in mundane verities declines. At such periods biog-
> raphy becomes deductive, ethical, didactic, or merely superficial. In
> periods, however, of speculation, doubt, or scepticism the reading
> public becomes predominantly interested in human behaviour, and
> biography, in order to meet this interest, becomes inductive, critical,
> detached, and realistic. (Novarr 1986: 47)

In Johnson's *Lives* a Plutarchian emphasis on accomplishment and an
Aristotelian order embedded in existence, not dissimilar to Vasari's view
of the human condition, contrast with Boswell's reliance on the evi-
dence before him. Instead of an ordered universe, Boswell's world con-
sisted of apparently random impulses which "were not toward a center,
but were endlessly centrifugal, pushing outward to miscellaneous ex-
hibits" (Whittemore 1988: 130). Though these conceptual options—
centred and determined accounts of unified lives as against diffuse
experiential accounts—still exist, the myriad forms life narrative can
take preclude easy classification. Consequently, though periodizing
biography is necessary here in order to monitor the intricacies of cul-
tural change, it is at best a flawed enterprise. The *Life of Thomas More*, as
an example, seems as relevant and vibrant now as perhaps it did when
written by his son-in-law Richard Roper (1496-1578), with a delicate
sensitivity and openness that exemplify the abiding allure of the genre.

Most biographies, however, are more firmly entrenched in their
historical moment than Roper's and display the cultural forces which
have set limits on their choice of subject and narrative technique. In
broad terms, as the West has become increasingly secular, biographical
effort has turned from embodying divine will to exploring the implica-
tions of life in this world. Protestantism, by encouraging the examina-
tion of the condition of one's soul, promoted *autobiographical* elabora-
tion of the intricacies of inner life; the discovery of scientific and natural
laws, on the other hand, stimulated *biographical* examination of specimen
lives.[2]

Leslie Stephen (1832-1904), Virginia Woolf's father, in his writ-
ing and in the crises of his personal life, struggled with tensions
between religion and culture similar to those which had surfaced earlier
in the biographical writing of Boswell and Johnson. A scion of the
Clapham Sect, an evangelical Anglican group of families noted for their
efforts toward humanitarian social reforms, Stephen took priest's orders
in 1859, the year that Charles Darwin published his *On the Origin of
Species*. Three years later, finding himself unable to conduct chapel serv-

ices in light of the changing face of scientific knowledge, he withdrew from the Church.[3] In words that indicate his preoccupation with both science and his interior life, he described his unconversion:

> Many admirable people have spoken of the agony caused by the abandonment of their old creed. Truth has forced them to admit that the very pillars upon which their whole superstructure of faith rested were unsound. The shock has caused them exquisite pain, and even if they have gained a fresh basis for a theory of life, they still look back fondly at their previous state of untroubled belief. I have no such story to tell. In truth, I did not feel that the solid ground was giving way beneath my feet, but rather that I was being relieved of a cumbersome burden. I was not discovering that my creed was false but that I had never really believed it. (Maitland 1906: 145)

Stephen styled himself an agnostic. For him metaphysical questions retreated as science closed the gap between the natural and supernatural. A Victorian "man of letters," he saw his task as alleviating the negative social effects of industrial life by applying "the newly rigorous moral principle that only knowledge provided truth" (Turner 1985: 215). In this role, not unlike a preacher's,[4] he wrote several biographies and served as the founding editor of England's influential and exemplary *Dictionary of National Biography*. His earnest consideration of life patterns, his search for certitude or explanation through biography, was a version of the nineteenth century's preoccupation with scientific explanation. Like Vasari and Plutarch before him, Stephen adopted a biographical strategy that emphasized character and achievement. However, unlike those two earlier biographers, he did not write within an unchanging universe. To Enlightenment notions of progress and rationally designed improvement he brought a concern with ethical behaviour that reflected the social reform legacy of his English Protestant background. Charles Taylor's remark that "the courage to face the unhallowed universe could be thought of as a sacrifice which agnostics were willing to make for human betterment" (Taylor 1989: 405) identifies the displaced religious sentiment that suffuses Stephen's biographies.[5] His profound influence on biographical practice, through his own work and indirectly through the Bloomsbury biographers, is reflected in the fluid cosmologies of modern biography, which allow a diversity of values and world views and yet sustain clear narrative structures.

The trend in biographical practice between Stephen and Strachey is typified by Froude's life of Thomas Carlyle (1882-84) which, because

of its focus on Carlyle's personal life rather than his public achieve-
ments, shocked the public when it appeared, and by Edmund Gosse's
Father and Son (1907), a moving account that revealed private aspects of
the relations between the two men and probed the implications of the
elder's conservative beliefs. Ruth Hoberman, in her study of modern
biography, concludes that Froude's *nature*, Gosse's *temperament* and Vir-
ginia Woolf's *personality* all suggest "the vastness of the self and its con-
sonance with vast forces" (Hoberman 1987: 30). The ethical ground to
which Leslie Stephen's agnosticism had tethered the narrative patterns
of life was not firm, and the mystery of life, as elusive as ever, continued
to elicit new kinds of biographical description. Hoberman suggests that
the flawed self-knowledge which both Froude and Gosse depicted as
pivotal for their subjects intimated not "human weakness" but "a titanic
destiny" (ibid.: 32): despite their human failings some greater design
prevailed. Hoberman proposes that in order to "shatter their forebears'
pretence of titanic scale and integrity," Strachey's generation "need
only find physical or psychological mechanisms underlying ostensibly
freely willed or spiritually dictated behaviour, and the meaning their
subjects attributed to their own lives evaporates" (ibid.: 33). Paradoxi-
cally, by rejecting the example of Victorian biography in favour of
modernism's insights, by supplanting an ethical model with a psycho-
logical version in an attempt to clarify the meaning of life, the modern-
ists preserved the mystery that sustains biography. Motives allied to the
unconscious were, by definition, unknowable. A "natural law" of life
writing seems to be that once the formula has become predictable, it
loses its efficacy and must be reconceived. It is the enigma of life that
biography describes.

PLUS ÇA CHANGE, PLUS C'EST LA MÊME CHOSE

In *Sacred Biography*, his analysis of medieval hagiography, Thomas Hef-
fernan supports the notion that a continuity exists within the long tra-
dition of life narratives despite the radical generic changes in the
eighteenth century. For him the genre is "exquisitely sensitive to the
demands of verisimilitude, since the biographer's aim is to render, as
ably as he or she can, the record of an individual life" (Heffernan 1988:
43). Heffernan ascribes our inability to understand the truth embedded
in the sacred biographies of medieval saints to our commitment to the
presupposition of post-Enlightenment "empirical biography" that the
biographer is an historian bringing forward verifiable facts from the
records of the past (ibid.: 40-42).[6] By describing the genre across many

centuries, Heffernan invokes Fernand Braudel's *longue durée* and reminds us that, despite historical event and social change, the human condition fosters distinctive experiences endemic to the embodied nature of our existence. Conceptual changes and variations in narrative style mark a continuing sensitivity to cultural influences. Hence the longevity of the genre's appeal.

Heffernan isolates three crucial methodological assumptions that characterize the writing of modern biographies: that events are causally related, that "an extraordinary degree of fidelity" exists between historical documents and the life they describe and, finally, that present biases can be controlled (ibid.: 53). Certainly modern biography is sensitive to empirical truth and disconcerted by factual error. The necessity for new versions of a life to set the record straight is accepted practice. Yet in the lives told by Stephen, Froude and Gosse, all solidly based upon fact, different ways of balancing data and intuition have created quite different narratives. Stephen's search for moral laws to replace theological explanations, like Gosse's meditation on the world he shared with his father, is finally a subjective attempt to make sense. The bond between historical documents and the life they depict is neither a matter by which to measure fidelity nor one freed of bias. Rather, that relationship represents an occasion for interpretation. A subtle strategy of modern biographical narrative, one that makes a vision of existence inherent in the record of any life, is the use of empirical evidence to display the meaning of life. Any acknowledged search for historical accuracy is presumed to belie bias. Biographers, complicit in the fiction that theirs is a transparent and empirical genre, validate their search for meaning by grounding transcendental truths in actuality.[7]

Approbation accorded empirical fact, in what Timothy Reiss has called the "analytico-referential" discourse of modernism, precludes the recognition of a variety of subjects and attitudes that fail to match current notions of reality or truth, that fail to produce appropriate evidence. Falling outside the dominant patterns of meaning, marginal topics are determined by cultural pressures to be "in the strictest sense 'unthinkable'" (Reiss 1982: 11). Among the subjects that have failed to raise stimulating discussion, until recently, have been the lives of women. Heffernan maintains that "biography must bridge the historical chasm and make the departed present to us" (Heffernan 1988: 42). That chasm is conceptual as well as historical. For many of his readers, Leslie Stephen's urge to establish a narrative and scientific base for human existence, freed from its ties to God, was unthinkable. His struggle to depict his subjects in acceptable and familiar terms that acknowl-

edged their achievements, while simultaneously insisting on secular and
ethical explication, parallels the efforts of late-twentieth-century writers
to describe the lives of women. Women's lives have traditionally been
lived on the margins, although some exceptional lives, like Elizabeth I
and Marilyn Monroe, have inspired considerable interpretation.
Stephen himself wrote a biography of George Eliot, an exceptional
woman described by Elaine Showalter as having "ruled the Victorian
novel as Queen Victoria ruled the nation" (Showalter 1990: 59). Eliot is
one of a very few women to receive extensive attention, and yet her
marginality is secure:

> Was Eliot a woman writer, as Nina Auerbach, Sandra Gilbert, and
> Mary Jacobus maintained, or was she, rather, in the words of the his-
> torian Sheldon Rothblatt, a "man of letters"? Was she a great precur-
> sor of the modern novel, or a dreary anachronism with little to say to
> our time? Within the small world of academia, at least, Queen
> George still has the power to divide daughters and provoke sons.
> (Ibid.: 75)[8]

As the twentieth century opened, the New Woman, who had rejected
the Victorian world of separate spheres and was intent on social and
political reform, had few models to follow. No biographer knew quite
how to tell a woman's life. Biographers do, however, contemplate the
unthinkable. Around the periphery of its principal subjects biographical
narrative attracts details, arguments and ideas that do not require the
same levels of verification as the subject's life. The genre probes the
horizons of our understanding, and in the early decades of the twen-
tieth century it did so with significant effect, just as it had when Boswell
wrote his life of Johnson.

"IN OR ABOUT 1910 . . ."

This second moment of critical change in the development of the
genre, second to Boswell's impact, can be appropriately characterized
by its inward and psychological turn as biographers attempted to
retrieve the dense inner lives of departed men and women. Lytton Stra-
chey's *Eminent Victorians* is a representative biography, parallel in influ-
ence to Boswell's biography of Johnson. Though still writing within
the parameters of individualism wrought at the end of the eighteenth
century, by carrying the insights of biographers like Froude and Gosse
within a more deliberate notion of psychological uncertainty, Strachey
challenged the clarity of achievement and the decorum of moral refine-

ment.[9] Writing of four nineteenth-century heroic British figures, he sought motives concealed behind their evident successes, claiming that the interest of a "modern inquirer" in individuals such as Cardinal Manning "depends mainly upon two considerations—the light which his career throws upon the spirit of his age, and the psychological problems suggested by his inner history" (Strachey 1984: 13). Strachey's vibrant and astringent style highlighted the contrast between emerging views of biography and the panegyrics of the previous century. Of Florence Nightingale, whose dedication and accomplishments remain unquestioned, Strachey observed that "her sarcasm searched the ranks of the officials with the deadly and unsparing precision of a machine gun" (ibid.: 127). He squarely snuffs the candle she customarily carries in our imagination. Again,

> if Miss Nightingale had been less ruthless, Sidney Herbert [whose reform of the War Office was crucial to her ambitions] would not have perished; but then, she would not have been Miss Nightingale. The force that created was the force that destroyed. It was her Demon that was responsible. (Ibid.: 149)

The orthodox heroism of his subjects is sabotaged. In his evaluation of the unconscious forces that propelled them, he questioned the nature of achievement with literary manoeuvres that implied a mystery at the centre of the human condition, fascinated his readers and exemplified the genre's capacity to forge timely, compelling hypotheses.

Virginia Woolf, a close friend of Strachey's for whom biography was the domain of the father,[10] literally as well as figuratively, also queried the conventions of the genre, convinced of the value of its inherent moral force:

> The biographer must go ahead of the rest of us, like the miner's canary, testing the atmosphere, detecting falsity, unreality, and the presence of obsolete conventions. . . . He must be prepared to admit contradictory versions of the same face. Biography will enlarge its scope by hanging up looking glasses at odd corners. And yet from all this diversity it will bring out, not a riot of confusion, but a richer unity. (Woolf 1961: 167)

She followed her father in her search for meaning in life but, freed from the necessity to separate her vision from the restraints of doctrinal religion, she sought deep truths more characteristic of the modernist quest. A novelist and critic as well as biographer, she explored dilemmas presented by the biographical subject in several of her works. She advo-

cated a flexible form of life story in "The New Biography," written in 1927, one that could combine the "granite-like solidity" of fact with the "rainbow-like intangibility" of personality (Woolf 1981: 149). In 1928, in *Orlando*, a whimsical and fantastic fictional biography, she experimented with time and gender by creating a protagonist, based on her aristocratic friend Vita Sackville-West, whose complicated life encompassed and reflected several centuries of British cultural change. However when Woolf came to write an actual biography, *Roger Fry*, in 1940, the restrictions of historical circumstance left her less sanguine. The factors that deterred her went beyond the historical record of Fry's life to include her actual relationship with him,[11] concern for his family and the stress she felt within herself as Britain moved toward war. She recorded her distress in her diary:

> [5 May 1938] I'm a little appalled at the prospect of the grind this book will be. I must somehow shorten and loosen; I *can't* (remember) stretch it to a long painstaking literal book: later I must generalize and let fly. But then, what about all the letters? How can one cut loose from facts, when there they are, contradicting my theories? (Woolf 1978: 278)

In "The Art of Biography" in 1939 she explored her revised opinion. Despite its apparent empiricism, the truth of biography cannot last as long as the visions of fiction. The narrated life is forever bound by the limitation of facts. "These facts are not like the facts of science—once they are discovered, always the same. They are subject to changes of opinion; opinions change as the times change" (Woolf 1961: 167). Biographical truths change; lives require revision:

> The artist's imagination at its most intense fires out what is perishable in fact; he builds with what is durable; but the biographer must accept the perishable, build with it, imbed it in the very fabric of his work. Much will perish; little will live. And thus we come to the conclusion, that he is a craftsman, not an artist; and his work is not a work of art, but something betwixt and between. (Ibid.: 168)

Nevertheless, if the biographer is a craftsman, not an artist, still biography "does more to stimulate the imagination than any poet or novelist save the very greatest," with "creative" facts, "fertile" facts that suggest and engender (ibid.: 169).

Woolf's Bloomsbury vision bears the Clapham Sect stamp. Like her father she had a refined sense of the value and purpose of life. Unlike him she was not pressured by the demands of the public sphere. Hers was a private world of women and death, literature and friends.

> Both in life and in art the values of a woman are not the values of a man. Thus, when a woman comes to write a novel, she will find that she is perpetually wishing to alter the established values—to make serious what appears insignificant to a man, and trivial what is to him important. (Woolf 1981: 81)

The experience of women, moreover, demanded particular language forms, among them "a sentence which we might call the psychological sentence of the feminine gender." She attributed very particular capacities to this sentence: "it is of a more elastic fibre than the old, capable of stretching to the extreme, of suspending the frailest particles, of enveloping the vaguest shapes" (Woolf 1988: 367). Woolf's impact on the writing of women's lives and any search for feminine sentences is inestimable and has become increasingly evident as perspective has been gained on the modernist period within which she wrote.[12] Her understanding of biography, writing and the intricacies of publishing, the relationship between women and language and, above all, the dynamic between ordinary life and her epiphanic "moments of being"—when she knew that the patterns of living cohere, ineffably—all this has rendered her a powerful force in contemporary literature by and about women.[13]

Between them Strachey and Woolf put forward options for the biographer. Few would venture from the conventional model to the extent that these two did, but by the end of our century, with the self and identity in question, their work seems prophetic. Woolf continually explored the shifting ground of experience and tested the limits of human nature against the aesthetic and political traditions of literature. Her awareness of the plasticity of those traditions is reflected in her claim that "in or about December 1910 human character changed": "All human relations have shifted—those between masters and servants, husbands and wives, parents and children. And when human relations change there is at the same time a change in religion, conduct, politics, and literature" (Woolf 1966: 321). The divide that Woolf posits reflects Steiner's broken covenant, that crucial moment when cosmos and logos ceased to coincide. Like Hayden White's insight concerning the tension between the realms of imagination and reality in the narration of current events, these changes are read against the backdrop of empiricism and individualism. Unlike Steiner, Woolf did not dwell on lost or troublesome capacities; instead, she imagined breaking through barriers of conventional and oppressive attitudes to more profound perceptions of life. She appears to have been continually striving to bring into words her "great and astonishing sense of something there, which is 'it.' It is

not exactly beauty that I mean. It is that the thing is in itself enough: satisfactory, achieved" (Woolf 1978: 90). Like Carr, she felt her own art was the route to understanding: "I thought, driving through Richmond last night, something very profound about the synthesis of my being: how only writing composes it: how nothing makes a whole unless I am writing" (ibid.: 1978: 202).

The inspiration for Virginia Woolf's remark on changes in human nature was an exhibition of post-impressionist continental art that Roger Fry brought to London in December 1910.[14] Another art exhibition in London that same year drew an observation from Fred Housser that pointed toward a parallel momentous change in Canada. In his influential book on the Group of Seven, *A Canadian Art Movement* (1926), Housser claimed that,

> Before 1910, a Canadian art movement, inspired by Canadian environment, was not thought possible. Canadian art authorities did not believe that our rough landscape was art material. For years it had been said that pine trees were unpaintable. Our hinterlands were supposed to be too ugly as a medium of expression for a painter unless disguised to look like Europe or England. Canadian artists and the Canadian public preferred the softer, mistier, and tamer landscape of the old world. Our Canadian scenery was painted after the manner of Corot, Constable, or the Barbizon School. The view held in artistic circles in the Dominion previous to 1910, and indeed a view still widely accepted, was that Canada was a colony of Great Britain and that the colonial must needs express himself through methods approved by time and the intelligencia. To reflect our day and environment would be a vulgar adventure. (Housser 1926: 11-12)

Emily Carr read Housser's book just before she went to Ottawa in 1927 to see the National Gallery of Canada's exhibition of *Canadian West Coast Art: Native and Modern* which introduced her painting to a national audience and brought her into contact with the Group of Seven. Housser's book and the Group of Seven were tremendous influences on her life and her work. Lawren Harris, especially, would facilitate her art and enlarge the dimensions of her spiritual life. Many of Housser's insights are echoed later in Carr's own writing: she wrote of a desire, common to many modernists, to reach deep below the surface of things. Changes in perception were apparent on both sides of the Atlantic. Northrop Frye's description of the force in Tom Thomson's landscapes characterizes stimuli propelling artistic sensibilities throughout the West:

The incubus is there, in the twisted stumps and sprawling rocks, the strident colouring, the scarecrow evergreens. In several pictures one has the feeling of something not quite emerging which is all the more sinister for its concealment. The metamorphic stratum is too old: the mind cannot contemplate the azoic without turning it into the monstrous. But that is of minor importance. What is essential in Thomson is the imaginative instability, the emotional unrest and dissatisfaction one feels about a country which has not been lived in: the tension between the mind and a surrounding not integrated with it. (Frye 1971: 200)

In 1910, the year to which both Woolf and Housser looked back, Carr travelled to Paris to encounter the New Art for herself. An intimation of her power as a biographical subject lies in the scope and vitality of her participation in foundational cultural changes that were taking place during her life. The significance of art in Paris in the first decade of the twentieth century is a convention of modernism. Though Shari Benstock, in *Women of the Left Bank: Paris, 1900-1940*, describes the period before the war as an extension of the nineteenth century's *belle époque* in fiction, poetry, drama and music (Benstock 1986: 72), advances in painting were exceptional. The signal work was Picasso's *Les Demoiselles d'Avignon* (1906):

a threshold, a breakthrough, one of those works that make looking, reading, or hearing different. It was an analogue, however tenuous, to Schoenberg's insistence on atonality, Proust's utilization of Bergsonian time, Einstein's papers for the *Annalen der Physik*, Freud's examination of dream, unconscious, and childhood sexuality, even to Modern dance, in Duncan and Nijinsky. However one judged it, it announced the new was here to stay. (Karl 1988: 268)

Carr's hunger for new techniques had taken her to San Francisco in the early 1890s and to London for five years as the century turned. Now it drew her toward a centre where views of art and the artist's role were being shaped; rooted in both nineteenth-century romantic concepts and the consequences of twentieth-century social forces, these views would strengthen the spiritual elements of her work. Though avant-gardeism as an antagonism to the existing order developed as early as the 1870s (ibid.: xvii), experimentation in Paris was especially intense around the time of Carr's sojourn. The external appearance of works seemed less important than volume, form, space and colour, much less important than an internal order which mirrored the inner reality deep within the artist (ibid.: 277-83).

Cubism would concern itself with space . . . angles, objects as imma-
nent or indwelling, not as manifest. Cubism is antinaturalistic and
nonrepresentational, *but realistic*—a distinction often ignored or
lost. . . . Central was the idea of the "hidden object," the immanent
object or person. . . .

[Picasso] found himself moving from a perceptual view of art to a
conceptual one; from one based on traditional means of "seeing" to
one based on idea. At this point, Picasso became a "visionary"; the
world was created anew, as if he were present at the Creation and
could direct it. His art would grow and develop not from former art
but from the maker. It was a sharp and final break from movements,
schools, and traditions to the individual. It was the ultimate avant-
garde. (Ibid.: 274-75)

The demeanour and intentions of Emily Carr during her stay in
Paris were set down by the artist in her autobiography *Growing Pains*.
Written near the end of her life, a time when memory becomes entan-
gled with persona, her account distils the pressures put on biographers
by the subject's personal archive. This version of her life—only one of
the several she created—is chiefly descriptive of her training as a
painter, writer and interpreter of the land and people of the west coast.
The bulk of her text deals with the dailiness of student life, reflecting
the style of her other writing in an easy movement into reverie and
anecdote. Her avoidance of dates, for example, diffuses any sense of
inevitability. Carr devotes most of her attention to her education in San
Francisco and London, leaving her studies in France until near the end
of the autobiography, after she has authenticated her devotion to British
Columbia and its people. "Indian Art taught me directness and quick,
precise decisions . . . but who except Canada herself could help me
comprehend her great woods and spaces? San Francisco had not, Lon-
don had not. What about this New Art Paris talked of? It claimed big-
ger, broader seeing" (*GP*: 212). Since her interest in Paris rested nei-
ther in its language or history, only in its New Art, she presented her-
self without delay at Harry Gibb's studio. Her rhetoric sets Parisian
sophistication in perspective:

Mr. Gibb's landscapes and still life delighted me—brilliant, luscious,
clean. Against the distortion of his nudes I felt revolt. Indians dis-
torted both human and animal forms—but they distorted with mean-
ing, for emphasis, and with great sincerity. Here I felt distortion was
often used for design or in an effort to shock rather than convince.
(Ibid.: 216).

The themes that emerge in *Growing Pains* concerning her stay in France include her ambivalence toward the full range and implications of New Art; the devastating effect of city life upon her health; the isolation that she felt living in a foreign country—unabated by her sister's presence but ameliorated by leaving Paris for the countryside; the acquisition of useful techniques which allied her efforts to new modernist developments; and, as always, her determination. She seems unaware of the lives and work of other artists in Paris except in so far as the talents of male artists were assumed to be superior. Carr quotes Gibb: " 'You will be one of the painters,—women painters,' " he modified, " 'of your day' " (ibid.: 219). We learn of her classes at "Colorossi's," her hospitalization and recuperation with Alice in Sweden, but mostly of experiences in rural France which she describes in affectionate detail. Before the chapter closes she briefly mentions two canvases "accepted and well hung in the Salon d'Automne (the rebel Paris show of the year)" (ibid.: 220) and studies in watercolour she undertook with an unnamed female artist.

The subsequent chapter, entitled "Rejection," covers the next sixteen years of her life in thirteen pages. Assessing her French experience she maintained that although her work gained in strength, the ultraconservative west failed to appreciate her radical vision. "Nobody bought my pictures; I had no pupils" (ibid.: 230). For the most part biographers have followed Carr's lead in describing her Paris sojourn: there is little evidence of her activities beyond her own account. Nevertheless, Paris in 1910 marked the culmination of her training. Despite the arduous path ahead of her, Carr's personal quest had begun.

THE IMAGE OF EMILY CARR: EARLY SHAPES

Carr's image of her life has prompted more than one biographer to refer to her tendency to exaggerate.[15] Paula Blanchard, crediting Carr with "highly crafted autobiography, dense with the personality of the writer," characterizes Carr's books as "self-vindication, a way of putting to rest old guilts and airing old grievances . . . primarily concerned with emotional rather than factual truth" (Blanchard 1987: 10). Carr was truthful in broad terms according to Blanchard, but inconsistent in detail: her facts changed as Virginia Woolf said facts must.

> She consistently portrayed herself as younger than she was; she exaggerated her isolation on trips north; she suppressed the identity of the man she loved; she submerged the encouragement of some Victorians under the hostility of most, tarring them all with the same brush; her

published memoirs of her father are in some respects harsher than reality and in others not harsh enough; she needed to maintain that her two eldest sisters were English-born; she was shy of revealing the depth of her feeling for Ira Dilworth; in her bitterness over her years of "landladying" she made herself seem more sinned against by her tenants than she actually was. And finally, the full force of her revulsion against the ordinary mass of human beings has been understated in the published writings, both by Emily herself and by the editors of her posthumously published writings. (Ibid.: 10)

Blanchard understands Carr to be "a remarkably angry person" but one who used her "rage against the society into which she was born" constructively (ibid.: 11-12). The alienation of the artist is, after all, a convention of modernism. As a twentieth-century revolutionary position, derived from the Enlightenment urge toward progress through radical reform, the oppositional stance of the avant-garde generated energy and insight. Carr's anger at her predicament is easily subsumed in this larger social condition, so much so that a recent commentator easily dismissed her struggle:

The notion of structural difference (the politics of location) seems particularly crucial to those of us involved with feminist struggle and cultural production who live and work in Canada. Except for a handful of Margaret Atwoods, Margaret Laurences, Mary O'Briens and Emily Carrs, it is safe to say that ours is a marginalized and colonial relationship to the larger field of theory, art and representation. (Borsa 1990: 36)

Biographical truths change, and it may be that Carr now seems to be an insider to some, a woman of privilege. As her biographical image has grown to its present prominence, some "facts" seem to have fallen away.

A glance at the chronology of her life recalls another perspective. When Carr went to France in 1910, still struggling to find the techniques that could express her vision, she was thirty-nine years old. Upon returning to Canada she did not receive the acclaim she had hoped for, certainly not the support she needed to be able to devote herself, financially or in spirit, to the exploration of her talent. And just when she had forged a plan to support herself by landladying, Canada went into recession. As a consequence, from her mid-forties to mid-fifties, Carr's energies were totally consumed by managing her apartment-house and breeding her dogs, by making clay pots and rugs to sell. Although her life was difficult, the humour, energy and events of those years would reappear later as occasions for her short stories.

From the beginning the effects of this lacuna were a component of her image. In *Canadian Forum* just after Carr's death, Kathleen Coburn wrote that *The House of All Sorts* "refers to the period when it was necessary for her to earn, as landlady, the living the public denied her as artist." "Her landladyhood burned itself into her like caustic, and left scars" (Coburn 1945: 24). In 1950 Donald W. Buchanan put Carr's hiatus in perspective with regard to the work of the world of art:

> For fifteen years, years in which the art of James Wilson Morrice was reaching its rich maturity, in which A. Y. Jackson and Lawren Harris and J. E. H. MacDonald were busily engaged in founding a new school of Canadian landscape painting, during all these years she did not once put her brush to canvas. That was the tragedy which was to cast its shadow over her whole life. (Buchanan 1950: 49)

Carr did not reach a national audience until she was fifty-six years old and the National Gallery featured her work in its 1927 exhibition, *Canadian West Coast Art: Native and Modern.* Such money as she made, never a great deal, came too late in her life to change its shape; any notion of marginalization in the arts in Canada must include Emily Carr.

Art historian Nancy-Lou Patterson has called Carr a "self-invented woman," one whose commitment to life and density of spirit opened up virgin spiritual territory. Another historian of Canadian art, Gerta Moray, has shown how the earliest stages of Carr's biographical image served purposes other than her own. Moray's work raises interesting biographical questions about the pressures on Carr in the period after national recognition, when she did all of her writing, much of her painting, and came under the influence of Lawren Harris and others. There are no empirical truths with which to determine whether Carr's image is her invention or an inevitable response to the pressures of her cultural moment. Certainly Carr's fame in the 1930s came following a decade or more of activity that drew national boundaries in a variety of ways. Politically, in the postwar decade, effort was put into articulating separation from Britain. The Social Gospel movement, devoted to creating a just society for all in an increasingly alienated and industrialized society, had an influence on the coalition of Presbyterian, Methodist and Congregationalist churches.

> Without underestimating other motives, one inevitably suspects a close relation between the peak of national self-awareness that was reached in the early years of this century and the movement for union of these denominations that culminated in the formation of the

United Church of Canada in 1925. One must seek the link, not in any desire for national self-aggrandisment but rather in a sense of responsibility for mission to the nation. (Grant 1967: 162)

To accept a part in imagining the national soul, to join with the Group of Seven in devising images for the Canadian imagination, was to adopt a persuasive and compelling rhetoric that rested easily on the shoulders of a modern artist in a young country.

In Europe there was a widespread fascination with the primitive in the decade after the First World War.

As artists and writers set about after the war putting the pieces of culture together in new ways, their field of selection expanded dramatically. The "primitive" societies of the planet were increasingly available as aesthetic, cosmological, and scientific resources. These possibilities drew on something more than an older Orientalism; they required modern ethnography. The postwar context was structured by a basically ironic experience of culture. For every local custom or truth there was always an exotic alternative, a possible juxtaposition or incongruity. Below (psychologically) and beyond (geographically) ordinary reality there existed another reality. (Clifford 1988: 120-21)

In Canada native cultures played a less exotic, less sophisticated, but still crucial role. Here the aboriginal peoples represented a prior and essential attachment to the land that European immigrants could not displace and must accommodate.[16] Moray points out that a process of cultural accommodation had already begun when Carr was invited onto the national stage. Eric Brown, director of the National Gallery, and co-coordinator of the 1927 exhibition with Marius Barbeau, an ethnologist at the Victoria Memorial Museum in Ottawa, hoped that the exhibition would be the "apotheosis" of artistic and anthropological activity in British Columbia. For them, Moray says, Carr was "a mediator between native 'art' and modern art," "a shaman-like wise woman, whose life among the Indians and understanding of their wisdom amounts to . . . going native" (Moray 1990: 2).

After the 1927 show Carr moved onto a broader stage. For the last fourteen years of her life, eight of which were restricted by increasingly bad health, she knew something of the creature she was to become in the national imagination.

Before her death, however, her widest audience knew her principally as a writer. In 1941, when she was sixty-nine, *Klee Wyck* won the Governor General's Award for non-fiction. Her stories were an immediate success, and two more volumes, *The Book of Small* and *The House*

of All Sorts, were published before she died.[17] Her autobiography, *Growing Pains* (1946), was published posthumously as were two more volumes of short stories, *Heart of a Peacock* and *Pause*, both published in 1953.

The first real burst of attention paid to Carr beyond the west coast occurred with the publication of *Klee Wyck*. Ira Dilworth, a friend and the editor of Carr's writing, wrote two articles in *Saturday Night*; *Klee Wyck* was reviewed by Robertson Davies for *Saturday Night* and by Lawren Harris for *The Canadian Forum*; and Donald W. Buchanan wrote an essay for the *University of Toronto Quarterly* comparing Carr's landscape painting and that of James Wilson Morrice. In his two articles Dilworth articulated the iconic image of Emily Carr in its principal terms. He began in a traditional manner, reminiscent of the forms authenticated by Leslie Stephen in the *Dictionary of National Biography*, by describing her place within her family and her family in the context of Victoria. He used her education as a thematic link to the death of her parents and to her sojourns in San Francisco and London. Illness aborted both the first European trip to London and the later trip to Paris. Once home, "an urgent passion to answer the call of the primitive wild beauty" precipitated her travels along the west coast.

> The story of these trips is almost incredible. Sustained by her deep desire to see nature in wild places and explore the life of the Indians in their native villages, with the courage that we at the present day can scarcely understand, she went into the most solitary parts of the British Columbia coast, into the Naas and Skeena River country, sometimes even over into the Queen Charlotte Islands. Poor transportation, loneliness, mosquitoes, difficult and often extremely dangerous stretches of sea meant nothing to her or at least not enough to make her turn back in these voyages into a world that called her so strongly (Dilworth 1941a: 26).

This is the core of the Carr image, present from the start: desire and wild nature, an element of mystery, close association with native Canadians, courage and adventure, and, especially, a *call*—a proclivity to pursue meaning.[18]

In the second article Dilworth introduced themes that continue to swirl around the life of this one woman. He began by reflecting upon his childhood memory of Carr pushing "a perambulator in which perched a small Javanese monkey dressed in a brightly colored costume." Along with "most of her fellow-citizens" he thought her eccentric. Dilworth also classified her work, as many others will do, to accord with a plausible and common metaphor of biological develop-

ment.[19] The early paintings, "fine and honest," made their most distinguished contribution in their native themes. A middle period, related to Carr's French studies, followed upon her contact with the Group of Seven: aboriginal subjects predominate, colour and composition have become formalized and the mood is stronger. In a third period she turned from the aboriginal material to the forest. "No one else has succeeded in capturing and putting on canvas so successfully the feeling of the West Coast forest, sea and sky" (Dilworth 1941b: 26). Turning to her writing, Dilworth characterized it as personally rewarding for Carr, often done "simply to comfort her loneliness." Like her paintings, her stories fall into groups: native villages, early Victoria, animals and childhood. He then raised the level of his rhetoric, elevating his sense of her being:

> I have seen Miss Carr working at her manuscripts, "peeling" sentence and paragraph as she calls it; I have heard her talking and watched her devour the conversation of others, of Lawren Harris, of Arthur Benjamin, of Garnett Sedgewick; I have watched her anger tower over some meanness in the work or conduct of an artist and I have seen her become incandescent with generous enthusiasm for another's fine work; I have seen her gentleness to an old woman, to an animal; I have beheld the vision of forest and sky enter and light her eyes as she sat far from them and I am convinced that Emily Carr is a great genius and that we will do well to add her to that small list of originals who have been produced in this place. (Ibid.: 26)

In his conclusion Dilworth quoted Thomas Hardy and referred to Rupert Brooke and to Wordsworth, thereby linking Carr to particular traditions. Admiration and fascination like his will not be uncommon responses to this "little old woman on the edge of nowhere."

Robertson Davies' review of *Klee Wyck*, "The Revelation of Emily Carr," in the same issue of *Saturday Night* as Dilworth's second article, is in a similar vein. For him the stories are "not sentimental tales about nonexistent 'redskins.'" Rather, told "without patronage, without sentimentality, but with great love and great art," by "a clear, powerful, original and rigorous mind," they offer "a great revelation of that secret Canada which is hidden from most of us, pale sojourners in a strange land" (Davies 1941: 18). In his article Buchanan linked Carr's work to the Group of Seven in its "awareness of the more austere aspects of Canadian nature" (Buchanan 1941: 74). For him her early "more amateurish" period "does not interest us much now." Stimulated by Lawren Harris, Carr's "organic conception of painting," "apparently discovered by herself within herself," created "a foreboding

dread, a fear almost of nature and its power" (ibid.: 75). He quotes west coast artist Jack Shadbolt: "she has, as no other artist among us yet, evoked the presence of the terrible and elemental forces of our landscape" (76). Buchanan also noticed the lightness of her latest paintings and remarked upon the limitations of "her occasional romanticism, her isolation, and her material struggles" (ibid.: 77).

Words to contain Carr's image during the last years of her life and in the early postwar years seem to be pushed toward new categories. This is from a review of *The House of All Sorts* by Kathleen Coburn printed the month after Carr's death:

> Certainly she is not detached enough to see life as any comedy of manners, except sporadically, and she is too pagan to see it as a divine comedy. She is, indeed, violently attached to life, living in a relation almost too conscious for happiness, to all the elements, sounds and silences and space, sea and forest and wind, the seasons, flowers, persons, dogs. (Coburn 1945: 24)

Thomas Daly, in *Saturday Night*, following an exhibition in 1945 "remarkable as the most ambitious retrospective of any Canadian artist yet held" (Moray 1993: 15)[20] and anticipating the forthcoming *Growing Pains*, addressed her "unified conception of the world" and connected it to Emerson and Whitman, a thread in her story that is not thoroughly explored until the 1970s. Emerson's notion of the artist as the mouthpiece of the universe explained to Daly something of the "tremendous force" of Carr's work (Daly 1945: 28).

Two other efforts in the mid-forties exemplify the range of these first attempts at setting Carr apart as a woman of meaning. M. E. Coleman's "Emily Carr and Her Sisters," a personal recollection that appeared in the *Dalhousie Review* in 1947, amplified Carr in her family setting. "All four of the Carr sisters whom I knew were remarkably gifted," with Emily being "the difficult one." Like Vasari's artists, Coleman's Carr will grow from her unique and trying beginnings to be gripped by "a tremendous creative urge that obliterated every other consideration and was to whip her, drive her through pain and bitter disappointment to the culmination of her life's work—her mystic paintings of the British Columbia forest" (Coleman 1947: 29, 31). A year earlier the first of six films on the artist's life, *Klee Wyck*, had been made by Graham McInnes for the National Film Board. A short fifteen minutes, it encapsulated the main thrusts of the image of Emily Carr as the century reached its half-way mark; but unlike the strong images in many other accounts, the film anticipated the conservative tone of work

to come during the next two decades. The rhetoric of the film's script is subdued: there is no elaboration of her intense feelings and only brief recognition of the hardship of her life. Instead her images of the landscape of the west and aboriginal life, seen at that time as a dying culture, are interpreted as the inspiration of an isolated artist.

By mid-century, then, the template for "Emily Carr" had been created, and it reflected a wartime yearning for highly charged artistic insight. Carr played a major role in shaping her image, no doubt influenced by the attitudes to art and artists in Europe and, more especially, in central Canada. She drew herself with bold gestures that were echoed by others who added rhetorical depth and reinforced her compelling emotional intensity. Later biographers may lament Carr's inaccuracies and shibboleths, but she put in place a persona they cannot discount. By 1950 Emily Carr was a figure of national interest implicated in areas of concern to other Canadians. Though much had been written, there was not yet a full biographical study of her—that awaited broad cultural shifts in Canada.

Mid-Century Spiritual Quests: Canadian Versions

The experiments in biography in Great Britain, centred on the efforts of the Bloomsbury Group, had a tremendous impact. The effects, however, were not easily discerned in Canadian biography until after mid-century. As a loyal British colony, Canada lacked the confidence that comes with tradition based on a developed sense of place (Thomas 1976: 189). As the senior, predominantly white Dominion, the country remained too tied to Britain to develop a range of strong autonomous art forms until shifts in power, interests and wealth occurred following the end of the war in 1945.[21] At mid-century there was a predilection for British culture, but it was clear that "the European countries' well-endowed systems of cultural support (rooted in the patronage of the church, the guild system, the aristocracy, and the merchant class) generally catered only to the 'high' arts—a practice that would have been criticized in Canada as élitist" (Tippett 1990: 73). In Canada there had been a great deal of local amateur activity and in 1941, when André Bieler organized the Conference of Canadian Artists, feeling grew that cultural activity was essential to national life.[22] Before the war ended an Artists' Brief was submitted to the government's Special Committee on Reconstruction and Re-establishment which had been set up to prepare for the advent of peace. The arts were perceived as transcending those human activities that encourage dissension. "This is so because

the life in the arts, being universal, transcends racial, religious, economic and political differences, and class interests . . ." (Canada 1944: 371). Sophisticated colonial cultural expression and analysis, which perceives and can imaginatively manipulate marginality and multiculturalism, are recent developments that owe a great deal to postmodern critical theory.[23] As the Second World War ended the demand was, more simply, for an order of meaning.

When the first substantial biographical essays on Carr began to appear, they reflected Canadian attitudes forged in the aftermath of war. In 1948, the year before the Government of Canada appointed Vincent Massey as chairman of the Royal Commission on National Development in the Arts, Letters and Sciences (the Massey Commission),[24] T. S. Eliot wrote *Notes Towards the Definition of Culture*. Responding to the existential dilemmas of the postwar world, Eliot sought an image of culture that could encompass the horror of the immediate past and some hope for the future.[25] Central to Eliot's essay was the notion that culture could only develop in relation to a religion (Eliot 1948: 27). For him religion and culture were not identical, nor were they separate. Nor was culture more comprehensive than religion; it was not "an ultimate value" for which religion merely supplied "ethical formation and some emotional colour" (ibid.: 28). Rather, "the culture of a people," properly understood, was "an incarnation of its religion" (ibid.: 33). Eliot's voice was powerful within the Anglo-American community.[26] As a poet and critic with ties to both the United States and Great Britain, he spoke for the two cultures that pressed in upon Canada when the Massey Commission gathered its evidence. His struggle toward definition reflected the instability of the idea of culture following the war and a growing awareness that it was a timely concept whose interpretation might heal the wounded world and direct the energies of peacetime. In an era of increasing social pressures and a strengthening of the effects of industrialization, especially the growth of cities and secularism, culture offered apparent alternatives for body, mind and spirit.

Although the word "culture" was "sedulously avoided" in the Massey Commission's report—according to Hilda Neatby, one of the commissioners (Neatby 1956: 37)—a brief and cautious definition was included: "*Culture* is that part of education which enriches the mind and refines the taste. It is the development of the intelligence through the arts, letters and sciences" (Shea 1952: 13). Without the precision of T. S. Eliot's rhetoric, this notion nevertheless shares his assumptions about the cultivation of the individual. By situating culture within the

realm of education, it reflects an attitude to the relationship of art and
society that had roots in the moral tones of nineteenth-century British
aesthetic theory. Critics such as A. W. N. Pugin, John Ruskin and
Matthew Arnold had linked art to morality and religion. Ruskin, fol-
lowing Pugin, thought the truth and beauty of art rested "fundamen-
tally on belief in a universal, divinely appointed order" (Williams 1960:
135). Arnold added imperatives to moral reform: he saw culture as
"right knowing and right doing" (ibid.: 125). This moral and commu-
nal vision of culture accompanied a romantic notion of genius which
stressed the responsibility of individuals for their own spiritual growth.
Thomas Carlyle, another influential nineteenth-century British moral-
ist, maintained that "the great law of culture is: Let each become all that
he was created capable of being" (Ostry 1978: 4). Within the context
of that law the romantic artist—whose life hinged more upon imagina-
tion than faith in the Creator—assumed powers of genesis and the abil-
ity to address pure spiritual existence (Jay 1984: 44). According to John
Keats, the English poet, "the Genius of Poetry must work out its own
salvation in a man; It cannot be matured by law and precept, but by sen-
sation and watchfulness in itself. That which is creative must create
itself" (Williams 1960: 44). If Keats' language is not conventionally or
explicitly Christian, his imagery evokes the sensibilities of Christian
culture. The romantic movement generated an attitude that art could
suffice as an alternative or substitute for religion (Gunn 1987: 183).
That view was not antithetical to Eliot's. Both positions valorized intel-
lectual and moral power.

Nowhere is the rhetoric of the British connection stronger than in
Vincent Massey's *On Being Canadian*, an apologia published in 1948
which stands as a testament to the ideas he held immediately prior to his
appointment to the Royal Commission.[27] The magnificent task of dis-
covering and sustaining "the essence of Canada" (Massey 1948: 29) was
facilitated by membership in the British Commonwealth, by following
the beacon that was the British model. To see through the institutions
and dissensions to a great and valuable goal or truth marked the faith in
Britain that Massey felt he shared with many Canadians.

> Our links with Great Britain are imponderable. They belong to the
> realm of things of the spirit; those subtle habits of mind we have in
> common and which elude definition. It is commonly said that such
> bonds are stronger than material ties: so they are but even they can be
> weakened. Only through constant contact can we keep alive a sense of
> our kinship. (Ibid.: 112)

For him nationality was "sacred" as "the instrument of labour and progress of all men" (ibid.: 8). Canadian unity was "more than skin-deep. It is a spiritual thing, not merely a matter of taxes and tariffs" (ibid.: 47). Massey defined nationality as "that principle compounded of past traditions, present interests, and future aspirations that gives a people a sense of organic unity" (ibid.: 25). *Organic* suggests a biological notion of growth and progress: "we shall talk of progress until it is achieved but however we use the word, the idea to us must be supreme, for in Canada the pursuit of unity is like the quest for the Holy Grail" (ibid.).[28]

> It is a basic element in our national faith that there is a common ground between all Canadians. The discovery of such common ground can come only from an interpretation of Canadian interests in the broadest and deepest meaning of the word, and that will require an adequate measure of agreement on all the great questions which confront us. Thus only can we acquire that sense of the whole which is greater than its parts. (Ibid.: 17)

It was against this view of culture in its relationship to religion and the emerging pride of Canada's inherently meaningful place in the world that the biographical image of Emily Carr began to take on a more elaborate form. It did so as an astonishing flourish in biographical writing took place. When Vincent Massey was taking up his duties with the Royal Commission, biographers in Canada "were speedily progressing toward a higher standard of excellence and a more comprehensive definition of the genre" (Thomas 1976: 193). The decade of the fifties witnessed the publication of a number of outstanding biographies: Bruce Hutchison's *The Incredible Canadian: A Candid Portrait of Mackenzie King* (1952); Donald Creighton's two volumes on John A. Macdonald (1952 and 1955); William Kilbourn's *The Firebrand: William Lyon Mackenzie King and the Rebellion in Upper Canada* (1956); William J. Eccles' *Frontenac: The Courtier Governor* (1959); and James M. Careless' *Brown of the Globe* (1959; 1963). According to Clara Thomas the legacy of Creighton's work was "a consciousness of style and a striving for grace of expression added to meticulous scholarly research" (Thomas 1976: 203). Those characteristics did indeed distinguish the finest works of the period, which tended to be the lives of male public figures, chiefly politicians, written by professional academic historians. While there were female subjects, among them Agnes McPhail and L. M. Montgomery, they did not achieve the amount of attention that male subjects did.[29]

From 1950 through the mid-sixties there was a cautious move-
ment toward a clearer description of Emily Carr. Her biographical
image seems trimmed of the excessive rhetoric of the forties, leaving a
more sensible and human figure with considerable presence and pro-
found insight. There was as yet no model to follow for the life of a
woman, let alone a woman artist, and in the fifties no complete biogra-
phies were written of her life. Instead there were a number of personal
reminiscences.[30] The most substantial of these is Carol Pearson's *Emily
Carr As I Knew Her* (1954). In the Foreword Kathleen Coburn[31]
remarks on Carr's innocent wisdom and "her nearness to the primal
source of things" (vii). The complexities of Carr's art are not in ques-
tion here. These are, rather, the warm recollections of someone Carr
treated as a daughter. They depict the intimacy and ordinariness of daily
living that characterized the autobiographical writing of women. Pear-
son, who called Carr "mom" and often stayed with her when she was
young, recalls much that seems relevant to the world we know in the
last years of the century.[32] Carr was, for example, troubled by her
appropriation of native motifs to decorate the pottery she made (ibid.:
32-34). There is, as well, a stronger physical aspect to Pearson's
memories of Carr than is found in other accounts. The body of this
short square woman, quite beautiful in her youth, had become heavy in
maturity and demanded special care. The physicality of her work—
painting, dog-breeding, home maintenance, to say nothing of life in her
caravan—is enhanced when her body is accentuated.

> Lavish though her use of colour and descriptive words may have been,
> when it came to dress Emily Carr was simplicity itself. She insisted on
> fresh clothes every day, but they were as plain as possible; her dresses
> were almost like shortened nightgowns. As she said, they were easiest
> to get into, also they were less showy on her plump little body. Once
> you knew her, you never gave a thought to her weight, mostly, I
> think, because she was the first to poke fun at herself. After only a
> minute or two with her, you were quite unaware of it, so completely
> engrossed would you become with her eyes, her hands, and the man-
> ner which, when she was interested or entertaining, was almost a
> magnetism. (Ibid.: 53)

Pearson looked back upon her own childhood with a woman who, in
turn, had found much of her own strength in looking back at a self
called Small. With sensitivity and a nostalgia that rings true, Pearson
recalls Carr's wisdom:

> There were so many little sayings, so full of meaning, that if you took time to think about them, you would wonder what incident in her life had caused thinking deep enough to put them in such careful wording. We know that her problems were puzzles that *had* to be solved. "Often, we learn our songs when it is too late to sing." This one has always upset me: she was so successful in so many ways, yet what was the ambition, or tune, that was missed? (Ibid.: 148)

Two essays on Emily Carr published in the *Queen's Quarterly* bracket the decade. Both are more subdued than the effusive declarations of the forties that lauded Carr's insight and passion; both reflect the seriousness of an earnest young nation. The first of these, by David Derek Stacton, illustrates mid-century desires to build a strong national identity through culture. Entitled "The Art of Emily Carr," Stacton's essay settles somewhat awkwardly between the artist and her work. He laments the "unfortunate history" her reputation has had: though her works are in the country's principal galleries, "she still remains obscure" and "no serious criticism has been attempted" (Stacton 1950/51: 499). He begins his interpretation by acknowledging the power of her work.

> Hers is not a comfortable art, but . . . it is an art of a high order. To the superficial eye there are two elements in her paintings that disturb us. One of these is an undefined and repelling sexuality. The other is a sensation of being watched. They are both rooted in the nature of the rain-forests which she painted. If we trace back these two elements, we discover that while she painted the rain-forest, she used it to express something she felt to be true about life, for hers is a mystical art. (Ibid.)

Though he grounds his thoughts in her person, in the physicality of sexuality and vision, as a mid-century modernist he quickly establishes a distanced view and concentrates on the formal properties of her painting—form, colour, perspective—and her techniques, particularly her brush-stroke. He is concerned that her work be put in a broader context: her mystical capacities and her brush-strokes parallel those of Zen painters in China and Japan and she resembles, in a number of different ways, European painters El Greco, Constable, Hals and Goya. More important for Canadians is her fascination with the culture of the native peoples. "She discovered her art in the rain-forests, and it was through the Indians that she came to the forest" (ibid.: 500). The author makes the power of this contact clear:

> The Indians of Vancouver Island were not a debased people. They possessed a culture of great spiritual insight, a symbolic oral literature of considerable sophistication, and a formal art of intense ritualistic formalism, hence they expressed themselves through traditional religious symbols. (Ibid.)

Stacton also distances Carr from herself: she was not a subjective painter. Rather, she attempted to paint the world as she saw and understood it to be. Hers is an art that matters to Canadians, one they can trust to give them a clear sense of themselves.

The shift in this essay, away from the artist to the contribution her art might be able to make toward national definition through culture, ties it to broader concerns in the West with an emerging sense of *culture* as a more inclusive term than *religion*. T. S. Eliot's notion of culture as an incarnation of religion demonstrated the possibility of developing a metaphysics focused on experience, a perspective of existence that could accommodate the realities of a much smaller globe. After the war, world order had changed and the nation was conscious of its status: "Canada was at the height of its power and prestige, taking an honourable place at the council tables of the world. At the dinner tables, too, Canada felt the need to acquire civilized graces" (Ostry 1978: 59). The Massey Commission was appointed to "give encouragement to institutions which express national feelings, promote common understanding and add to the richness and variety of Canadian life, rural as well as urban" (ibid.: 60). Its report, a massive and literate effort, addressed the substance of national identity. Charles F. Comfort, who had been one of Canada's war artists, wrote the submission on "Painting." "Art, to be 'Canadian' in the only sense worth talking about, is the creative expression of the artist, creating out of his own experience in his own environment, reflecting the spirit of both, which may be national and yet be universal in the most profound sense" (Comfort 1951: 407). George P. Grant, in his submission on philosophy, lamented the severed link between religion and society. Canada had come of age in an era of science:

> Our spiritual climate is largely formed by our partaking in the ideas of [the Western society of nations], which during the years of Canada's development, was being transformed by the new mass industrialism. With that industrialism went certain dominant ideas that effected an almost incalculable spiritual change in the west. In the light of the amazing power of science, men no longer doubted that they could easily perfect their societies. (Grant 1951: 121)

Carr's images, created out of her own experience with the forest and the sea, described a spiritual power capable of confronting the dominant ideas of industrialization. Her paintings, her words and invincible spirit suggested alternatives.

Virginia Woolf, whose father found the doctrine of institutional religion hollow and untenable, sought meaning inwardly, as he had. He searched for a rational ethic that could reconcile his loss of faith with his yearning for meaning; for her, meaning was a deeper psychological reality. She shunned or subverted the institutional world and created a different order and explication through art. In her *moments of being*—epiphanies experienced by others of her generation through "the intense inwardness of the arts, which Kandinsky stressed as the incandescence of the soul" (Karl 1988: 216)—she located a spiritual realm to offset the harsh technologies of her time. Carr's experience parallels Woolf's, or is perceived as having followed a similar trajectory. Theirs was the journey of the modernists: "a journey of the soul, an analogue in modern terms of the medieval journey of the mythical hero or knight. Here the grail is the self reaching toward achievement or self-recognition; not a form of conduct, but a way of believing, a source of self-comprehension" (ibid.: 198). "The significance of these moments can not be overstressed, . . . they give modern life its experiential base" (ibid.: 47).

The transformative experiences of the arts offered to replace contact with the Creator that had been lost to progress and science (ibid.: 106). There was, however, the problem that openly religious language was suspect, irrational, degraded. Though inherent in the processes of secularism, this attitude was pronounced in the period after the war when the supremacy of technology seemed guaranteed. Picasso's thoughts on the word "sacred," that "people would put a wrong interpretation on it" characterizes the modernists' dilemma (Lipsey 1989: 19). In 1952 historian Arthur Lower recognized the *Massey Report*'s struggle to define the Canadian soul against the pressures of American postwar strength:

> The Report of the Commission is a classic document. The Canadian state now turns to the highest function of a state, building the spiritual structure (the word is not used in the religious sense) of a civilization, the material foundations of which it has already sturdily laid. If the builders can continue to be men and women of the calibre and vision of those who prepared this Report, the work will go forward to brilliant achievement in future ages. (Lower 1952: 32)

The statement is itself a classic indication of the rhetoric that combined a religious sense of national destiny with the highest purposes of nation-building facilitated by participation in the once great British Empire. That Lower is self-conscious enough to step back at his own use of "spiritual," as though there were a definition of the word that was not religious, may be a clear signal that the vision he understood could hold no longer.

Stacton's analysis of Carr's painting articulated access to religious truth as it was available to Canadians through the work of an artist, someone he styled objective, one whose works embraced the globe. Firmly rooted in the traditions of the West, Carr used techniques from the Orient. Writing within the precepts of modernism, Stacton suggested that psychological truth, which had overtones of scientific reasoning, empowered her art. But his is an early gesture; there is still insufficient cultural density, an inadequate layering of experience according to the customs of the West, to dare to say more.

Stacton's essay addresses biographical practice directly only in his avoidance of her personal story. Near the end of the decade, in 1958, again in the *Queen's Quarterly*, Ruth Humphrey wrote a conventionally "intimate view of a great-hearted woman" (Humphrey 1958: 270). A rambling sketch, Humphrey's contribution covers a wide array of material without being either intimate or particularly informative. However, given that very little had been written before that time for a national audience, her portrait gave Carr's image necessary exposure. Shaped anecdotally, it begins with an image of Carr in old age writing to the author, then moves to the "derision" with which Carr's work was received in Vancouver in 1912, her contacts in central Canada, visitors to her studio, her writing, journeys and childhood, even her "lack of a specifically literary sophistication" (ibid.: 276). Like Carol Pearson's account, Humphrey's writing adds a layer to the cultural density of Carr's image but it lacks Pearson's warm humour and commitment. It displays the cautious reserve of its decade but is a diffuse experiential account, like Boswell's, to match Stacton's more Johnsonian sense of destiny.

THE 1960s: CONSOLIDATION

The decade of the fifties passed without a major biography of Emily Carr; so too would the sixties. However, during the decade of the flag debate, centennial celebrations and Montreal's Expo 67, attitudes in Canada changed, as they did elsewhere. Gone was the postwar simplic-

ity of continuous expansion. In the contexts of tumultuous change, brought to the surfaces of consciousness in the events of May 1968, the modernist vision of a holier realm came to ground at Woodstock, on the streets of Paris, in Pierre Trudeau's rose and sandals. Emily Carr's image settled more comfortably. Perhaps enough time had passed since her death; perhaps her green world had acquired a new significance. Carr emerged in art histories and as the subject of a bibliography published by the University of British Columbia's School of Librarianship. Marguerite Turpin's *The Life and Work of Emily Carr (1871-1945); A Selected Bibliography* (1965) amassed and classified the fragments of Carr's image and made clear its faceted nature. Personal reminiscences continued to appear. In 1969 Edythe Hembroff-Schleicher's *m. e.: A Portrayal of Emily Carr*, her first work on Carr, focused on the thirties and recalled the friendship between the author and the artist, details of Carr's life and of their sketching trips together. Her concern in this book is with painting techniques, exhibitions and the art world. Though Carr could be fussy or brusque, supportive and intense, Hembroff-Schleicher acknowledged her friend's insight and spirituality. Personal memories of Carr, like this one, are a rich and variable aspect of the composite image. Perhaps more than formal accounts—full biographies, essays and exhibition catalogues—they add depth and immediacy and, of greater significance to the faceted image, they add other perspectives, differences of opinion and experience that generate ambiguity and infuse the matter of Carr's life with the momentum to persist.

The unique temper of the sixties is more evident in Roy Daniells' talk, sponsored by the Institute of Canadian Studies and published jointly by Carleton University and the University of Toronto Press as part of a continuing series of biographical essays called *Our Living Tradition*. Daniells *explains* Emily Car in a warm, humorous and measured assessment of her importance to Canada.

> It is altogether fitting that this formal gesture of homage and this institutional recognition should be directed towards an old woman who had as little as possible to do with institutions or formalities of any kind during her lifetime. For this, surely, is in the habit and tradition of Canadian life, that the impulse of the individual soul, in its uniqueness, in its creativeness, should at last be made part of the national impulse, the collective tradition. (Daniells 1962: 119)

This essay is not about information or even focused interpretation, though Daniells insists that Carr's sensitivity was not sensuality (ibid.: 126) and that she liked native peoples not because they were "bearers of

the primitive virtues" but because they were themselves (ibid.: 127). It addresses instead an iconic repository of the national soul. He speaks so that his audience will know more about this image of themselves.

Daniells describes British Columbia and Victoria as essential determinants of Carr's nature: "as a child she found herself in a partial vacuum in which some good-sized molecules of British civilization were circulating" but she did not experience "the advantages of a mature culture and a homogeneous community" (ibid.: 120). The details of her life are not his concern, for the details of her life fill her books. However, because she "disliked self-analysis in writing submitted for publication . . . we must dig down a bit deeper for the implications" (ibid.: 123). Acknowledging the centrality and power of this "old woman," he turns to specific themes through which he can elaborate her influence. He absolves her of all uncharitableness, having some experience of his own with tenants like hers, and suggests that her "hatred of London and of so much in English life" is explicable if late Victorian and Edwardian habits of "meaningless snobbery and petty class distinction" are remembered. She never married, though she might have, perhaps because of "devotion early turned . . . [to] the world of nature." As for her fifteen-year hiatus: "the current of her vitality only went underground. She never really deviated from her goal, which was to express fully in painting her transcendent sense of life" (ibid.: 123-24). Her paintings can be read as revelation or examined for the evolution of her techniques (ibid.: 128), but he suggests that her work is best thought of as autobiography. "She was not primarily interpreting Canada to the world. She was interpreting herself to herself by the symbols which the forest provided." Daniells does not shy away from subjectivity as Stacton had a decade before. In Daniells' view, Carr pursued, uniquely and with singleness of purpose, "something in the landscape that would respond and correspond to her own spirit" (ibid.: 129).

> Her life, her books, her canvases, all say the same thing and say it with overwhelming conviction—that in this world of stupidity and squalor the white fires of candour and courage still burn, that they illuminate the ill-defined but powerful ultimate truths of life. And these, most easily found in the gestures of simple people or in the face of nature itself, are the immemorial impulses of the will to live and to create, the impulse of charity towards life and hatred of all that impedes life. (Ibid.: 132)

For Roy Daniells, Emily Carr is a saint, one of the community of believers, an exemplar.

> She suffered deprivation: lack of a firm stratum of society, lack of
> sympathy, lack of a clientele, lack of constructive criticism, lack of
> money, lack of time, lack of good health and good luck, till all too
> near the end of her career. Her example proclaims itself with
> immense power. Like her, we can resist, work, escape, learn, endure,
> return, create, record, develop, and finally triumph. (Ibid.)

Just as, in the fifties, Stacton's focus on the impact of Carr through
her art contrasts with Ruth Humphrey's intimate account of daily life,
in the sixties Flora Hamilton Burns' recollection and analysis offered a
view of Emily Carr from a perspective different than Roy Daniells'.
Again the female biographer has offered an embodied, grounded or
experiential account at variance to the idealized Carr in the male ver-
sion. This gender division, though significant, does not continue to
remain so clearly marked. It may be more useful, in terms of Carr's life
story as a cultural site, to imagine these contrasting versions as the initial
divisions of a biographical image that becomes increasingly faceted.
However, it is significant that Burns wrote when there may already have
been glimmerings of the momentous changes about to take place in the
envisioning and writing of women's lives.

Burns' substantial biographical essay appeared in a "celebratory"
collection on Canadian women, a centennial project of the Canadian
Federation of University Women, *The Clear Spirit* (1966). The collec-
tion comprised "documented, serious biographies based on the social
history of the subject's time and place" (Innis 1966: xii). Intended to
increase interest in the lives of Canadian women, the fifteen essays

> display the very real struggle of able and forceful women against very
> real obstacles. It is easy and partly right to blame men and their vested
> interests for making women's path difficult. But only partly
> right—many barriers are built and kept in repair by women them-
> selves, tradition-bound, envious or timid. Advance sometimes seems
> slow but, as this book shows, for an able and determined woman
> obstacles make the road intriguing. (Ibid.: xii)

Though Burns knew the artist, her conventional portrait reveals little of
her friendship with Carr; it is not an intimate portrait. The serious pur-
pose of establishing a rounded, contextualized image of Carr as a
woman artist is paramount. The portrait is not without humour and
warmth. Rather, in the limited space at her disposal, writing the first
intentionally complete version of Carr's life, Burns has no room for
rambling or musing; hers is clear and carefully crafted writing. She uses
traditional biographical form as we have come to expect it: birth, child-

hood (father a problem; mother mild and sympathetic), education (San Francisco meant freedom; England was difficult; France, difficult but important). Victoria, Vancouver and Canada failed to appreciate Carr. Burns doesn't dwell on Carr's hiatus of hardship but faces it squarely and then moves through the blend of names and events that distinguish the period of Carr's national reputation and her writing. She attends to Carr's relations with native Canadians, holding to the view that when Carr had outgrown that contact, she was able to go directly to the forest and into her final spiritual phase. This biographical essay recalls the careful plan and measured tones of Leslie Stephen's exemplary diction-ary-style sketches. As a story of Carr's experiences, the facts, it does not dwell on her thoughts or her art but attempts to acknowledge her achievements and assess her worth. In the final paragraph, Burns reveals the essential significance of this one woman and demonstrates the dif-ference between words and visual images:

> Through her paintings and her books Emily Carr has written her own biography and they speak for themselves. Her books give us many of the events of her life but her paintings show us the unfolding of her soul. The eye of the artist revealed the appearance of things, but the soul of the mystic sought behind the appearance for the underlying meaning, the ultimate reality.
>
> As a figure of world stature Emily Carr was too big to fit into the Victoria frame in the early twentieth century. She has been called a genius and like all geniuses, she overflowed and outran her time. (Burns 1966: 240)

As the sixties close, Emily Carr has grown in stature; mystery and mys-ticism fill the spaces of her painting, her writing and her soul. Broad cultural shifts are about to make hers a fascinating life, to create the words and alter the genre so that her life can become a substantial bio-graphical subject.

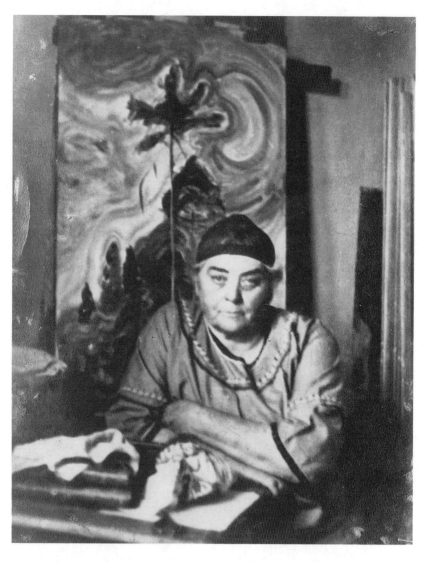

THE ARTIST IN HER STUDIO
(British Columbia Archives & Records Service HP20328, used with permission)

LIFE AND TEXT: THERE ONCE WAS AN ARTIST NAMED EMILY CARR . . .

Without stories [woman] is alienated from those deeper experiences of self and world that have been called spiritual or religious. She is closed in silence. . . . Since women have not told their own stories, they have not actively shaped their experiences of self and world nor named the great powers from their own perspectives.

— Carol Christ and Charlene Spretnak (1982: 327-28)

Lust for Life [a film on Vincent van Gogh] performs and validates a notion of the life and work of an artist as an ordered unicum, an artwork in its own right, characterized by an essential homogeneity and self-identity. It was clear that the film biography derived its own naturalness from the implied existence of a universal archive of equivalent vitae. And . . . that the vita functions as a paradigm for other kinds of lives—those of a people, race, nation, or period—and that in so doing, it operates as a microperiod in the diachronic evolution of art as such.

— Donald Preziosi (1989: 40)

The literature and art of modernism, as currently defined and categorized, marginalizes or excludes women's experience, gives priority to the public world. . . . It is now possible to question this categorization, and to show how many women artists, experimenting in aesthetic form, were formulating the specifically female experience of modernity.

— Janet Wolff (1990: 61)

Notes to this chapter are on pp. 171-78.

The changes in biographical form at the end of the eighteenth cen-
tury exemplified by Boswell's *Life of Johnson*, and those at the
beginning of the twentieth century, of which Strachey's *Eminent Victo-
rians* is representative, are paralleled by current transformations in the
genre related to the broad cultural condition of postmodernism. The
decades between the first of this century's devastating global wars and
the assault on the infrastructures of Western culture emphasized by the
events of 1968, five decades marked by technological innovation and
industrial expansion, brought the modernist aesthetic to its apogee. The
energies of that period forged a heroic *puissance* congenial to archetypal
patterns in the lives of men, especially configurations of achievement
and power, but failed to accommodate narrative images that acknowl-
edged the life experiences of women.[1] The energies of postmodernism,
which can neither abide nor discard that heroism, are marked by a
search for the place of women.

Confidence and optimistic faith in the beneficent effects of tech-
nology and science, attitudes that had guided actions through the wars
and into the era of postwar prosperity, were transformed in the 1960s.
As the processes of democratization drew new information from previ-
ously ignored or inaccessible archives, the immense human costs of
progress became clearer. According to David Tracy's descriptive litany,

> we late-twentieth-century Westerners find ourselves in a century
> where human-made mass death has been practiced, where yet another
> technological revolution is occurring, where global catastrophe or
> even extinction could occur. We find ourselves unable to proceed as if
> all that had not happened, is not happening, or could not happen. We
> find ourselves historically distanced from the classics of our traditions.
> We find ourselves culturally distanced from those "others" we have
> chosen both to ignore and oppress. We find ourselves distanced even
> from ourselves, suspicious of all our former ways of understanding,
> interpreting, and acting. (1987: 8)

This is the rhetoric of postmodern awareness that attributes institutional
collapse to flaws in the designs of patriarchy. The configuring power of
patriarchy as a metaphor is a profound illustration of the foundational
effects of narrative. Sallie McFague, whose theological writing works
to re-image divinity, stresses the point that metaphor is not merely a
trope, a conceit, but rather "the way language and, more basically,
thought works" (McFague 1982: 37). "At the heart of patriarchalism as
root-metaphor is a subject-object split in which man is envisioned over

against God and vice versa. God, as transcendent being, is man's superior Other and woman in this hierarchy becomes man's inferior other." The tensions spawned by these dualisms are reflected in a host of oppositions—"mind/body, spirituality/carnality, truth/appearance, life/death" (ibid.: 148)—which, adhering to perceptions of the masculine and feminine, infiltrate the biographies of men and women. Commonly, the feminine absorbs the inferior term; as object to the subject she is body, carnality or death, unconscious fears, and the dark and threatening aspects of human nature which tend to be repressed.[2]

As the genre that renders life into narrative, that tells the story of the body as well as the mind, biography has been responsive to metaphors and to the moods of patriarchy. Elaborating the differential powers of God and Man to account for the special status of the modern artist was a response to the same cultural imperatives that impelled the development of modern biography: a loss of faith in God and a new interest in the creature's own capacities and singularities. Movement from Renaissance humanism to Enlightenment individualism had encouraged a displacement of divinity:

> Until the nineteenth century, the analogy between God and artist could be assimilated into orthodox religious faith: the artist is *like* God; he is a kind of secondary god whose power comes from God. The artist imitates God, and the world-in-itself which is the work of art is like God's world in that it is ordered and unified by a just and benevolent power. Poetic justice reflects divine justice. With the gradual collapse of religious values during the nineteenth century, however, an important change appears in the artist-as-God concept. When the artist loses his belief in God and can see in the universe no evidence of a divine plan, but only chaos and disorder, then he no longer considers himself a secondary god, but a successor to God. (Beebe 1964: 13-14)

The artist who acquired the accoutrements of divinity was male. As his status was elevated, that of the female artist diminished. Denied access to training and ideological affirmation, omitted from the texts of art history, she became instead simply woman, an object of the male gaze,[3] one of many who thronged to art schools, the private passive ballerina who fascinated Degas.[4] Simultaneously, anomalously, she was also a threatening and mysterious natural force, the inspiration for images like Picasso's *Demoiselles d'Avignon*.

Quite apart from the special case of artists' lives, the problems set in place by male dominance of biography, both as subjects and authors,

have been significant enough to place in question the value of the genre
for women.[5] Susan Mann Trofimenkoff, directing her remarks to the
work of feminist historians, has challenged the capacity of biography to
address the lives of contemporary women and the value of its judgment
of historical lives:

> An occasional queen, saint or female "first" might be allowed to slip
> through the net of exclusivity but their presence among the Great
> Men merely accentuates their own marginality and even more so that
> of the entire female population which they do not represent in any
> case. . . . Even those more conventionally deserving—a Mary Woll-
> stonecraft or a George Sand—frequently find their intellectual and
> literary work belittled in favour of their liaisons with famous or infa-
> mous men. (1985: 2-3)[6]

Trofimenkoff's fear that to correct this imbalance feminist historians
might read current preoccupations back into the lives of their biographi-
cal subjects is realistic only if biography's generic qualities are forgotten.[7]
It is not history. The intellectual forum created by the genre is exactly
the location for testing concepts and impressions, for acquiring a power
that comes with "the ability to take one's place in whatever discourse is
essential to action and the right to have one's part matter" (Heilbrun
1988: 18). The insights of social history, psychoanalysis and feminist the-
ory are among the most effective means to enable biography to ade-
quately retrieve women's experience precisely because they are contem-
porary analytical tools. The biographical interpretations of Emily Carr
written in the 1970s and 1980s could not have been written at the same
time as Donald Creighton's life of Sir John A. Macdonald; cultural shifts
represented by the declaration that the personal is political, a key notion
in the recovery of women's experience,[8] were not a feature of the intel-
lectual landscape at mid-century. The *woman question*, though prominent
in the final decades of the nineteenth century, had faded during those
twentieth-century decades marked by technological innovation and war;
it reappeared only when the dislocations of the 1960s loosened the tight
social patterns of the immediate postwar years.[9] Biography measures the
temper of its time: in the 1950s of my own childhood, the compelling
lives of British queens supported the spiritual quest envisaged by Vincent
Massey for Canadian inheritors of British traditions.[10] Although these
regal exemplars contradicted any notion of essential gender inferiority,
they effectively reinforced the structures of patriarchy.[11]

 The enigmatic qualities of narrative lives, their capacity to raise
difficult issues and to renew interest in familiar lives, facilitate interpre-

tations of changing cultural conditions. In Carolyn Heilbrun's judgment, Nancy Milford's *Zelda* (1970) signalled a loosening of the bonds of tradition in women's biography and an impulse toward innovation. Instead of appearing as the mad, silenced and storyless wife of F. Scott Fitzgerald, Zelda emerged as a subject in her own right. Leon Edel, whose contribution to biography and biographical theory has been immense, assessed the same biography, or one very like it:

> Very few biographers can be said to have conquered their emotional involvements with their materials. In this I am mindful, in our recent attention to the lives of women written by feminists, of such gross exaggerations as occur, for example in the life of Zelda Fitzgerald, however much her own creativity may have been thwarted by the creativity of her husband. In such instances one must write the lives of both victims of the interpersonal tangle; to focus on one is to do injustice to the other: and there should be no distribution of blame—for who is to judge in such difficult situations in which two egos clash in a path of mutual destruction? (1984a: 157-58)

His point is well taken. However he speaks, due to his pre-eminence, from the centre of the biographical forum. Ruth Hoberman, another theorist, answers from her knowledge of biography during the decades when the woman question languished under the glare of modernism— the years of Zelda Fitzgerald's life, and of Emily Carr's: "The lives of women are by definition inaccessible to biographical narration, maids and prostitutes representing only an extremer form of their marginality, their silence or secrecy" (1987: 159). Like Trofimenkoff, Hoberman describes the biographical endeavour as a kingdom of men. The achievements of biographical subjects, the wisdom of the fathers, are transcribed by younger men and passed down through the generations: "For women, both biography and inheritance are problematic. . . . The role of inheritance is to provide continuity from the valorized past . . . to the present, and that past's value rests on its exclusion of women" (ibid.: 147).[12] By this assessment Nancy Milford's *Zelda* could not have been written before it was. To conceptualize her experience as valid and inheritable required new structures for meaning. Edel's voice is persuasive; his judgments represent the finer aspects of the biographer's art before its most recent transformations. However, the authority with which he speaks, which values fair play and assumes symmetry between genders, no longer goes unquestioned.[13] The attention women's lives are receiving, a direct consequence of the postmodern fracturing of systems of meaning, reflects a democratization of the genre which has led

to an interest in *all* lives.[14] Biographers are "once more in the business of writing exemplary lives. But now the example is the life itself, not what the life enabled the person to achieve. Or, more precisely, the life *is* the achievement" (Skidelsky 1988: 13).

In a disconcerting article, "Selves in Hiding" (1980), Patricia Spacks has drawn attention to the profound absence of models for women. Noting the failure of five prominent women to articulate their twentieth-century successes in terms of self-development—all were born in the nineteenth century like Emily Carr—she locates a void, an absence of being.[15] Any sense of individual destiny, of accomplishment, was stillborn. In its place are images of purity, goodness and social commitment, images of selflessness and humility that have been identified by feminist theologians as sinful for women.[16] "The traditional notions of sin as pride and self-assertion serve to reinforce the subordination of women, whose temptations *as* women lie in the realm of 'under-development or negation of the self'" (Keller 1986: 12). Happiness for these women, Spacks suggests, originated in relationships and social commitment. Though all five heroically transcend the personal minutiae of life, a sense of loss pervades their autobiographical writing and a "rhetoric of *uncertainty*: about the self, about the value of womanhood, about the proper balance of commitments" (Spacks 1980: 131).

Several issues are raised by the disproportion of female to male biographical subjects. Aside from the lack of lives which can inform and inspire, with few narrative accounts of women's experience, the assumption is easily made that women's reactions to designated historical moments will be similar to the definitional experiences of men. Without adequate examples in sufficient numbers, and continual reinterpretation, we cannot know the experience of women in any depth; we cannot determine the shape of their lives in terms that are meaningful to us now. Joan Kelly's assessment of the effects of the Italian Renaissance reveals the inadequacy of assumptions of equality.

> There was no renaissance for women—at least, not during the Renaissance. The state, early capitalism, and the social relations formed by them impinged on the lives of Renaissance women in different ways according to their different positions in society. But the startling fact is that women as a group, especially among the classes that dominated Italian urban life, experienced a contraction of social and personal options that men of their classes either did not, as was the case with the bourgeoisie, or did not experience as markedly, as was the case with the nobility. (1986: 19-20)

In effect, the Renaissance set up Machiavellian protocols for the separation of gendered spheres of activity, after a late medieval period of relative equality, that are with us still. "All the advances of Renaissance Italy, its protocapitalist economy, its states, and its humanistic culture, worked to mold the noble-woman into an aesthetic object: decorous, chaste, and doubly dependent—on her husband as well as the prince" (ibid.: 47).

The notion of public and private spheres acknowledged the unique characteristics of women's lives but removed them from the kinds of life experience deemed biographical. "By the late nineteenth century, middle-class women had been more or less consigned (in ideology if not always in reality) to the private sphere. The public world of work, city life, bars, and cafés was barred to respectable women" (Wolff 1990: 58).[17] The period and place of Carr's life were not exceptional: the world of middle-class women was of no interest to modernity; the world of working-class women was unseen. Undoubtedly, an aspect of Carr's biographical appeal has been its tendency to query many of the social and intellectual assumptions that are currently under deconstruction. In addition to the contradictions established by opposing the private to the public sphere, Carr resented or subverted the limiting effects of other dichotomies—child/parent, European/native, sacred/profane, male/female—and she addressed them in her writing. As the product of her latter years, most of that writing is characterized by qualities of reflection and stasis. Tensions, remaining unresolved, seem integral to the very nature of her being and continue to stimulate biographical interpretation. Her fierce independence rests uneasily beside the neediness of Small; her intolerance of the townsfolk of Victoria jars beside compassion for her native friend Sophie. It is difficult to judge whether the contradictions within her self-portrait are accurate, the result of writing her books considerably later than the time that they describe, or her response to the cultural metaphors of her era. Certainly the tensions and contradictions prevent any closure of her composite biographical image.

In her powerful work *Writing a Woman's Life* Carolyn Heilbrun draws attention to the paucity of life narratives which address the intricacies of women's actual existence. Questions of birth, childhood, mothers and mothering, ambition, achievement, friendships, marriage, old age, varieties of experience and versions of knowing have not been adequately discussed. The broad terms of critical analysis—issues of language that arise through French feminisms, the implications of class

among British cultural Marxists and the pragmatism of experience in American criticism[18] coalesce for Heilbrun, more simply, as the problem of power and the necessity of establishing a dense archive of possible narratives from which women can choose to shape their lives (1988: 43). With regard to Emily Carr's life, several of Heilbrun's points make especial sense. The notion of a hiatus in women's lives, which Heilbrun develops from Erik Erikson's notion of a moratorium, details a period of life when momentum stalls and direction seems lost. For men this is often a time of useful preparation for a real vocation which "all unrecognized, awaits" (ibid.: 49). The quest which fills young men with hope is paralleled in young women's lives by a period of uncertainty, perhaps entrapment in the conventions of a marriage/romance plot.[19] The genre's failure to accommodate a diversity of marital arrangements, attend sufficiently to the particular nature of women's friendships or the exceptional energies of postmenopausal women are representative of Heilbrun's concerns and can only be addressed by an accumulation of incisive life narratives.

Faced with inadequately developed models, Carr's recent biographers have assessed her life against the interests of late-twentieth-century readers, interests which might have been irrelevant when Carr lived. Perhaps Carr's landladying struggles and the general difficulties of her daily life were only briefly discussed in early portraits because there were no categories to adequately distinguish barriers to her professional life from the inevitability of retreat during recessionary times. For Carr's generation, gaining access to the public sphere was difficult: "for all women, there was the tension between the ideal of the woman at home and the reality of women's work" (Prentice 1988: 113). Of the "remarkably gifted" Carr sisters, only Clara married. Edith, the eldest, headed the family after the death of both parents when Emily was still in her teens. Of the two sisters closest in age to Emily, Alice ran a school in her home and Lizzie became a physiotherapist. These three younger sisters made their own way in the world, two of them striking out in quite new directions. Though we now judge Emily's struggle to have been heroic, Lizzie's choice of physiotherapy was also innovative (Coleman 1947: 30).

Carr's domestic life and her work are integrally linked to her status as a spinster, a figure whose literary power and social role have been effectively described by Nina Auerbach and Elaine Showalter. Auerbach sets an image of the Victorian old maid, trailing Medusa-like strands of dark intent, bound by the pain of exclusion within a life of poverty and

disease or one of unnatural power and attraction, against what she elaborates as "a general Victorian myth of the spinster as hero . . . in which the old maid transcends the laughter and tears with which cultural complacency endows her, to 'establish her own landmarks' with the audacity and aplomb of an authentic hero" (Auerbach 1982: 112). Florence Nightingale served Lytton Strachey's purposes well precisely because she had forged her own destiny, freed from the constraints of the domestic sphere. Concentrating on the British example like Auerbach, Showalter focuses on the spinster at the turn of the century, during the years when Carr herself might have been expected to marry. Census figures from 1861 indicated a surplus of unmarried women whose existence challenged prevailing social categories and created new economic ones (Showalter 1990: 19). By 1900, when Carr was in her late twenties and about to spend five years in England, celibacy was seen by some suffragists and feminists as a gesture against oppressive relations with men. "More moderate feminists endorsed celibacy on ideological, medical or spiritual grounds, or advocated it as a temporary political strategy." One woman judged an unmarried life to be a test of character: "I think an unmarried woman living a true life is far nobler than a married woman" (ibid.: 22-23).

It is difficult to know how pervasive and sustaining these attitudes were. In our time, with marriage and family values under seige and new patterns of relationship forming, Carr's status as a spinster is linked to her professional achievements as factors that draw our attention to her condition and her decisions. Did she, we wonder, have real choices? She was, certainly, one of a group of "outstanding single women" who "tested their society's commitment to equality" in the years between the wars when "few Canadians knew what to expect of the public performance of talented spinsters" (Strong-Boag 1988: 105).[20]

As the lives of women who were modernists and artists have been retrieved, the strength of their commitment and their capacities to forge new art forms and unconventional life styles has become clearer. Carr was contemporary to the women that Gillian Hanscombe and Virginia L. Smyers trace in *Writing for their Lives: The Modernist Women 1910-1940* (1987);[21] like them, she was "anti-conventional" (ibid.: 11) and subject to the same romantic and modernist imperatives. She too knew the art worlds of London and Paris, the pressures of expatriation, and had the additional frustrations of living in a colony distant from its imperial cultural centre. Like Dorothy Richardson, Harriet Monroe and Gertrude Stein, Carr assigned importance to individuality and spir-

ituality. Though her sexuality is a muffled and enigmatic facet of her image, and her experience more limited than that of her cosmopolitan peers, she shared the determination of women like these to direct their own sexual expression. Like the "odd woman" of the late nineteenth century, these modernist women "conflated elements of the lesbian, the angular spinster, and the hysterical feminist" (Showalter 1990: 23).

> Because women's destinies are assumed to derive from their sexual roles and practices, it's clear that any woman who refuses sexual relationships is behaving as radically as her lesbian counterparts. The unattached woman—in whichever condition of chastity or celibacy she lives—demonstrates her independence both from the destiny laid before her and from those men who would have her fulfil it. Her choice may—and will—provoke from men derision, or pity, or even—sometimes—a sentimental adulation; but more importantly, their judgments of her sexuality will influence their judgments of her work and worth, as is the case with any woman whose life is not perceived to be conventionally heterosexual. Unattachment is, after all, as subversive of social expectation as is lesbianism. (Hanscombe and Smeyers 1987: 246)

If marriage and spinsterhood offered very different routes to selfhood, so too did religion. In both cases women could accept or reject the institution; rejection, however, was difficult and seemed odd. Except for Emily, the Carr sisters would continue to practise Christianity devoutly, sharing the missionary fervour of the time.[22] Despite her impatience with her sisters' professions of faith, in Carr's particular childhood in Victoria there would not have been opportunities for religious expression outside the Church. Within the institutions of the Church, however, there was a significant element of choice for the Carrs. "*Our* religion was hybrid: on Sunday morning we were Presbyterian, Sunday evening we were Anglican." Emily's father's Presbyterian religion was "grim and stern"; her mother's Anglicanism, "gentle" (*Small*: 26). Within Anglicanism they attended the Reformed Episcopal Church of Bishop Cridge, a breakaway congregation from Christ Church Cathedral. Carr was an infant when a controversy over Cridge rocked Victoria. A local schism developed, reminiscent of the bitterness caused by the Oxford Movement in England, when Cridge, an "Evangelical of unswerving conviction," took exception to tendencies toward increased ritualism in the cathedral of which he was Dean (Peake 1959: 79).[23] As an example of options within the faith, particularly the necessity of pursuing and maintaining personally significant beliefs and practices, the Carr family's religious habits exhibit a freedom reminiscent of

Leslie Stephen's capacity to move easily to agnosticism. In addition, they anticipated attitudes to religious expression common in late-twentieth-century Canada where there has been "a major shift in religious styles . . . involving the increasing movement from religious commitment to religious consumption" (Bibby 1987: 81). According to Reginald Bibby, in *Fragmented Gods*, "the fragmentation of Canada's gods is characteristic of highly developed countries in general" (ibid.: 232). Emily Carr's quest for meaning throughout her life in many places, churches and systems—including art—presaged "the increasing tendency of Canadians to consume religion selectively" (ibid.: 81).

That there were women of Carr's generation who did gain some measure of religious autonomy, in spiritualism in particular, suggests reactions to doctrinal religion that, unlike Leslie Stephen's complete break with divinity, proposed alternative paths toward the supernatural. Carr's pragmatism and directness, her focus on the real and not the sham,[24] would have separated her from the world of female spiritualism described by Alex Owen in *The Darkened Room* (1989). Owen's subjects did, however, like Carr, display an inclination to create a new religious order, to affirm their own visionary insights. Though it is difficult to measure the extent of spiritualists' activities in Canada, the work that has been done suggests a similarity to the activities in Britain that Owen describes; Susanna Moodie, for example, encountered the table-rapping Fox sisters in upstate New York at mid-century (Cook 1985: 66).[25] Spiritualism, whatever else it promised, engaged questions of immortality in the spirit of science and offered an alternative to the sciences of technology. *Cosmic Consciousness: A Study of the Evolution of the Human Mind* (1901), a widely read exploration of mystical enlightenment written by Richard Maurice Bucke, a psychiatrist in southern Ontario, was another alternative that had considerable influence on literary Canadians. Like the reforming zeal of Social Gospel and the indwelling mystery of Carr's art, Bucke's study attested to the presence of divinity on earth and blurred the divide between the sacred and the secular. His close relationship with Walt Whitman, whose poetry was tremendously important to Carr, grew from their similar views of creation.

The religious ground Carr occupied as a mature woman, with her insistent idiosyncrasy and exploratory fervour, may have been more like the world of the Fox sisters than her own sisters.[26] Alex Owen describes women who took intuition from the parlour where, as a manifestation of their femininity, it tended to exclude them from serious pursuits, into public forums where it could become a source of considerable

power. Carr's sense of divinity, equally intuitive, suffused the images that displayed her vision. Owen's study identifies the level of unconventional religious behaviour among female spiritualists as the response of powerless, marginalized women searching for authority outside traditional Christian practices.[27] Her account of a widespread form of communication with another kind of reality, in passive writing and seances, reveals a preoccupation with transcendental reality not unlike the romantic notion of inspirational artistic genius and the abstract Theosophical ideas that interested Carr during her friendship with Lawren Harris. The links that Auerbach, Showalter and Owen make between the social, political and spiritual conditions of women's lives and the contradictions inherent in their cultural representation, as objects and subjects, seem stark and powerful in our postmodern context. The lives of women artists—Carr, Georgia O'Keeffe, Frida Kahlo, Elizabeth Siddal and Berthe Morisot, all powerful biographical figures at present—turn on questions of their art and its meaning in the context of the conditions of their lives. The genre is particular: it deals with specific lives. Carr must be evaluated in accord with what we know of her world but, ultimately, it is the singularity of her life that becomes a vehicle for her biographers' insights.

FEMINIST INVERSIONS IN THE BIOGRAPHICAL SPHERE

Changes in women's biography that Carolyn Heilbrun attributes to developments around 1970 coincided with the increase in feminist writing across a broad range of disciplines.[28] Rita Felski's notion of a feminist public sphere, developed to link literature to social change and political meaning, suggests a discursive forum that resembles the biographical sphere as a locus of intellectual exploration. Neither space attracts unitary quests for certitude or stable meaning like that articulated by Vincent Massey at mid-century. Rather, as Felski puts it, "oppositional discursive arena[s] within the society of late capitalism" (1989: 9) allow fragmentary and multiple meanings to exist in endless and changing configurations, confined only by the horizons of our collective capacities for comprehension. Without these accommodating discursive spaces, the various views of Emily Carr in the early 1970s can be read, and perhaps were at the time, as demands for separate and essential truths. Within spatialized intellectual discussions, like those in Felski's feminist public sphere and the biographical sphere, opposition can exist—and is encouraged to do so—as an enriching factor: argument becomes conversation.

By 1970, although there was still no full biographical treatment of Carr, her presence had been firmly established as a national figure. Canadian centennial celebrations in 1967 had opened Canada to the world and created a stimulus for exploring national culture. The feminist movement, at an exciting stage, signalled in Canada by the Royal Commission on the Status of Women, generated awareness of the special nature of women's experience.[29] Even though Carr's biographical trajectory had not yet been set, there was substantial activity around her life, enough to generate diverse and contradictory images. In the absence of a definitive biography—a complete record available to a wide audience—there was no particular reference text, no account to support or challenge except, of course, Carr's own writing.

In 1971 Doris Shadbolt, a curator, art historian and one of the principal contributors to Carr's composite image, wrote a short essay, "Emily Carr: Legend and Reality" for *artscanada*. Carr, in Shadbolt's version, had begun her art studies with only a general sense of vocation; she died, however, "feeling herself called to a high and serious vocation, demanding total dedication, the responsibility of knowing and mastering a craft, and accepting the notion of certain sacrifice." Within parameters like those, legend and reality elide. To Shadbolt Carr is remarkable for her determination, eccentricity and "sense of her own *otherness*" (1971: 17). Carr's tendency toward hyperbole in her writing was matched for Shadbolt by "extraordinary determination, toughness and ingenuity in working out a succession of living solutions which enabled her to subsist, while at the same time maintaining a clear stance as artist." Practical, narrow and prudish in her morality, "as critical of the pomposities and banalities of the clergy as she was of anyone else" (ibid.: 18) but vulnerable and frightened, with a tendency to take sick in large cities, Carr found her most suitable themes among the Indians and in the forest, away from the sources of her problems. In Shadbolt's view, Carr lived her life "romantically, fully, passionately" (ibid.: 20).

In the view of Maria Tippett, a cultural historian and another of Carr's principal biographers, legend and reality do not merge easily. In " 'A Paste Solitaire in a Steel Claw Setting': Emily Carr and Her Public" published in *BC Studies* (1973-74), Tippett reacted negatively to Carr's exaggerations. She claims that the myth "created by the artist and a few friends, then perpetuated by later journalists and other writers" (ibid.: 3) unduly chastised the west for the thin cultural soil it had provided for the cultivation of Carr's talent. The west, Tippett insists, did not wait on central Canada's approval to attend to Carr's talent, either in 1927 after the National Gallery's show in Ottawa or in 1941 after the

publication of *Klee Wyck*. By returning to very early reviews and the
accounts of the reception of Carr's work, Tippett demonstrates the pos-
itive climate and the support that townsfolk in Victoria accorded Carr.
Though she disputes the details of Carr's "discovery" by Eric Brown of
the National Gallery and others from central Canada, Tippett acknowl-
edges Carr's 1927 journey to the east, when she met the Group of
Seven, as pivotal.

> Accepting the Group's own version of its struggle against a hostile
> press and their possessive attitude toward the Canadian landscape, she
> wove her similar myth of struggle into theirs and adopted her own
> possessiveness of the British Columbia landscape. Knowing of the
> Group's "struggles," and urged to write of her own by Eric Brown,
> press hostility became a mark of merit. With Carr, however, it is even
> more difficult than with the Group to document a hostile press. What
> hostility existed seems to have been the other way around. (Ibid.: 11)

Tippett minds Carr's failure to acknowledge such support as Victorians
gave her and the repetition of that failure by others, including Doris
Shadbolt (ibid.: 12). In Tippett's opinion Carr's temperament—her
dislike of publicity, suspicion of praise and her temper—determined
the nature of her career and occasioned her loneliness.

Tippett's attitude was quickly and minutely dissected by Ruth
Humphrey within the year in the same journal. Humphrey, who had
known Carr and published a number of letters she had received from
her in the *University of Toronto Quarterly* in 1972, criticized Tippett's use
of sources. "Quotations given out of context, or shorn of significant
words, must always risk being misleading. [Tippett's] essay, unfortu-
nately, contains a number of both" (Humphrey 1974: 48). Citing sev-
eral examples, Humphrey concludes by contrasting Tippett's image of
Carr as "a resentful woman taking refuge in a 'self-imposed' solitude"
with an article in the Victoria *Daily Colonist* in 1964 entitled "Emily
Carr: Modest, Kindly and Full of Fun" (ibid.: 49).

Maria Tippett published another article, "Who 'Discovered'
Emily Carr?" in 1974, this time in *The Journal of Canadian Art History*.
Again, she is intent on debunking the myth: "This long perpetuated
story of Emily Carr's 'discovery' may be questioned. She had not
stopped painting in 1913. Brown had known of her work since 1921.
And there is little evidence to suggest that Barbeau either visited or pur-
chased works from Carr before 1926" (Tippett 1974: 30). As a cultural
historian, Tippett reviews the record in order to establish Carr's partici-
pation in the processes of her own career. Upon learning in 1926 that

Barbeau was giving a lecture series at the University of British Columbia, as an instance, Carr had written to him suggesting he come and see her work, indicating that she looked forward to meeting him (ibid.: 32). Tippett contends that the show had been planned as "a showplace" for the recent British Columbia work of the Group of Seven and that

> it was not until the West Coast show was conceived that Carr fitted into the eastern art scene. Carr was chosen to contribute to the exhibition because she had, like no other artist, made a record of Indian totems and villages. The work exhibited was that of her 1912-13 period, not her more advanced landscape work of the early Twenties. (Ibid.: 33)

Carr's work was included not for its greatness but because of its usefulness, and then only at her own suggestion.

These articles of the early seventies were the first of a number of efforts that preceded the appearance of major biographies later in the decade. How caustic these exchanges might have been at the time is of less significance than the indication they give of the personal investment placed by these writers in the life of one woman. Life narratives frequently engage biographers in transformative relationships.[30] In broader genre terms, these forays into the writing space of Carr's life represent differing attitudes to narrative truth. Those who knew Carr, like Ruth Humphrey and Edythe Hembroff-Schleicher, rely on intuitive and experiential knowledge to enrich their memory. Their facts are not so crucial to the larger composite image as the qualities of their tone. Doris Shadbolt's perspective, which will continue through two substantial biographical works, by embracing the artist *and* her work shares the approach of the traditional monographs which, as feminist art historians have pointed out, were so influential in sustaining the privilege of male artists. Her tone, reflective and accommodating, without the crisp edges of Tippett's work, depicts the tensions in Carr's life as characteristics affecting the meaning and impact of her work. While Shadbolt probes to understand, ever increasing her scope, Tippett renders a demanding account that generates tensions of its own.

To the extent that the various perspectives on Carr's life and work seem to be in competition—each an attempt to discern the accurate version of her life—the biographical model remains traditional; the quest, though it may include many versions, is toward an exemplary truth. However, in so far as these differing perspectives occupy a place of knowing where they must exist simultaneously—as they do in fact—they become facets of the biographical image, participants in elu-

sive postmodern patterns, each written from a particular and *always* legitimate position, an understanding shaped by the life experiences of the biographer. Ruth Humphrey defends Carr against Tippett's manipulation of the record; Tippett, engaged in the agonistic politics of academic scholarship, seems eager to locate complexities and contradictions. Shadbolt, committed to generating cultural insight, envisions Carr as a creator in the world of art.

These essays, like much of what is written about Emily Carr, are not confrontationally, or even deliberately, feminist. They belong, first, to the biographical sphere and its durable traditions. However, the very act of bringing a woman's life forward can initiate change. In early attempts to discern the boundaries of Carr's life, questions and attitudes that belong to the feminist public sphere are adumbrated, to become clearer in retrospect with the development of feminist analyses. As versions of Carr's experiences have multiplied, the terms of her challenge to tacit assumptions, to the mainstays of authority, have become apparent. In describing the feminist public sphere, Rita Felski claims it serves a dual function:

> *internally*, it generates a gender-specific identity grounded in a consciousness of community and solidarity among women; *externally*, it seeks to convince society as a whole of the validity of feminist claims, challenging existing structures of authority through political activity and theoretical critique. (Felski 1989: 168)

To insist that Carr's image belongs in Felski's sphere would violate the enigmatic nature of the genre. However, to consider the many lives of this exceptional woman as vibrating in a zone of relevant cultural interpretations and intonations, which must include feminist critique, contributes to an understanding of the power and fascination of her image.

PORTRAITS OF THE ARTIST AS A FEMALE
IN THE (POST)MODERN WORLD

For Carr's life perhaps the strongest revisionist challenges—those that pull her into a discursive space like Rita Felski's—come from the work of feminist art historians. Carr lived, studied and achieved a measure of professional status at a time when women were pressing in upon the structural supports of the institutions of art. Opportunities to study art were limited although, perhaps surprisingly, two women from Victoria had preceded Carr to Europe and gone on to substantial careers as artists.[31] When Carr was in England from 1899-1904 and in France in

1910-11, she experienced typically dismissive attitudes to women's art. The expectation was that "significant and vital content in *all* art presupposes the presence of male erotic energy" (Duncan 1982: 306). Picasso's *Demoiselles d'Avignon* had appeared just a few years before Carr arrived in Paris: "no other modern work reveals more of the rock foundation of sexist antihumanism or goes further and deeper to justify and celebrate the domination of woman by man" (ibid.: 305). Carr plainly understood the condition of women painters. In 1937 when her reputation was established, Carr wrote in her journal that it behooved her to support other women artists even though she did not enjoy the publicity necessary to make her opinion effective (*H&T*: 287).

Women artists were considered "specially gifted by their delicate sensitiveness, their quickness of comprehension, their initiative faculty" (Greer 1979: 314). But, as George Moore wrote in *Modern Painting* (London 1893), "women astonish us as much by their want of originality as they do by their extraordinary power of assimilation" (ibid.: 314). Carr was just one of many women who flooded art schools during the period bringing, as expected, a purity to their art which was

> feminine, delicate, dainty, small and soft-voiced, and concerned itself with intimate domestic scenes, especially mothers and children. They did not often see that the qualities men welcomed in women's art were the same that they reviled in their own, and that by acting out their sex roles [women] were condemning themselves to the second rank. (Ibid.: 321)

They "were not sensual enough to be great artists" (ibid.: 320). Elizabeth Fox-Genovese has made a similar point in her analysis of the interdependency of feminism and the main tenets of Western thought: "the deepest message of individualism was self-determination, yet the only self-determination open to women lay in the choice of the authority to which they would submit" (Fox-Genovese 1991: 126). The role of women in the confined world of art reflected these contradictions. Though they constituted the majority of art students, a condition which might be expected to favour acceptance of them as contributing and individual artists, still their principal function was to define the heroic humanity of their male teachers. Carr's achievement is immense judged against the regimen set out for her. Not only did she struggle to forge an economic and professional space as an artist, but she defied the expectations for women's art and found her own authentic forms.[32]

For feminist art historians like Griselda Pollock there is a double task: aside from recovering the lives of women artists, they must decon-

struct the "discourses and practices of art history" (1988: 55).[33] Art is not
simply aesthetic, an object or a collection of objects created by inspired
geniuses; it is, rather, a social practice, "a totality of many relations and
determinations" (ibid.: 5). By construing art as "constitutive of ideol-
ogy . . . not merely an illustration of it" (ibid.: 30), Pollock moves away
from the liberal idealistic view of creativity and inspiration which treats
women as the victims of unfavourable conditions but allows *art* and the
artist to retain places of privilege on tacit scales of value. Certainly female
artists were discriminated against; excluded from life classes, their inade-
quate knowledge of anatomy prevented them from executing history
painting, that "most highly regarded" form of art (ibid.: 44). Linda
Nochlin, in a pivotal article, "Why Have There Been No Great Women
Artists?" (1971) and Germaine Greer in *The Obstacle Race* (1976), two
comparatively early feminist assessments, criticized the psychological and
structural practices that discriminated against women but—and this is a
point that Pollock stresses—they did not question the category of *woman*
(Pollock 1988: 35). Their criticism permitted the artist to remain "as
the archetypal masculine personality structure, ego maniacal, posturing,
overidentified with sexual prowess, sacrificing everything and everyone
for something called his art" (ibid.: 40). To Pollock it is important to
see beyond mere restriction to the signification of sexual difference, to
analyze the construction of meaning inherent in social and economic
habits (ibid.: 56). Women were excluded from full participation in the
institutions of art, deprived of a place in the production of meaning, left
in a category of their own to paint domestic scenes.

One specific difference Pollock examines is the domestic construc-
tion of women's space set against the public construction of space for
men: "the literature of modernity describes the experiences of men. It
is essentially a literature about transformations in the public world and
its associated consciousness" (ibid.: 66). Her analysis of the public world
is particularly interesting with regard to Carr's life in the stress she
places on the role of the city. Cities, Carr freely claimed, made her sick.
Pollock has an explanation:

> It is generally agreed that modernity as a nineteenth-century phe-
> nomenon is a product of the city. It is a response in a mythic or ideo-
> logical form to the new complexities of a social existence passed
> amongst strangers in an atmosphere of intensified nervous and psychic
> stimulation, in a world ruled by money and commodity exchange,
> stressed by competition and formative of an intensified individuality,
> publicly defended by a blasé mask of indifference but intensely
> "expressed" in a private, familial context. (Ibid.: 66)[34]

Carr's illness in large cities and her longing for the forest suggest the lethal menace of modernity. Life writing itself has participated in the support of those hazards. Monographs and biographies on individual artists sustained gender power and privilege in the art world for they championed individuality and delineated the heroic artists' "linear progress from birth to death which produces a coherent subject, an author for an oeuvre" (ibid.: 94).[35] Looking at the figure of the artist, without accounting for the strong traditions of biographical writing, Pollock can say that "the artist is constructed by art historical practices as a being transcendent of history, a free creative agent, independent of social relations. The history of art consists of a glittering sequence of Great Individual Men, a category which structures the relativity of women artists" (ibid.: 97). Women artists as females are not present. Instead of being an alternative to the male artist, the woman artist is a negative imprint of his positive image. She cannot, therefore, simply be recovered but must be reconstituted in light of the system that denies her any self-determination (Parker and Pollock 1987: 60-70).[36] In addition to the contribution of prevailing social constructions in the art academies—like current captivation by Foucault's assessment of "the potentially oppressive socio-psychic production of sexuality" (Pollock 1988: 161)—Pollock questions less obvious practices such as those which determine the nature of archival texts, like parish records, which validate particular events and patterns of relations. "The archive is part of a system of representation by means of which the past seems to be left deposit in the present; it is a fissured, uneven, contradictory monument of the past" (ibid.: 98). Though Pollock criticizes the genre of biography for sustaining the figure of the unique and autonomous artist fashioned according to male talents and predilections, few biographies are written with sufficient detachment to lay bare the processes of their own constructions.[37] The contribution of feminist art historians has been the application of postmodern deconstructive methods to their own discipline. That the artist need no longer be an innovative male genius has encouraged biographers, such as Anne Higonnet in *Berthe Morisot* (1990), to reveal the quality of the female artist's life *as such*, to acknowledge her talent, dedication, ingenuity and success as well as the obstacles that she overcame in the course of her career.

RECONSTRUCTION AND INTERPRETATION

A desire to acknowledge the peculiar nature of life writing, "the mimetic relationship between literature and life," which is challenged by the nature of postmodern criticism—particularly the assault on the categories of the author and the self/subject—has occasioned a declaration by Susan Groag Bell and Marilyn Yalom in the introductory remarks to *Revealing Lives* (1990). The "much maligned referentiality" of life writing that assumes the subject of the life "is indeed the privileged textual double of a real person"

> gives autobiographical and biographical writing its particular tension and flavor. Whatever their differences, autobiography and biography presuppose the factual data of a lived existence, if only to provide the nest from which the author's imagination and interpretation may then take flight. (Ibid.: 2)

Carolyn Heilbrun expands the concept of a particular function for narrative accounts of life experiences by noting their importance as stories:

> what matters is that lives do not serve as models; only stories do that. . . . We live our lives through texts. They may be read, or chanted, or experienced electronically, or come to us, like the murmurings of our mothers, telling us what conventions demand. Whatever their form or medium, these stories have formed us all; they are what we must use to make new fictions, new narratives. (1988: 37)

As aspects of cultural change, feminist critical theory and women's biography have followed parallel developmental paths. Narrative, which lies at the root of both projects, "constitutes one of the most deeply embedded and culturally significant forms of the symbolic production of meaning" (Felski 1989: 127). Two recent theorists have side-stepped the slippery issue of subjectivity and narrative to address the condition of women and writing in terms that recall Steiner's covenant between word and object. Like him they posit direct links between what is and what it is said to be. Their sophisticated awareness of critical theory renders their efforts tenable; their subversion of those same critical tenets in favour of women's actual experience, a multivalent manoeuvre, illustrates postmodern pragmatism. Taking the literary enterprise as a legitimate and worthy one, Joanne S. Frye and Elizabeth A. Say address some of the moral and theological implications of narrative experience which bear directly upon the retrieval and reconstruction of women's lives.

In *Living Stories, Telling Lives*, though Frye is concerned with constructing a feminist poetics of the novel, her analysis and agenda can be

applied with ease to biography. Her political purpose, the recovery and legitimation of women's lives, has the cadence of Social Gospel. "A woman writer, woman painter, is a contradiction in terms and must herself live the conflict that shapes the available female-centred plots" (1986: 3). Beginning with a recognition that "women writers, like women characters, have been denied the authority of their own stories as they have been denied the support of cultural precept" (ibid.: v), Frye responds to the same late-twentieth-century conditions that prompted Felski and Heilbrun, like her, to articulate the necessity and the means to move beyond the limitations set by ideological cultural texts. Convinced of the power of literature as cultural expression, Frye describes her goal as one shared with feminism in general: "to under-stand women's lives—and hence men's—as they are shaped by a male-dominated sexual ideology, and to develop ways to improve those lives" (ibid.: 11). Like Felski and Jane Flax, she resists dichotomies and chooses to promote dialogue "between disciplines, between systems and individuals, between literature and life" (ibid.). Like Trofimenkoff, she wonders if the language available "can elucidate women's lives" or if it is "inescapably patriarchal" (ibid.: 15).

Frye's moral purpose is reminiscent of Leslie Stephen's position a century before: both move from metaphysics toward corporeality.[38] Stephen had turned from theology to ethics, Frye's turn is from inade-quate ideological categories to the languages of experience. For the nineteenth-century biographer and the twentieth-century feminist nar-rative connects living and telling:[39]

> We use narrative to assess cause and effect in a pattern of significance, to relate ourselves to a sense of purpose, to claim a shared reality with other people, and to identify a specificity and a continuity of self through memory. In short we use the process of creating narrative shape to identify our place in the world. (Frye 1971: 19)

Frye's concerns are "decidedly political: to alter literary form is to par-ticipate in the process of altering women's lives" (ibid.: 33). The rise of individualism which encouraged the development of the novel was the same Enlightenment energy that distinguished Boswell's biographical efforts; nineteenth-century schisms between heaven and earth fostered the identities of George Eliot's characters and Leslie Stephen's subjects. Frye suggests that it is the twentieth-century's "increased subjectivity and unwillingness to try to define a social reality" that has made the possibility of retelling women's lives more likely. "If isolated subjec-

tivity is everyone's reality, then women can have access to the dominant 'reality' " (ibid.: 43).

> In a feminist redefinition of the conventions, then, social reality derives from the recognition that the structuring activity is a shared human need and is the effect of the culturally available paradigms by which people interpret the world around them. For women writers and readers the claiming of subjective experience and the development of narrative explanations for what is specifically female in that experience becomes a crucial way of identifying an altered social reality. (Ibid.: 44)

Women's exclusion from mainstream culture has made novel and biography reading "an important means of gauging their own experience" (ibid.: 191).

Elizabeth Say, more explicitly religious in her agenda than Frye, takes the efficacy of the novel a step further and suggests it is a form of female discourse as able to dissect theological ideas as it is to explore women's lives. Like Frye she claims that narrative can facilitate structural change (Say 1990: 115) and recalls the novel's "power to conceptualize and articulate problems that were central to early modern experience" (ibid.: 61). For Say the novel holds a particular place in the continuing development of narrative. Unlike earlier romance forms, which reflected stable social orders in the late medieval world, the novel began by addressing a changing historical world with an empirical eye on experiences that had escaped other deliberations (ibid.: 62-64). "Although women shared in the propositional theologies of men, abstracted from men's lives, they could not return these to their own life experiences and have the same awareness of congruence" (ibid.: 129). Private worlds and the personal realm, brought forward and enhanced in fiction, constituted the sphere of women; the focus on the individual life as a source of truth legitimized woman's experience as a source of moral example. Though women could be excluded from traditional theological discourse, their private, personal experience was particularly suited to the novel. Furthermore, the novel facilitated the transition of women's voices from the private to the public domain (ibid.: 76). Say assesses the novel's impact in making women's voice part of the public realm and initiating "the process of self-definition, the creation of a tradition" (ibid.: 113): "Women's narratives constitute both a moral discourse and a ground for theology. They challenge normative judgments established by the patriarchal tradition as to how human beings should be in the world" (ibid.: 123).

Both Frye and Say exemplify the late-twentieth-century proclivity to infer a legitimate order of things from any identifiable perspective. The importance of interpreting women's experience, particularly through the mediating images of the arts, has been put into a Canadian context by Ellen Leonard who, at the same time, moves with rhetorical ease from personal to national experience and on to global inferences. Pivotal to her argument is a perceived shift in theological reflection from analyses of the past, as a source of experience, to contemporary attempts to rediscover tradition within communal experience (Leonard 1990: 144). The past is not jettisoned but is "appropriated" in the light of present perspectives (ibid.: 145). Accordingly, the reclamation of women's experience generates new theologies and corrects the bias of earlier versions based solely on male circumstances. Leonard sees opportunities to create contextual theologies in feminist experiences that have paralleled more general national trajectories. Just as Canadians have moved from a preoccupation with wilderness survival at home to the survival of world ecosystems, so feminism has moved from "the identification of women with nature to women's concern with ecology." Canada's transition from colonial status to global responsibility matches the movement of women's lives from hierarchically defined status within patriarchy to mutual empowerment. Likewise, at a national level the move to multiculturalism from biculturalism has been reflected in the multivalency of feminism, the profusion of feminisms. For Leonard each of these experiential transitions "challenges our image of God, of humanity and of church" (ibid.: 149).

Emily Carr's biographical image exhibits and expands Leonard's model. Through encounters with Carr, readers appropriate the past and renew traditions. A figure embedded in Canada's colonial past, Emily Carr is also an influential female in new definitions of the profound power of the natural world and, in the enigmatic intricacies of her life, she is host to an array of feminisms. The plasticity of novelistic narrative reflects the advantage of that genre for women and concomitant disadvantages with male-defined empirical biography.

There is, however, evidence of blurring boundaries. Both biography and the novel, substantially marked by late-eighteenth-century intellectual, social and political developments, are being forced by current cultural energies to undergo further significant changes now. Modernism rejected the sentimental and romantic preoccupations of Victorian fiction and, with them, facets of emotional identity commonly associated with women writers and their novels (Clark 1991: 2). With the subsequent diminishment of the novel as a forum for explor-

ing woman's identity,[40] and biography as a form more suited to the
male enterprise, the twentieth century has characteristically suppressed,
rather than supported, female identity through narrative. The power of
biography as a locus of narrative identity for women at the close of the
twentieth century may be based upon a general acceptance that the
genre, freed from the restrictive model of modern male experience, is
suitable for the narration of all personal experience. Even as postmod-
ernism casts suspicion on the concepts of self and subjectivity, biogra-
phy is capable of conveying a sensed identity.[41]

Carolyn Heilbrun's assertion that "women come to writing . . .
simultaneously with self-creation" (1988: 117) acknowledges the force
of narrative as an instrument of sensibility. If women artists, as modern-
ists, were forced to reject the sentimental in order to perform ade-
quately within the avant-garde, now they need to reclaim that sensibil-
ity in both historical and psychological terms in order to discover them-
selves. Carr's life and her work, through the vehicle of her biographical
image, draw upon profoundly subjective and emotional sensitivities—
romantic sentiments—that have sustained her character and her soul in
the face of modernism's abstractions.

VERSIONS

Between 1975 and the end of 1979 Emily Carr emerged full-blown
onto bookshelves in a gathering of versions that exemplifies the bio-
graphical process at work on the reconstruction of women's lives. In
1975 a small volume in Fitzhenry and Whiteside's series, The
Canadians, made the artist's life available to school children. Following
the established account of Carr's life as a woman of talent who won
through, late, against tremendous odds, Rosemary Neering's *Emily Carr*
emphasizes the obstacles that faced Carr as a female artist. That same
year Nancy Ryley's two-part film biography for the Canadian Broad-
casting Corporation, *Growing Pains*[42] and *Little Old Lady on the Edge of
Nowhere* appeared, as did a reprint—presumably for wider distribu-
tion—of Doris Shadbolt's catalogue for the touring exhibition in
1971-72. In 1977 Charles Taylor included Carr in his collection of
essays on inspirational Canadians, *Six Journeys*, and Maria Tippett, with
Douglas Cole, wrote *From Desolation to Splendour*, a history of the cul-
tural construction of British Columbia's landscape that begins with the
declaration of Captain George Vancouver in 1792 that Howe Sound
was sublime but repellent (1977: 17), culminates in the vision of Emily
Carr and concludes with current environmental concerns. Edythe

Hembroff-Schleicher's *Emily Carr: The Untold Story* appeared the following year. In an earlier work, *m. e.: A Portrayal of Emily Carr* (1969), she had included her own recollections along with several letters received from Carr. This second publication, an idiosyncratic compilation of opinion and carefully sorted detail, comprises such things as a chronology of Carr's life, a history of her exhibiting career, an analysis of the signing and dating of the paintings and the author's response to Barry Lord's Marxist misinterpretation of Carr's life. Hembroff-Schleicher presented the public with a potpourri of Carriana just a year before the appearance of Maria Tippett's award-winning *Emily Carr*[43] and Doris Shadbolt's satisfying *The Art of Emily Carr*.[44] There would not be such substantial scrutiny of Carr's life again for a decade. The consequence of this activity, especially the simultaneous publication of Hembroff-Schleicher's collection, Tippett's biography and Shadbolt's attention to the artist's work, was a biographical image fragmented from its inception. Appearing to a national audience in triplicate, resonant within a field of smaller works, the image of Emily Carr could remain elusive—an epic still, not ever to become a dossier.

The fragmented, kaleidoscopic nature of Carr's image has not gone unremarked. Peter L. Smith, in a review for *BC Studies*, classed Tippett's work of "meticulous detail" as "comprehensive" and "well-researched" and commended her insights for avoidance of "sensationalism" and "psychoanalytic exaggeration" (1980: 130). He praises Shadbolt's analysis of "the spiritual and technical development of Carr's career as an artist" and her readable commentary on the "lavish set" of illustrations of Carr's work (ibid.: 131). Hembroff-Schleicher's contribution makes "uncommonly good reading"; despite its repetitions and peculiar format, it has "considerable authenticity" (ibid.: 132-33). While not without criticism, Smith has no difficulty reading the three versions of Carr as complementary. In other words, no one version is Carr; each is an interpretive fragment. That dissonance can arise within a multiple portrait is made clear in Monique Kaufman Westra's review for *artmagazine*. Concentrating on just Tippett and Shadbolt, with a small reference to Hembroff-Schleicher, she distinguishes the works in much the same fashion as Smith and agrees they should be read together. Tippett's, the "first serious biography" (1980: 23), is clear, succinct, strongest on a discussion of Carr and the Northwest Coast Indians, weakest with "psychoanalytical clichés" (ibid.: 25). Shadbolt's sensitive and thematic portrait is a "much-needed photographic repository of Carr's work" (ibid.: 23) but ultimately disappointing. It repeats ideas from Shadbolt's earlier catalogue, fails to "fully" develop "insight-

ful observations" and is, despite expensive and lavish production, a
poorly designed monograph (ibid.: 26). Westra's review is particularly
interesting for its apparent immersion in the energy field surrounding
Carr's biographical image. In chastising Tippett for factual errors and
Shadbolt for weak scholarship and production, Westra *engages* in the
debate, criticizing both Tippett and Shadbolt for their misinterpretation
and adding a view of her own.

The details of Carr's life do not differ among the biographical por-
traits as we insist novels must one from another, nor is each biography
necessarily more accurate once the record has been set. Instead, Carr's
image has exploded in a variety of forms. In *Improvising a Life* (1990)
Mary Catherine Bateson insists on a fluidity of text that allows contin-
gent relations among author, text and reader. Françoise Lionnet, in her
examination of postcolonial autobiography, describes the weaving of
multiple strands of a women's life in narrative as *métissage* (1989: 13-15).
These responses to the creation of meaning in the lives of women pro-
mote a high measure of creativity but they also render women's lives
liminal to mainstream culture. Caroline Walker Bynum has claimed a
similar quality for women's biographical lives in medieval Europe.
Exploring the narrative implications of Victor Turner's concept of lim-
inality—"the suspension of social and normative structures" at crucial
moments within social dramas—Bynum describes salient features in
accounts of women's lives. Whereas men's experiences were narrated
around critical turning points generated in moments of liminality,
women's lives featured continuity rather than change in images derived
from ordinary daily life. Though female lives could be read on their
own terms, they also offered reversals of the images of male lives, the
negative of male experience.[45] Margery Kempe's life serves as an
example. By and through her own account of her life she becomes
more truly herself but in her intensity, the extent and restlessness of her
travels, and her relentless self-examination, she also offers her text as "a
means of escape from and reintegration into status and power" (Bynum
1984: 110). The narrative of her life becomes a liminal zone capable of
generating profound insight in others.

Indeed the pattern of women's lives depicted in medieval hagiog-
raphy manifests patterns of discontent and difference that mirror the
preoccupations of the writers of women's lives now. Thomas Heffernan
has described four principal characteristics that distinguish female saints'
lives: "the redefinition of ideas of kinship; freedom from the Pauline
notion of sexual 'indebtedness'; the importance of prophetic visions;
and the change from virgin, wife, or widow to *sponsa Christi*" (1988:

185). Without drawing precise and inappropriate parallels between these categories and Emily Carr's life, it is not difficult to perceive similarities in the desire to be released from the bonds of patriarchy, including liminal status, and the desire to see clearly toward some suitable social role—*sponsa Christi* conflated important motifs such as "spotless virgin," "loving gentle mother," "regal queen of heaven" and the notion of the Church itself (ibid.: 260).

Pulling Emily Carr's life into a biographical arena shared with medieval saints suggests analogies more easily rejected on the bases of logic and fact than exploited for insight into contemporary attitudes to biographical images. However, is our general preoccupation with interesting and exemplary lives so very different?[46] In a study of Lytton Strachey's *Eminent Victorians*, Millicent Bell maintained that if the essays

> are unified by any theme it is not so much the effect of religion on the Victorian personality, as is often said—though all of Strachey's subjects were religious and even felt they had a religious mission, a vocation of service to the Christian God. His subjects are linked more significantly by their common quality of being creatures possessed of a personal energy that had nothing particularly religious about it. It was the same energy that had effected all the transformations and achievements of the great nineteenth century. In the possession of it they were truly representative of the Victorian age. (Bell 1989: 77)

Bell goes on to suggest that the four histories are parodies which can be seen as Victorian saints' lives.

> Manning, Nightingale, Arnold and Gordon all saw themselves as soldiers of the faith. Arnold saw himself as a kind of prophet of moral truth to the heathen. Nightingale saw herself as suffering and sacrificing, besieged by enemies, chained to her bed of pain, striving to imitate Christ. Gordon saw himself as the foreordained martyr who waited to embrace his death with eagerness. In reading these biographies against their hagiographical or quasi-hagiographical sources we see how Strachey deliberately mocks by parodistic imitation the view of these personages which either they themselves or the age accepted. (Ibid.: 77-78)

Does he? Or is he, rather, suggesting another and a new explanation, still unsophisticated in its rhetoric, which will develop and come to dominate twentieth-century biography as an interpretation of unaccountable knowledge and inspiration? In describing the impulse to act as determined by the body's experience in the world rather than the soul's agenda, by psychoanalytic rather than Christian codes, Strachey

was taking a move that has become commonplace in the twentieth century. By grounding life story in experience, the distinguishing aspects of existence become visible. Other realities, though, may fade from view. Picasso's reluctance to use "sacred" recalls the difficulty our century has had with explicitly religious language. The problem Millicent Bell addresses is not simply the differentiation of energies as religious, or not, but a perennial incapacity in the modern West to define religious experience. If the energy common to Strachey's figures "had effected all the transformations and achievements of the great nineteenth century" and the carriers of it understood it as religious and themselves as "soldiers of the faith," what purpose is served by deleting religion in favour of a generic energy?

Several versions of Carr's life underscore the complicated issues of experience, embodiment and religious meaning. Earlier, in discussing Carr's autobiographical writing, I mentioned the powerful intimacy of her letters. Doreen Walker's *Dear Nan* (1990), a recent collection edited in the full light of feminist literary awareness, brings a vulnerable, aging and intense human protagonist to the reader, a protagonist displayed in the refinements of late-twentieth-century book production, a profusion of endnotes and bibliographical data. The urgency of dailiness, the agonistic sparing of friends, pleading and blessing, appear in random order, condensed from a reality we presume to share. These letters set a private Carr before us in the spontaneous gestures of the genre. Has she been violated by this retrospective elaboration? Has she finally succumbed to the impersonality of Foucault's dossier, losing thereby her heroic stature? Or is the reader faced with an undecipherable closeness that raises questions of essential meaning much as Strachey's use of Freud did almost a century ago?

The contrast between two recent plays highlights the significance of the ordinary realm and the complexity of intimacy. Jovette Marchessault's *Emily Carr: A Shaman's Voyage*,[47] a radio play performed on the CBC's Sextet series in 1990, which subsequently won a Governor General's Award, is a fantastic version of Carr's life that confronts spirituality directly. Able to move between this world and a parallel angelic realm, Marchessault's Carr encounters D'Sonoqua, the wild woman of the woods, as a source of power. Her sister Lizzie observes her from a distinctly terrestrial plane. Eileen Whitfield's *Alice and Emily*,[48] performed in 1992, draws the audience into the house that an aged and slightly deaf Emily shares with her sister whose own infirmity is poor sight. There is no overt religiosity in this play; instead, a powerful intimacy echoes the intensity of Carr's letters.

In her exploration of the versions of reality that divide Anglo- and French Canadian feminists, Gail Scott posits a repression of the feminine in English Protestant society and its affirmation among Quebéçoises with a Roman Catholic heritage. Scott's surmise, that "English-Canadian feminist writing has tended to be content-oriented compared to the more radical contestation of language and form that has taken place in Québec" (1989: 39), is reflected in the contrast between the two plays. Marchessault's sisters inhabit separate worlds, one beyond the other; Lizzie offers a contrast between lives like her own, restricted to this world, and Emily's existence as a shaman who moves in other realms as well. Whitfield's Alice establishes intimacy through the immediacy of her presence on the same earthbound terms as Emily.[49] And, indeed, through the intensity of dailiness, including sparring between the sisters and the gentle decorum of afternoon tea, the mystery of living encroaches upon the humour and frustrations taking place on stage. Questions of ultimacy thrive on the details of life that seem least likely to initiate religious analysis. Perhaps because they are not directly addressed, these questions hover with disconcerting inevitability. The house she shares with Alice is, Emily says, "cosy," and it has become her world.

> Doctor's orders. I'm not allowed to go to the woods. I think that's why I'm so mean to Alice. A lot of time I'm a jagged old sourpuss. At least I can *think* myself in the woods—the trees, so inexplicably lovely, leaves expanding every minute . . . (looks around) Still, this is a good enough place. A good enough place to dream and die in. (Whitfield 1992: 13-14)

There is a "spirit of buoyant purposefulness" in these sentiments that suggests a sustaining irony. "It remains possible to display an excess of spirit which, not being demanded, is freely chosen" (Kariel 1989: 121). Irony, not parody, sustains choices, offers options of faith. And irony suggests that alternative explanations remain, always.

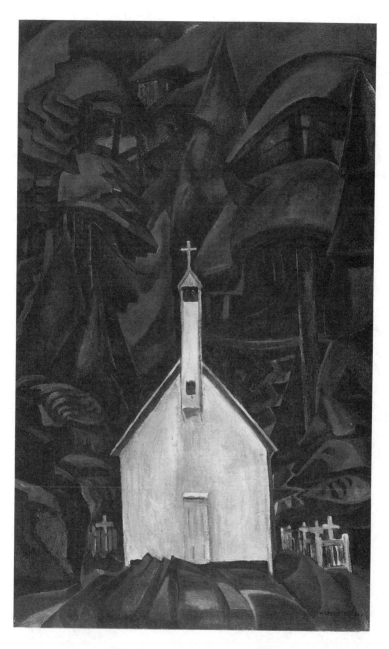

INDIAN CHURCH, 1929
(Toronto, Art Gallery of Ontario. Bequest of Charles S. Band, 1970, used
with permission)

EMILY AND THE ELEPHANT
(British Columbia Archives & Records Service HP65557, used with permission)

DEEP NATURE: SURVIVAL IN A CONSTRUCTED WORLD

The most significant characteristic of twentieth-century thought is that of the self's improvising and experimenting with ways of maintaining self-confidence. We move away from metaphysics toward forms of epistemology; self-definition becomes a series of improvisational gestures; there is a profound and poignant distrust of traditional schemes of definition. In his most confident moments of self-assertion, modern man is still in the act of willing his wholeness, his prospects of enduring time, his dignity and his worth.

— Frederick Hoffman (Lyons 1978: 227)

How extraordinarily alone everyone is! Each one walking along his own path to the one gate through which every one goes alone. Art and religion are alike. It doesn't matter what our sect or what our method, the one thing that matters is our sincerity.

— Emily Carr (*H&T*: 177)

I believe a debate about the spiritual in art is long overdue. . . . Among the most central of all questions affecting art and craft in our century [is] the severance of the arts from religious tradition and their existence within an increasingly secular culture. Modernist art historians tend to regard this as unproblematic. But incorrigible atheist and aesthete that I am, I believe it to be a moot point whether art can ever thrive outside that sort of living, symbolic order, with deep tendrils in communal life, which, it seems, a flourishing religion alone can provide.

— Peter Fuller (1990: 189)

Notes to this chapter are on pp. 179-86.

CONSTRUCTING LIVES AND CONSTRUCTED ABSENCE

In both the hagiographies of the medieval period and biographies in the modern West, women's lives have been narrated as marginal, liminal, tangential to the norm; they have offered a counterpoint to and a critique of the prevalent societal model, the narrative of male experience. The medieval world described by Thomas Heffernan and Caroline Walker Bynum—for us a closed system within the domain of divine rule, where unities of time and place held—is gone, long since replaced by a hierarchy of reasoning men on earth.[1] Among those men some were particularly blessed with divine inspiration or insight. The *genius* that distinguished Renaissance figures like Francis Bacon, stimulating him to accommodate both the old medieval and new modern worlds, that encouraged Galileo to relate his observations in the characteristically instrumental idiom of the modern age, was of a kind never available as an attribute to all of God's creatures.[2]

An evaluative term, *genius* conferred privileged status on the bearer of particular skills and abilities. That individual, depicted in Christine Battersby's *Gender and Genius*, became definitionally male. In her elaborate etymology and history of social practices surrounding the idea of genius Battersby has shown how pivotal the concept has been to European culture and how, through the nineteenth century and well into the twentieth, genius came to denote a spark of divinity restricted to a small elite (Battersby 1989: 2).

> The genius was a male—full of "virile" energy—who *transcended* his biology: if the male genius was "feminine" this merely proved his cultural superiority. . . . The creative woman was an anomaly that simply introduced complications into the patterns of exclusion. A woman who created was faced with a double bind: either to surrender her sexuality (becoming not *masculine*, but a surrogate *male*), or to be *feminine* and *female*, and hence to fail to count as a genius. (Ibid.: 3; italics in original)

Since male artists often adopt qualities of intuition and emotional sensitivity, it is not the feminine that is excluded from culture but the female. The creation of the modern world, then, is the product of male genius, a creation for men in which *woman* joins other categories of being, like *child* and *wilderness*, in exclusion.[3]

Battersby politicizes the concept of the *Other*. Instead of supporting it as a linguistic spectre, a Lacanian notion of the unconscious,[4] she points to subtleties of usage and notes a differentiation between margin-

alized *Others* "who, because of our racist and sexist paradigms of normal humanity, get viewed as not-quite-human" and *Outsiders* "those who are viewed as fully-human but not-quite-normal. Under this category come 'feminine' males, genius males, crazy males, degenerate males, shamanistic males . . . even pseudo-males" (ibid.: 138). An important conclusion she draws from her analysis is that the art of females will not be more highly valued nor more richly configured in its traditions simply by establishing a better understanding of biological or psychological characteristics, histories and conditions. "It is rather a matter of being consigned—on the basis of the way one's body is perceived—to a (non-privileged) position in a social nexus of power" (ibid.: 145). As long as "writing like a woman" and "writing as a woman" are conflated, female artists will fall into the category of Others. Battersby also distinguishes between the views of contemporary critics like Roland Barthes who "want to kill off authors and eliminate selves and individuality completely"—the point is often made that the *self* has been devalued just as women are delineating their versions—and views, like those expressed by Michel Foucault in "What Is an Author?" that emphasize the complexity of the issues involved in the processes of inscription (ibid.: 151). What is required to alleviate the imbalances she describes is not the simplicity of androcentric social organizations but the rich density of heterogeneous community.

It is against the background of cultural analyses like Battersby's that the biographical retrieval of women's experience, particularly the experience of women artists, seems crucial.[5] Hers is one of many voices urging the abandonment of structures of community which, though suitable for the goals of the West in the modern age, are inadequate, often destructive, in the global contexts of the late twentieth century. As an illustration of the deconstruction of foundational assumptions, Battersby's study demonstrates the depth and intensity of social and intellectual ferment that has stimulated the recent proliferation of women's biographies. Articulation of female lives authenticates gendered distinctiveness and casts light upon the shadowy presence of the excluded Other, upon categories of thought and being that have been previously unthinkable.[6] New meanings take shape.

SITES OF MEANING

In the period of this century's wars—paeans to technology and instrumental reason—easy or deliberate communication on religious matters became perplexing for many, inconceivable for others. Traditionally

powerful sites of meaning such as sentiments of belief, fascination with divinity, even openness to wonder, appeared irrational within the broad cultural boundaries of modernism. In this alienating world of industry and nation states, a zone heavily dependent upon secular and scientific terminology, the arts came to play a significant role in the cultivation of meaning. Sheltering religious sensibilities and introducing new meta-phors, the arts created a forum where 'irrational' views, often displayed as contents of the unconscious, could be reasonably and energetically explored. Even so, in the exuberant expansion of the postwar Western economies at mid-century, that role was limited. With the growth of unbelief and the parallel loss of sites of religious meaning, art became a "refuge for religious emotion." In the late nineteenth century this turn of events was a subject for discussion; by the twentieth century the "secular form of belief" had become "inadmissible . . . so that by now we find it indescribably embarrassing to mention *art* and *spirit* in the same sentence" (Krauss 1986: 12). Picasso's claim that the word "sacred" would be misunderstood has been echoed recently by Max Oelschlager's observation in *The Idea of Wilderness*: in our secular world, "where the objective mode of knowledge enjoys cognitive hegemony," the notion that nature is sacred is "virtually incomprehen-sible" (1991: 19). Scientific and disinterested thought have dislocated religious language and rendered non-rational matters irrational.

Yet as early as the turn of the century the avant-garde, a contrary voice since its emergence in the late nineteenth century, judged "scien-tific miracle workers" to have "failed society miserably." For all sci-ence's advances, life had not "intrinsically improved" (Karl 1988: 200). And though patterns of religious certainty had faded, the yearning for transcendent truth and order had remained. Roger Lipsey, writing on the place of religion in twentieth-century art, defined the spiritual as "an incursion from above or deep within to which the ordinary human being in each of us can only surrender." It is "a dramatic shift in expe-rience and an undoing of what we take to be ourselves" (Lipsey 1989: 10). Applying *sacred* to familiar sensibilities in this world gone awry was irreverent, or irrelevant, but to approach inherent or profound meaning through the language of art or the unconscious could create a fresh spir-itual awareness. By working on her own, "without formal adherence to religious or spiritual traditions" (ibid.: 11), Emily Carr exemplified the avant-garde task of reconnoitring new territory for the rest of society. Her intense need to express personal truths felt deep within her being and her urge to experiment with colour and form were representative of the modernist's quest for a renewed order in the world. Since inspi-

ration was, however, a spark of divinity reserved for male genius alone, her efforts were anomalous.

Even though Carr's status as an artist was definitionally constrained, her rich inner life was enhanced through contacts with others, often men, whose responses to art and religion were similar to her own. The letters she received from Group of Seven member Lawren Harris frequently exhibited a penetrating awareness of sacrality. He wrote to her in June 1930: "Profundity to me, is the interplay in unity of the resonance of mother earth and the spirit of eternity. Which though it sounds incongruous, means nature and the abstract qualities fused in one work." Harris went on to recommend immersion in the natural world, "in our place, the trees, skies, earth and rock, and let our art grow out of these. If it becomes abstract, wholly or in part or not at all is not the paramount thing. It is the life that goes into the thing that counts" (Reid 1985: 18). The processes of creation yielded meaning. In describing an exhibition of abstract art in 1927 for *The Canadian Forum* he made similar connections: "the most convincing pictures were directly created from an inner seeing and conveyed a sense of order in a purged, pervading vitality that was positively spiritual" (ibid.: 15). These words are reminiscent of Clive Bell's view of art as timeless rather than strictly oppositional. A key phrase in his *Art* was *significant form*:

> Instead of recognizing its accidental and conditioned importance, we become aware of its essential reality, of the God in everything, of the universal in the particular, of the all-pervading rhythm. Call it by what name you will, the thing that I am talking about is that which lies behind the appearance of things—that which gives to all things their individual significance, the thing in itself, the ultimate reality. (Bell 1914: 69-70)

His sentiments are not unlike those of his sister-in-law Virginia Woolf when she spoke of moments of being. Like Carr, Bell equated art and religion; both were concerned with "the world of emotional reality, and with material things only in so far as they are emotionally significant. For the mystic, as for the artist, the physical universe is a means to ecstasy" (ibid.: 81).

The capacity to link the self to wonders in a hidden realm was the goal of many who turned from the confining limitations experienced within Christianity toward other religions, the unconscious, the primitive world or the occult.[7] As scientific theorems and rational technologies increasingly defined the modern world, energies to escape their alienating order emerged. The appeal of Theosophy in Canada and its

impact upon modern art revealed the willingness of artists, among others, to experiment with intellectual and religious options. The Theosophical Society, founded in 1875 in New York by Madame Helena Blavatsky, drew upon traditions of both East and West, Spiritualism and the enthusiasm in the late nineteenth and early twentieth centuries for the exploration of unconscious desire. The concept of a fourth dimension in art, influential in the nineteenth century "as a higher unseen world hidden in the intricacies of non-Euclidean space," was described by Einstein at the beginning of the twentieth century as the relationship between space and time. The visual potential of a proposed curved space "invalidated Renaissance linear perspective" and generated the enthusiastic innovations of modern art, like Cubism, where form itself became the content (Dunning 1991: 116, 154-55). Theosophical thought and the fourth dimension, like Freud's science of the unconscious, were attempts to bridge disparate realities.

A tremendous amount of energy was involved in devising new ways to break free from instrumental reason. Though only a few artists became Theosophists, among them Lawren Harris, many like Emily Carr came in contact with the Society's teachings. It has been suggested that the impact of Theosophic thought in North America in the 1920s on artists like Georgia O'Keeffe and Lawren Harris was "due in part to the lack of flourishing avant garde traditions" in the late nineteenth century and "lukewarm enthusiasms in these places for religiously informed art in general" (Welsh 1987: 4). If there was a cultural void, however, there was also the particular power of North American geography. The closing of the frontier had rendered the natural world as it existed more precious.[8] Transcendentalism, Emersonian pragmatism, Thoreau's attention to nature, Whitman's vision and his influence opened imaginations to a tangible order beyond and within words and images, the order of a wide, open and natural cosmos.[9] At the time the absence of inherited cultural density seemed to put few obstacles between the natural world and its new European inhabitants.

Like the Group of Seven Carr was attracted by the "transcendentalists' acceptance of an ideal spiritual reality beyond the world of ordinary experience, which intuition can grasp and which infuses all things" (Shadbolt 1990: 66). Carr's love of Whitman's poetry, like her sympathetic comprehension of native art, buttressed her religious understanding of solitude—"how extraordinarily alone everyone is"— and her distrust of institutional religion. Her interest in Theosophy and an East/West Christianity confirm a curiosity and openness to spiritual insight typical of modernist artists. That she acknowledged her frustra-

tion with the abstractions of Theosophy and her allegiance to Christian tradition late in her life was, perhaps, an acceptance of wisdom gathered during a long life and an awareness that during the ascendancy of modernism it was art and not the institutional Church that was a repository for the sacred, a bridge between realities, a vehicle for the soul.[10]

SIGNS OF LIFE

Thus Emily Carr, a female artist trained at centres of Western art, with an intense and spiritual inner life, existed within a culture that denied her professional ambitions, the rewards of perseverance and the demands of her soul. For women the institutions of art and religion were, quite simply, inadequate and there were few alternatives. Nonetheless, Carr created an identity that has been received with increasing enthusiasm in the half-century since her death. For Jean-Paul Sartre the "struggle to achieve an authentic sense of identity is perhaps the only remaining religious drama worth reenacting." Biography gives life significance in narrative form: to analyze an identity, a biography, is "to uncover a cosmogonic myth and to witness creation of a 'world' and a 'self' within it" (Charmé 1984: 125). Life story absorbs innumerable details, tensions and concerns, social patterns and mysteries which are, as a consequence, sacralized. Through the effects of its generic clarity, biography draws significant and inherent meaning from any coalescence of features combined to create the story of a life. Frederic Jameson's description of genres as "essentially literary *institutions*, or social contracts between a writer and a specific public, whose function it is to specify the proper use of a particular cultural artifact" (Felski 1989: 85), underscores the distinctive nature of biography. The elements of a narrated life make sense because they *must*. Though the sense may be idiosyncratic, even tenuous, cohesion is insured by the temporal and spatial existence of the biographical subject. The telling of a life confers a mantle of ultimate significance upon existence, upon a particular existence.

That relatively few female lives were told before 1970 signifies a spiritual void which the proliferation of biographies since then has been filling. That Emily Carr's life has been told so often and in so many different forms˙ since then confirms her embodiment of contemporary conundrums. Her story is told to make sense of her life. Through repetitious re-evaluation a succession of biographers, using the lens of their own preoccupations, has explored the dimensions of her nature, her time and her place. That she was a religious female artist of genius challenges many assumptions. That her life is being reconstructed

simultaneously with those of similar women, like Georgia O'Keeffe and Frida Kahlo,[11] suggests that her experience represents a cultural element in the processes of invention, that webs of significance are being densely wrapped around the figure of the women artist, the female creator.[12]

Wilson Snipes' notion of the biographer as a centre of reference gives conceptual priority to the biographer as interpreter. I am suggesting that the biographical subject confers a coherence and legitimacy upon the biographer's speculations that would not otherwise be granted. Those speculations may be more or less supported by evidence. Carolyn Heilbrun has pointed out the difficulty of admitting that "biographies are fictions necessary to the biographer": "the chance involved in what 'facts,' documents, memories survive has been far too little credited: we dislike admitting that the results of our scholarship, while rewarding, may be far from conclusive" (1990: 29). Notions that are not empirically or rationally sustainable, that are hidden behind admissible categories, that are unthinkable, can and often must be addressed if we understand them to be integral to the experience of a biographical subject. Current fascination with the lives of women artists, fuelled by a societal urge to redefine and reclaim the sacred, particularly the sacred feminine,[13] takes advantage of the genre's capacity to circumscribe *any* view of the world, to create a metanarrative, to infer a cosmology.

The success of attempts to confront the spiritual and religious life of Emily Carr hinges on acceptance of religious meaning and on the currency of words like *sacred* that have been impugned as irrational. Or, in a reversal of considerable power that is common in the realm of charismatic biographical figures—and links them firmly to the hagiographical lives of more certain paradigms—a biographical subject like Carr, after having acquired considerable presence, moves to a mystical, religious or spiritual realm, trailing devotees.[14] Frequently such lives fascinate readers precisely because they force attention toward topics that—though they may have little validity outside the peculiar lives of particular people—have about them a certain urgency. Once again Louis Riel is a clear and representative example.[15] As long as a patriarchal and conservative notion of Canadian history held, until advocacy movements began in the 1960s, Riel was a minor figure as notable for the coincidence of his execution with the completion of the transcontinental railway as he was for his devotion to native and Métis rights. As support for aboriginal rights has grown in recent years, so too has the depth of character accorded Riel. His role as a mystic and visionary has been delineated as it has become necessary, or useful, to acknowledge his

prophetic actions. The errant dynamics of the biographical process, characteristic of the genre's enigmatic disposition, both foster and monitor the movement of social thought.[16] Thus interest in Carr's life not only exemplifies new efforts to retrieve women's lives on their own terms, it also illustrates the late twentieth century's fascination with the feminine sacred and a revisioning of spirituality and religion.

Lives of a Mystic

Most versions of Carr's life have been primarily developmental accounts of her character and her artistic vision. An early reference to her spirituality, after the initial reception of her vision in the 1940s but before the redefinition of women's lives in the 1970s, appeared in the catalogue to an exhibition of Carr's works at the University of Waterloo in 1967. Nancy-Lou Patterson, an art historian, artist and a profoundly religious woman herself,[17] declared that Carr "was no simple nature-worshipper, but a genuine mystic who was intensely sensitive to the divine even in the smallest things" (n.p.). Though the publication of Carr's journals, *Hundreds and Thousands* (1966), certainly sharpened its contours, the essence of her spiritual life could be glimpsed in the earlier, autobiographical *Growing Pains* which Patterson quoted:

> One night I had a dream of greenery. I never attacked the painting of growing foliage quite the same after that dream I think; growing green had become something different to me.
> In my dream I saw a wooded hillside, an ordinary slope such as one might see along any Western roadside, tree-covered, normal, no particular pattern or design to catch an artist's eye were he seeking subject-matter. But in my dream that hillside suddenly lived— weighted with sap, burning green in every leaf, every scrap of it vital!
> Woods, that had always meant so much to me, from that moment meant just so much more (*GP*: 262).

Having compared Carr to St. Thérèse of Lisieux, both single-minded in their drive to apprehend divinity, Patterson remarked on a similar juxtaposition made by Rosemary Kilbourn in a review of *Hundreds and Thousands*. Kilbourn thought Carr "would have assented" to Teilhard de Chardin's conviction that "at every moment He awaits us in the activity of the work to be done. He is in a sense at the point of my pen, my pick, my paintbrush, my needle, my heart, and my thought" (Kilbourn 1967: 76-77). Assessments of this kind have drawn Carr's

life from the "edge of nowhere" into the heart of spiritual and religious cultural traditions.

A decade later Charles Taylor included Carr in his *Six Journeys: A Canadian Pattern*. Though he chose his exemplars on the basis of their individual lives, Taylor noticed they shared a common British heritage as well as an "exuberant spirit" that he associated with Victorians, a "passion for the exotic" and "an appetite for more than their society had to offer them" (Taylor 1977: iii).

> Each was seeking a nobler and more spiritual way of being human than their Canadian society encouraged or even tolerated. They were believers and even visionaries; their lives were directed by an impulse which was basically religious, although hardly constrained by mere orthodoxy. (Ibid.: iv)

> Faced with a strange mixture of opposition and indifference, each of these Canadians was forced into a life of loneliness and isolation. They felt compelled to escape their Canadian society, and to sharpen the edges of their identities in different forms of exile. For it was not only that each had a deeper, richer vision which demanded to be lived, and which Canada-as-modernity denied. It was also that to live that vision, each sought fulfillment in the older values of another civilization. (Ibid.: v)

In 1966 Flora Hamilton Burns had described Carr's hiatus through the details of "fourteen years of frustration and relentless struggle" (Burns 1966: 230). In Taylor's account, with his emphasis on spirit, the same moratorium takes on a different kind of reality:

> What had happened? How can we explain this new authority and passion, suddenly erupting after all the long years of dreary toil and little painting? Carr's journals offer few explicit clues. But it may well have been that she found her new strength and inner vitality, not despite the barren years, but *because* of them. . . . Her hardships drove Carr deeper into herself, in search of a faith that could triumph over all her tribulations (Taylor 1977: 177).

Having described a life he intends to be inspirational, Taylor summed up Carr's existence:

> Fusing the spiritual and the sensual, the Apollonian and the Dionysian, she was celebrating the continuous process of life, eternally changing, yet eternally the same. Coming to terms with the wilderness, accepting it within herself and not letting it destroy her, she won a spiritual victory, and entered a world of grace. (Ibid.: 186)

The form Taylor gave his tale and the details he amassed to convey her life are well within the conventions of the genre. His Emily Carr is, however, unique in being explicitly configured as exemplary. Taylor clearly acknowledges the inherent and powerful influence of biographical images.

Innovative writing about Carr's spiritual life awaited a groundwork of clear and full biographies, a base of information provided in the late 1970s by Maria Tippett, Doris Shadbolt and Edythe Hembroff-Schleicher. Several recent works, all predicated upon a general awareness of the structure and events of Carr's life, stand out as striking interpretations of her spirituality: John Barton's *West of Darkness*, a cycle of poems published in 1987, Jovette Marchessault's *Emily Carr: A Shaman's Voyage*, and an essay by Maria Tippett which appeared in the catalogue of a 1991 British exhibition, *The True North: Canadian Landscape Painting 1896-1939*.[18]

Barton's cycle of poems touches upon many of the familiar details, events and preoccupations that have coalesced around the figure of Emily Carr. Self-aware, he recognizes that his portrait is idiosyncratic and multiple: it both is and is not Emily Carr. " 'You should not have said that,' one Emily could censure the other. What do these differences mean?" (Barton 1987: 124). Working on *West of Darkness* in 1979, Barton found Maria Tippett "paradigmatic and loving" and Doris Shadbolt invaluable (ibid.). Though he had lived in Victoria, a dense site of Carr memorabilia, he gained his strongest impressions of the artist from his mother during a childhood on the prairies. "In the end I absorbed something of all points of view, but what I have come up with is only another version. I believe it is faithful to the woman herself, the one who is at the heart of her. I know I have composed out of respect" (ibid.: 125-26).

Devotees will recognize Barton's references—"walking along the Dallas cliffs" (1987: 14), "the dreadful weight of Paris rudeness" (ibid.: 16)—and his meditations on specific paintings like Indian Church and Blunden Harbour. His images of darkness deepen Carr's existence: "I hunt the darkness for warmth" (ibid.: 38), "the forest's coal-dark heart" (ibid.: 41), a "forest like myself a fragment of God" (ibid.: 59). Pivotal moments, expected, are not missed. The picnic with her mother, when Emily made daisy chains, is an oasis of lyrical bliss as it is in Paula Blanchard's biography. Like Jovette Marchessault, Barton pays particular attention to the chairs Carr raised on pulleys to the ceiling to clear her studio space and discourage unwelcome visitors (ibid.: 95). Like Maria Tippett, he emphasizes the Freudian implications of her father's "brutal

telling" (ibid.: 105-106).[19] Barton's images exude meaning: "The heart of the forest thrown open before me, I approached overwhelmed, myself a daughter of prayer conceived by Father in Mother, for God's pleasure, at the edge of the world" (ibid.: 74). When the new art puts a match to Carr's darkness (ibid.: 71), she discerns "interior light" within a "totem mother"; she can recognize "hands so full with love I made them huge and distorted as they enfolded the child" (ibid.: 74). As war comes and death approaches, the light fades: "we are nothing beside the darkness of our unknowing" (ibid.: 109). Darkness and light alternate as Carr struggles for freedom to create, to escape the constrictions—of family, cities, convention—that silence.

Though each voice is unique, the intention to recover or invent spiritual meaning distinguishes these recent works from earlier biographies. Marchessault, a Montagneise Cree and feminist Québeçoise playwright able to call upon languages of vision, names Carr a shaman. The voices of two Indian women, Carr's friend Sophie and another called Marie, chanting high rhythms, evoke powers that could not have been assigned to Carr within the patterns of traditional Anglo-Canadian religiosity nor can they be linked to avant-garde sensibilities. A creative and unusual enactment, imagining a newly empowered Emily Carr, Marchessault's play participates in the surge of feminist spirituality that has accompanied the current wave of the women's movement.[20] Like Paula Gunn Allen, a feminist Laguna Pueblo/Sioux Indian, Marchessault suggests a "very real power or force," a sacred power, is embedded in literature (Allen 1986: 72).

The tone of Maria Tippett's 1991 essay is radically different from her earlier work on Carr's narrative image. While she did not evade Carr's religiosity in *Emily Carr: A Biography* (1979), which continues to rank as *the* definitive biography, neither did her portrayal of Carr's spiritual quest rise significantly above other important elements in the life. The sheer accumulation of detail in definitive lives can easily obscure important themes which remain unnoticed until they are emphasized by later biographers. Hence, for example, despite the comprehensive work of both Tippett and Shadbolt, Paula Blanchard was able to say that there was room for yet another version when her own appeared in 1987. In Tippett's recent article the tone is not unlike that which enlivens hagiographical saints' lives and gives them their power. In the context of an exhibition showcasing Canadian landscape art to the British, she draws strong shaping lines that contain Carr's experience, lines that firmly tie Carr's talent to spiritual purpose. For Tippett "the causes and the conditions that brought [Carr's mature] work about and

resulted in a break-through of landscape perception" begin with views of landscape that Carr held most of her life, views rooted in her knowledge of west coast native Indian myth and iconography and the prevalence of "the late nineteenth-century British perception of the landscape shared by her fellow Victorians" (Tippett 1991: 87). A result of Carr's break-through, which occupied a brief period late in her life, was a resolution of her troublesome relations "with God, the forest, with her enforced landlady chores, even with her friends and sisters" (ibid.: 96). The key lay in Carr's "inner spiritual condition . . . her realization that her paintings must express that condition; and her discovery of a style and an appropriate subject-matter to express that spiritual condition" (ibid.). Tippett summarizes other aspects of Carr's life as subsidiary to the compulsions of her spirit. What makes this essay unusual is its smooth clear surface. Tippett's early treatments of Carr in the 1970s were fractious, her major work in 1979 exhaustive and complex. The sense of this more recent view was presaged in *From Desolation to Splendour*, which Tippett coauthored with Douglas Cole in 1977. There— in tracing the perception and depiction of British Columbia's forests from the sketches made on discovery voyages in the eighteenth century through to the fading interest in landscape in the mid-twentieth century—Carr's work was quintessential. For Tippett in this 1991 essay Carr's quest for meaning has become the principal category to which other aspects of her life relate: her early alienation within the family, her education—including her study of Theosophy and her treks into the forest. Barton's poem cycle and Marchessault's drama utilize form to add religious depth to Carr's life; Tippett's iconic image owes less to narrative form than it does to an explicit concern with Carr's spirituality.

CULTURAL DETERMINANTS/SPIRITUAL IMPERATIVES

> The fashioned, fictional self is always located with reference to its *culture* and coded modes of expression, its *language*.
> — Clifford 1988: 94; italics in original

A further consideration of the notion of culture and its relation to the fluid concepts of religion and spirituality helps to account for the strength and authenticity of these latest biographical images of Emily Carr. In T. S. Eliot's postwar attempts to describe the relation between religion and culture—his claim that culture was the incarnation of religion—religion remained the broader and more inclusive term. Since then the balance between the two terms has reversed. What Peter

Berger called a sacred canopy in 1967, the notion of an ordered, mean-
ingful and shared cosmos, supports Eliot's idea of the encompassing
place of religion. However, many of the assumptions tacitly held by
Eliot and Berger as religious might now more commonly be called cul-
tural. Among the complex forces of our shrinking planet, religion has
become one aspect of many in lives whose variations are more easily
accommodated as differences of culture, differences inlaid in a shared
humanity, than as competing systems imposed by remote divinities
whose natures are under discussion.[21] In becoming the more inclusive
term, culture has absorbed ideas, attitudes and habits that formerly sus-
tained the discourses of religion. Tasks once seen as lying within the
purview of the Church as the institution of religion have passed to sec-
ular organizations, leaving to religion the task of personal redemption.
In postwar Canada, typically, there was "a tendency . . . to pay little
attention to what the church said outside a narrowing area within
which its special competence was admitted" (J. W. Grant 1988: 180).

However, if the Church and conventional religious expression
were increasingly seen to have a narrow redemptive focus, sensibilities
once housed there could be identified in other locations once the con-
cept of culture became more fully elaborated. Roger O'Toole, in apply-
ing the notion of implicit religion to the arts in Canada, gives a sense of
how easily religious ideas migrated beyond the confines of the Church.
According to O'Toole the nebulous realm of implicit religiosity, which
retains an "analytically untidy character," relies upon "functional defi-
nitions that depict religion in terms of 'ultimate concerns,' 'grounds of
meaning,' identity-formation,' and 'moral community'" (O'Toole
1993: 157). The latent-manifest continuum, which Bryan Wilson used
to analyze religious *function*, is associated with *form* in this case.[22] Here
explicit, manifest religion refers to "those institutionalized beliefs and
practices that are conventionally termed 'religious' by participants in a
given social context." Implicit religion, on the other hand, indicates
"beliefs and practices not conventionally designated as 'religious'"
under similar circumstances (ibid.: 158). Indeed, "much of the ago-
nized self-examination and soul-searching that constitutes the perennial
pursuit of an elusive 'Canadian Identity' bears the unmistakable mark of
an implicitly religious quest" (ibid.: 159). Carr's life, when set against
widely shared notions of Canadian and northern soul, supports what
O'Toole identifies as the postulate of "the artist or writer as an inher-
ently religious figure" (ibid.: 169).

The elaboration of women's lives generally, but specifically and
anomalously women artists' lives, adds new tension to the implicit/

explicit dichotomy. The cultural and religious changes that have been
effected, or are anticipated, by the newly found strength in women's
voices suggest that what has been considered as *implicit* in terms of tradi-
tional habits and structures is being brought into discourse as *explicit* and
challenging traditional institutional and structural boundaries. Feminist
or women's spirituality derives power from inclusiveness (Ochs 1983),
from recognition of the ordinary (Sexson 1982), from an appreciation
of women's particular experience of time and space and the validation
of women's work (Rabuzzi 1988), from women's moral sensibilities
(Gilligan 1982) and from a pervasive sense that "feminism rather than
religion" can articulate "a universal spirituality grounded in multipar-
ticularity" (Reuther 1987: ix). In myriad forms this spirituality achieves
a measure of explicitness that its extra-institutionality might seem to
deny. The tensions inherent in the postmodern challenge to tacit
assumptions, and in movement toward a postfoundational comprehen-
sion of our condition, stimulates the sacralization of experience.

No longer an encompassing feature but, instead, a facet of culture,
religion can be utilized as an instrument of societal criticism (Wilson
1988: 202). Its imperatives and ideals can be wielded to isolate and
describe the marginality of women, merging the remembered sense of
"that marginality which is imposed by oppressive structures and that
marginality one chooses as site of resistance—as location of radical
openness and possibility" (hooks 1990: 153). As a political gesture,
women's spirituality can draw upon cosmologies of other times,
reworking their terms to bring what has always been known to con-
sciousness. A feminist retrieval of lives, or a postmodern interpretation
of women's lives, rejecting notions of imperfect identity,[23] sustains the
validity and significance of embodied human experiences while simul-
taneously questioning the traditional authority of the subject. Cultural
shifts promoted by legitimating the experience of women are momen-
tous and, though they would seem to be inevitable on bases of social
justice and individualism, such has not been the case.[24]

Definitions of culture are numerous. For William Westfall culture
provides "ideas, beliefs, and attitudes through which an individual, soci-
ety, or group, interprets existence"; it establishes "a pattern of interpre-
tation for organizing the unstructured data of life."[25] As one of the
"systems of belief that answer the questions that cultures ask" (Westfall
1989: 13), though a reluctant and unnatural *system*, at the very least
feminist spirituality challenges traditional modes of institutional reli-
giosity and encourages a more thoroughly *engaged* participation in the
complexities of existence, participation reminiscent of places or periods

when the functions and forms of religion were less distinguishable as manifest and latent.[26] The possibility that Carr's biographical image can effectively promote alternative forms of religious expression appears more than likely in light of the traditions of women's lives in medieval hagiography. Within patriarchy, which encompasses that time and our own, depictions of women's lives, inevitably marginal, have frequently been intentionally subversive, critical and calculated sites of enthusiasm.

Berger's sacred canopy is an effective notion of religion against which to measure the lives of able and public-spirited men, the sort that were the subjects of Canadian biographies in the 1950s, men of action who embodied transcendent ideals. The retrieval of women's lives in the past several decades has cast new light upon perceptions and assumptions nurtured in the shadows of the sacred canopy.[27] Women cannot embody the ideal; they have not been models for society. However, female lives have acquired new salience since "aristocratic notions of 'achievement'" have lost appeal and been replaced by interest in *any* life that illustrates the more "democratic notion of 'fulfilment.'" In modern biography "the example is the life itself, not what the life enabled the person to achieve. Or, more precisely, the life *is* the achievement; what used to be called the achievement is now only one accompaniment, possibly a minor one, of a style of living" (Skidelsky 1988: 13).

A particularly useful notion of culture for addressing the changes which have opened up the biographical genre since 1970 is Roy Wagner's concept of the invention of culture, a process of continuous redefinition necessitated by dialectical tensions within society. Derived from anthropological analyses of cross-cultural contact, in which the "invention" of an unfamiliar culture makes visible the dimensions of one's own, Wagner's formulation depicts that other culture as contingent. The effects of its invention are "profound" and "unconscious":

> The "control," whether subject culture or artist's model, forces the representer to live up to his impressions of it, yet those impressions themselves change as he becomes more and more absorbed in his task. A good artist or scientist becomes a detached part of his culture, one that grows in strange new ways, and carries its ideas through transformations that others may never experience. This is why artists can be called "educators"; we have something—a development of our thoughts—to learn from them. (Wagner 1981: 12)

Wagner's concept validates the enterprise of those, like Carolyn Heilbrun and Mary Catherine Bateson, who have focused on women's experience as routes to a more viable and fluid perception of humanity.

The recovery, or simply the depiction, of women's lives offers opportunities to imagine a new culture, one that reflects the ideas and attitudes of modern Western civilization. Bateson, daughter of anthropologists Margaret Mead and Gregory Bateson, describes life itself as "an improvisatory art" (1990: 3). "Because we are engaged in a day-by-day process of self-invention—not discovery, for what we search for does not exist until we find it—both the past and the future are raw material, shaped and reshaped by each individual" (ibid.: 28). Drawing attention to the increase in the number of biographies about women, she remarks that "the women's history movement," paralleling other processes of democratization like the black history movement, is attempting "to make the invisible visible, . . . provide role models and empower aspirations, . . . recognize common patterns of creativity that have not been acknowledged or fostered" (ibid.: 5).

The shift away from life stories told within the confines of conventional, traditional and institutional definitions of religion was clearly marked by Leslie Stephen's biographical forays over one hundred years ago. Since then most biographies, even those of significantly religious lives, have been written within the secular terms of their humanity.[28] In the case of Emily Carr, the capacity of her biographical image to address alternatives, among them an intense spirituality, is enhanced by her participation in the oppositional, alienated and Utopian avantgarde. Though modern art cannot be seen as offering a systematic view of society, it can be viewed as a cultural system within society that offers primary documents in the social history of the imagination (Geertz 1976: 1498).[29] Accounts of Carr's life—as examples of an autonomous, innovative female existence—are just such primary documents. They support Clifford Geertz's contention that though "art is notoriously hard to talk about," there is, nonetheless, "a depth necessity to talk about it endlessly" (ibid.: 1473-74).

DEFINITIONAL ELASTICITY AND THE
NECESSITY OF IMPROVISATION

Winston L. King's definition of religion—the organization of life around the depth dimensions of experience—easily adapts to the late-twentieth-century balance between religion and culture. Eschewing systematic analysis, unless that is a specific project of the biographer, biographies ably describe that organization and the depth dimensions of experience. King's phrase, "organization of life," admits any amount of institutional practice, or none at all, and his choice of "depth" rouses

readers to perceive the unconscious energies and the contingency of events that are the grist of life story. Emily Carr's proclivity to address matters of significance with a vocabulary of depth and to organize her life around axes of religiosity—modernism, Christianity, nature—fits without difficulty into King's flexible definition.

Analyses of feminist or women's spirituality, often experimental, thrive within conditions of elastic definition. "Legitimacy," according to Emily Culpepper, "is a primary patriarchal construct" (1991: 158). Carol Ochs' description of women's spirituality, developed from notions of love and experiences of mothering, work and community, invokes a non-elitist process of fulfilment. For her, religion is "insight into the common experiences of mankind" (1983: 8)[30] and spirituality stimulates a "coming into relationship with reality" (ibid.: 10). Measured against the conventions and institutions of familiar religious traditions, these definitions may seem too loose and general but Ochs, a philosopher, turns this simplicity into the ground of a compassionate and practical faith. For Ellen Leonard a common-sense definition as opposed to a philosophical one allows her to include in "religious experience" "all that contributes to our situation, both our political and personal contexts and our near and distant histories. Such an understanding of experience is open-ended and flexible rather than definitive" (1990: 143). "Religious experience" can thus be moved beyond William James' claim that it is an exclusive term for "the feelings, acts, and experiences of individual men [sic] in their solitude, so far as they apprehend themselves to stand in relation to whatever they may consider the divine." Instead, it can become an inclusive "orientation toward holy mystery which constitutes our essence as subject and as person. In this sense all experience is religious" (ibid.: 143-44).

The strength of women's voices and creative energies,[31] amplified by large numbers of educated women with extensive opportunities for networking, often funded by governments and international organizations, has made the personal effectively political and shredded many surviving premises of a private sphere.[32] The intricacies of that privileged sphere, exposed and dissected, have yielded insight into and evidence of undeserved and unnecessary suffering. In terms of her private life as a woman, Carr was not exceptional. Aligned with her talent and the acclaim her works have received, the frustration and neglect that were her lot become egregious evidence of systems and institutions unable to support the rhetoric of their own ideals. Only when traditional definitions are stretched beyond old structures and truly democratic notions of experience are upheld does the embodied existence of this particular

woman assume profound meaning. Such an enterprise is stimulated by the tension between religion and culture in our postmodern, postfoundational world where the issues of equality and opportunity have become spiritual as well as economic, social and political.

> An increasing number of women have decided against channeling our energies into the reconstruction of any religion. We choose instead to create more eccentric pathways that aid us and encourage others to deviate as widely as possible from patriarchal centres of meaning. The old androcentric faiths may sometimes provide fragments of inspiration, but we do not judge them to be trustworthy means for moving beyond patriarchy. We are women who may have grown up in a religion and left it, tried several, or never been part of an organized religious tradition. What we have in common is a depth perception of our life path as a feminist journey. The transformative feminist insight that "the personal is political" has also become for us "the personal is political is spiritual." (Culpepper 1991: 146)

Culpepper's movement between variants of *religion* and *spirituality* has become common practice, perhaps indicating that calibrated distinctions between the words belong to earlier dilemmas. If there is a general trend, it seems to favour spirituality as an inclusive concept and relegate religion to institutional practices and developed cultural traditions.[33]

Any objection that Emily Carr would not have patiently tolerated these distinctions would likely be true, but for her biographical image—which is not the same entity as the creature herself—such concerns are entirely appropriate. Commentary on the National Gallery's 1990 retrospective exhibition of Carr's work disclosed disparate interpretations of her religiosity. John Bentley Mays, reviewing the exhibition for *The Globe and Mail*,[34] began by noting the current vogue for Carr's work in thematic exhibitions in Europe and North America, "on topics ranging from spirituality and the North to nature and the natives." He found neither "her well-known religious notions" nor her "fascination with the forlorn villages of the Pacific coast's native peoples" of interest. What he wanted to know was: "just how good and important an artist was she?" Immune to "her charm as a subject of biography," Mays finds Emily Carr "a genuinely gifted painter, but hardly the innovative, consistently original artist her fans would like her to have been." Carr's work, he opines, is "sometimes marked by drive and a sense of struggle"; more often by "lazy dependence on whatever painting style she was currently admiring." Most of all he seems to mind her participation in "the then popular idea that art should be the servant of the 'dynamic forces' of 'nature' (or worse, the 'spirit')" and

finds himself "completely at a loss to understand what serious people find attractive about Carr's opinions, those hackneyed Wordsworthian warblings about nature, the pious twaddle on the subject of God or 'nature.'" Canadian poet Dorothy Livesay, in a letter to the editor of *The Globe and Mail*, contended that Mays was a "smart alec," "paltry" and "smug."[35] Other readers called him a "hyena" and asked "why it is that when two or more men paint in a similar style, using similar subject matter, it is a 'movement' but when a woman participates her work is labelled 'derivative?'" Mays' insistence on energy, innovation, originality and substantial theology exemplifies the view of art that art historians like Griselda Pollock and Linda Nochlin, Rozsika Parker and sociologist Janet Wolff would call gender-biased.[36] Susan Crean writing the following spring lamented distorted portraits of Carr, misinterpretations, the fact that "she has been the victim of other people's projections."

> She did her best work after 1927 and her 56th birthday, when she finally figured out how to paint the forest primeval from the *inside* instead of the outside (as European tradition had it), how to portray its silence and its life force. What emerged was huge, raw and sexually charged, an astonishing vision for a woman her age and of her age. And right there I think we have part of the explanation for the experts' discomfort with Carr and her genius. How could that batty old baglady who lived on the fringes of late Victorian Victoria, who was well past menopause and probably still a virgin, be credited with such a vision? (Crean 1991: 18)

It becomes clear from this juxtaposition of sensibilities that there is a different core of meaning in Carr's life for Crean than that which stimulates Mays' thought. Crean's views, representative of contemporary feminist analysis, reveal the intricacies of Carr's insight and the depth of her spirituality.

For Emily Culpepper the concept of women's spirituality responds to the metaphor of a quilt. Her quilt, an "eclectic crazy quilt of spiritual paradoxes" stimulates what Nelle Morton called a "fantastic coherence" (Culpepper 1991: 151). Culpepper chose the metaphor

> because it arises from an image of woman's creativity, fashioning from whatever scraps of material available something new and useful and beautiful. It may not sound as grand as systematic theology or an analytic philosophy, but it can meet real human needs in a direct way. I do not want to romanticize this metaphor. While many women found sustenance (both solitary and communal) in their quiltmaking, many women did not like it and suffered from the requirement that

they do so. Nor do I myself take any literal stitches in fabric to make quilts. There is in this metaphor some irony and ambivalence, and a sharp knowledge that one's form of creativity and comfort must be chosen with a free heart. When our work is chosen, it can be luminous, with meanings beyond the particulars. . . . Like most feminist freethinkers, I choose to stitch together wildly diverse stories. We select ones that carry ideas and feelings that touch a deep nerve of spiritual honesty and power. We swap stories as we meet, sharing the threads of meaning that help us weave our worlds into existence. (Ibid.: 153)

Even had Carr no articulable religious attitudes, Culpepper's image would have a remarkable potency and relevance. That Carr experienced pronounced and motivating religious urges—which surfaced in her habits, her writing, her art and within the circle of her friends— makes her life a particularly appealing vehicle for similarly inclined biographers. She recollected the experiences of Small in religious settings and questioned the role of religion within and outside the institutional Church. Her experiences with native peoples, particularly with Sophie, and her connections with nature are complexly religious in personal terms and in their connections to the dilemmas of her era and our own. Carr's predilection for meaning couched in religious terms influences biographical assessments of her inner life and the contexts of her work, her family and her social life.

Beyond immediate personal concerns Carr's attitudes toward "the depth dimensions of experience" resonate with more general attitudes in Canada at that time. According to Carl Berger the imperialist mind had a "tendency to infuse religious emotion into secular purposes" (1970: 217). Vincent Massey's enthusiasms for British culture were an example: Empire was an agency of providence, a secular instrument for divine purpose. Like art, this cultural zeal sustained categories of religious emotion even as the march of technology impaired its practice. The prevalence of evangelical nationalism, a related enthusiasm aroused through the reform-mindedness of Social Gospel from 1890 to 1930, put God on the side of social change and social justice.

Carr's biographical image is not unusual in its panoptic range: the facility of shaping the limitless features of any time or place and making them cohere is a major characteristic of the genre. To self-conscious readers, inevitably perceiving late-twentieth-century preoccupations in a life that ended before mid-century, the process may seem incomplete, flawed. It is in this gap between the life and its biographical image that we begin to invent ourselves. Or, if that seems too radical an undertaking, we can use biographical forays, as biographers and readers, to test

new and familiar life strategies. Biography becomes a site of explora-
tion, of conversation, with significance beyond the life in question.

THE (IM)POSSIBILITY OF KNOWING MORE

The narration and interpretation of lives comprises a distinctive epis-
temology, a unique way of knowing particular kinds of information
that are otherwise inaccessible.[37] Impressions move around the bio-
graphical subject, the object of our gaze. Understanding grows tangen-
tially: as we amass more fragments of the life, related topics are brought
into play—perhaps geography, relationships, philosophies, history and
politics. The advantages of biography's exploration of themes of con-
temporary concern lies in its elisions and ellipses. There need not be
full explanations, nor must one area of interest make sense with regard
to any others. The core that binds the details, influences and intricacies
of a life is *the life*. Spinning along the trajectory of years, the life draws in
and expels a kaleidoscopic mélange of sensations and data. Françoise
Lionnet's word, *métissage*, and the more common *bricolage* are postmod-
ern terms signalling an awareness of the fortuitous coalescence of char-
acteristics, events, objects, places and attitudes that fabricate a life.

Certain themes in Carr's life become politically charged concerns
only if activated by the interests of her biographers. Questions regarding
her health, for example, particularly her hospitalization in England, can
be linked to current preoccupations with women and medicine.[38] At
the turn of the century the "woman problem" rose up ubiquitously,
with insistent and bewildering frequency (Gilbert and Gubar 1988: 21).
By the 1890s

> the system of patriarchy was under attack not only by women, but also
> by an avant-garde of male artists, sexual radicals, and intellectuals,
> who challenged its class structures and roles, its system of inheritance
> and primogeniture, its compulsory heterosexuality and marriage, its
> cultural authority. (Showalter 1990: 11)

Emily Carr, however, was not an enthusiastic feminist. Occasionally
there are references in Carr's writing that indicate her awareness of
feminist agendas: at Gibb's studio, upon her arrival in France, she noted
his remark that she could be a great *woman* artist (*GP*: 219) and later she
felt she should, perhaps, show support for other women artists (*H&T*:
287). Only recently have feminist art historians deciphered the struc-
tural elements within the art world that prevented women artists from

receiving real and substantial rewards in that world's terms. That all of those conditions were not seen as contingent by Carr does not mean they were not operative. It is precisely because lives of density like hers are available that present insights can be measured against earlier experiences. Weaving her life into the new fabric of feminist spirituality does not violate her experiences but, rather, pulls them like threads into the patterns of our understanding. Biographical images like Carr's manifest, explain and test an array of suppositions, some in multiple versions. There is, however, no final or complete version; attempts to be definitive highlight the limits set by the genre's form. Though much can be inferred, the gaps created by "the impossibility of knowing" are, ultimately, biography's strength. "We continue to talk about others precisely because we cannot finally understand them" (Spacks 1986: 90).

Because the interpreted life remains incomplete, no matter how elaborated its patterning nor how decisively the biographer insists on narrative closure, it promotes the narrative exploration of concepts that can reach well beyond the domain of the subject. Carr's biographical image confronts, for example, ideas of wilderness. The natural world permeates her image, connecting her life to present ecological concerns and the moral precepts they have generated. Psychoanalytic elements, embedded in the visual and verbal vocabularies of modernism and pivotal to the development of biographical form in the twentieth century, reinforce the significance of nature with their own codes. In addition, this combination of factors—nature, ecology, moral precepts, psychoanalytical perceptions and life narrative—merge to support and explain Carr's affinity to aboriginal Canadians, dwellers on the threshold between the Victorian outpost of Empire and the wilderness.

DEEP NATURE: RELIGIOUS AND PSYCHOLOGICAL DIMENSIONS

When, as viewers, we see the forest in Carr's *Indian Church* push forward against the picture plane and simultaneously feel it drawing us into a dark and mysterious natural world, the realm of D'Sonoqua, a fourth dimension, we have entered Emily Carr's world. Though the natural world permeates her work in its various forms, it continued as a mystery to her:

> I am painting a flat landscape, low-lying hills with an expanding sky. What am I after—crush and exaltation? It is not a landscape and not sky but something outside and beyond the enclosed forms. I grasp for a thing and a place one cannot see with these eyes, only very, very faintly with one's higher eyes. (*H&T*: 61)

Displaying a subjective environment, her images provoke a desire to engage her biographical image, to understand her life. Efforts to explore central mysteries that remain inaccessible are displaced in the biographical exercise; thwarted, their energy suffuses less evident concerns. Biographers and readers alike draw peripheral notions toward the subject.

My response to Carr at this level of conceptual exploration, stimulated by interests of my own and the protraction of my encounter with her, led to reflection on her ties to the traditions of British landscape painting, connections seldom queried for their broad cultural and religious implications. Carr's sensitivity to Canadian landscape has often been linked to the nationalistic sentiments of the Group of Seven, particularly Lawren Harris' mystical version. Attention has also been directed to the consequences of her studies of colour and form in France in 1910-11.[39] Recently Maria Tippett, noting that no landscape paintings have survived from Carr's sojourn in England (1991: 89), remarked that Carr "shared the late nineteenth-century British settlers' vision of [Canada] that regarded the forest wilderness with fear and related that fear to God" (ibid.: 88). That is not, however, how the English always regarded their own landscapes. Carr recalled "with affection and gratitude" that each of her teachers in Britain had left her with "something special." "Mr. Whiteley's pet phrase was, 'The coming and going of foliage is more than just flat pattern.' Mr. Talmage had said, 'Remember, there is sunshine too in the shadows,' when my colour was going black" (GP: 181). In the manuscript version of her autobiography Carr was more elaborate, describing the "indescribable depths and the glories of the greenery, the coming and going of crowded foliage that still had breath space between every leaf" (Blanchard 1987: 87).

The relation between landscape painting and religion within the traditions of British art is a subject in Peter Fuller's study of John Ruskin, *Theoria: Art and the Absence of Grace* (1988b). Fuller maintains that the best of British art in the twentieth century denies modernity (ibid.: 184).[40] Without a disruptive and violent political revolution to temper the national soul, Britain lacked the vision of a new order that characterizes much of European art. Instead, profound meaning was conveyed though landscape images:

> In Britain, the aesthetic imagination flowed most intensely into those forms of painting which may, originally, have been intended to minister to a desire for prestige: here landscape painting, and painting based upon imaginative response to natural form, flowered as it did nowhere else. . . . Only in [Britain] did landscape painting come to be the vehicle for that combination of noble sentiments, religious and

empirical truths which Ruskin spent so much of his life endeavouring
to understand. (Ibid.: 185)

"Ruskin's aesthetic ideas were rooted in the religious and scientific
thinking of his day [and] depended upon the idea that nature was in
some sense a garden made by God, for man" (ibid.: 5). In Ruskin's
words "external nature . . . has a body and a soul like man; but her soul
is the Deity" (ibid.: 31). The assault upon theological reasoning by sci-
ence and forays into the natural world by the forces of industry broke
Ruskin's spirit, but not before he had explored his dilemmas in the five
volumes of his *Modern Painters* (1846-60). His views on the creation and
appreciation of art and the meaning inherent in nature were those of an
intellectual fully engaged by the impulses of modernity within the insti-
tutions of his time and place. Carr's views of those forces and changes
were equally engaged but, excluded from full participation in the public
sphere, she has been depicted as resistant to intellectual habits of mind.[41]
Although she did not analyze her position in Ruskin's manner, a strik-
ing aspect common to all accounts of her life is her determination to
forge words for her insights from within the resources available at her
edge of the world.

 When Ruskin's divine garden was threatened, he was able to write
to a friend: "Of all the things that oppress me, this sense of the evil
working of nature itself—my disgust at her barbarity—clumsiness—
darkness—bitter mockery of herself—is the most desolating" (Fuller
1988b: 114). Carr did not articulate a similar sensation. Instead, she wrote:

> What most attracts me in those wild, lawless, deep, solitary places?
> First, nobody goes there. Why? Few have anything to go *for*. The
> loneliness repels them, the density, the unsafe hidden footing, the
> dank smells, the great quiet, the mystery, the general mix-up (tangle,
> growth, what may be hidden there), the insect life. . . . In the abstract
> people may say they love it but they do not prove it by entering it and
> breathing its life. They stay outside and talk about its beauty. This is
> bad for them but it is good for the few who do enter because the hol-
> iness and quiet is unbroken. (*H&T*: 207)

"I like decency. Wild places are totally decent but tame places that are
slovenly and neglected are disgusting beyond words" (*H&T*: 323).
Carr's motives seem subversive measured against Ruskin's articulated
dismay. He annotated the natural occurrence of forms in nature, dis-
tinguished between "mere sensual perception of the outward qualities
and necessary effects of bodies" (aesthesis) and "the response to beauty
of one's whole moral being" (theoria) (Fuller 1988b: 45). He struggled

to align the systems of science and the tenets of his faith with the natural world, a world whose truths he had glimpsed in J. M. W. Turner's luminous landscapes. But outside—and despite—the elaborate and sustaining intellectual constrictions tradition placed on him, Ruskin was at risk. Carr, excluded from the conventions by which she might have calculated risk to herself, could only persevere. Though well enough read, eager to learn and influenced by various wise friends, Carr is generally portrayed as adamant in her rejection of those institutions of art that did not respond to, nor accommodate, her desires. Her determination to penetrate the mystery of the forest is no less strong and, in truth, no simpler than Ruskin's resolve. Hers is, however, a different language, one accessible outside the forum of British intellectual history. Through her passion for the forest and the art of the indigenous people who knew it, and her rejection of the new technological order—most dramatically confirmed by her incapacity to live in large European cities—Carr's ordered meaning yielded a profound awareness of place and an analysis of modernity not unlike Ruskin's.

The mystique of the western sea and mountains drew upon "that combination of noble sentiments, religious and empirical truths" that had confounded Ruskin (1988b: 185). Emily Carr painted and wrote about a distinctive landscape, one that had stimulated European imaginations since the "most memorable scenes of our transactions as could be expressed by a professed and skilled artist" had been supplied to Captain James Cook in the late eighteenth century (Tippett and Cole 1974: 18). The artist Paul Kane had gone west in the mid-nineteenth century and many other painters followed later on Canadian Pacific Railway passes.[42] Lucius O'Brien's letter, published in the Toronto *Mail*, evoked the mood of the mid-1880s:

> We have been unable to tear ourselves away from these lovely mountains of the Selkirk range. . . . The interest of this scenery is inexhaustible, not only from the varied aspects it presents from so many different points of view, but from the wonderful atmospheric affects. At one moment the mountains seem quite close, masses of rich, strong colour; then they will appear far away, of the faintest pearly grey. At one time every line and fork is sharp and distinct; at another the mountains melt and mix themselves up in the clouds so that earth and sky are almost indistinguishable. (Woodcock 1989: 232)

Emily Carr knew the landscapes of British Columbia, a world of idiosyncratic dimensions, *the west beyond the west*.[43] Yet, even as she was born, national parks were already being created to preserve the cherished North

American experience of the natural world from the blight of progress.[44] Those rugged and magnificent landscapes, with a different aesthetic history, one shorter and less elaborated than the European vistas that Ruskin took to heart, nonetheless reflected the pulsations of industry and urban expansion that beat through all the nation-states of the West.

The religious component in sentimental responses to landscape on both sides of the Atlantic, like the psychological interpretation of picture space, was connected to a romantic perception of meaning in the natural world. The emotional power of Carr's canvases draws viewers into unforgettable spaces, spaces within nature that lead further into the dark spaces of imagination. In *Art and Psychoanalysis* Peter Fuller discusses "the affective meaning" of pictorial space (1988a: 139) in terms that link inspiration to profound personal truths and emphasize the wide acceptance of subconscious impulses as vital and viable components of twentieth-century cultural ideas. Having acknowledged "the external otherness" of the outside world, early modernist painters, according to Fuller, "sought to transfigure and transform it, to deny, or otherwise interrupt it, as a means of expressing subjective feelings too" (ibid.: 156). Fuller describes the aesthetic emotion that Clive Bell experienced as "a capacity of painting to revive something of the spatial sensations and accompanying 'good' emotions which the infant feels at his mother's breast" (ibid.: 157). Fuller correlates the spatial representation of the artists' subjects within the painted picture—which had begun to change radically with Cézanne and the rise of modernism—with *object-relations theory* and D. W. Winnicott's concept of *potential space*, Freudian concepts derived from pre-Oedipal relations with the mother.[45] By Fuller's account Carr's mysterious forest would be primeval, a space of safe exploration, dark certainly but meaningfully so, perhaps a " 'transcendence' [that] may often in fact be a penetration downwards into the obscurely recognized terrain of biological potentiality rather than a reaching 'upwards' into the mythical" (ibid.: 186–87).[46] Fuller makes no sweeping claims for his theorizing beyond a connection between affective response to pictorial *space* and our psychobiological being (ibid.: 232). Carr's vocabulary and her emotions give cogency to these ideas:

> There is a robust grandeur, loud-voiced, springing richly from earth untilled, unpampered, bursting forth rude, natural, without apology; an awful force greater in its stillness than the crashing, pounding sea, more akin to our own elements than water, defying man, offering to combat with him, pitting strength for strength, not racing like the sea to engulf, to drown you but inviting you to meet it, waiting for your advance, holding out gently swaying arms of invitation . . .

> There are no words, no paints to express all this, only a beautiful
> dumbness in the soul, life speaking to life. Down under the top
> greenery there is a mysterious space. (*H&T*: 200)

There is a robustness to Carr's voice that is enriched by Fuller's scheme
more fully than it can be by simple correlation to an eruption of mysti-
cism in the decade from 1910 to 1920 that was marked by the correla-
tion of art and religion in Clive Bell's *Art* (1914) and in Rudolf Otto's
Idea of the Holy (1917) (Fuller 1988a: 215-16).

In *Leonardo da Vinci and a Memory of His Childhood* (1910), Freud
had introduced his concept of pathography: "the psychoanalytical
investigation of the relations between an artist's life and works and [the]
interpretations based on these relations" (Spitz 1985: ix).[47] With con-
servative tastes rooted in nineteenth-century conventions of romanti-
cism Freud devised "pathography" intending to imply the suffering, ill-
ness and feeling often associated with the uniquely endowed artist.
Works produced by artists gifted in this manner link internal and exter-
nal worlds: the narrative of the artist's life can be inferred from the
created works and, in turn, that narrative illumines the works. Though
there have been no pathographies, nor even any psychobiographies of
Emily Carr, Paula Blanchard's *The Life of Emily Carr*, constructed upon
a psychological base, demonstrates how natural psychological assump-
tions seem when applied to the life of an artist. Her biography focuses
on "the inner conflicts of a woman painter of Emily Carr's time and
place and tries to answer once more the nagging, familiar question of
why one woman transcended them when others did not" (1987: 9-10).
Blanchard has combed the Carr archive noting inconsistencies and, in
the editing of the journals, an amelioration of Carr's less appealing
traits. It is not, however, for new information—nor even a fresh inter-
pretation—that a Carr devotee would turn to Blanchard's work.
Rather, this version of Carr's life achieves a fine balance between inner
and outer worlds that sustains Carr's image of herself. Narratively ele-
gant, it draws upon psychological concepts without revealing any par-
ticular theoretical bias. Blanchard uses a Freudian template to inspect
Carr's childhood, especially the small girl's relations with her father. To
describe Carr's lifelong attraction to the natural world, she uses a Jung-
ian sense of implicit meaning. Neither the intricacies of the art world
nor of Canadian culture takes Blanchard's attention from Carr's life, its
trajectory and desires. Her focus is not split between the art and the
artist. Concealed within enticing prose, according to the definitions of
their shared culture, Blanchard's Carr is a twentieth-century type, an

avant-garde artist.[48] Problematic issues of self or identity, existential and
teleological questions, are subsumed within this paradigm. Blanchard
uses the conceptual tools available to her to depict an artist who created
a way into the natural world that others can follow, a "potential space"
like the one Peter Fuller describes that draws upon deep experiences of
living in an environment of trust and creativity.

The obverse of Carr's forest is the harsh reality of the city and her
negative reactions to it, which place her irrevocably within the modern
era and in a gendered space. Like the natural world, the city has psycho-
logical aspects. The literature of modernity, according to sociologist
Janet Wolff, "is essentially a literature about transformation in the public
world and its associated consciousness," about "the public world of
work, politics, and city life . . . from which women were excluded"
(1990: 34). She quotes a commentary written in 1983 on Jane Jacobs'
The Death and Life of Great American Cities (1961): "women had some-
thing to tell us about the city and the life we shared, and that we had
impoverished our own lives as well as theirs by not listening to them til
now" (Wolff 1990: 41). The city has typified the rule of the rational
sciences and the rampant codes of patriarchy. In London and again in
Paris Carr's visceral response to the city indicated an assault upon her
health. That cities should seriously threaten her is not surprising.

> A city's geometric, topological, and temporal economies purport to
> operate as grids of certainties within historically specific codes of visi-
> bility or legibility. This order is spatiotemporal: Cities act as devices
> to track, stabilize, control, and predict behaviour over space and time,
> thereby marking, demarcating, and defining what shall constitute
> appropriate behaviour. . . . Indeed, it might be suggested that the vis-
> ual environment is for the fabrication of the world as legible; it is a set
> of templates for constru(ct)ing the social self. (Preziosi 1989: 170-71)

Carr's social self, which we come to know through her vulnerabilities
and her determined strategies, could not submit to that regime. We
understand a principal source of her power to be nature, the feminine/
female, the unconscious. Her ability to arrange the chaos of nature, to
reveal its dimensions and contingent sacrality, is central to the appeal of
her biographical image in its broadest cultural terms.

> The values of the Western world lost their former inviolability with
> the collapse of traditional faith. The most material consequence of the
> loss was a blurring of the distinction between the sacred space of the
> temple and the profane space outside. . . . Some people avoided nihil-
> istic despair and learned to create their own sanctuaries. This was to

be the great creative effort of the overmen, the artists and intellectuals
who affirmed life and learned to love their fate in the face of the void.
If there are no holy temples, any place can become sacred; if there are
no consecrated materials, then ordinary sticks and stones must do, and
the artist alone can make them sacred. (Kern 1983: 179)

Woman, nature, power, space, health, cities: loci of late-twentieth-cen-
tury concern. Without treating these subjects discretely, the composite
image of Emily Carr draws them into her domain where they freely
interact with the matters of her daily life and her existential dilemmas.
The presence of depth, whether through meaning that is religious and
psychological or sustained within the dark forest, answers questions,
profound questions like those faced by John Ruskin, set into motion
along the trajectories devised by Carr's biographers.

DEEP NATURE: DIMENSIONS OF THE PRIMITIVE

The idea of the primitive, a compelling feature of twentieth-century
thought, is entangled with the psychoanalytical power attributed to a
natural world that lies at the periphery of technology and instrumental
reason. Both the primitive and the unconscious involve associations
with original and unspoiled energy. The confluence of these forces is
effectively interpreted by Doris Shadbolt in her third text on the artist,
Emily Carr, published in conjunction with the National Gallery's retro-
spective exhibition. Carr's journey into the heart of the natural world
leaves the city and passes through the lives and spaces of aboriginal
Canadians in an embrace of native peoples and their culture that dated
from her earliest years in Victoria: "the natives' plight as outcasts from
conventional society only made them potentially more appealing to
Carr since she felt herself to be something of a social misfit" (1990: 15).
The strong bond she felt with native peoples propelled her through
their lives and their art to the edge of a natural world intended for her
alone. She went "through the eye of the Indian . . . into the forest, into
nature."

> A witness to the completion of this internal rite of passage is the
> painting GREY in which the locale of "watching presence" is shifted
> to the forest itself. In GREY there is no Indian form, though much of
> the Indian spirit is there: a dim and enfolded world, an iconic con-
> fronting silence, a symbolic eye, a glimpse into the secret inner heart
> of the timeless placeless forest. In no work do we find a stronger or
> more poetic statement of Carr's mystical participation in the dark and
> haunted spirit of the forest to which the Indian had awakened her.

> She was now free to move her art into other areas of nature's expression with a deepened sense of identification. (Ibid.: 143)

Carr's instincts reflect twentieth-century attitudes to *the primitive*, an analysis of the *other* rooted in European philosophy and in anthropological efforts to approach/invent different cultures. A powerful concept in the modern West, the primitive was stimulated by the experiences of colonialism. In British Empire male quest romances like Rider Haggard's *She*, it was represented as a "yearning for escape from a confining society"

> to a mythologized place elsewhere where men can be freed from the constraints of Victorian morality. In the caves, or jungles, or mountains of this other place, the heroes of romance explore their secret selves in an anarchic space which can be safely called the "primitive." (Showalter 1990: 81)[49]

Exemption from the constraints of time and place held great appeal in a rapidly changing society. But fascination with the primitive was more than that. James Clifford has drawn attention to "a disquieting quality of modernism": "its taste for appropriating or redeeming otherness, for constituting non-Western arts in its own image, for discovering universal, ahistorical 'human' capacities (Clifford 1988: 193). In 1914 Clive Bell wrote:

> Most people who care much about art find that of the work that moves them most the greater part is what scholars call "Primitive." . . . In primitive art you will find no accurate representation; you will find only significant form. Yet no other art moves us so profoundly. (Bell 1914: 22)

Without representation that could be understood or interpreted but faced with evident and powerful meaning, modernists recognized a significance in form that drew art and religion together. In preindustrialized cultures art was used to depict the sacred as "the realm of the larger truths surrounding or conditioning our lives or dwelling within; it is the realm of the hidden, and therefore of revelation" (Lipsey 1989: 12). Shadbolt describes native art in similar terms: "the art speaks of a shadowy world of tension, where at times the forces of control and containment are barely able to hold the restless and daemonic spirits that are straining to get out" (1990: 85).

Terry Goldie's analysis of the *image* of the indigene in literature, according to a dialectic of attraction and repulsion, sets out grounds for its powerful force in Carr's life. Trapped between categories—the restorative landscape and the hostile wilderness, the dusky maiden and the fiendish

warrior—the autonomous subjectivity of the indigene has gone unrecog-
nized. No matter how sensitive and compassionate the observer may be,
limits have been set by the symbol systems of white culture: "the necessi-
ties of indigenization can compel the players to participate but they can-
not liberate the pawn" (Goldie 1989: 18). More than that, as an image of
tremendous psychological force, at once foreign and native, the indigene
blocks the attempts of colonizers to establish roots, to be new peoples in a
new world. The gaze of the arts can fix the indigene at varying positions
along such thematic spectrums as art/nature, civilization/chaos, nature/
mysticism, and insinuations of pre-historicity can lock the values of indig-
enous culture within an irretrievable and primordial past. These manoeu-
vres drain power from efforts to alter contemporary political realities
while simultaneously promoting the myth of an earlier theological truth
(ibid.: 150). Goldie's thoughts on nature and mysticism relate directly to
the biographical image of Emily Carr. In rebellion against traditional reli-
gion she participated in a common view of indigenous religion as a "posi-
tive emanation of nature" (ibid.: 132). Goldie wonders if the process is
not inevitable: seeking to belong to this new world, artists, among others,
turn to its original inhabitants "as the spiritual power of the land."
"What better way to acquire that consciousness than through the contact
between white searcher and indigenous sage? . . . The essence of the
Other in the indigene becomes ethereal manifestation, an aura of indige-
nous presence rather than the indigene as material reality" (ibid.: 138).
By setting out the image of the indigene as a term of European colonial
culture and delineating its appeal, Goldie illuminates Carr's own role as a
cultural icon. As a biographical subject, she serves as a proxy for us in our
own later versions of this encounter.[50] Her liminality becomes the bridge
to an ecologically positive future for readers of her life.

 Sensitivity to the presence of negative assumptions embedded in
patriarchal notions of hierarchy prompts close scrutiny of modernist
art.[51] Carr's attitude to natives is not free of the systemic arrogance that
has been uncovered:

> She tried harder than most to rid herself of prejudice, but her conserva-
> tive background and sense of caste, belonging as she did to a pioneer
> family of money and privilege, prevented her. Still breathing the air of
> colonization, she could not, with the best will in the world, have
> regarded the Indians as her equals. (Hembroff-Schleicher 1978: 94-95)

> For her the Indians were just simple, guileless people, good companions
> and guides on her sketching trips, and most important, good carvers. As
> a story-teller rather than a precise recorder of facts, she found them ideal

subjects, and she was innocent of any conscious condescension when she made them the butt of her sometimes trenchant humour. (Ibid.: 98)

For Edythe Hembroff-Schleicher Carr was swayed by a "deep-seated romanticism" (ibid.: 95). "It is fair to say that the image of the Indian Emily bequeathed to us is sentimental, somewhat demeaning, and unreal; and that the book *Klee Wyck*, although autobiographical, is a blend of fable and fact" (ibid.: 105). Hembroff-Schleicher's remarks were part of her compendium of the facets of Carr's life, *Emily Carr: The Untold Story*, which was intended to set the biographical record straight. Doris Shadbolt's intentions in *Emily Carr* are different. For her the strength of Carr's bond with the Indians conceals its flaws:

> Her contempt for anything she could interpret as pretension led her to gravitate towards people in simple walks of life whose hold on basic human values was uncomplicated by excessive cerebration or social airs. Because natives lived outside the class of society whose narrow values she had rejected early in life and in relation to which she considered herself something of an "outsider," she felt a certain bond with them. (Shadbolt 1990: 87)

Shadbolt's purpose is not to set the record straight. Writing twelve years later than Hembroff-Schleicher, eleven after her own previous study of Carr, there is little to add. Rather, this biography is an interpretation of the artist's life contextualized within the larger social forces of her time. Shadbolt's portrait bears few traces of an intimate encounter between biographer and subject. Instead she circles her subject, stalking her, drawing boundaries around the life in a series of overlapped sightings. No one ever got close to this Emily Carr:

> She could talk to others about the externals of art—the mechanics, the system, even the gossip—but about its deepest meanings and problems she talked only to herself. There were caring friends near her in Victoria but never a group of artist peers with whom to exchange ideas. She complained about that particular aloneness from time to time, but the truth is that she needed their absence more than their presence; her art was too deeply lodged within herself for discussion. That is the real essence of Carr's isolation. (Ibid.: 24)

This artist is too serious, too profound, to be scaled down by failings common to her generation. Likewise, the vitality of her encounter with the indigene deflects intolerance.

> Indeed the spirit that characterizes Carr's mature nature paintings—
> the sense of a unifying universal life force which animates the forests,
> woodlands, beaches and skies—to some degree at least developed out
> of her prolonged immersion in the native art and culture of her part
> of the world. (Ibid.: 83-84)

This recent portrait of Carr sets aside the conventional patterns
and trajectories of biography—the childhood encounters of Small, the
details of life as a student in London or Paris, the raising of animals and
camping in the woods—for meditations on the points of intersection
between Emily Carr and our concerns. We want to know particular
things about this storied woman; we need to understand her saintliness,
her wisdom. And so Shadbolt emorcellates her subject. The contexts of
Carr's life, her development as an artist, her beliefs, "the Indian pres-
ence," and transcendence in nature are the subjects of penetrating and
concentric explorations, rhythmed queries that set boundaries for this
particular life, for now. Yet in the end, perhaps because we already
know *the facts*, Carr emerges from this portrait as a vigorous woman and
an artist in thrall to the profundities of her era. The forces of the uncon-
scious, the indigene and the natural world, all powerful realities in the
present, merge in Shadbolt's depiction. Archival pressures retreat. This
Carr inhabits something akin to D. W. Winnicott's potential space:

> Any inclination to subjective interpretation disappeared once [Carr]
> perceived nature in its broadest terms as simply the continuing process
> of creation, an oceanic world of continuous ebb and change, with
> nature's particular manifestations and herself as part of them swept up
> into its larger life. The cycle-of-life theme then is translated into the
> enormous pervasive sexual energy of her painting as openings and
> enclosures vibrate with light and movement, trunks thrust upward
> into the sky, earth fecundates, and death and decay are assimilated
> into the irresistible regenerative cycle. (Ibid.: 205)

Like biographers before her, as her book closes Shadbolt invokes
cultural figures "not necessarily connected by nationality or time" to
Carr, mystical artists whose images stretch the implications of Carr's
life: Lawren Harris, Mark Tobey, Samuel Palmer, Arthur Dove "and
even" William Blake (ibid.: 218). Perhaps the list can be stretched even
further to include Hildegard of Bingen, Georgia O'Keeffe, Frida Kahlo
and other mystic artists, women whose profound visions have ignited
spirits and powered shifting paradigmatic axes, particularly since 1970.

A vibrant biographical image participates in change and draws cul-
tural themes toward its subject's life as they rise to the surface of public

concern. The charged controversy surrounding Emily Carr's life and work in the winter of 1994 characterized a new phase in the development of her image. In his essay in *Canadian Art* Robert Fulford assessed cultural appropriation as a contemporary societal energy brushing across the shared image of this particular woman. His is a reflective voice displaying the perspective of central Canada, searching for a feasible balanced view. Contrary voices from British Columbia, the geographical space of her vision, tempered by the tenets of postcolonial criticism, link Carr's relations with native culture to British imperialism and read her responses as a product of her social and political position of privilege. This rhetoric of contemporary critical theory pries apart assumptions, exposes the apparently fragile supports of custom and heralds a realignment of practical energies and symbolic meaning. At stake are foundational definitions. Scott Watson describes Carr's landscapes as "haunted . . . with the ruins of other civilizations" and claims that "the middle class cult of Emily Carr," fuelled by biographers who avoid her sexuality, blurs the implications of her projected "poetic vitalism" (1991: 109-10).[52] He does, however, clearly understand the terms of contestation. When prodded by Fulford's article, Watson wrote to the editor: "out here on the Edge of the Continent, Emily is kind of like our grandmother, a figure who nurtures our rebelliousness." In contrast to Fulford's attempts to protect Carr's image, he claims that her mythic status as a bridge between cultures invites an investigation of identity and historical circumstances. Watson flags substantive issues that Carr's life raises as open to question, confident that the forum she offers is safe: she "is not on trial, nor are her achievements in doubt" (1994: 5).[53]

The disjuncture of these philosophical and ideological positions marks a contemporary zone of important and intense investigation. Even as postcolonial sensibilities query the legitimacy of Carr's cultural elevation, Gerta Moray's doctoral thesis, "Northwest Coast Culture and the Early Indian Paintings of Emily Carr, 1899-1913" (1993), has introduced a counteracting level of historical analysis. The essential incompleteness of any biographical image is emphasized by Moray's introduction of new material. To correct and expand the record of Carr's life, she has drawn dense contextual issues into the forum. Matters that had been peripheral have suddenly come closer to the shifting centre of our views of Carr: race relations in British Columbia, missionary activity and ethnographic perspectives are among her themes. Not only does Moray navigate the dense archival record, political issues, living memories and the terrain itself, she challenges Carr's traditional niche in the narrative of Canadian art history and the mythic dimensions of Carr's biographical image.

As well as political and aesthetic challenges, this particular debate highlights spatial re-ordering, a rearrangement of knowledge that opens traditions to new categories of influence. Zones of power have shifted and British Columbia, no longer on the periphery of Empire, is a cultural centre on its own terms, one where many traditions meet; its alignments have shifted toward global powers at work around the Pacific Rim. Fulford's sentiments address these matters. His is not a voice at work on the biographical image as such but, rather, one cognisant of the larger questions catalyzed by cultural energies drawn to Carr's life. Stepping back from the fray, the issues become philosophical or sociological, historical or legal, and work like Dean MacCannell's *Empty Meeting Grounds: The Tourist Papers*, a perceptive study of the implications of contemporary attitudes to identity, community, tourism and migration, identify what is at stake.

> No matter how hard we try to forget, modern civilization was built on the graves of our savage ancestors, and repression of the pleasure they took from one another, from the animals and the earth. I suspect our collective guilt and denial of responsibility for the destruction of savagery and pleasure can be found infused in every distinctively modern cultural form. (1992: 25)

If these new energies are about to induce changes in the biographical image of Emily Carr, the implicit religious dimensions of Carr's work continue to stimulate more familiar cultural undertakings. The organization of her life "around the depth dimensions of experience" (King 1987: 286) complements an increasingly common spirituality allied to ecological perspectives, one that parallels the romantic sentiments of Western art. Judy Chicago's addition of self-portraits of Carr and Frida Kahlo as exemplary female artists in a recent edition of her influential autobiography, *Through the Flower: My Struggle as a Woman Artist* (1993), indicates a movement of Carr's image beyond Canadian borders. Since no explanatory text is added, Chicago is relying solely on familiar interpretations of Carr's life. Any shifts in Carr's position attributable to institutional crises would increase her value in terms of Chicago's own struggles within the world of art.

In so far as biography provides a cultural forum, the existence of debate and fresh insight are crucial. Questions close to the margins of our understanding recharge the image. Where logic fails and there are no precedents, affect empowers; biographical images, with their elusive authority, play a critical role in the elasticity of our responses. As long as Carr is relevant to questions of culture, her biographical image will offer a guide to terrain at the edges of our knowing.

After Life

[The] quest for the singular, the contingent event which by def-
inition refuses all conceptualization, can clearly be related to the
project of constructing a form of knowledge that respects the
other without absorbing it into the same.

— Robert Young (1990: 10)

I think Walt Whitman was right that after a certain stage your
own inside *honesty* is the only critic you can trust.

— Emily Carr to Nan Cheney, 22 December 1940
(*DW*: 281)

B iography engages, entices. The biographical sphere, a discursive
space of fragmentary and multiple meanings, sustains process and
resists closure. Within it the subject and the reader are companions
attempting to wrest meaning from life. Through the biographical image
of Carr's life, observers can reflect upon contemporary critical themes:
the fragmentation of the individual subject, the exhaustion of liberal
ideology and the significance of theory generated by marginalized
groups and individuals, the limits of feminism, the politics of genius.
Richly configured, Carr's life is an exceptional subject/object for the
task at hand: analysis of biography as a genre able to convey knowledge
through its privileged relation to tacit assumptions.

My own encounter with Carr is representative.[1] Though I knew
her name and could place her art with the Group of Seven's landscapes
as a child, my first significant recollection is the exhibition of her work
at the Royal Ontario Museum in Toronto in the winter of 1972. I
remember being profoundly moved, and when Maria Tippett's account
appeared in 1979, I eagerly read it. Carr then moved to the back of my

The notes to this After Life are on p. 186.

mind, an exemplar of sorts. The image of her hiatus proffered support through the sloughs of my own existence but she did not become an exceptional symbol, perhaps because Canadian culture languished under standards of imperial appraisal, British and American.

Following work on Virginia Woolf and biography, almost two decades later, I turned to Carr again. In order to apply what I had learned about women, words and life stories, I sought a Canadian woman with a substantial biographical profile, a visual artist who could be called a modernist, like Woolf, but one whose story would not be centred on a reciprocal fascination by the subject and her biographer with the craft of writing. There was only Emily Carr: a powerful figure for pilgrims who have made their way to Victoria or the wilderness of British Columbia and for others who know her through her work or as she exists as a biographical image, an icon.

Though filtered through a lens of academic detachment, I know my encounter with Carr to be pivotal, for such is the nature of pro-longed sojourns in the biographical arena. Already the religious stimuli of my childhood, considerable but at the margins of custom, become clearer as I contemplate Carr's intense rejection of conventional prac-tice. The image of her life attracts and shapes catalytic tales of fractious religiosity from my parents' youth in the 1920s. Like Carr, they lived within modernism when patriarchy was in a technologically expansive phase; like her, their desire for meaning found substance in the arts.

The biographical encounter, shaped by tradition and convention, nourishes reflection at contingent points where stories meet. *I encounter Emily Carr at the stage in my life that belonged to the moratorium in hers; the range of exemplary lives to choose from has been small. The increased number over the last two decades is, lamentably, another kind of challenge. I did not know that "women need and desire other women to compensate for what they lack themselves. Women need and desire images of other women for the same reasons"* (Pearce 1991: 21). *I had not heard Audre Lorde describe eros as "the nurturer . . . of all our deepest knowledge"* (1989: 210), *nor Beverly Wildung Harrison call a feminist ethic "deeply and profoundly worldly, a spirituality of sensuality"* (1989: 214). *Nor did it occur to me that self-display, a necessary ability for an artist, might build confidence rather than signal vanity* (Wyatt 1990: 57). *I did not know how much women need other women—in fact and in image—to locate and articulate significant feeling. Carr struggled to break free. She went to the woods, into the woods, compelled by some indiscernible but crucial "reason." Her resistance, as clear as the shape of her body, strange in its apparel, delivers a warning: spirituality and carnality are not at odds.*

Though her striving toward the light, the God in all things, shimmers in her last paintings, her medium remains grounded, practical, domestic, eternal. She inhabits the earth as a mistress of images, of animals, of technique. Her travels, perhaps not as exotic as she claimed, were unyieldingly physical. If Virginia Woolf slipped the bonds of custom in epiphanic manoeuvres, strategies of phrasing that left grammarians awestruck, Emily Carr—only slightly her senior— stood firm and used such tools as came to hand. One woman lay closeted in dark madness, thin and pale, in pain; the other, denied comfort, managed her strength, forced meagre resources to carry her vision. What does it mean, does it matter, that their embodied selves leave as strong an impression—perhaps more intensely valued—than their work?

Without postmodern insights to decode her predicament, excluded from full participation in the institutions of her era, Carr had prescient skills for living on the margins of social, economic, political and religious systems. Even when her art gained favour with national audiences, she continued to be perceived as an eccentric and indomitable woman, only domesticable by her own standards. That was how she "told" herself, and even Maria Tippett, though hers is the loudest declamation of Carr's hyperbole, cannot bind this particular life with narrative inevitability. It remains marginal and sensitive to dualisms that easily discount female experience: mind/body, spirituality/carnality, truth/appearance, life/death.

Biography deals in particulars; it is suspicious of universals and absolutes. Emily Carr is not an inspirational model because she was a great artist, a genius. Her greatness—inextricably woven into the fibres of her being, the moments of her living, the images of her art—lies in the ways she fashioned her life. A precious value of her life's story, like most biographies, is its insouciant denial of generalities. "Women's experience is concrete and particular; presuppositions of commonality, while allowing for common action, often deflect our analysis from the exploration of the myriad and complex factors that shape women's lives" (Daveney 1987: 48). Though women's spirituality is an issue of urgency as this century draws to a close, it will not always have priority.[2] Different concerns demand attention that other lives can better address through the genre's unique illusion of intimacy. Compellingly focused on the nature of genius and the demands of physical disability, Stephen Hawkings' life, like Carr's, deals with limits to instrumental reason but does so through a different series of spiritual and religious questions embedded in cosmological design. Functioning epistemologically, biography authenticates matters of ultimate concern within the

specifics of lives as they are lived. The persuasive methods of analysis and discovery belong to the genre, not to its subjects, nor to its practitioners. Like Plutarch's classical heroes and Vasari's Renaissance artists, or Saint Thérèse of Lisieux, Emily Carr and Stephen Hawkings are exceptional biographical subjects, but their determination and courage are shaped to suit our era. We marvel at their gifts, their vision and, through the conventions of a genre that displays the minutiae of their lives, we gaze upon them in wonder, fascinated by the intimacy of patterned meaning.

EMILY CARR WITH HER MONKEY AND DOGS, by Arthur Lismer
(National Gallery of Canada, Ottawa, used with permission)
Gift of the artist, Montreal, 1960

A Brief Chronology of Emily Carr's Life and Writing

1871	Born 13 December in Victoria, British Columbia.
1886	Death of her mother, Emily Saunders Carr.
1888	Death of her father, Richard Carr.
1890-93	Studied at the California School of Design, San Francisco.
1899	Visit to the Nootka Indian mission at Ucluelet on the west coast of Vancouver Island.
1899-1904	Studied in England [London, Cornwall, Berkshire and Hertfordshire]
1903-1904	In East Anglia Sanatorium, Suffolk, from January 1903 to March 1904.
1906-10	After a short time in Victoria, moved to Vancouver where she taught and had a studio.
1907	Summer trip to Alaska with her sister Alice.
1908-1909	Travels to Alert Bay and Campbell River, Lillooet, Hope and Yale.
1910-11	Studied in Paris and in the French countryside.
1911-13	Returned to live in Vancouver.
1912	Major sketching trip to Indian villages in the Queen Charlotte Islands, the Upper Skeena River and Alert Bay.
1913-27	Returned to Victoria and established the House of All Sorts which preoccupied her throughout this period.
1927	Participated in the National Gallery of Canada's *Canadian West Coast Art: Native and Modern*. Met Lawren Harris and other members of the Group of Seven.
1928	Major sketching trip to Indian villages in Alert Bay and Fort Rupert regions, the Queen Charlotte Islands, and the Skeena and Nass Rivers.
1929	"Modern and Indian Art of the West Coast" published in *Supplement to the McGill News*.
1930-36	Wider recognition of her work, two trips east, sketching trips in her caravan "The Elephant." Began to write regularly.
1937	Suffered her first heart attack; solo exhibition at the Art Gallery of Toronto.

1939–45	Her health continued to deteriorate and she turned to writing.
1940	Broadcast of her stories on the CBC.
1941	Publication of *Klee Wyck* which won a Governor General's Award.
1942	Last sketching trip; serious heart attack. Publication of *The Book of Small*.
1943	Solo exhibitions in Montreal, Toronto, Vancouver and Seattle.
1944	Publication of *The House of All Sorts*.
1945	Fatal heart attack 2 March.
1946	Publication of *Growing Pains*.
1953	Publication of *Pause* and *The Heart of a Peacock*.
1966	Publication of *Hundreds and Thousands*.

Chronologies of Carr's life can be found in Ruth Gowers, *Emily Carr* (1987); Edythe Hembroff-Schleicher, *Emily Carr: The Untold Story* (1978); Doris Shadbolt, *Emily Carr* (1990); and Doreen Walker, *Dear Nan: Letters of Emily Carr, Nan Cheney and Humphrey Toms* (1990).

THREE RESPONSES TO CARR'S BIOGRAPHICAL IMAGE

NANCY-LOU PATTERSON

Originally published in *The Canadian Forum* (July 1961), this poem was written by Nancy-Lou Patterson as her response to a visit to the Vancouver Art Gallery in 1960 where she had seen a roomful of Carr's work.

Emily Carr's Forest

A heavy lady in an odd black coif
 Made these: she poses squat and lined
Among the trees; her chipping photograph,
 Which shows her, brush in hand,

Lies under glass. Up stairwells, over walls
 Of civil rooms in matching frames,
Her green ignited world burns. Each one holds
 A freshly-kindled votive flame.

A room alight with these live boughs must seize
 Fire too, must flicker, move, be seen
To writhe around the corners of the eyes
 Though unconsumed. Rectangles drawn

From living growth, these forest squares are rife
 With lambent surfaces, awry
In early winds, or springing taut and stiff
 With stinging pitch, young needled, spry

With breezes, spurred, alive. All these are masks,
 From whose void eyes the darker boles
Peer out—the riot presences that frisk
 In hollows, house themselves in holes,

Hide, interstitial spirits, swift in spare
 Concavities, home in shifting
Grottoes of contained arboreal air:
 Space conformed to cups of closing

Growth. Each emptiness is filled with being;
 Each painted canvas harvests an
Oncaymeon by sickle strokes, seeing
 Into sheaves all green creation.

PAM O'ROURKE

For Emily Carr and Hagar

If they really saw
 John the Baptist
 the locusts hanging from his mouth . . .

Emily and Hagar
 I drew strength
for you were strong to
 have lived with
 indifference
to survive dislike
 contempt but mostly indifference

you were strong to have survived
 the pointed fingers
 sins of others

I draw hope for
 you were haughty
 proud and sharp tongued
 and sinful
and lived to say
 the forgiving
 motherword

"There there"
to yourself
and to heaven

Eileen Whitfield

In the week of 9 June 1992 I read the following in *The Globe and Mail*'s "Noises Off" column:

> In the early 1980s, those who called *Saturday Night* magazine might well have reached a somewhat distracted receptionist named Eileen Whitfield. The reason she was distracted was that, in her spare time, she was working on a play about the life of Emily Carr and her sister, Alice. "I figured that the time between phone calls was spare time," Whitfield says.
>
> Actually, Whitfield was an actor at the time, doing temp work at *Saturday Night* to make a living. She eventually went on staff at the magazine, becoming among other things Robert Fulford's assistant, and worked as a freelance writer for *SN* as well. But the playwriting went on, between the calls and elsewhere, and *Alice and Emily* is now scheduled to be produced this fall by Robin Phillips at Edmonton's Citadel Theatre.

In response to my inquiries, Eileen Whitfield wrote the following:

> I've been crazy about Emily Carr for years, and first thought of this play as one of those one-person "monodramas." But somehow Alice kept making her way onstage. I think that, in the end, I began to use Emily's recitation of her life, with Alice's editorial comments, as a way to dramatize the problems of family—in this case, two sisters who have lost each other, and are reaching out, trying to reconstruct what they believe they shared as children. But the fact that they can't agree on what the past actually was makes this difficult. So do their physical obstacles—Emily's deafness, Alice's blindness—and other, more mysterious, handicaps. Incidentally, I have never been able to answer, even to my own satisfaction, why Emily, so notoriously private and even misanthropic, should be pouring out her heart to a bunch of strangers [the audience]—be that as it may!
>
> Some of Carr's dialogue is fashioned from her own words, though stitched together in new contexts. I read every book by and about Carr I could find, and then read her unpublished letters and manuscripts in the National Archives. Meanwhile I kept notebooks on every interesting turn of phrase, metaphor, wisecrack, etc. I did this because I couldn't hope to mimic her verbal colour on my own.

(1982). Also note the conversation between George Steiner who, *In Blue-beard's Castle: Some Notes Towards the Redefinition of Culture* (1971), pointed out the inadequacies of T. S. Eliot's understanding of modernism in *Notes Towards the Definition of Culture* (1948). Steiner continues to look for the relation between religion and culture in *Real Presences* (1989). Suzi Gablik's *Has Modernism Failed?* (1984) retains a surprisingly conservative sense of the values embedded in modernism. Astradur Eysteinsson, in *The Concept of Modernism* (1990), defines modernism as a fundamentally oppositional mode, as does Rita Felski in *Beyond Feminist Aesthetics* (1989). For related material on the avant-garde, see Renato Poggioli, *The Theory of the Avant-Garde* (1968), and Frederick R. Karl, *Modern and Modernism: The Sovereignty of the Artist 1885-1925* (1988).

5 "Fresh Seeing" is the title of a public lecture Carr gave to the Victoria Women's Canadian Club in 1930 and of the book in which it was published.

6 For material on the social realities of women artists, see especially Janet Wolff, *Feminine Sentences: Essays on Women and Culture* (1990); Rozsika Parker and Griselda Pollock, *Old Mistresses: Women, Art and Ideology* (1981); Griselda Pollock, *Vision & Difference: Femininity, Feminism and Histories of Art* (1988); Jan Marsh, *The Legend of Elizabeth Siddal* (1989); and Anne Higonnet, *Berthe Morisot* (1990).

7 "I am sixty-three tomorrow and have not yet known real success" (*H&T*: 209). "I have had lots of recognition . . . and I have not properly appreciated it. . . . Praise embarrassed me so that I wanted to hide. You've got to meet success half-way" (ibid.: 224).

8 For examples, see Shadbolt (1990: 91), Tippett (1979: 76, 107) and Gowers (1987: 53). Blanchard's description of Carr's 1912 trip as "a considerable undertaking for a lone woman" acknowledges the hyperbole and the heroics. "Pioneer women and missionary wives had penetrated the far north for decades, but always as helpmates and followers, not on their own. Emily was never totally alone on this trip in the sense of being out of touch with humanity (though afterward she implied she was). But her guides and hosts were all transitory and casual, and she had to make her way from one to another as best she could" (Blanchard 1987: 128). For a consideration of Carr's adherence to the genre's conventions, see Timothy Dow Adams, " 'Painting Above Paint': Telling Li(v)es in Emily Carr's Literary Self-Portraits" (1992).

9 Writing recently of "feminist struggle and cultural production" in Canada, Joan Borsa called ours "a marginalized and colonial relationship to the larger field of theory, art and representation" except for "a handful of Margaret Atwoods, Margaret Laurences, Mary O'Briens and Emily Carrs" (Borsa 1990: 36). That Carr should be excluded on these particular terms erases her self-reading and questions, if not the impact of her autobiographical image, at least its stability.

10 Three collections of stories appeared before her death in 1945. The story of her travels among the native peoples of British Columbia, *Klee Wyck,* won a Governor General's Award in 1941. In *The Book of Small* she created her

Notes

Introduction: Preliminary Thoughts on Biography and Meaning

1 I have used the term "life writing" to refer to works in which the principal project is the display of an individual's existence. Here the particular individual is Emily Carr. Autobiography is then the writing she herself did that displays her life; biography, writing about her by others. For recent discussions about terms that characterize autobiography, see Helen M. Buss, *Mapping Our Selves* (1993: 4-21) and Marlene Kadar's introduction to her edited volume, *Essays on Life Writing: From Genre to Critical Practice* (1992). I would like to see an imaginative extension of boundaries across media so that film, and perhaps other arts, would be readily considered for their contribution to a "biographical image."

Chapter 1—"The Edge of Nowhere": Emily Carr and the Limits of Autobiography

1 For a brief chronology of Emily Carr's life, see Appendix A.

2 Mildred Valley Thornton, "Display of Abstract Art by Lawren Harris at Gallery," *Vancouver Sun*, 1 May 1941. Quoted in Reid, *Atma Buddhi Manas* (1985: 36).

3 Modernism, though rooted in changes in the West during the nineteenth century, is characterized by twentieth-century technological innovation. Postmodernism, often linked with the events and attitudes of 1968—the student riots in Paris, Soviet tanks in Czechoslovakia, Pierre Trudeau's leadership in Canada—registers the continuing crisis of thought and action engendered by the forces of modernism. The two terms are particularly useful as periodizing concepts (Jameson 1983: 113). Dianne Wood Middlebrook, noting that "postmodern" refers to Western culture in Europe and North America after the Second World War, points out that "in usage it has become a handy label for whatever disturbs our expectations by disrupting and recombining traditional elements, achieving effects of discontinuity" (Middlebrook 1990: 155).

4 See Timothy J. Reiss' notion of material suppressed, or occulted, in the development of the rhetoric of modernism in *The Discourse of Modernism*

157

childhood; in *The House of All Sorts* she described her life as the landlady of a small apartment house and her trials as a dog-breeder. Two more volumes appeared in 1953: *The Heart of a Peacock*, a varied collection, and *Pause*, stories of the months she spent in a sanatorium in England in her early thirties. Her formal autobiography, *Growing Pains*, one of two versions she wrote, was published the year after her death. Though she thought autobiography "the only biography that can truthfully be done" (Walker 1994: 307), she also thought "it very bad taste to publish an autobiography til you're dead" (ibid.: 403). Excerpts from her journals of 1927 and 1930-41 were published in 1966 as *Hundreds and Thousands*. The most recent addition to Carr's autobiographical record is a meticulously edited volume of correspondence between Carr, Nan Cheney and Humphrey Toms: Doreen Walker's *Dear Nan*, which appeared in the spring of 1991.

11 Domna Stanton quotes Philippe Lejeune's definition of autobiography: "a retrospective narrative in prose that a real person makes of his own existence when he emphasizes his individual life, especially the story of his personality." She notes that "this identity between a real person, the narrator, and the object of narration was the basis for [Lejeune's] autobiographical pact between author and reader" (Stanton 1987: 10). Bell and Yalom claim that various poststructuralist theories question the mimetic basis of this definition but they support it nonetheless. The "much maligned referentiality gives autobiographical and biographical writing its particular tension and flavor." The genres "presuppose the factual data of a lived existence, if only to provide the nest from which the author's imagination and interpretation may then take flight" (Bell and Yalom 1990: 2).

12 Nicole Ward Jouve, considering criticism as autobiography, points out that "any writing constructs and betrays a subject. It is not a question of choice." But, she goes on, "one might as well make something of the process" (Jouve 1991: 10).

13 Diane Wood Middlebrook defines a "postmodern anxiety about authorship [as] awareness that both author and subject in a biography are hostages to the universes of discourse that inhabit them." She points to "gender relations [as] embedded at the very root of the subject-object split that postmodernism has foregrounded as its special territory. . . . The question of gender, once opened, cannot be closed; it can only be pursued" (Middlebrook 1990: 164-65).

14 For the significance of the search for new languages, see Karl: "the languages the artist needed to acquire were, in a broad sense, metaphysical, since they went beyond any spoken or written language of sight, sound and understanding, existing outside or beyond the syntax of his own tongue" (Karl 1988:99). The importance of this as a religious act flows easily from Winston King's definition of religion as "the organization of life around the depth dimensions of experience" (King 1987:286).

15 See my note 6, especially Janet Wolff, and Griselda Pollock's third chapter, "Modernity and the Spaces of Femininity." Also see chap. 4 here.

16 My reference is to Margery Kempe who, in describing her life and relation to God, named herself "this creature." *The Book of Margery Kempe* has been cited as the first autobiography in English (Jelinek 1986: 15).

17 "Biographers write biography; they rarely spend much time thinking about how they ought to be writing it—at least not in [England]" (Skidelsky 1988: 14).

18 Jelinek notes that few of these women represented the fine arts. In the 1940s and 1950s autobiography by white women subsided, but there was a surge of black women's writing (Jelinek 1986: 148). Some interesting points have been made relating Canadian women's experience to their writing. James Doyle found that the image of the New Woman in the 1890s was not as available to Canadian women writers as to their American counterparts (Doyle 1990: 32). Helen Buss found "an imaginative identification of self-development with the experience of the land" in autobiographies by Canadian women (1990b: 131); many women reacted "to the strangeness of the Canadian landscape by merging their own identity, in some imaginative way, with the new land" (ibid.: 126). Susan Jackel draws attention to an imaginative use of domestication, noting that "feminist consciousness in Canada grew up side by side with national consciousness," coincidental with Anglo-American feminist agitation, and emerged "as the social-reformist or maternal feminism that historians see as the norm in this country" (Jackel 1987: 99).

19 These qualities are, in a sense, those of modernism and can also be found in the work of males. However, the general consensus follows Jelinek: "in contrast to the self-confident, one-dimensional self-image that men usually project, women often depict a multidimensional, fragmented self-image colored by a sense of inadequacy and alienation, of being outsiders or 'other.' . . . Paradoxically, they project self-confidence and a positive sense of accomplishment in having overcome many obstacles to their success. . . . [The style] is integral with such a paradoxical self-image: episodic and anecdotal, nonchronological and disjunctive" (Jelinek 1986: xiii).

20 "What becomes clear [in modernism] is the formal and conventional impossibility of a feminist heroine, of an ideologically subversive plot, or of a female body perceived without all the connotations and meanings of a patriarchal system of representation and of viewing" (Wolff 1990: 69). For the exclusion of women's writing from studies on autobiography, see Stanton (1987: 4) and Jackel (1987: 105). A definition of gender used by Bell and Yalom in their work on autobiography and biography is of value here: "that deep imprinting of cultural beliefs, values, and expectations on one's biological sex, forming a fundamental component in a person's sense of identity. When viewed collectively, it is a system of difference between men and women, and a system of relations between the two groups, with males almost universally in a position of dominance" (Bell and Yalom 1990: 5).

21 As the work of women artists is being brought forward, definitions of modernism must change. Lauter makes clear some aspects of women artists'

work; Wolff and Parker and Pollock specify the differences that work makes to the modernist canon.

22 For useful criticism on letters specifically, see Nancy Walker, "Wider than the Sky: Public Presence and Private Self in Dickinson, James and Woolf" (1988), and chap. 4, "Borderlands," in Patricia Spacks' *Gossip* (1986).

23 The term "genteel Tory recreation" is used by Susan Jackel in reference to the activities of the British "marginal middle classes" who settled in Canada (1987: 98).

24 Diane Wood Middlebrook notes the influence of the burgeoning archives late in the twentieth century, especially the effect of the Humanities Research Centre in Austin, Texas (1990: 158).

25 Included in this edition are *Klee Wyck*; *The Book of Small*; *The House of All Sorts*; *Growing Pains*; *The Heart of a Peacock*; *Pause: A Sketch Book*; and *Hundreds and Thousands: The Journals of An Artist*.

26 For stimulating discussions of the effects and intricacies of "the primitive" in twentieth-century Western culture, see Marianna Torgovnik, *Gone Primitive* (1990), and James Clifford, *The Predicament of Culture* (1988), especially his chapter "Histories of the Tribal and the Modern."

27 In Jean Barman's *The West Beyond the West* (1991), a history of British Columbia, Carr is frequently noted and quoted as representative of that province's particular culture.

28 For the significance of male gaze and the spaces of modernity as masculine, see Griselda Pollock, *Vision & Difference* (1988), especially pp. 66-67.

29 Showalter's history, *The Female Malady* (1985), makes the relationship of illness and limitation clear. Alice James, Emily Dickinson and Virginia Woolf are among those who " 'suffered' nervous disorders that seemed linked to the struggle for control over their lives" (N. Walker 1994: 278). Nicole Ward Jouve, looking at Peter Lomas' work, says: "the bodily symptoms . . . convey 'information about a problem, the desire to solve it, and the fear of facing it': but not 'knowledge' (which would include some volition and awareness). . . . Art is precisely the domain in which symptoms can be translated into symbols" (1991: 95-96).

CHAPTER 2—THE ENIGMA OF BIOGRAPHY

1 My intention in quoting Hayden White is to draw attention to the concern with systems of meaning. Michel Foucault's *Order of Things* (1966) is relevant here, as is Clifford Geertz's remark that our species is meaning-seeking, that without "organized systems of significant symbols" human behaviour "would be virtually ungovernable, a mere chaos of pointless acts and exploding emotions, [our] experience virtually shapeless" (Geertz 1973: 46).

2 For a discussion of the use of biographical conventions, including childhood, see my "Lives of the Avant-garde Artist: Emily Carr and William Kurelek" (1995).

3 Though the biographical urge persists, there are marked cycles of production. Two interesting works that address the historical conditions and development of biography are Ira Bruce Nadel, *Biography: Fact, Fiction and Form* (1984) and Reed Whittemore, *Pure Lives: The Early Biographers* (1988). A psychological account of the construal of the self in different countries is offered in Hazel Rose Markus and Shinobu Kitayama's "Culture and the Self: Implications for Cognition, Emotion, and Motivation" (*Psychological Review* 98, 2 [1991]: 224-53).

4 The notion of a "virtual" biographical subject comes to mind. Slightly frivolous, it draws upon the concept of computer-generated "virtual reality," which exists in no actual form, and suggests the development of new capacities of imagination congruent with current technologies.

5 Historical accounts of biography in English are largely based on the British experience until after the Second World War. For accounts of biography in Canada, see Clara Thomas, "Biography in Canada," in *Literary History of Canada*, edited by Carl F. Klinck, 2d ed. (1976), and Shirley Neuman, "Life-Writing," in *Literary History of Canada: Canadian Literature in English*, edited by W. H. New (1990).

6 A similar point is made by Harold Fromm in "Recycled Lives: Portraits of the Woolfs as Sitting Ducks" (1985). He objects to the appropriation of lives for political purposes and laments a "pornography of the soul . . . soul-cake . . . a form of gossip elevated to metaphysical heights promising a transcendent payoff." He matches Glendinning's "daily littleness" of the subject's life with a frustration with the "inexhaustibility of the Infinitessimal" (ibid.: 416).

7 I am using the word *icon* to postulate "Emily Carr" as an image that echoes the traditional sense of person as well as a more recent usage, associated with computer software, as sign.

8 I am not concerned here with a distinction between higher levels of truth accorded to definitive, often academic, biographies and the derision with which popular biographies are often greeted. Carolyn Heilbrun has called Jane Howard's biography of Margaret Mead "the sort of journalistic jumble of impressions, errors, and occasional insights characteristic of *People* or the newsmagazines. . . . Howard has accumulated 'facts' wholly unaware of the narrative imperatives of biography." Mary Catherine Bateson's memoir of Mead's life, *With a Daughter's Eye*, on the other hand, "advances the question both of women's biography and of daughters' attitudes toward mothers and foremothers" (Heilbrun 1990: 30). Though the differences are real— see, for example, Lynn Z. Bloom, "Popular and Super-Pop Biographies: Definitions and Distinctions" (1980)—the life that resonates as a religious subject is of interest at *all* levels.

9 In early accounts of Carr's life her financial hardships are glossed over; in recent accounts there is acknowledgment that her difficulties were major determinants of both her temperament and career. Whether biographers consider her privileged may reflect factors in their own lives. The Carr

family's position was certainly comfortable when she was a child. In her short story "Sunday" from the *Book of Small* Carr speaks with pride of the "fine big house" her father built in 1863. "It was made of California redwood. The chimneys were of California brick and the mantelpieces of black marble. Every material used in the building of Father's house was the very best, because he never bought anything cheap or shoddy" (*Small*: 10). According to John Adams of BC's Heritage Properties Branch, what Emily thought of as marble was discovered to be marbled slate during restoration work on the house in the spring of 1990. The desire for quality is certainly present but whether real or imitation was a significant issue in nineteenth-century America, according to Miles Orvell in *The Real Thing: Imitation and Authenticity in American Culture 1880-1940* (1989).

10 For attention to renderings of Carr's life not dealt with here, see Eva-Marie Kröller's "Literary Versions of Emily Carr" (1986). Of particular interest are her analyses of Don Harron/Norman Campbell's musical *The Wonder of it All* (1971), Herman Voaden's *Emily Carr: A Stage Biography with Pictures* (1960), Florence McNeil's cycle of poems, *Emily* (1975) and *Klee Wyck: A Ballet for Emily* (1975) choreographed by Anna Wyman.

11 Carr's work in several media is central to the holdings of both the print and visual collections of the BC Archives & Records Service. For an accessible description of Carr materials in Victoria and elsewhere, see the documentation in Doreen Walker's *Dear Nan* (particularly pp. xxiii-xxx). The Richard Carr House, opened in 1989, draws tourists during the summer months, many of them as pilgrims to Emily's shrine, according to the curator. The Emily Carr Gallery, run by the province in her father's building on the waterfront, was closed due to fiscal restraints in early 1991.

12 Until recently such attention as was directed toward biography, while thoughtful, was written by biographers for the most part and dealt with matters of concern to them. Among the notable texts are Leon Edel's *Writing Lives: Principia Biographica* (1984, 1959), Paul Murray Kendall's *The Art of Biography* (1985, 1965) and Virginia Woolf's two essays, "The Art of Biography" and "The New Biography" which were written between this century's wars. A summary of such thinking is provided in David Novarr's *The Lines of Life: Theories of Biography, 1880-1970* (1986).

13 In *Orlando*, her exceptional fictional biography of Vita Sackville-West, Virginia Woolf does use the interaction between life and landscape to hilarious and subversive effect. Orlando's life, which encompasses several centuries and a sex change, is a visceral response to the cultural forces at work in British society.

14 There have been a number of attempts to categorize types of biography which allow for both dense historical efforts and lighter evanescent interpretations. Katherine Frank, "Writing Lives: Theory and Practice in Literary Biography" (1980), distinguishes between lengthy and dramatic Plutarchean recreations, and scholarly, interpretive lives which keep the literary works central. Wilson Snipes has listed categories devised by an ensem-

ble of other theorists: "Nicholson's pure and impure; Maurois' artistic and scholarly; Bowen's narrative, topical, essay and interior forms; Clifford's objective, scholarly-historical, artistic-scholarly, narrative, fictional, and ironical; Edel's chronicle, pictorial, and novelistic; or Davenport and Siegel's formal, informal, and popular" (1982: 216).

15 Bruce Hutchison's biography of Mackenzie King, *The Incredible Canadian*, published two years after King's death, is a journalist's account, notable for its immediacy and easy acceptance of King's private life. Later, when the record of King's life had been established by academic historians and others, Joy Esberey's psychobiography of King, *Knight of the Holy Spirit* (1980), suggested there was more to the man's story than the objective truth. Heather Robertson's *Willie: A Romance* (1984) is an outrageously appropriate fictionalization. The many biographies of Riel follow a similar pattern. Mavor Moore, who played in John Coulter's drama *Riel* and created the libretto for Harry Sommers' opera on the Métis hero, wrote that Riel, "like the insignificant prince of Elsinore who became 'Hamlet the Dane' through circumstances beyond his control, [had] become the personification of some of the great liturgical themes of humankind. None of these themes is tied down to a particular instance; rather, each of them sweeps up any instance that vaguely serves its purpose and whirls it into the zeitgeist" (*The Globe and Mail*, 9 March 1985, p. E5).

16 A stage on the route to legendary status may be studies that treat single issues within the patterns of a life. C. P. Stacey's *A Very Double Life* (1976) attempted to explain strange behaviours in King's private world; Thomas Flanagan's emphasis in *Louis 'David' Riel, Prophet of the New World* (1979) focused on Riel's visionary religiosity.

17 For the importance of this issue to a modernist artist, see my "Lives of the Avant-garde Artist: Emily Carr and William Kurelek" (1995).

18 For a stimulating overview of the field, see Elaine Showalter's *The Female Malady: Women, Madness and English Culture, 1830-1980* (1985). Her reference to Doris Lessing's suggestion that madness is "a way of learning, of getting around or breaking through the paralysing impasses of contemporary life" (Showalter 1985: 240) and to R. D. Laing's theory of "ontological insecurity" and madness as a female strategy within the family (ibid.: 246) are some of the notions that must be considered with relation to Carr's health.

19 A fragmenting viewpoint—suggested by the hypothetical gallery patron carrying multiple objects marked "EMILY CARR"—has been used to good effect in Dorothy Thompson's *Queen Victoria: Gender and Power* (1990). Thompson examines just those facets of her subject's life that suit her themes. In a short essay from *Moments of Being* (1985), "Am I a Snob," Virginia Woolf implies that fragmentation may be intrinsic to women's relation to power and language. She describes three women who are unable to obtain a viable balance between political or personal power and language and, consequently, are incapable of sustaining either action or communication.

20 See Dennis Reid's *Lucius R. O'Brien: Visions of Victorian Canada* published by the Art Gallery of Ontario in 1990.

21 Mary Ann Caws uses Lytton Strachey's phrase "writeaboutability" to describe "the tale of art and life" she weaves in her *Women of Bloomsbury* (1990).

22 Carr's attitude to language, deliberate and innovative, is addressed by Laurie Ricou in "Emily Carr and the Language of Small" (1987).

23 "One of the very earliest uses of the term 'postmodern,' dating from the time of the Second World War, was that of Arnold Toynbee in his *A Study of History*. He used it to describe the new age of Western history which, according to Toynbee, began in the 1870s with the simultaneous globalization of Western culture and the re-empowerment of non-Western states" (Young 1990: 19).

24 At the end of *The Order of Things* Foucault postulates the erasure of "man" whose fragile dimensions resemble a face drawn in sand at the edge of the sea. That creating images in the sand between tides is irresistible suggests to me a fundamental creative joy in the ephemeral quality of life stories, a quality which Virginia Woolf noted when she said that "the biographer must accept the perishable, build with it, imbed it in the very fabric of his work" (1961: 168).

However, following Lynne Pearce, who claims that all texts do not serve postmodern criticism equally well (1991: 3, 25), I would point out that though all biographies presuppose some meaning in life, they do not all repay effort spent drawing out religious dimensions. Also of relevance here are attempts to come to terms with lives that have resisted telling, perhaps because the documentary evidence is not there, as in Anne Higonnet's *Berthe Morisot* (1990), or because the bourgeois basis of Western lives has excluded that life's classification, as in Carolyn Kay Steedman's *Landscape for a Goodwoman* (1986).

25 Excellent examples are Leon Edel's *Writing Lives: Principia Biographia* (1984), which was originally published in 1959, and Paul Murray Kendall, *The Art of Biography* (1985), first published in 1965.

26 It may be that a movement toward fragmentation seen in postmodernism is reflected in the appearance of biographies of women whose lives have been considered peripheral. Patricia Bosworth's *Diane Arbus* (1984), straightforward at a narrative level, creates a compelling portrait from the bizarre and tragic circumstances of this New York City photographer's life. In his *Changing Woman* (1989) Jay Scott synthesizes the life and art of New Mexico artist Helen Hardin; his careful prose clarifies the redemptive encounter of the artist's troubled life with the mystical and traditional elements of her Santa Clara Pueblo heritage.

27 Patricia Morley's life of William Kurelek (1984) is a rare example of a self-consciously postmodern contemporary biography. The lives of medieval religious women are also receiving sophisticated critical attention. Margery Kempe, credited with the first autobiography in English, is a primary

example. See Sidonie Smith's chapter *"The Book of Margery Kempe*: This Creature's Unsealed Life" (1987). In "Women's Stories, Women's Symbols: A Critique of Victor Turner's Theory of Liminality" (1984) Carolyn Walker Bynum uses Turner's insights to describe marginality in medieval women's lives. Marina Warner, in *Joan of Arc: The Image of Female Heroism* (1981), carefully deconstructs the historical narrative of her subject, addressing topics such as prophecy, heresy and androgyny and the inevitable and variable cultural limits placed on Joan's image over time.

28 The use of story in therapies, to ground and display possible life narratives, has grown over the past two decades. Sam Keen's *To a Dancing God: Notes of a Spiritual Traveler* (1990, 1970), Madonna Kolbenschlag's *Kiss Sleeping Beauty Good-bye* (1988, 1979) and Robert Bly's *Iron John* (1990) exemplify the appeal of this approach.

29 Robert Young notes Sartre's struggle to clarify how "individual actions, separate multiplicities, make up *'one* human history, with *one* truth and *one* intelligibility" (1990: 33). Clifford Geertz voiced a similar idea: "one of the most significant facts about us may finally be that we all begin with the natural equipment to live a thousand kinds of life but end in the end having lived only one" (1973: 45).

30 Gail Scott is representative of many women writers who may fail to achieve mega-status but are seriously at work on important critical issues. Nicole Ward Jouve is another. Of interest is a statement made by James Joyce: "Women write books and paint pictures and compose and perform music. And there are some who have attained eminence in the field of scientific research. . . . But you have never heard of a woman who was the author of a complete philosophic system, and I don't think you ever will (Gilbert 1988: 233).

31 Scott says more: "Maybe my resistance to the narrative conventions of the novel [has] to do with what I think of as its Protestant qualities: its earnest representation of the 'real,' its greed for action, its preference for the concrete over the philosophical" (Scott 1970: 90). Scott, along with several other Anglo- and French Canadian writers, addressed the issue of language in a National Film Board Studio D film, *Fragments of a Conversation on Language* (1991). Another Studio D film, *Fireworks: Louky Bersianik, Jovette Marchessault, Nicole Brossard* (1986) treats some of the same issues.

32 For me, important analyses of French feminist thought are Alice Jardine's *Gynesis: Configurations of Woman and Modernity* (1985) and Nicole Ward Jouve's *White Woman Speaks With Forked Tongue: Criticism as Autobiography* (1991).

33 In *Writing a Woman's Life* Carolyn Heilbrun writes: "In 1984, I rather arbitrarily identified 1970 as the beginning of a new period in women's biography because *Zelda* by Nancy Milford had been published that year" (1988: 12). It remains an arbitrary but useful choice.

34 The joys and personal stake in theorizing are central to Nicole Ward Jouve and to Nancy K. Miller in *Getting Personal: Feminist Occasions and Other*

Autobiographical Acts (1991). "If one of the original premises of seventies feminism (emerging out of sixties slogans) was that 'the personal is the political,' eighties feminism has made it possible to see that the personal is also the theoretical: the personal is part of theory's material" (Miller 1991: 21). The importance of theorizing is also central to Elizabeth W. Bruss in *Beautiful Theories: The Spectacle of Discourse in Contemporary Criticism* (1982) and to Mark C. Taylor in *Erring: A Postmodern A/theology* (1984).

35 Françoise Lionnet's *métissage* is similar in its attention to multiplicity.

36 The dismantling of authority, the disabling of subjectivity and the exhaustion of individualism figure in many works such as Michel Foucault's "What Is an Author?" (1974) and Mark C. Taylor's *Erring* (1984).

CHAPTER 3—A MIRROR TO CULTURE: MOMENTS IN THE DEVELOPMENT OF THE GENRE

1 See especially William Epstein, "Recognizing the Life-Text: Towards a Poetics of Biography" (1983), and examples in chap. 2, n.14.

2 In "Secularizing Divination: Spiritual Biography and the Invention of the Novel" (*Journal of the American Academy of Religion*, 59, 3 [1992]: 441-66), J. Samuel Preuss concludes that "in a secular world, the hard-eyed judge is no longer God with the Book in his lap. Now it is the Reader, with a Novel in his lap" (ibid.: 461). Biographical texts are no different in this respect. There is a sense in which the example of another life, as in *Robinson Crusoe*, will "reveal the meaning and destiny" of our own lives (ibid.: 459).

3 Noel Annan, Stephen's biographer, has called the Clapham Sect Britain's intellectual aristocracy (1955). In the late eighteenth and early nineteenth centuries its interconnected families, with names like Wedgwood, Darwin, Wilberforce, Macaulay and Trevelyan had considerable impact on social reform in that nation. Originally concerned with a decline in church life and its values, they developed an ascetic, Christocentric and non-doctrinal faith concerned with personal salvation. Though many, like Stephen, drifted away from the Church, they retained a commitment to life, "a continuing sense . . . of the deep seriousness of life, of the overriding strength of evil, of the deep cosmic and personal significance of our struggles against it" (Cockshut 1974: 75). These sentiments remained evident in later generations, notably among members of the Bloomsbury Group like Virginia Woolf.

4 In the mid-nineteenth century men of letters included poets and novelists, historians and social critics. Changing economic conditions had led to the creation of a market economy and a sufficiently large literate reading public that a living could be made by educated men writing for the periodical press (Heyck 1982: 24-25). Thomas Carlyle included the man of letters among his exemplars in his 1840 lectures "On Heroes, Hero-Worship and the Heroic in History."

5 Stephen's reputation today rests largely on his biographical work. When he strayed outside this area of thoughtful reflection toward more scientific thought, as in his ponderous *Science of Ethics*, or toward introspection as he did in his *Mausoleum Book*, he lost the fine touch that enabled him to describe the ultimate significance of the particular life.

6 Heffernan defines the hagiographical saint's life as a "narrative text of the *vita* of the saint written by a member of a community of belief" (1988: 16).

7 Though modern biography relies on an empiricism embedded in fact to align life narratives with an encompassing reality, its narrative techniques do not vary so very much from those of the Venerable Bede in his seventh-century *Historia Ecclesiastica Brittaniarum*. Bede understood the English to be recipients of God's particular favour and, in the conversion of the Pagans and the Celtic Christians to the faith of the universal Church of Rome, he saw a process in history which prefigured "the final reward or punishment waiting each individual" (Hanning 1966: 75). The processes of life narrative have not changed so much as have the definitions of fact.

8 For an analysis of the biographical representation of George Eliot, see Ira Nadel's third chapter: "Versions of the Life: George Eliot and Her Biographers" (1984).

9 Strachey had read Sigmund Freud when he wrote *Eminent Victorians*. Later his brother James was analyzed by Freud and translated all his works into English. Freud also read Strachey and thought his *Elizabeth and Essex* (1928) a fine example of the psychoanalytic method applied to history (Edel 1984: 255). Virginia Woolf found this work a failed biography (1961: 164).

10 In the last decades of the twentieth century Susan Mann Trofimenkoff wonders if biography, because it is a genre dominated by a male perspective, is even worth writing (1985: 1).

11 Woolf was requested by the family to write the biography. She was reluctant to accept; aside from the complications of her own friendship with Fry, he had been her sister's lover.

12 Consideration of Woolf's stature varies. She is still resisted as a force in Britain but adored by American feminist critics, who use French literary and feminist theory to explain her power.

13 The list of works that clearly acknowledge her influence is extensive. Examples range from Mary Meigs' autobiographical *Lily Briscoe*, named for a character in *To the Lighthouse*, through Janet Wolff's sociological *Feminine Sentences* to Carolyn Heilbrun's *Writing a Woman's Life*. Bookstores and journals are named for her, and religious insight credited to her presence.

14 Frederick R. Karl has noted the differences between American and British receptions of modern art. "The Armory Show in New York, in February 1913, showed the new Parisian styles. . . . Probably more than any other influence, the Armory Show moved American artists from social realism and, in fact, made social realism the art solely of the academy."

In England, Roger Fry attempted to present the new and mounted a Post-Impressionist Exhibition in November 1910, as well as a second one in 1912; but England, more interested in literary innovation, ignored the implications and hooted at the work" (1988: 281).

15 For an example, see chap. 1, n.8; see also Hembroff-Schleicher (1978: 11, 15).

16 In *Fear and Temptation: The Image of the Indigene in Canadian, Australian and New Zealand Literature*, Terry Goldie claims that "the importance of the alien within cannot be overstated. In their need to become 'native,' to belong here, whites in Canada, New Zealand, and Australia have adopted a process which I have termed 'indigenization.' A peculiar word, it suggests the impossible necessity of becoming indigenous. For many writers, the only chance for indigenization seemed to be through writing about humans who are truly indigenous, the Indians, Inuit, Maori, and Aborigines" (1989: 13).

17 Several of Carr's stories were read on CBC radio. Dr. G. G. Sedgewick gave two readings early in 1940 on a local station. Other readings were done by Ira Dilworth from 1940 to 1942 for a national audience (Hembroff-Schleicher 1978: 38; Blanchard 1987: 274). In a letter to Nan Cheney in May 1941 Carr indicated her pleasure: "Did you hear Canoe? That is my favourite of all the Indian ones. Mr. Dilworth did it last week and *beautifully*" (*DW*: 326).

18 Carolyn Heilbrun describes the call: "for women who wish to live a quest plot, as men's stories allow, even encourage, them to do, some event must be invented to transform their lives, all unconsciously, apparently 'accidentally,' from a conventional to an eccentric story" (1988: 48). In "Selves in Hiding" (1980) Patricia Spacks notes how necessary it has been for some women, like Eleanor Roosevelt, to have greatness *thrust* upon them.

19 See note 28 below.

20 The exhibition was intended to be "a self-portrait revealing the most marked characteristics of her personality as an artist" and "the continuous effort to achieve expression of themes she felt so deeply" (Carr 1945: 7). The exhibition catalogue included two brief essays: a biographical sketch by Ira Dilworth and an account of her paintings and drawings by Lawren Harris.

21 For a history of the arts in Canada to 1950, see Maria Tippett, *Making Culture: English Canadian Institutions and the Arts before the Massey Commission* (1990).

22 The 1941 conference was less anglocentric than the *Massey Report* in 1951, or the formation of the Canada Council in 1957, would be. In addition to Canadians, Beiler invited two American speakers, one regional artist and another who had worked with the Fine Arts Project under the Works Progress Administration, and he had received financial aid from the Carnegie Foundation (Francis K. Smith 1980: 89-91).

23 Françoise Lionnet's *Autobiographical Voices: Race, Gender, Self-Portraiture* (1989) examines women's writing from various cultural margins indicative of postcolonial attitudes.

24 Massey's Royal Commission was preliminary to the foundation of the Canada Council in 1957 which would direct Canadian postwar cultural policy until the late 1960s.

25 George Steiner had serious difficulties with Eliot's failure to account for the horror of war in his definition of culture and responded with his own lectures in the same series, *In Bluebeard's Castle: Some Notes Towards the Redefinition of Culture* (1971). Eliot's were the views of a religious man and Steiner's those of a philosopher. In the early 1950s anthropologists were also consolidating their definitions and would come to dominate definitions of culture. See, for example, A. L. Kroeber and Clyde Kluckhohn, *Culture: a Critical Review of Concepts and Definitions* (1952).

26 "The cultural triumph of the Anglo-American form of modernism was largely, almost exclusively, Eliot's personal triumph" (Poirier 1987: 22).

27 The great-grandson of the staunch Methodist founder of a farm machinery company that bore the family name, Vincent Massey led a career balanced between business, government and the arts. Jack Granatstein judges Vincent Massey to have been "almost a caricature for the Canadian anglophile, a man who made even the British elite feel unspeakably colonial" (1985: 28); that bond Massey felt toward Britain, according to Granatstein, was not mutual.

28 Victor Turner, a social anthropologist, discussed the importance of metaphor as a means of defining large-scale cultural patterns in *Drama, Fields and Metaphors* (1974). The biological metaphor presents a "unified theory of order and change" which posits a variety of preordained stages (ibid.: 31). Although Turner preferred the less predictable metaphor of drama which rests upon a fluid notion of process, the concept of "organic unity" clearly suited Massey's purposes.

29 Clara Thomas' account of biography in Canada is most useful. Interest in biography has always been high. Two seminal series that set standards and established the canon were *The Makers of Canada* (1903-1908), a twenty-volume set that set a "high and complex ideal which combined professionalism, patriotism, and practicality" (Thomas 1976: 188), and the thirty-two volumes of *The Chronicles of Canada* (1914-16) which were for a more general audience than the earlier series. The *Dictionary of Canadian Biography*, published by the University of Toronto Press, follows the tradition set by these earlier sets and the model initially created by Leslie Stephen for Britain's *Dictionary of National Biography*.

30 The many personal accounts of encounters with Carr lend credence to her eccentricities. Aside from Philip Amsden's "Memories of Emily Carr" (1947) and Carol Pearson's *Emily Carr as I Knew Her* (1954), both included in my bibliography, a number of short pieces were published as personal impressions and memories of Emily Carr. Among them were Margaret Clay, "Emily Carr As I Knew Her" (*The Business and Professional Woman* 26, 9 [1959]: 1, 9); M. E. Coleman, "My Friend, Emily Carr" (*Vancouver Sun*, 12 April 1952, p. 14); Pat Dufour, "Emily Carr Was Her Landlady"

(*Victoria Times*, 24 March 1964, p. 25); Elizabeth Forbes, "More About 'Miss Emily' From One Who Knew Her Well" (*Victoria Daily Times*, 26 October 1966, p. 4); N. de Bertrand Lugrin, "Emily Carr as I Knew Her" (Victoria *Sunday Times Magazine*, 22 September 1951, p. 3); and Ada McGeer, "The Emily Carr I Knew" (Victoria *Daily Colonist*, 25 November 1973, p. 3).

31 Kathleen Coburn taught at Victoria College in the University of Toronto where she was remembered in an obituary as "the outstanding Coleridge scholar of the century." "Among her students was Northrop Frye and for years she was remarkable as a women's role model at the university" (*The Globe and Mail*, 2 October 1991).

32 I find it intriguing that many of the most compelling biographical subjects—Marilyn Monroe, Louis Riel, Georgia O'Keeffe, Elizabeth I, Mackenzie King, Joan of Arc—are solitary figures. Often, if there are spouses—William Kurelek is an example—they seem to be kept at, or keep, a distance. In Carr's case Carol Pearson's recollections describe an extended period she spent with Carr as a child. They detail the special view of one who is/is not her daughter.

CHAPTER 4—LIFE AND TEXT: THERE ONCE WAS AN ARTIST NAMED EMILY CARR . . .

1 For an articulation of the power enjoyed by male artists, see Carol Duncan, "Virility and Domination in Early Twentieth-Century Vanguard Painting" (1982). Suzanne Jones, *Writing the Woman Artist: Essays on Poetics, Politics, and Portraiture*, acknowledging the work of Josephine Donovan, notes the "structural conditions" that have shaped women across time and cultures: "(1) a psychology of oppression or otherness, (2) confinement to the domestic sphere where labour is nonprogressive, repetitive, and static, (3) creation of objects for use rather than exchange, (4) shared physiological experiences such as menstruation and sometimes childbirth and breastfeeding, (5) childrearing or caretaking, what Sara Ruddick calls 'maternal thinking,' which involves 'keeping' rather than 'acquiring,' 'holding rather that 'questing,' and (6) a gender personality that values relationship, as Nancy Chodorow explains in her theory of the reproduction of mothering" (1991: 14).

2 Commenting on the effects of the Freudian Oedipal struggle, Janet Wolff pulls the metaphor of patriarchy into the area of female creativity. Wolff says that "males continue to repress ties to the other (because of a fear of reincorporation and engulfment), and are unable to experience themselves relationally." The consequences affect theories of knowledge. "The commitment to objectivity is nothing other than a psychic need to retain distance. Invested in this is the man's very sense of gender identity, and in this light the fear of the female, and the fear of merging, make sense of a continuing way of being in the world founded on distance and differentia-

tion. . . . With regard to science and knowledge in general, it offers an account which links the institutional fact of male dominance both with the social realities of men's and women's lives in our culture and with the psychological needs and tendencies that these produce. The scientific ideal of 'objectivity' appears now as the formal and theoretical equivalent of a deep and fundamental aspect of the male psyche in western society" (1990: 80). Wolff's analysis, which draws insights from several disciplines, is part of a growing tendency in feminist scholarship to address, indeed confront, foundational constructs that have traditionally been the province of theologians and religionists.

For an examination of the construct of the self and the gendered nature of knowledge from within the philosophical traditions of the West, see Catherine Keller's *From a Broken Web* (1986).

3 For women as disenfranchised artists, see Germaine Greer (1979), Parker and Pollock (1981), Pollock (1988) and Marsh (1989). For images of women created by artists at the turn of the century, see Dijkstra (1969); for images created by male avant-garde modernists, see Duncan (1982).

4 Norma Broude in "Degas's Misogyny" notes that "an established convention in the Degas literature" has become "that of seeing personal malevolence as the unavoidable implication of Degas's rejection of feminine stereotypes" (1982: 248), and maintains that one can argue that he attempted to see them as "distinct human beings" (ibid.: 261). That may be true within the contexts of his own generation. In terms of current sensibilities his images remain the objectifications of a *flâneur*, a Parisian who gazes upon the scene before him without participating.

5 Virginia Woolf observed that within the modernist world the garrulous sex was not female, as commonly thought, but male and, what was more, his interests were limited: "in all the libraries of the world the man is to be heard talking to himself and for the most part about himself" (1979: 41-42).

6 The question of biography and class is not central to Carr's biographical image but it has been addressed in Carolyn Kay Steedman's *Landscape for a Good Woman* (1988). She makes it clear that the conventional middle-class script for the destiny of woman was not applicable to working-class women growing up in postwar Britain.

7 For the most part my use of *feminist* is broad and mirrors the notion of "feminist undertaking" that Carolyn Heilbrun takes from Nancy Miller: "the wish 'to articulate a self-consciousness about women's identity both as inherited cultural fact and as process of social construction' and 'to protest against the available fiction of female becoming.'" "It is hard," Heilbrun says, "to suppose that women can mean or want what we have always been assured they could not possibly mean or want" (1988: 18).

8 In 1991 Emily Culpepper noted that "the transformative feminist insight that 'the personal is political' has also become for [women who see the life path as a feminist journey] 'the personal is political is spiritual' " (1991: 146).

9 Gender relations and the condition of women at the turn of the century are subjects in Elaine Showalter's *Sexual Anarchy* (1990). In the NFB Studio D film *Behind the Veil* several nuns articulate the restrictions common to their orders before Vatican II.

10 The tradition of royal adventurers—which, for this schoolgirl in the fifties included biographies by Margaret Campbell Barnes as welcome respite from Nancy Drew—goes on. Among the worthy successors must be Edith Sitwell's *The Queens and the Hive* (1962), glorious in its idiosyncrasy, Antonia Fraser's *Mary Queen of Scots* (1969) and Carolly Erickson's *The First Elizabeth* (1983).

11 Lives of exemplary and strong women, whether actual or fictional like Scarlett O'Hara, often support traditional social structures. The continuing power of romance as an elusive component of patriarchy is examined in Suzanne Clark's *Sentimental Modernism* (1991) and Jean Wyatt's *Reconstructing Desire* (1990).

12 The entrenchment of gender duality into the structures of language and the seriousness of social and cultural ramifications are made clear in Terry Eagleton's example of the Derridean deconstruction process: "Woman is the opposite, the 'other' of man: she is non-man, defective man, assigned a chiefly negative value in relation to the male first principle. But equally man is what he is only by virtue of ceaselessly shutting out this other or opposition, defining himself in antithesis to it, and his whole identity is therefore caught up and put at risk in the very gesture by which he seeks to assert his unique, autonomous existence. Woman is not just an other in the sense of something beyond his ken, but an other intimately related to him as the image of what he is not, and therefore an essential reminder of what he is" (1983: 132).

13 A pivotal essay on the loss of authority is Michel Foucault's "What Is an Author?" (1974).

14 The anthropological recovery of lives has an effect on the processes of democratization. Nancy Shostak's *Nisa* is a stunning example of the epistemological richness of the genre. However, the persistence of the attitude that only significant lives are worth telling, and the difficulties of measuring significance, were brought home to me during a CBC interview with University of Toronto historian and author Michael Bliss on the quality of Cameron Smith's *Unfinished Journey: The Lewis Family* (1989). Bliss remarked that it was a fine book but wondered why anyone would be interested in the Lewises, who seemed to him subjects of little real consequence. To me the Lewises are a family of notable achievement and influence in Canadian political culture. However, they are also a family that can be characterized as marginal by race, religion and political affiliation to the idealized British model of Canadian culture.

15 The five women in Spacks' study were Emmeline Pankhurst, Dorothy Day, Emma Goldman, Eleanor Roosevelt and Golda Meir.

See Christiane Olivier's *Jocasta's Children* (1989) for a Freudian inter-pretation of the void that Spacks has isolated in the autobiographies of these women. Typically Olivier's analysands have articulated images of emptiness such as "I blow about like a leaf in the wind. Well, you see, a leaf doesn't have any depth or solidity" (1989: 76).

16 Valerie Saiving's "The Human Situation: A Feminine View" (1992), origi-nally published in 1960, continues to be cited as a clear articulation of this notion.

17 Gail Cuthbert Brandt has pointed out that attention to the lives of non-élite women has revealed the artificiality of the notion of separate public and private spheres. "One of the most convincing ways they have done so is by documenting the interconnections between the formal and informal econ-omy that women's waged and non-waged labour, performing within and outside of the household, provided" (1991: 446). For an articulation of the ideology of the private sphere, see Betty A. DeBerg's *Ungodly Women: Gender and the First Wave of American Fundamentalism* (1990).

18 These distinctions among the three feminisms have become commonplace, which is perhaps an indications that the edges are blurring. A useful over-view of the current situation is Dawn H. Currie and Valerie Raoul, "The Anatomy of Gender: Dissecting Sexual Difference in the Body of Knowl-edge" (1992).

19 For Heilbrun, Dorothy Sayers' life is "an excellent example of a woman's unconscious 'fall' into a condition where vocation is possible and out of the marriage plot that demands not only that a woman marry but that the mar-riage and its progeny be her life's absolute and only centre" (1988: 51).

20 "New opportunities helped give rise to an unprecedented generation of outstanding single women in everything from politics to the arts and to the professions. Individuals like Agnes Mcphail, Charlotte Whitton, Mazo de la Roche, Cora Hind, Ethel Johns, Eunice Dyke, Anne Savage, Florence Wyle, Frances Loring, Emily Carr, Monica Storrs, and Hilda Neatby carved out lives that were the equal of or better than many of their more conventional contemporaries." Most of these women came to maturity in the 1920s and 1930s; only Emily Carr and Cora Hind are cited as having been "affected by the suffragist agitation" (Strong-Boag 1988: 105).

21 Hanscombe and Smyers' study is a collective biography of literary women whose lives joined to form a loose network in Europe and America. Among those discussed are the writers and poets Djuna Barnes (1892-1982), Bryher (1894-1983), Mary Butts (1890-1937), H. D. (1886-1961), Amy Lowell (1874-1925), Mina Loy (1882-1966), Harriet Monroe (1860-1936), Marianne Moore (1887-1972), Dorothy Richardson (1873-1957) and Gertrude Stein (1874-1946).

22 The first separate female missionary society was founded in Nova Scotia in 1870 as a response to the refusal of male-controlled societies to sponsor female missionaries. These societies grew rapidly in all denominations. "The missionary society women in practice challenged the men's control

of important work both at home and abroad, but most women did not see themselves as part of a larger movement. . . . Their societies were the first large-scale women's organizations in which women were able to act independently and to develop confidence in their own abilities" (Prentice et al. 1988: 170-72).

23 The controversy, which erupted when Cridge rose at the service consecrating the new cathedral in December 1872 and voiced his objection, did not soon settle. After much fuss, in the Church and in the courts, Cridge was removed from his ministry in October 1874. He joined the newly formed Reformed Episcopal Church, taking with him the greater part of the congregation. They opened their own church, the Church of our Lord, in January 1876. In 1895 the Presbyterian College of Montreal conferred an honorary Doctor of Divinity on him for his service to the Protestant cause. For an account of the crisis, see Peake (1959: 76-86).

24 Carr's revulsion when confronted by sham was typical of her generation. In *The Real Thing: Imitation and Authenticity in American Culture 1880-1940* Miles Orvell notes the nineteenth-century "culture of imitation was fascinated by reproductions of all sorts—replicas of furniture, architecture, art works, replicas of the real thing in any form or shape imaginable. . . . The culture of authenticity that developed at the end of the century and that gradually established the aesthetic vocabulary that we have called 'modernist' was a reaction against the earlier aesthetic, an effort to get beyond mere imitation, beyond the manufacturing of illusions, to the creation of more 'authentic' works that were themselves real things (1989: xv).

25 Bibby contrasts Canadian religious habits with those of the British and Americans. The Fox sisters operated within "the American religion market [which] is, and always has been, a dynamic one, characterized by aggressive, persistent claims to truth . . . (1987: 218). The English, on the other hand, have "historically been characterized by a pervasive interest in the supernatural. In addition to the visible role played by Christianity over the centuries, interest in magic, superstition, spiritualism, and psychic phenomena has been high" (ibid.: 222). Ramsay Cooke's work in *The Regenerators* (1985) indicates a more reform-minded, subdued, but still responsive attitude to alternatives like spiritualism and Theosophy. Ann Davis, in *The Logic of Ecstasy* (1992), relates events and ideas in Canada to the art world.

26 In *Growing Pains* Carr recounts a table-rapping session during her school days in San Francisco (*GP*: 21).

27 Considering spiritualism as a complex "social movement with a special world view" (1989: xviii), Owen exposes the "deeply contradictory discourse" which sprang from mediumship as "a power strategy predicated on the notion of female fragility and wielded from a position of social inferiority" (ibid.: 233).

28 In 1992 Carol Seajay described the explosion in feminist publishing and women's bookstore sales during the 1980s. See her "Books: 20 Years of Feminist Bookstores" (*Ms.* 3, 1 [1992]: 60-63).

29 Other milestones were the publication of Kate Millett's *Sexual Politics*
 (1970), Germaine Greer's *The Female Eunuch* (1971) and the first issues of
 Ms. magazine (1972).

30 Carol Ascher, Louise DeSalvo and Sara Ruddick's *Between Women: Biogra-
 phers, Novelists, Critics, Teachers and Artists Write about Their Work on Women*
 (1984) is a compendium of the relationships of biographers to their sub-
 jects.

31 The work of Sophie Pemberton, one of the two women who went to
 Europe to study before Carr, was on display in Victoria in 1990 at the same
 time as *The Logic of Ecstasy* exhibition curated by Ann Davis.

32 In her biography of Berthe Morisot, Anne Higonnet describes similar
 innovative tendencies in her subject's art while at the same time making
 clear the difficulty of reconstructing female artists' lives. The documenta-
 tion is, quite simply, inadequate and much must be inferred.

33 Others working at similar tasks are Linda Nochlin (1988) and Lynne Pearce
 (1991).

34 Though Carr did not like cities, she was proud of her ability to frequent
 their less savoury parts: "The little corners that I had poked into by myself
 interested me most. My sight-showers would have gasped had they known
 the variety and quality of my solitary wanderings. It would have puzzled
 them that I should want such queernesses. . . . I went into the slums of
 Whitechapel, Poplar, and Westminster and roamed the squalid crookedness
 of Seven Dials, which is London's bird-shop district, entering the dark
 stuffiness of the little shops to chirp with bird prisoners, their throats,
 glory-filled and unquenchable, swelled with song even in these foul captive
 dens" (*GP*: 153-54).

 Pollock displays a female response to modernity in a quotation from
 the journals of Marie Bashkirtseff, an artist who lived and worked in Paris.
 Written in January 1879, when Carr was still a child, Bashkirtseff's words
 of lament exemplify the world that Carr found threatening and rejected:
 "what I long for is the freedom of going about alone, of coming and going,
 of sitting in the seats of the Tuileries, and especially in the Luxembourg, of
 stopping and looking at the artistic shops, of entering churches and muse-
 ums, of walking about old streets at night; that's what I long for; and that's
 the freedom without which one cannot become a real artist. Do you imag-
 ine that I get much good from what I see, chaperoned as I am, and when,
 in order to go to the Louvre, I must wait for my carriage, my lady compan-
 ion, my family" (Pollock 1988: 70).

35 In art criticism the term "monograph" is reserved for studies of an individ-
 ual artist's work.

36 As an example, Pollock addresses the recovery of Elizabeth Siddal as an
 individual subject formed "in the historically specific material practices of
 the social relations of class and gender differences" (1988: 98). In *The Leg-
 end of Elizabeth Siddal* (1989) Jan Marsh follows an agenda similar to that
 recommended by Pollock. She uncovers shifting views of femininity, sex-

ual politics and mystery but very little about Siddal as an individual. Initially obscured by Dante Gabriel Rosetti's life and the drama of her own death, Siddal became familiar as a subject of his work, then as an image of femininity and 1890s decadence, notable for her "silence, beauty, passivity" (ibid.: 37). In examining the sources for Siddal's life, Marsh notes the Rosetti family's interest in preserving Dante Gabriel's reputation and their ability to control Siddal's biography (ibid.: 34). As twentieth-century interest in the story replaced the Victorian demands for propriety, the failure of Siddal's marriage to Rosetti emerged as a factor relevant to her death. Marsh traces the fluctuations in Siddal's image as she gains recognition on terms of her own. In the 1940s she appeared as a neurotic and suicidal female, in the 1960s as a fascinating adjunct to the Pre-Raphaelite Brotherhood. More recently, as feminist interests turned to her image, notions of anorexia replaced those of consumption and neurosis. In 1985, writing her own biography of Siddal, Marsh allowed her to be talented and ambitious, an artist in her own right. From the responses of individuals to the biography, Marsh glimpsed the "powerful fascination still exerted by this quasi-historical, quasi-legendary figure. The desire to know 'what she was really like' is both combined with and countered by the desire to maintain the myth, in a paradigm of the tension inherent in the redefinitions of femininity in our time" (ibid.: 154).

37 One that does attempt to be more responsive to critical theory is Patricia Morley's biography of Canadian artist William Kurelek. Kurelek emerges as an enigmatic and driven artist whose rigid doctrinal beliefs can scarcely restrain his curious energies.

38 In examining "the genealogy of the modern individual as object" Michel Foucault drew attention to the movement of narrative lives from the hero model of traditional epics to the detailed compendiums of contemporary dossiers. "What had once been a device for lauding heroes—luminous attention to their lives, fixed in writing—is now reversed. The most mundane activities and thoughts are scrupulously recorded. . . . The ritual of the examination produces dossiers containing minute observations. The child, the patient, the criminal are known in infinitely more detail than are the adult, the healthy individual, and the law-abiding citizen. The dossier replaces the epic" (Dreyfus and Rabinow 1983: 159). The shift is also comprehensible as one from metaphysics to epistemologies, one marked by the democratization of knowledge.

39 Working from an assumption that "literary conventions are socially created structures in the search for a shared reality" (1986: 31), Frye discusses three other qualities of the novel—flexibility, popularity, and a concern with the individual—along with elements that distinguish the genre as a form— plot, character, reality and thematic unity. Perceived as novelistic, these categories are no less biographical.

40 The novel, while still a significant forum for the depiction of women's lives, no longer enjoys the prominence it had for the Victorians. Phyllis

Rose's *Parallel Lives* (1984) questions the roles open to women—including George Eliot—during that period. In *No Man's Land* (1988) Sandra M. Gilbert and Susan Gubar describe the gathering strength of a tradition of male writers in the twentieth century (see especially 153-54).

41 "Feminist literature reappropriates some of the concerns first addressed by bourgeois subjectivity while rejecting both its individualism and its belief in the universality of male bourgeois experience" (Felski 1989: 155). "Postmodernists intend to persuade us that we should be suspicious of any notion of self or subjectivity. Any such notion may be bound up with and support dangerous and oppressive 'humanist' myths. However, I am deeply suspicious of the motives of those who would counsel such a position at the same time as women have just begun to re-member their selves and to claim an agentic subjectivity available always before only to a few privileged white men" (Flax 1990: 220).

42 I have been unable to locate a copy of *Growing Pains* through the CBC.

43 Tippett's biography, like Carr's *Klee Wyck* in 1941, won a Governor General's Award as did Jovette Marchessault's play in 1991.

44 Also in 1979: Linda Street's MA thesis "Emily Carr, Lawren Harris and Theosophy, 1927-1933." Although not available to the general public, Street's thesis has been frequently consulted.

45 See note 12, above, for Terry Eagleton's description of this same notion in the vocabulary of postmodernism.

46 At the close of *Fragmentation and Redemption: Essays on Gender and the Human Body in Medieval Religion* (1992) Caroline Walker Bynum juxtaposes medieval and current attitudes to life after death, drawing attention to notions in science fiction and the periodical press that reflect the earlier concepts.

47 The play has been published both in French and in English versions: in 1990 as *Le Voyage Magnifique d'Emily Carr* and in 1992 as *The Magnificent Voyage of Emily Carr*, translated by Linda Gaboriau.

48 Directed by Floyd Favel, the play was performed late in 1992 on the Rice Stage at Edmonton's Citadel Theatre. Eileen Whitfield has since written a biography of Mary Pickford to be published soon by MacFarlane, Walter & Ross.

49 According to Eileen Whitfield, the producer of her play, Robin Philips found Alice "a far more intriguing character than Emily, because she has more secrets. He also thought that Canadians don't like to celebrate their heroes, and that the use of Alice to puncture Emily's balloon was a very Canadian way to both celebrate and humanize her" [from her letter to me, 30 June 1992]. See also Appendix B.

CHAPTER 5—DEEP NATURE: SURVIVAL IN A CONSTRUCTED WORLD

1 The concept of the individual relates to medieval narrative lives as the concept of the self involves modern biography. For the earlier period, see especially Carolyn Walker Bynum's "Did the Twelfth Century Discover the Individual?" (1982) and her "Women's Stories, Women's Symbols: A Critique of Victor Turner's Theory of Liminality" (1984), as well as Robert W. Hanning, *The Individual in Twelfth-Century Romance* (1977). For an account of the development of the notion of the self in cultural contexts, see Charles Taylor's *Sources of the Self* (1989).

2 "As Galileo irrevocably changed the fundamental conception of science, and thereby divorced the scientific idea of nature from the idea of wild nature, so Bacon envisioned a second world, or *mundus alter*, that humankind might create through science. In one philosophical stroke he revolutionized the idea of humankind's relation to the natural or first world, abandoning the prevailing ideology with its intrinsically conservative orientation and affirming modernism with its inherent dynamism. Neither the prehistoric ideal of life in harmony with nature nor the classical ideal of nature as a bountiful world that sustained humankind was acceptable: Bacon's ideal was no less than a complete mastery of nature (Oelschlaeger 1991: 81).

3 "Genius . . . is thought of as an atemporal and mysterious power somehow embedded in the person of the Great Artist. Such ideas are related to unquestioned, often unconscious, meta-historical premises. . . . To encourage a dispassionate, impersonal, sociological, and institutionally oriented approach would reveal the entire romantic, elitist, individual-glorifying, and monograph-producing substructure upon which the profession of art history is based" (Nochlin 1988: 153).

4 Jacques Lacan's development of Freudian psychoanalysis "stresses the linguistic structure of the unconscious as a site of repressed meanings" (Weedon 1987: 51). "The subject cannot be considered the agent of speech; it is (through) the Other (i.e. the unconscious) that language speaks the subject" (Grosz 1990: 97-98).

5 Other cultural analyses that both benefit and are enhanced by the biographical retrieval of women's experience are Wolff, *Feminine Sentences* (1990) and DeBerg, *Ungodly Women* (1990).

6 Jan Marsh's *The Legend of Elizabeth Siddal* (1989) exemplifies the strange admixture of attitudes and interpretations that existed regarding one female artist. Had women's lives a narrative tradition of their own, I wonder if Siddal's life could have been interpreted so variously.

7 In England there is a long practice of combining the occult/arcane and Christian traditions. The works of Charles Williams, T. S. Eliot and Colin Wilson are examples. Canadian scholars are unearthing combinations of our own that have not been generally appreciated. See Ramsay Cook's *The Regenerators* (1985) and Ann Davis' *The Logic of Ecstasy* (1992) for examples.

8 "As the nineteenth century began, wilderness existed in abundance; even on the East Coast great expanses of land, timber and water were yet to be encroached upon. By 1900 demand for wilderness was beginning to outstrip supply. Frederick Jackson Turner's famous book, *The Frontier in American History* (1893), is a monument to the closing of the American frontier, the wildness that Turner believed essential to American culture" (Oelschlaeger 1991: 3).

9 Miles Orvell has called Whitman "an enormous cultural sponge" who "absorbed the transformations in American life" (1989: 4) and created a poetic form in *Leaves of Grass*, "a way of organizing experience . . . commensurate with the multiplicities of the new age" (ibid.: 19).

10 In a letter to Nan Cheney in December 1940 Carr described her frustration with Theosophy: "by & bye the whole thing soured on me. mainly the supercillious attitude towards the bible & their denial of the *devinity* of Christ, & the atonement. christ was *only a good man* to them. Bess [Harris] sent me a Madam Blavatsky book which infuriated me. I flung it across the room when partly read & then burnt it & told Bess & Lawren I did not like Theosophy. I liked & beleived in plain bible, & I burnt Madam B. & they sighed and we've never mentioned the matter since. in our letters" (*DW*: 280).

11 Aside from Kahlo and O'Keeffe, Siddal and Morisot, and Carr, there has been recent interest in the lives of female surrealists. Mary Ann Caws et al., *Surrealism and Women* (1990), and Estella Lauter's *Women as Mythmakers* (1984) provide examples.

12 This is a reference to Clifford Geertz: "The concept of culture I espouse . . . is essentially a semiotic one. Believing, with Max Weber, that man is an animal suspended in webs of significance he himself has spun, I take culture to be those webs, and the analysis of it to be therefore not an experimental science in search of law but an interpretive one in search of meaning. It is explication I am after, construing social expressions on their surface enigmatical" (1973: 5).

13 Paula Gunn Allen's attention to her own native tradition exemplifies a source of pressures toward redefinition felt in larger spiritual communities. "The word *sacred*, like the words *power* and *medicine*, has a very different meaning to tribal people than to members of technological societies. It does not signify something of religious significance and therefore believed in with emotional fervor—'venerable, consecrated, or sacrosanct,' as the Random House dictionary has it—but something that is filled with an intangible but very real power or force, for good or bad" (1986: 72).

14 See Aviad M. Kleinberg's *Prophets in Their Own Country: Living Saints and the Making of Sainthood in the Later Middle Ages* for the impact of saints upon their communities. "The process of recording the saints started already in their lifetime. Those considered holy were observed with special attention by their followers; their words and gestures were carefully noted and committed to memory. In the general sound and fury of everyday life,

the saints signified something. It was not always clear what their actions and words meant, but they could not have been meaningless. The saints of God were there for a reason. They demanded attention and consideration. Their spectators had a sacred duty to save the saints from oblivion" (1992: 40).

15 Even as I write the subject is addressed by David Roberts in an article in *The Globe and Mail*'s weekend *Focus* section: "Was He Martyr, Traitor, Madman or Saint?" (11 July 1992, p. D4).

16 After Mark Taylor's work with errant words (*Erring* 1984), stray thoughts can never again seem amiss to me.

17 Patterson's poem, written on the occasion of first seeing a room full of Carr's paintings in the Vancouver Art Gallery, is included in Appendix B.

18 As time passes the biographical image gets too large and various to monitor. Even as I write I am told that there is a poet in the west who was inspired by Carr and writes poems comparing construction tools to kitchen utensils, a fictional account passing through a word processor somewhere, and a play by Eileen Whitfield called *Alice and Emily*. See chap. 4 and Appendix B.

19 The "brutal telling" was Carr's description, late in her life, of a private conversation with her father. It is not known exactly what was said but the consensus among researchers is that it was likely of a sexual nature.

20 Jovette Marchessault's appearances in NFB Studio D films, especially her portrait in *Firewords*, identifies her with the current wave of powerful and creative French-language feminist writers in Quebec. A useful assessment of feminist spirituality as it represents a new religious movement is Cynthia Eller's *Living in the Lap of the Goddess: The Feminist Spirituality Movement in America* (1993).

21 "Religion is both a problem (or *the* problem) where its structures of dominance have oppressed women, and a solution where its vision of liberation or equality has generated powerful movements for social change. The same religious tradition may be both a problem and a solution. Islam's vision of human equality or the Hindu affirmation of women's power (*shatki*) may be sources of strength even when much of the tradition compromises women's equality or power. . . . In many cultures the English word 'religion' is neither meaningful nor useful" and can be substituted with such terms as *values, ethics, tradition and cultural tradition* (Eck and Jain 1987: 2-3).

22 See Bryan Wilson's notion of the manifest and latent functions of religion in "The Functions of Religion: A Reappraisal" (1988).

23 "Advancing from the Greek, through the Jewish, to the Christian, the sacred is transformed from exteriority to interiority. While the Greek suffers the sacred from without and the Jew encounters it in and through wilful transgression, the Christian experiences the sacred as an outside that is inside, forever faulting his identity" (Julia Kristeva in Wyschogrod 1990: 248).

24 See the litany of failed promises and constant dangers in Marilyn French's *War Against Women* (1992). On a linguistic level, Irigaray's *This Sex which Is Not One* (1985) clearly articulates the impossibility of defining woman.

25 Westfall's interpretation of culture suits my purpose on its own terms but also because it reflects his understanding of the Canadian situation.

26 The importance of community has been emphasized by feminist writers who see alienation as an obstacle to the full participation of women in public life. Madonna Kolbenschlag's *Lost in the Land of Oz* (1988) uses literature and myth to suggest new models of relationship as the foundation of vital community. Jessica Benjamin's *The Bonds of Love: Psychoanalysis, Feminism and the Problem of Domination* (1988) urges a form of intersubjectivity that promotes mutual recognition and fosters social change.

27 This image springs from Alice Jardine's comment that "modernity is a rethinking not only of secular boundaries, but of the sacred boundaries as well—in an attempt to both reconceptualize and control the archaic spaces that, hidden in the shade of the Big Dichotomies, finally emerged in all of their force in the nineteenth century" (1985: 80).

28 Mother Teresa's exemplary behaviour is fascinating to a diverse range of cultural groups who may not be interested in the intricacies of her personal faith. On the other hand, the faith statements of astronauts add an element of humanity to lives mysteriously enmeshed in technology.

29 H. R. Kedward (1966) cautioned against seeing art as providing a systemic view of society in the early decades of this century. He was an advocate of multiplicity of fact and perspective before the events of 1968 forced that view to become more widely held.

30 Ochs' definition begins with this phrase from John Dunne.

31 Contributions to a growing literature on women and religion are numerous and varied: Mary Daly's radical revisioning of language to enable a religiosity evoked by female experience; Starhawk's propagation of rituals and attitudes drawn from Wiccan or neopagan registers; Madonna Kolbenschlag's articulate dissection of the impact of stories, imagination and communal power; Christine Downing and Jean Shiboda Bolen's explication of goddess archetypes; the elucidation of Jungian perspectives by Marion Woodman and Demaris S. Wehr and the development of those themes into elucidation of the female journey in Carol Christ and Annis Pratt; the Freudian material of Jessica Benjamin and Naomi Goldenberg. Many of these writers have broad popular followings. Other scholars whose work is more specialized have unexpectedly wide audiences. The area of medieval piety, for example, has expanded significantly. Stimulated by the appeal of Matthew Fox's creation spirituality and his sponsorship of Hildegard of Bingen, and by the work of scholars like Caroline Walker Bynum, the lives and writings of medieval mystics have become the currency of weekend retreats. New comprehension of the preoccupations of women in the medieval European world grant more appeal to the hagiographical lives that Heffernan discusses than might be expected. Accompanying this expansion of resources for women are works which continually monitor developments, perhaps a tendency that was set in motion through the politicization of women's lives during the 1960s. An awareness of the fragility of women's achievements,

in the midst of rancour that exposes systematic resistance to the democratization of liberal human rights, has brought forward other works, not especially concerned with religion or spirituality, that document the climate of opinion within which women continue to exist and by which they can be defined. Naomi Wolff's *Beauty Myth* (1990), Susan Faludi's *Backlash* (1991), Gloria Steinem's *Revolution from Within* (1992) are recent examples. Others draw upon the work of women in religion to support their more general social criticism: Marilyn French, in *The War against Women* (1992), draws upon Betty A. DeBerg's *Ungodly Women: Gender and the First Wave of American Fundamentalism* (1990). Studio D of the National Film Board, acting within its original mandate, stimulates discussion with a list of topical and sensitive subjects. Many of the studio's films bring issues of women's spirituality, or the spiritual and moral dimensions of everyday life, into communities of all sizes across Canada.

32 The Emily Carr exhibition in Ottawa in the summer of 1990 was part of the Royal Commission on the Status of Women's twentieth anniversary celebrations.

33 Though "spirituality" and "women's spirituality" are in common usage in the early 1990s, a decade ago at a local meeting of Christian and Jewish women, all active in their religious communities, few had any real sense of the words.

34 Mays' review "Signs of Struggle" appeared on 7 July 1990. Dorothy Livesay's letter was printed on 14 July; Nancy Hazelgrove and V. Fullard were two of four complainants on 21 July.

35 Dorothy Livesay had explored the possibility of writing a biography of Carr in 1938-41 (*DW*: 153, 168, 307-309).

36 Parker and Pollock discuss the relation between the art of Jackson Pollock and Helen Frankenthaler. They describe the feminine stereotype that blinded the critics who associated Frankenthaler's work with "nature" rather than "intellect and theory," "a notion both contradicted by the artist herself and by the facts of her class, background, education, involvement with key theories of the period and obvious grasp of their implications" (1981: 146).

37 In *Retelling / Rereading: The Fate of Storytelling in Modern Times* Karl Kroeber describes the significance of narration as "the articulation of meaning for contingent events without gainsaying their contingency" (1992: 1). For him "each retelling of a story permits the articulation of deeper possibilities that exist because they were *not* explicitly expressed in the original telling. This implicit richness of story is precisely the kind of latency one tries to avoid in 'scientific' discourse" (ibid.: 48).

38 Women and medicine meet on several fronts: the medical diagnosis and treatment of women; the exclusion of women from the higher levels of the profession; the appropriation by doctors of traditional female healing arts. For work in this area, see Elaine Showalter, *The Female Malady: Women, Madness and English Culture, 1830-1980* (1985), and Wendy Mitchinson, *The Nature of Their Bodies: Women and Their Doctors in Victorian Canada* (1991).

39 See especially the catalogue for the 1991 show: Ian M. Thom, *Emily Carr in France* (Vancouver: Vancouver Art Gallery, 1991).

40 Malcolm Yorke's *The Spirit of Place: Nine Neo-Romantic Artists and Their Times* offers a study of work and attitudes that exemplify Fuller's opinion. "The years just before, during, and after the Second World War offered one of those periods when the conditions and cultural climate were conducive to Romantic painting. Romantic art has a message to convey about Man's relationship with, and response to, Nature" (1988: 19). Yorke quotes Raymond Mortimer on the unusual variety of groups at work in Britain in the early 1940s: "the appeal of their art, I fancy is to mystics and particularly to pantheists who feel a fraternity, or even a unity, with all living things, to those with the 'sense sublime of something far more deeply interfused.' Their work can be considered the expression of an identification with nature" (ibid.: 22).

41 Shadbolt remarked upon Carr's discomfort in intellectually sophisticated company (1990: 27), that she was "neither an intellectual nor a theorist" (ibid.: 68) but also pointed out how books were important to her both for their words and their images (ibid.: 58).

42 Following the opening of the transcontinental Canadian Pacific Railway in 1886, free passes were offered to artists whose paintings could publicize the route of the new lines.

43 This is the title of Jean Barman's recent history of British Columbia. Barman describes that province as quite distinct from the rest of Canada. Entries from Robert M. Hamilton and Dorothy Shields' *Dictionary of Canadian Quotations and Phrases* (1979) support Barman's assessment: "It is an empty land. To love the country here—mountains are worshipped, not loved—is like embracing a wraith" (*s.v.* "Rupert Brooke" [1919]); "British Columbians like to think of their province as a large body of land entirely surrounded by envy" (*s.v.* "Eric Nicol" [1958, *Macleans*]). Barman quotes Bruce Hutchison: "Crossing the Rockies, you are in a new country, as if you had crossed a national frontier. Everyone feels it, even the stranger, feels the change of outlook, tempo and attitude" (1979: 353).

44 The first large-scale North American wilderness preservation site, Yellowstone National Park, was set aside in 1872, the year after Carr's birth. See also this chapter, note 8.

45 The significance of very early life events created a need for modern artists "to go back to experiences at the breast (and before) in order to find again, in a new way, [their] relationship to others and the world" (Fuller 1988a: 175).

46 Peter Fuller preferred depth to transcendence. He described one painter's approach as "a penetration metaphorically downwards, into the region of psycho-biological being, into that great reservoir of *potentiality* upon which our hopes for a better personal and social future ultimately rest (1988a: 208).

47 In a work intended to open up and organize this area, *Art & Psyche: A Study in Psychoanalysis and Aesthetics*, Ellen Handler Spitz claims that we have "assimilated much that is central to the psychoanalytic point of view" (1985: 50).

48 In so far as hagiography can be defined as an exemplary life written by a believer (Heffernan 1988: 16), and the definition of belief is carried lightly, this work qualifies.

49 Showalter continues: "Quest narratives all involve a penetration to the imagined centre of an exotic civilization, the core, Kôr, coeur, or heart of darkness which is a blank place on the map, a realm of the unexplored and unknown. For the fin-de-siècle writers, this free space is usually Africa, the 'dark continent,' or a mysterious district of the East, a place inhabited by another and darker race" (1990: 81).

50 R. Bruce Elder names the encounter with Amerindians as one of three primal experiences that distinguish Canadians. "Settlers arriving in Canada in the nineteenth century and even into the twentieth century confronted a three-pronged challenge to the ideas they brought with them. First, they faced great diversity among the people who were forging a new country and a new political unity. Secondly, they encountered the Amerindians, whose way of life, beliefs and relationship to nature was far different from their own. Thirdly, they encountered a landscape that was inhospitable and seemed intractable to any familiar conceptual system. Nothing could have been more out of place in this environment than Wordsworthian rhapsodies about the tranquil glories of nature" (1989: 16). Emily Carr's vision is focused on two of those encounters, that with the Indians and that with the landscape. To the extent that those primal experiences cast their shadows over future generations, Carr's image offers a vital encounter of the biographical kind.

51 Many of the cultural critics and historians intent on writing women's experience into the record have questioned the assumptions of modernism in the West. In the context of this study examples are Parker and Pollock (1981), Pollock on her own (1988), Duncan (1982), Pearce (1991) and Greer (1988).

52 For a thoughtful account of her own awareness of Carr's sexuality as a result of the 1990 show at the National Gallery in Ottawa, see Joan Murray, "The Passion of Emily Carr" (1990).

53 In her forceful essay, "Construction of the Imaginary Indian," Marcia Crosby (who writes as a Haida/Tsimpsian woman) implicates Emily Carr in her analysis of cultural boundaries. Using the force of postmodern categorical rearranging, she describes her own encounter with Euro-Canadian cultural habits, her "uncomfortable recognition of the dominant culture once again engaged in a conversation with itself, using First Nations people to measure itself, to define who it is or is not" (1991: 271). Crosby's words mirror Virginia Woolf's earlier claim that the libraries that disallowed her presence—containing, as they did, books written by, about and for

men—contained thought relevant to neither her experience nor her history.

See also Robert Linsley, "Painting and the Social History of British Columbia," which is mentioned by Fulford, and other essays written in *Vancouver Anthology: The Institutional Politics of Art* (1991), edited by Stan Douglas.

AFTER LIFE

1 The mention of Carr's name seldom fails to elicit accounts of the impact her life, either as a model, a source of inspiration or simply as the story of an interesting Canadian. Only occasionally is her name unfamiliar.
2 That female medieval mystics, a select group of women in Europe that included Hildegard of Bingen, Catherine of Sienna and Margery Kempe, are of interest at present testifies to the rare emergence of unusually developed women's spirituality.

References and Sources Consulted

On Emily Carr

Adams, Tim Dow. 1992. "'Painting Above Paint': Telling Li(v)es in Emily Carr's Literary Self-Portrait." *Journal of Canadian Studies/Revue d'études canadiennes* 27, 2: 37–48.

Amsden, Philip. 1947. "Memories of Emily Carr." *Canadian Forum* 27 (December): 206.

Barton, John. 1987. *West of Darkness: A Portrait of Emily Carr*. Kapuskasing: Penumbra Press.

Blanchard, Paula. 1987. *The Life of Emily Carr*. Seattle: University of Washington Press.

Breuer, Michael, and Kerry Mason Dodd. 1984. *Sunlight in the Shadows: The Landscape of Emily Carr*. Toronto: Oxford University Press.

Brown, Laurie. 1994. "Documentary: The Writings of Emily Carr." *Prime Time News*, 21 January. Toronto: Canadian Broadcasting Corporation.

Buchanan, Donald W. 1941. "The Gentle and the Austere—a Comparison in Landscape Painting." *University of Toronto Quarterly* 11 (October): 72–77.

_____. 1950. "Emily Carr (1871-1945): An Expressionist among the Totem Poles." In *The Growth of Canadian Painting*. London: Collins.

Burns, Flora Hamilton. 1966. "Emily Carr." In *The Clear Spirit: Twenty Canadian Women and Their Times*. Edited by Mary Quayle Innis. Toronto: University of Toronto Press.

Carr, Emily. 1945. *Emily Carr: Her Paintings and Drawings*. Toronto: Oxford University Press.

_____. 1953. *Pause: A Sketch Book*. Toronto: Clarke, Irwin.

_____. 1972. *Fresh Seeing: Two Addresses by Emily Carr*. Toronto: Clarke, Irwin.

_____. 1986. *The Book of Small*. Toronto: Irwin.

_____. 1986. *Growing Pains: The Autobiography of Emily Carr*. Toronto: Irwin.

_____. 1986. *The House of All Sorts*. Toronto: Irwin.

_____. 1986. *Hundreds and Thousands: The Journals of Emily Carr*. Toronto: Irwin.

_____. 1986. *Klee Wyck*. Toronto: Irwin.

————. 1986. *The Heart of a Peacock*. Edited by Ira Dilworth. Toronto: Irwin.

————. 1993. *The Emily Carr Omnibus*. Introduction by Doris Shadbolt. Vancouver: Douglas & McIntyre.

Coburn, Kathleen. 1945. "Emily Carr: In Memoriam." *Canadian Forum* 25 (April): 24.

Cole, Douglas. 1989. Review of *The Life of Emily Carr* by Paula Blanchard. *Canadian Historical Review* 70, 1: 128-29.

Coleman, M. E. 1947. "Emily Carr and Her Sisters." *Dalhousie Review* 27, 1 (April): 29-32.

Crean, Susan. 1991. "The Female Gaze: If You Knew Emily: A Reevaluation of Carr's Painting and Writing." *Canadian Art* 8, 1: 17-18.

Daly, Thomas C. 1945. "To Emily Carr Art and Writing were Twins." *Saturday Night* 61 (15 December): 28.

Daniells, Roy. 1962. "Emily Carr." In *Our Living Tradition*. 4th series. Edited by Robert L. McDougall. Toronto: University of Toronto Press.

Davies, Robertson. 1941. "The Revelation of Emily Carr." *Saturday Night* 57 (8 November): 18.

Davis, Ann. 1993. "Emily Carr's Search for God." *The Literary Review of Canada* 2, 2 (February): 11-13.

Dilworth, Ira. 1941a. "Emily Carr—Canadian Artist-Author." *Saturday Night* 57 (1 November): 26.

————. 1941b. "Emily Carr—Canadian Painter and Poet in Prose." *Saturday Night* 57 (8 November): 26.

————. 1945. "Emily Carr, Biographical Sketch." In *Emily Carr: Her Paintings and Drawings*. Toronto: Oxford University Press.

Duval, Paul. 1945. "Emily Carr's Was a Growing Art." *Saturday Night* 61 (3 November): 4-5.

Fenton, Terry. 1978. "Two Isolated Modernists [David Milne and Emily Carr]." In *Modern Painting in Canada: Major Movements in Twentieth Century Canadian Art*. Terry Fenton and Karen Wilkin. Edmonton: Hurtig Publishers.

Fulford, Robert. 1993. "The Trouble with Emily: How Canada's Greatest Woman Painter Ended Up on the Wrong Side of the Political Correctness Debate." *Canadian Art* 10, 4: 32-39.

Gowers, Ruth. 1987. *Emily Carr*. Leamington Spa, Hamburg and New York: Berg.

Harris, Lawren. 1941. "Emily Carr and Her Work." *Canadian Forum* 21 (December): 277-78.

————. 1945. "The Paintings and Drawings of Emily Carr." In *Emily Carr: Her Paintings and Drawings*. Toronto: Oxford University Press.

Hembroff-Schleicher, Edythe. 1969. *m. e.: A Portrayal of Emily Carr*. Toronto: Clarke, Irwin.

————. 1978. *Emily Carr: The Untold Story*. Saanichton: Hancock House.

Henry, Lorne J. 1950. *Canadians: A Book of Biographies*. Toronto: Longmans.

Herbert, Emily. 1957. "Carr, Emily." *Encyclopedia Canadiana* 2: 251-52. Ottawa: Grolier.

Hubbard, R. H. 1960. "Biographies of Artists: Carr, M. Emily." In *An Anthology of Canadian Art*. Toronto: Oxford University Press.

Humphrey, Ruth. 1958. "Emily Carr—An Appreciation." *Queen's Quarterly* 65 (Summer): 270-76.

————. 1972. "Letters from Emily Carr." *University of Toronto Quarterly* 41, 2 (Winter): 93-150.

————. 1974. "Maria Tippett: 'A Paste Solitaire in a Steel-Claw Setting': Emily Carr and Her Public" (A Reply). *BC Studies* 23 (Fall): 47-49.

Kilbourn, Rosemary. 1967. "*Hundreds and Thousands*." *Tamarack Review* (Spring): 76-77.

Kirk, Heather. 1994. "Will the Real Emily Carr Please Stand Up?" *The Literary Review of Canada* 3, 6 (June): 16-17.

Kröller, Eva-Marie. 1986. "Literary Versions of Emily Carr." *Canadian Literature* 109 (Summer): 87-98.

Lord, Barry. 1974. "The Achievement of Emily Carr." In *The History of Painting in Canada: Toward a People's Art*. Toronto: NC Press.

McInnes, Graham. 1946. *Klee Wyck*. National Film Board (film).

————. 1950. *Canadian Art*. Toronto: Macmillan.

Marchessault, Jovette. 1990a. *Emily Carr: A Shaman's Voyage*. Canadian Broadcasting Corporation Sextet Series (radio play).

————. 1990b. *Le Voyage Magnifique d'Emily Carr*. Ottawa: Leméac Éditeur.

————. 1992. *The Magnificent Voyage of Emily Carr*. Translated by Linda Gaboriau. Vancouver: Talonbooks.

Mays, John Bentley. 1990. "Signs of Struggle." *The Globe and Mail*, 7 July, pp. C1, C11.

————. 1994. "Squabble Over Carr the Woman Muddies Critique of Her Painting." *The Globe and Mail*, 9 April, p. C15.

Moray, Gerta. 1990. "Constructing a National Canadian Art: The Legend of Emily Carr." Paper presented at the UAAC Conference, Montreal.

————. 1993. "Northwest Coast Culture and the Early Indian Paintings of Emily Carr, 1899-1913." Ph.D. diss., University of Toronto.

Murray, Joan. 1990. "The Passion of Emily Carr." *Journal of Canadian Studies* 25, 3: 167-70.

Neering, Rosemary. 1975. *Emily Carr*. Don Mills: Fitzhenry and Whiteside.

Parkinson, Edward John. 1988. "Reading and Writing Emily Carr." M.A. thesis, McMaster University, Hamilton.

Patterson, Nancy-Lou. 1967. *Emily Carr*. Waterloo, ON: Theatre of the Arts, University of Waterloo.

Pearson, Carol. 1954. *Emily Carr as I Knew Her*. Toronto: Clarke, Irwin.

Reid, Dennis. 1973. "Emily Carr, LeMoine Fitzgerald, and David Milne." In *A Concise History of Canadian Painting*. Toronto: Oxford University Press.

Ricou, Laurie. 1987. "Emily Carr and the Language of Small." In *Everyday Magic: Child Languages in Canadian Literature*. Vancouver: University of British Columbia Press.

Ryley, Nancy. 1975. *Little Old Lady on the Edge of Nowhere*. Canadian Broadcasting Corporation (film).

Sanders, Bryne Hope. 1958. *Carr, Hind, Gullen, Murphy. Famous Women*. Toronto: Clarke, Irwin.

Shadbolt, Doris. 1971. "Emily Carr: Legend and Reality." *arts canada* (June-July): 17-21.

————. 1975. *Emily Carr*. North Vancouver: J. J. Douglas.

————. 1987 [1979]. *The Art of Emily Carr*. Vancouver: Douglas and McIntyre.

————. 1990. *Emily Carr*. Vancouver and Toronto: Douglas and McIntyre.

Smith, Peter L. 1980. "Emily Carr: A Review Article." *BC Studies* 45 (Spring): 128-34.

Stacton, David Derek. 1950-51. "The Art of Emily Carr." *Queen's Quarterly* 57, 4: 499-509.

Stich, K. P. 1984. "Painters' Words: Personal Narratives of Emily Carr and William Kurelek." *Essays on Canadian Writing* 29 (Summer): 152-74.

Street, Linda. 1979. "Emily Carr, Lawren Harris and Theosophy, 1927-1933." M.A. thesis, Institute of Canadian Studies, Carleton University, Ottawa.

Taylor, Charles. 1977. "Emily Carr." In *Six Journeys: A Canadian Pattern*. Toronto: Anansi.

Thom, Ian M. 1991. *Emily Carr in France*. Vancouver: Vancouver Art Gallery.

Thom, William Wylie. 1969. "Emily Carr in Vancouver: 1906-1913." In "The Fine Arts in Vancouver, 1886-1930: An Historical Survey." M.A. thesis, University of British Columbia, Vancouver.

Tippett, Maria. 1973-74. "'A Paste Solitaire in a Steel-Claw Setting': Emily Carr and Her Public." *BC Studies* 20 (Winter): 3-14.

————. 1974. "Who 'Discovered' Emily Carr?" *Journal of Canadian Art History* 1, 2 (Fall): 30-34.

————. 1979. *Emily Carr: A Biography*. Toronto: Oxford University Press.

————. 1991. "Art as Act: Emily Carr's Vision of the Landscape." In *The True North: Canadian Landscape Painting 1896-1939*. Edited by Michael Tooby. London: Lund Humphries/Barbican Art Gallery.

Tippett, Maria, and Douglas Cole. 1977. "The First Conscious Expression of the Rhythm of Life: Emily Carr." In *From Desolation to Splendour: Changing Perceptions of the British Columbia Landscape*. Toronto: Clarke, Irwin.

Turpin, Marguerite. 1965. *The Life and Work of Emily Carr (1871-1945): A Selected Bibliography*. Vancouver: School of Librarianship, University of British Columbia.

Walker, Doreen, ed. 1990. *Dear Nan: Letters of Emily Carr, Nan Cheney and Humphrey Toms*. Vancouver: University of British Columbia Press.

Walker, Stephanie Kirkwood. 1995. "Lives of the Avant-garde Artist: Emily Carr and William Kurelek." In *Art and Interreligious Dialogue: Six Perspectives*. Edited by Michael S. Bird. New York: University Press of America.

Wallace, William Stewart. 1963. "Carr, Emily." In *The Macmillan Dictionary of Canadian Biography*, 16. Toronto: Macmillan.

Watson, Scott. 1994. Letter to the Editor, *Canadian Art* 11, 1 (Spring): 5.

Westra, Monique Kaufman. 1980. "Two Views of Emily Carr." *artsmagazine* (September/October): 23-26.

Whitfield, Eileen. 1992. *Alice and Emily*. Unpublished play performed on the Rice Stage at the Citadel Theatre, Edmonton. Directed by Floyd Favel.

GENERAL BIBLIOGRAPHY

Aitken, Johan Lyall. 1987. *Masques of Morality: Females in Fiction*. Toronto: Women's Press.

Allen, Paula Gunn. 1986. *The Sacred Hoop: Recovering the Feminine in American Indian Traditions*. Boston: Beacon Press.

Annan, Noel. 1955. "The Intellectual Aristocracy." In *Studies in Social History*. Edited by J. H. Plumb. London: Longmans Green.

Ascher, Carol, Louise DeSalvo, and Sara Ruddick. 1984. *Between Women: Biographers, Novelists, Critics, Teachers and Artists Write about Their Work on Women*. Boston: Beacon Press.

Auerbach, Nina. 1982. *Woman and the Demon: The Life of a Victorian Myth*. Cambridge and London: Harvard University Press.

Barman, Jean. 1991. *The West Beyond the West: A History of British Columbia*. Toronto: University of Toronto Press.

Bateson, Mary Catherine. 1990. *Composing a Life*. Markham: Plume/Penguin.

Battersby, Christine. 1989. *Gender and Genius: Towards a Feminist Aesthetics*. Bloomington and Indianapolis: Indiana University Press.

Beebe, Maurice. 1964. *Ivory Towers and Sacred Founts: The Artist as Hero in Fiction from Goethe to Joyce*. New York: New York University Press.

Bell, Clive. 1987 [1914]. *Art*. Edited by J. B. Bullen. London: Oxford University Press.

Bell, Millicent. 1989. "Lytton Strachey's *Eminent Victorians*." In *The Biographer's Art: New Essays*. Edited by Jeffrey Meyers. London: Macmillan.

Bell, Susan Groag, and Marilyn Yalom, eds. 1990. *Revealing Lives: Autobiography, Biography and Gender*. Albany: State University of New York Press.

Benstock, Shari. 1986. *Women of the Left Bank: Paris, 1900-1940*. Austin: University of Texas Press.

————. 1988. "Authorizing the Autobiographical." In *The Private Self: Theory and Practice of Women's Autobiographical Writings*. Edited by Shari Benstock. Chapel Hill and London: University of North Carolina Press.

Berger, Carl. 1970. "Mission." In *The Sense of Power: Studies in the Ideas of Canadian Imperialism 1867-1914*. Toronto: University of Toronto Press.

Berger, Peter. 1967. *The Sacred Canopy: Elements of a Sociological Theory of Religion*. Garden City, NY: Anchor Books.

Bibby, Reginald. 1987. *Fragmented Gods: The Poverty and Potential of Religion in Canada*. Toronto: Irwin.

Bloom, Lynn Z. 1980. "Popular and Super-Pop Biographies: Definitions and Distinctions." *biography* 3, 3: 225-39.

Borsa, Joan. 1990. "Towards a Politics of Location: Rethinking Marginality." *Canadian Woman Studies* 11, 1: 36-39.

Bosworth, Patricia. 1984. *Diane Arbus: A Biography*. New York: Avon.

Bradbury, Malcolm. 1988. "The Telling Life: Some Thoughts on Literary Biography." In *The Troubled Face of Biography*. Edited by Eric Homberger and John Charmley. London: Macmillan Press.

Brandt, Gail Cuthbert. 1991. "Postmodern Patchwork: Some Recent Trends in the Writing of Women's History in Canada." *Canadian Historical Review* 72, 4: 441-70.

Braudy, Leo. 1986. *The Frenzy of Renown: Fame and Its History*. New York: Oxford University Press.

Brodzki, Bella, and Celeste Schenk. 1988. *Life/Lines: Theorizing Women's Autobiography*. Ithaca: Cornell University Press.

Broude, Norma. 1982. "Degas's 'Misogyny.'" In *Feminism and Art History: Questioning the Litany*. Edited by Norma Broude and Mary D. Garrard. New York: Harper & Row.

Brooker, Bertram, ed. 1929. *Yearbook of the Arts in Canada: 1928-1929*. Toronto: Macmillan.

Bromwich, David. 1984. "The Uses of Biography." *Yale Review* 73, 2: 161-76.

Bruss, Elizabeth W. 1982. *Beautiful Theories: The Spectacle of Discourse in Contemporary Criticism*. Baltimore: Johns Hopkins University Press.

Bucke, Richard Maurice. 1974 [1901]. *Cosmic Consciousness: A Study in the Evolution of the Human Mind*. New York: Causeway.

Buckley, Jerome Hamilton. 1984. *The Turning Key: Autobiography and the Subjective Impulse since 1800*. Cambridge: Harvard University Press.

Buss, Helen M. 1990a. "The Different Voice of Canadian Feminist Autobiographers." *biography* 13, 2: 154-67.

————. 1990b. "Women and the Garrison Mentality: Pioneer Women Autobiographers and their Relation to the Land." In *Re(Dis)covering Our Foremothers: Nineteenth-Century Canadian Women Writers*. Edited by Lorraine McMullen. Ottawa: University of Ottawa Press.

Bynum, Caroline Walker. 1984. "Women's Stories, Women's Symbols: A Critique of Victor Turner's Theory of Liminality." In *Anthropology and the Study of Religion*. Edited by Robert L. Moore and Frank E. Reynolds. Chicago: Centre for the Scientific Study of Religion.

————. 1982. "Did the Twelfth Century Discover the Individual?" In *Jesus as Mother: Studies in the Spirituality of the High Middle Ages*. Berkeley: University of California Press.

Calvino, Italo. 1979. *If on a Winter's Night a Traveler*. New York: Harcourt Brace Jovanovich.

————. 1988. *Six Memos for the Next Millenium*. Cambridge: Harvard University Press.

Cameron, Elspeth. 1990. "Biography and Feminism." In *Language in Her Eye: Views on Writing and Gender by Canadian Women Writing in English*. Edited by Libby Scheier, Susan Sheard and Eleanor Wachtel. Toronto: Coach House Press.

Canada. House of Commons. Special Committee on Reconstruction and Re-establishment. 1944. *Minutes of Proceedings and Evidence*. Ottawa: King's Printer.

Caws, Mary Ann, Rudolph Kuenzli and Gwen Raaberg, eds. 1990. *Surrealism and Women*. Cambridge, MA: MIT Press.

Charmé, Stuart L. 1984. *Meaning and Myth in the Study of Lives: A Sartrean Perspective*. Philadelphia: University of Pennsylvania Press.

Chicago, Judy. 1993 [1975]. *Through the Flower: My Struggles as a Woman Artist*. New York: Penguin.

Christ, Carol P., and Charlene Spretnak. 1982. "Images of Spiritual Power in Women's Fiction." In *The Politics of Women's Spirituality: Essays on the Rise of Spiritual Power within the Feminist Movement*. Garden City: Anchor Books.

Clark, Suzanne. 1991. *Sentimental Modernism: Women Writers and the Revolution of the Word*. Bloomington and Indianapolis: Indiana University Press.

Clifford, James. 1988. *The Predicament of Culture: Twentieth-Century Ethnography, Literature and Art*. Cambridge, MA: Harvard University Press.

Clifford, N. Keith. 1985. "His Dominion: A Vision in Crisis." In *Religion and Culture in Canada*. Edited by Peter Slater. [Waterloo, ON]: Canadian Corporation for Studies in Religion.

Cockshut, A.O.J. 1974. *Truth to Life: The Art of Biography in the Nineteenth Century*. New York: Harcourt, Brace, Jovanovich.

Cole, Douglas. 1974. "Painting in British Columbia: A Review Article." *BC Studies* 23 (Fall): 50-53.

Colgate, William. 1941. *Canadian Art: Its Origins and Development*. Toronto: Ryerson.

Comfort, Charles. 1951. "Painting." In *Royal Commission Studies on National Development in the Arts, Letters and Sciences*. Ottawa: King's Printer.

Cook, Ramsay. 1985. *The Regenerators: Social Criticism in Late Victorian English Canada*. Toronto: University of Toronto Press.

Crane, Diana. 1987. *The Transformation of the Avant-Garde: The New York Art World, 1945-1985*. Chicago: University of Chicago Press.

Crosby, Marcia. 1991. "Construction of the Imaginary Indian." In *Vancouver Anthology: The Institutional Politics of Art*. Edited by Stan Douglas. Vancouver: Talonbooks.

Culpepper, Emily. 1991. "The Spiritual, Political Journey of a Feminist Freethinker." In *After Patriarchy: Feminist Transformations of the World Religions*. Edited by Paula M. Cooey, William R. Eakin and Jay B. McDaniel. Maryknoll, NY: Orbis Books.

Currie, Dawn H., and Valerie Raoul. 1992. "The Anatomy of Gender: Dissecting Sexual Difference in the Body of Knowledge." In *Anatomy of Gender: Women's Struggle for the Body*. Ottawa: Carleton University Press.

Darnton, Robert. 1985. "Peasants Tell Tales: The Meaning of Mother Goose." In *The Great Cat Massacre and Other Episodes in French Cultural History*. New York: Vintage Books.

Davaney, Sheila Greeve. 1987. "The Limits of the Appeal to Women's Experience." In *Shaping New Vision: Gender and Values in American Culture*. Edited by Clarissa W. Atkinson et al. Ann Arbor: WMI Research Press.

Davis, Ann. 1992. *The Logic of Ecstasy: Canadian Mystical Painting 1920-1940*. Toronto: University of Toronto Press.

DeBerg, Betty A. 1990. *Ungodly Women: Gender and the First Wave of American Fundamentalism*. Minneapolis: Fortress Press.

Dijkstra, Bram. 1969. *Idols of Perversity: Fantasies of Feminine Evil in Fin-de-Siècle Culture*. New York: Oxford University Press.

Douglas, George H. 1986. *Women of the Twenties*. Dallas: Saybrook.

Doyle, James. 1990. "Canadian Women Writers and the American Literary Milieu of the 1890s." In *Re(Dis)covering Our Foremothers: Nineteenth-Century Canadian Women Writers*. Edited by Lorraine McMullen. Ottawa: University of Ottawa Press.

Dreyfus, Hubert L., and Paul Rabinow. 1983. *Michel Foucault: Beyond Structuralism and Hermeneutics*. 2d ed. Chicago: University of Chicago Press.

Duncan, Carol. 1982. "Virility and Domination in Early Twentieth-Century Vanguard Painting." In *Feminism and Art History: Questioning the Litany*. Edited by Norma Broude and Mary D. Garrard. New York: Harper & Row.

Dunning, William V. 1991. *Changing Images of Pictorial Space: A History of Spatial Illusion in Painting*. Syracuse: Syracuse University Press.

Eagleton, Terry. 1983. *Literary Theory*. Oxford: Basil Blackwell.

Eck, Diana L., and Devaki Jain, eds. 1987. *Speaking of Faith: Global Perspectives on Women, Religion and Social Change*. Santa Cruz: New Society.

Edel, Leon. 1980. *Bloomsbury: A House of Lions*. New York: Avon.

———. 1984a. *Writing Lives: Principia Biographica*. New York and London: W. W. Norton.

———. 1984b. "Transference: The Biographer's Dilemma." *Biography* 7, 4: 284-91.

Elder, R. Bruce. 1989. *Image and Identity: Reflections on Canadian Film and Culture*. Waterloo, ON: Wilfrid Laurier University Press.

Eliade, Mircea. 1990. *Symbolism, the Sacred, and the Arts*. Edited by Diane Apostolos-Cappadona. New York: Crossroad.

Eliot, Thomas Stearns. 1949. *Four Quartets*. London: Faber and Faber.

———. 1948. *Notes Towards the Definition of Culture*. London: Faber and Faber.

Epstein, William H. 1983. "Recognizing the Life-Text: Towards a Poetics of Biography." *Biography* 6, 4: 283-306.

Eysteinsson, Astradur. 1990. *The Concept of Modernism*. Ithaca: Cornell University Press.

Felski, Rita. 1989. *Beyond Feminist Aesthetics: Feminist Literature and Social Change*. Cambridge: Harvard University Press.

Felman, Shoshana. 1989. *Jacques Lacan and the Adventure of Insight*. Cambridge: Harvard University Press.

Flanagan, Thomas. 1979. *Louis David Riel: Prophet of the New World*. Halifax: Goodread Biographies.

———. 1982. "Problems of Psychobiography." *Queen's Quarterly* 89, 3: 596-610.

Flax, Jane. 1990. *Thinking Fragments: Psychoanalysis, Feminism, & Postmodernism in the Contemporary West*. Berkeley: University of California Press.

Fleishman, Avrom. 1983. *Figures of Autobiography: The Language of Self-Writing in Victorian and Modern England*. Berkeley: University of California Press.

Fox-Genovese, Elizabeth. 1991. *Feminism Without Illusions: A Critique of Individualism*. Chapel Hill and London: University of North Carolina Press.

Foucault, Michel. 1974. "What Is an Author?" In *Textual Strategies: Perspectives in Post-Structuralist Criticism*. Edited by Josué V. Harari. Ithaca, NY: Cornell University Press.

Franco, Jean. 1991. " 'Manhattan Will Be More Exotic this Fall': The Iconisation of Frida Kahlo." *Women: A Cultural Review* 2, 3: 220-27.

Frank, Katherine. 1980. "Writing Lives: Theory and Practice in Literary Biography." *Genre* 13 (Winter): 499-516.

Freiwald, Bina. 1990. " 'The Tongue of Woman': The Language of the Self in Moodie's *Roughing It in the Bush*." In *Re(Dis)covering Our Foremothers: Nineteenth-Century Canadian Women Writers*. Edited by Lorraine McMullen. Ottawa: University of Ottawa Press.

French, Marilyn. 1992. *The War Against Women*. Toronto: Summit Books.

Friedman, Susan Stanford. 1988. "Women's Autobiographical Selves: Theory and Practice." In *The Private Self: Theory and Practice of Women's Autobiographical Writings*. Edited by Shari Benstock. Chapel Hill and London: University of North Carolina Press.

Fromm, Harold. 1985. "Recycled Lives: Portraits of the Woolfs as Sitting Ducks." *Virginia Quarterly Review* 61, 3: 396-417.

Frye, Joanne S. 1986. *Living Stories, Telling Lives: Women and the Novel in Contemporary Experience*. Ann Arbor: University of Michigan Press.

Frye, Northrop. [1971]. *The Bush Garden: Essays on the Canadian Imagination*. [Toronto]: Anansi.

Fuller, Peter. 1988a. *Art and Psychoanalysis*. London: Hogarth Press.

————. 1988b. *Theoria: Art, and the Absence of Grace*. London: Chatto & Windus.

————. 1990. *Images of God: The Consolations of Lost Illusions*. London: Hogarth Press.

Gablik, Suzi. 1984. *Has Modernism Failed?* New York: Thames and Hudson.

Geertz, Clifford. 1973. *The Interpretation of Cultures*. New York: Basic Books.

————. 1976. "Art as a Cultural System." *MLN* 91: 1473-99.

Geiger, Susan N. G. 1986. "Women's Life Histories: Method and Content." *Signs: Journal of Women in Culture and Society* 11, 2: 334-51.

Gifford, Don. 1990. *The Farther Shore: A Natural History of Perception*. New York: Atlantic Monthly Press.

Gilbert, Sandra Caruso Mortola, and Susan Dreyfuss David Gubar. 1987. "Ceremonies of the Alphabet: Female Grandmatologies and the Female Authorgraph." In *The Female Autograph: Theory and Practice of Autobiography from the Tenth to the Twentieth Century*. Edited by Domna C. Stanton. Chicago: University of Chicago.

Gilbert, Sandra M., and Susan Gubar. 1979. In *The Madwoman in the Attic: The Woman Writer and the Nineteenth-Century Literary Imagination*. New Haven and London: Yale University Press.

_____. 1988. *No Man's Land: The Place of the Woman Writer in the Twentieth Century*. New Haven: Yale University Press.

Gillespie, Diane Filby. 1988. *The Sisters' Arts: The Writing and Painting of Virginia Woolf and Vanessa Bell*. Syracuse: Syracuse University Press.

Gilligan, Carol. 1982. *In a Different Voice: Psychological Theory and Women's Development*. Cambridge, MA: Harvard University Press.

Glendinning, Victoria. 1988. "Lies and Silences." In *The Troubled Face of Biography*. Edited by Eric Homberger and John Charmley. London: Macmillan.

Goldenberg, Naomi R. 1990. *Returning Words to Flesh: Feminism, Psychoanalysis, and the Resurrection of the Body*. Boston: Beacon.

Goldie, Terry. 1989. *Fear and Temptation: The Image of the Indigene in Canadian, Australian and New Zealand Literature*. Kingston, Montreal and London: McGill-Queen's University Press.

Grant, George P. 1951. "Philosophy." In *Royal Commission Studies on National Development in the Arts, Letters and Sciences*. Ottawa: King's Printer.

Grant, John Webster. 1967. "The Church and Canada's Self-Awareness." *Canadian Journal of Theology* 13, 3: 155-64.

_____. 1985. "Religion and the Quest for a National Identity: The Background in Canadian History." In *Religion and Culture in Canada*. Edited by Peter Slater. [Waterloo, ON]: Canadian Corporation for Studies in Religion.

_____. 1988. *The Church in the Canadian Era*. Burlington: Welch Publishing.

Granatstein, J. L. 1985. "The Anglocentrism of Canadian Diplomacy." In *Canadian Culture: International Dimensions*. Edited by Andrew Fenton Cooper. Waterloo, ON: Centre on Foreign Policy and Federalism, University of Waterloo/Wilfrid Laurier University; Canadian Institute of International Affairs.

Greer, Germaine. 1979. "The Nineteenth Century." In *The Obstacle Race: The Fortunes of Women Painters and their Work*. London: Picador.

Griffin, Gail. 1978. "The Autobiographer's Dilemma: Ruskin's Praeterita." In *Interspace and the Inward Sphere: Essays on Romantic and Victorian Self*. Edited by Norman A. Anderson and Margene E. Weiss. Macomb, IL: Western Illinois University.

Grosskurth, Phyllis. 1985. "Search and Psyche: The Writing of Biography." *English Studies in Canada* 11, 2: 145-56.

Grosz, Elizabeth. 1990. *Jacques Lacan: A Feminist Introduction*. London and New York: Routledge.

Gunn, Giles. 1987. *The Culture of Criticism and the Criticism of Culture*. New York: Oxford University Press.

Gunn, Janet Varner. 1982. *Autobiography: Toward a Poetics of Experience*. Philadelphia: University of Pennsylvania Press.

Gusdorf, Georges. 1980. "Conditions and Limits of Autobiography." In *Autobiography: Essays Theoretical and Critical*. Edited by James Olney. Princeton: Princeton University Press.

Hall, Jacquelyn Dowd. 1987. "Second Thoughts: On Writing a Feminist Biography." *Feminist Studies* 13, 1: 19-37.

Halpin, Marjorie M. 1986. *Jack Shadbolt and the Coastal Indian Image*. Vancouver: University of British Columbia Press.

Hanning, Robert W. 1966. *The Vision of History in Early Britain*. New York: Columbia University Press.

Hanscombe, Gillian, and Virginia L. Smyers. 1987. *Writing for Their Lives: The Modernist Women 1910-1940*. Boston: Northeastern University Press.

Harrison, Beverly Wildung. 1989. "The Power of Anger in the Work of Love." In *Weaving the Visions: New Patterns in Feminist Spirituality*. Edited by Judith Plaskow and Carol P. Christ. San Francisco: HarperSanFrancisco.

Heffernan, Thomas J. 1988. *Sacred Biography: Saints and Their Biographers in the Middle Ages*. New York and Oxford: Oxford University Press.

Heilbrun, Carolyn G. 1988. *Writing a Woman's Life*. New York and London: W. W. Norton.

————. 1990. "Margaret Mead and the Question of Woman's Biography." In *Hamlet's Mother and Other Women*. New York: Ballantine Books.

Hennell, Michael. 1958. *John Venn and the Clapham Sect*. London: Lutterworth Press.

Herrera, Hayden. 1983. *Frida: A Biography of Frida Kahlo*. New York: Harper & Row.

Heyck, Thomas William. 1982. *The Transformation of Intellectual Life in Victorian England*. New York: St. Martin's Press.

Higonnet, Anne. 1990. *Berthe Morisot*. New York: Harper & Row.

Hoberman, Ruth. 1987. *Modernizing Lives: Experiments in English Biography, 1918-1939*. Carbondale: Southern Illinois University Press.

Holroyd, Michael. 1988. "How I Fell into Biography." In *The Troubled Face of Biography*. Edited by Eric Homberger and John Charmley. London: Macmillan.

Homberger, Eric, and John Charmley, eds. 1988. *The Troubled Face of Biography*. London: Macmillan.

Honan, Park. 1979. "The Theory of Biography." *Novel* 13, 1: 109-20.

hooks, bell. 1990. "Choosing the Margin as a Space of Radical Openness." In *Yearning: Race, Gender, and Cultural Politics*. Toronto: Between the Lines.

Housser, F. B. 1926. *A Canadian Art Movement: The Story of the Group of Seven*. Toronto: Macmillan.

Howarth, William L. 1980. "Some Principles of Autobiography." In *Autobiography: Essays Theoretical and Critical*. Edited by James Olney. Princeton: Princeton University Press.

Innis, Harold A. 1952. *The Strategy of Culture*. Toronto: University of Toronto Press.

Irigaray, Luce. 1985a. *Speculum of the Other Woman*. Translated by Gillian C. Gill. Ithaca: Cornell University Press.

————. 1985b. *This Sex which is Not One*. Translated by Catherine Porter with Carolyn Burke. Ithaca, NY: Cornell University Press.

Jackel, Susan. 1987. "Canadian Women's Autobiography: A Problem of Criticism." In *Gynocritics: Feminist Approaches to Canadian and Quebec Women's Writing*. Edited by Barbara Godard. Toronto: ECW Press.

Jameson, Fredric. 1983. "Postmodernism and Consumer Society." In *The Anti-Aesthetic: Essays on Postmodern Culture*. Edited by Hal Foster. Port Townsend, WA: Bay Press.

Jardine, Alice A. 1985. *Gynesis: Configurations of Woman and Modernity*. Ithaca: Cornell University Press.

Jay, Paul. 1984. *Being in the Text: Self-Representation from Wordsworth to Roland Barthes*. Ithaca: Cornell University Press.

Jelinek, Estelle C. 1986. *The Tradition of Women's Autobiography: From Antiquity to the Present*. Boston: Twayne Publishers.

Jones, Suzanne, ed. 1991. *Writing the Woman Artist: Essays on Poetics, Politics, and Portraiture*. Philadelphia: University of Pennsylvania Press.

Jouve, Nicole Ward. 1991. *White Woman Speaks with Forked Tongue: Criticism as Autobiography*. London and New York: Routledge.

Kamuf, Peggy. 1988. "Penelope at Work: Interruptions in *A Room of One's Own*." In *Feminism & Foucault: Reflections on Resistance*. Edited by Irene Diamond and Lee Quinby. Boston: Northeastern University Press.

Kandinsky, Wassily. 1977. *Concerning the Spiritual in Art*. Translated by M. T. H. Sadler. New York: Dover.

Kariel, Henry S. 1989. *The Desperate Politics of Postmodernisn*. Amherst: University of Massachusetts Press.

Karl, Frederick R. 1988. *Modern and Modernism: The Sovereignty of the Artist 1885-1925*. New York: Atheneum.

Kedward, H. R. 1970. "Modern Man in Search of His Art." In *The Social Context of Art*. Edited by Jean Creedy. London: Tavistock.

Keller, Catherine. 1986. *From a Broken Web: Separation, Sexism, and Self*. Boston: Beacon Press.

Kelly, Joan. 1986. "Did Women Have A Renaissance?" In *Women, History, and Theory: The Essays of Joan Kelly*. Chicago: University of Chicago Press.

Kempe, Margery. 1985. *The Book of Margery Kempe*. Translated by B. A. Windeatt. Harmondsworth: Penguin.

Kendall, Paul Murray. 1985 [1965]. *The Art of Biography*. New York and London: W. W. Norton.

Kern, Stephen. 1983. *The Culture of Time and Space 1880-1918*. Cambridge: Harvard University Press.

King, Winston L. 1987. "Religion." In *The Encyclopedia of Religion*. Vol. 12. New York: Macmillan.

Kleinberg, Aviad M. 1992. *Prophets in Their Own Country: Living Saints and the Making of Sainthood in the Later Middle Ages*. Chicago: University of Chicago Press.

Kline, Marcia B. 1970. *Beyond the Land Itself: Views of Nature in Canada and the United States*. Cambridge, MA: Harvard University Press.

Kolbenschlag, Madonna. 1988 [1979]. *Kiss Sleeping Beauty Good-Bye*. Toronto: Bantam.

Krauss, Rosalind E. 1986. *The Originality of the Avant-Garde and Other Modernist Myths*. Cambridge and London: MIT Press.

Kris, E., and Kurz, O. 1979. *Legend, Myth and Magic in the Image of the Artist: A Historical Experiment*. New Haven and London: Yale University Press.

Kroeber, A. L., and Clyde Kluckhohn. 1952. *Culture: A Critical Review of Concepts and Definitions*. New York: Vintage.

Lauter, Estella. 1984. *Women as Mythmakers: Poetry and Visual Art by Twentieth-Century Women*. Bloomington: Indiana University Press.

Lee, Dennis. 1977. *Savage Fields: An Essay in Literature and Cosmology*. Toronto: Anansi.

Lejeune, Phillipe. 1991. "The Genetic Study of Autobiographical Texts." *biography* 14, 1: 1-11.

Leonard, Ellen. 1990. "Experience as a Source for Theology: A Canadian and Feminist Perspective." *Studies in Religion/Sciences Religieuses* 19, 2: 143-62.

Linsley, Robert. 1991. "Painting and the Social History of British Columbia." In *Vancouver Anthology: The Institutional Politics of Art*. Edited by Stan Douglas. Vancouver: Talonbooks.

Lionnet, Françoise. 1989. *Autobiographical Voices: Race, Gender, Self-Portraiture*. Ithaca and London: Cornell University Press.

Lippard, Lucy. 1977. "Quite Contrary: Body, Nature, Ritual in Women's Art." *Chrysalis* 2: 31-47.

Lipsey, Roger. 1989. *An Art of Our Own: The Spiritual in Twentieth-Century Art*. Boston and Shaftesbury: Shambhala.

Lorde, Audre. 1989. "Uses of the Erotic." In *Weaving the Visions: New Patterns in Feminist Spirituality*. Edited by Judith Plaskow and Carol P. Christ. San Francisco: HarperSanFrancisco.

Lower, A. R. M. 1952. "The Massey Report." *Canadian Banker* 59: 22-32.

Lyons, John O. 1978. *The Invention of the Self: The Hinge of Consciousness in the Eighteenth Century*. Carbondale: Southern Illinois University Press.

Lynes, Barbara Buhler. 1989. *O'Keeffe, Steiglitz, and the Critics, 1916-1929*. Ann Arbor: UMI Research Press.

MacCannell, Dean. 1992. *Empty Meeting Grounds: The Tourist Papers*. London and New York: Routledge.

McFague, Sallie. 1982. *Metaphorical Theology: Models of God in Religious Language*. Philadelphia: Fortress.

McGowan, John. 1991. *Postmodernism and Its Critics*. Ithaca and London: Cornell University Press.

Macpherson, Jay. 1966. "Autobiography." In *Literary History of Canada: Canadian Literature in English*. Edited by Carl Klinck. Toronto: University of Toronto Press.

Maitland, Frederic W. 1906. *The Life and Letters of Leslie Stephen*. London: Duckworth.

Markus, Hazel Rose, and Shinobu Kitayama. 1991. "Culture and the Self: Implications for Cognition, Emotion, and Motivation." *Psychological Review* 98, 2: 224-53.

Marsh, Jan. 1989. *The Legend of Elizabeth Siddal*. New York: Quartet.

Mason, Mary G. 1980. "The Other Voice: Autobiographies of Women Writers." In *Autobiography: Essays Theoretical and Critical*. Edited by James Olney. Princeton: Princeton University Press.

Massey, Vincent. 1948. *On Being Canadian*. Toronto: J. M. Dent & Sons.

Middlebrook, Dianne Wood. 1990. "Postmodernism and the Biographer." In *Revealing Lives: Autobiography, Biography and Gender*. Edited by Susan Groag Bell and Marilyn Yalom. Albany: State University of New York Press.

Miller, Nancy K. 1991. *Getting Personal: Feminist Occasions and Other Autobiographical Acts*. New York and London: Routledge.

Monroe, Harriet. 1969 [1938]. *A Poet's Life: Seventy Years in a Changing World*. New York: AMS Press.

Morris, Robert. 1989. "Words and Images in Modernism and Postmodernism." *Critical Inquiry* 15 (Winter): 337-47.

Nasgaard, Roald. 1984. *The Mystic North: Symbolist Landscape Painting in Northern Europe and North America 1890-1940*. Toronto: Art Gallery of Ontario.

Nadel, Ira Bruce. 1984. *Biography: Fact, Fiction and Form*. New York: St. Martin's Press.

Neatby, Hilda. 1956. "The Massey Report: A Retrospect." *Tamarack Review* 1: 37-47.

Neuman, Shirley. 1990. "Life-Writing." In *Literary History of Canada: Canadian Literature in English*. Edited by W. H. New. Toronto: University of Toronto Press.

Nochlin, Linda. 1988 [1971]. "Why Have There Been No Great Women Artists?" In *Women, Art, and Power and Other Essays*. New York: Harper & Row.

Novak, Mark. 1985-86. "Biography After the End of Metaphysics: A Critique of Epigenetic Evolution." *International Journal of Aging and Human Development* 22, 3: 189-204.

Novarr, David. 1986. *The Lines of Life: Theories of Biography, 1880-1970*. West Lafayette, IN: Purdue University Press.

Ochs, Carol. 1983. *Women and Spirituality*. Totowa, NJ: Rowman & Allanheld.

Oelschlaeger, Max. 1991. *The Idea of Wilderness: From Prehistory to the Age of Ecology*. New Haven and London: Yale University Press.

Olivier, Christiane. 1989. *Jocasta's Children: The Imprint of the Mother*. New York: Routledge.

Olney, James. 1980. "Autobiography and the Cultural Moment: A Thematic, Historical, and Bibliographic Introduction." In *Autobiography: Essays Theoretical and Critical*. Edited by James Olney. Princeton: Princeton University Press.

Orenstein, Gloria Feman. 1987. "Jovette Marchessault: The Ecstatic Vision-Quest of the New Feminist Shaman." In *Gynocritics: Feminist Approaches to Canadian and Quebec Women's Writing*. Edited by Barbara Godard. Toronto: ECW Press.

Ortner, Sherry. 1974. "Is Female to Male as Nature Is to Culture?" In *Women, Culture, and Society*. Edited by Michelle Z. Rosaldo and Louise Lamphere. Stanford: Stanford University Press.

Orvell, Miles. 1989. *The Real Thing: Imitation and Authenticity in American Culture 1880-1940*. Chapel Hill: University of North Carolina Press.

Ostry, Bernard. 1978. *The Cultural Connection: An Essay on Culture and Government Policy in Canada*. Toronto: McClelland & Stewart.

O'Toole, Roger. 1985. "Society, the Sacred and the Secular: Sociological Observations on the Changing Role of Religion in Canadian Culture." In *Religion/Culture: Comparative Canadian Studies*. Edited by William Westfall et al. Ottawa: Association for Canadian Studies.

————. 1993. "In Quest of Hidden Gods in Canadian Literature." In *The Sociology of Religion: A Canadian Focus*. Edited by Warren E. Hewitt. Toronto: Butterworths of Canada.

Owen, Alex. 1989. *The Darkened Room: Women, Power, and Spiritualism in Late Nineteenth Century England*. London: Virago Press.

Owens, Craig. 1983. "The Discourse of Others: Feminists and Postmodernism." In *The Anti-Aesthetic: Essays on Postmodern Culture*. Edited by Hal Foster. Port Townsend, WA: Bay Press.

Pachter, Marc, ed. 1981. *Telling Lives: The Biographer's Art*. Philadelphia: University of Pennsylvania Press.

Paglia, Camille. 1992. "An Icon Named Diana." *The Globe and Mail*, 25 July, p. D5.

Parker, Rozsika, and Griselda Pollock. 1987. *Old Mistresses: Women, Art and Ideology*. New York: Pandora.

Peacock, James L. 1983. "Religion and Life History: An Exploration in Cultural Psychology." *Proceedings of the American Ethnological Society*, pp. 94-115.

Peake, Frank A. 1959. *The Anglican Church in British Columbia*. Vancouver: Mitchell Press.

Pearce, Lynne. 1991. *Woman/Image/Text: Readings in Pre-Raphaelite Art and Literature*. Toronto and Buffalo: University of Toronto Press.

Pearson, R. M. 1928. *How to See Modern Pictures*. New York: Dial Press.

Poggioli, Renato. 1968. *The Theory of the Avant-Garde*. Translated by Gerald Fitzgerald. Cambridge: Belknap Press of Harvard University Press.

————. 1970. "The Artist in the Modern World." In *The Sociology of Art and Literature*. Edited by M. Albrecht, J. Barnett and M. Griff. New York: Praeger.

Poirier. Richard. 1987. *The Renewal of Literature: Emersonian Reflections*. New Haven: Yale University Press.

Pollock, Griselda. 1988. *Vision & Difference: Femininity, Feminism and Histories of Art*. New York: Routledge, Chapman & Hall.

Pratt, Annis. 1981. *Archetypal Patterns in Women's Fiction*. Bloomington: Indiana University Press.

Prentice, Alison, et al. 1988. *Canadian Women: A History*. Toronto: Harcourt Brace Jovanovich.

Preuss, J. Samuel. 1991. "Secularizing Divination: Spiritual Biography and the Invention of the Novel." *Journal of the American Academy of Religion* 59, 3: 441-66.

Preziosi, Donald. 1989. *Rethinking Art History: Meditations on a Coy Science*. New Haven and London: Yale University Press.

Rabuzzi, Kathryn Allen. 1982. *The Sacred and the Feminine: Toward a Theology of Housework*. New York: Seabury Press.

————. 1988. "Women's Work and the Sense of Time in Women's Lives." In *Sacred Dimensions of Women's Experience*. Edited by Elizabeth Dodson Grey. Wellesley, MA: Roundtable Press.

Reid, Dennis. 1985. *Atma Buddhi Manas: The Later Work of Lawren S. Harris*. Toronto: Art Gallery of Toronto.

Reiss, Timothy J. 1982. *The Discourse of Modernism*. Ithaca: Cornell University Press.

Richter, Harvena. 1986. "The Biographer as Novelist." In *Essaying Biography: A Celebration for Leon Edel*. Edited by Gloria G. Fromm. Honolulu: Biographical Research Centre, University of Hawaii Press.

Robinson, Roxana. 1990. *Georgia O'Keeffe: A Life*. New York: Harper.

Rose, Phyllis. 1984. *Parallel Lives: Five Victorian Marriages*. New York: Vintage.

Rosen, Charles, and Henri Zerner. 1984. *Romanticism and Realism: The Mythology of Nineteenth-Century Art*. New York and London: Norton.

Ruether, Rosemary Radford. 1987. Foreword to *Speaking of Faith: Global Perspectives on Women, Religion and Social Change*. Edited by Diana L. Eck and Devaki Jain. Santa Cruz: New Society.

Runyan, William McKinley. 1980. "Alternative Accounts of Lives: An Argument for Epistemological Relativism." *biography* 3, 3: 202-24.

Sagan, Eli. 1988. *Freud, Women and Morality: The Psychology of Good and Evil*. New York: Basic Books.

Said, Edward W. 1979. "The Text, the World, the Critic." In *Textual Strategies: Perspectives in Post-Structuralist Criticism*. Edited by Josué V. Harari. London: Methuen.

————. 1983. "Opponents, Audiences, Constituencies, and Community." In *The Anti-Aesthetic: Essays on Postmodern Culture*. Edited by Hal Foster. Port Townsend, WA: Bay Press.

Saiving, Valerie. 1992. "The Human Situation: A Feminine View." In *Womanspirit Rising: A Feminist Reader in Religion*. Edited by Carol P. Christ and Judith Plaskow. San Francisco: HarperSanFrancisco.

Sanders, Valerie. 1989. *The Private Lives of Victorian Women: Autobiography in Nineteenth-Century England*. London: Harvester Wheatsheaf.

Say, Elizabeth A. 1990. *Evidence on Her Own Behalf: Women's Narrative as Theological Voice*. Savage, MD: Rowman & Littlefield.

Schwalm, David E. 1980. "Locating Belief in Biography." *biography* 3, 1: 14-27.

Schwartz, Sanford. 1985. *The Matrix of Modernism: Pound, Eliot, and Early Twentieth Century Thought*. Princeton: Princeton University Press.

Scott, Gail. 1989. *Spaces Like Stairs*. Toronto: The Women's Press.

Scott, Jay. 1989. *Changing Woman: The Life and Art of Helen Hardin*. Flagstaff, AZ: Northland Publishing.

Scott, Nathan A., Jr. 1970. "The 'Conscience' of the New Literature." In *The Shaken Realist*. Edited by J. Friedman and John B. Vickery. Baton Rouge: Louisiana State University Press.

Seajay, Carol. 1992. "Books: 20 Years of Feminist Bookstores." *Ms*. 3, 1: 60-63.

Sexson, Linda. 1982. *Ordinarily Sacred*. New York: Crossroad.

Shea, Albert Aber. 1952. *Culture in Canada: A Study of the Findings of the Royal Commission on National Development in the Arts, Letters and Sciences, 1949-51*. Toronto: CORE.

Showalter, Elaine. 1985. *The Female Malady: Women, Madness and English Culture, 1830-1980*. Harmondsworth: Penguin.

_____. 1990. *Sexual Anarchy: Gender and Culture at the Fin de Siècle*. Markham: Viking Penguin.

Sinclair, Jennifer Oille, ed. 1989. "Bertram Brooker and Emergent Modernism." In *Provincial Essays*. Vol. 7. Toronto: Phacops Publishing Society, The Coach House Press.

Skidelsky, Robert. 1988. "Only Connect: Biography and Truth." In *The Troubled Face of Biography*. Edited by Eric Homberger and John Charmley. London: Macmillan Press.

Slater, Peter. 1977. "Religion as Story: The Biography of Norman Bethune." In *Religion and Culture in Canada*. Edited by Peter Slater. [Waterloo, ON]: Canadian Corporation for Studies in Religion.

Smith, Bernard. 1988. *The Death of the Artist as Hero: Essays in History and Culture*. Oxford: Oxford University Press.

Smith, Frances K. 1980. *André Bieler: An Artist's Life and Times*. Toronto: Merritt Publishing.

Smith, Sidonie. 1987. *A Poetics of Women's Autobiography: Marginality and the Fictions of Self-Representation*. Bloomington and Indianapolis: Indiana University Press.

Snipes, Wilson. 1982. "The Biographer as a Center of Reference." *biography* 5, 3: 215-25.

Spacks, Patricia Meyer. 1980. "Selves in Hiding." In *Women's Autobiography: Essays in Criticism*. Edited by Estelle C. Jellinek. Bloomington: Indiana University Press.

_____. 1986. *Gossip*. Chicago: University of Chicago Press.

Spellman, Elizabeth V. 1988. *Inessential Woman: Problems of Exclusion in Feminist Thought*. Boston: Beacon Press.

Spengemann, William C. 1980. *The Forms of Autobiography: Episodes in the History of Autobiography*. New Haven: Yale University Press.

Spitz, Ellen Handler. 1985. *Art and Psyche: A Study in Psychoanalysis and Aesthetics*. New Haven: Yale University Press.

Sprinker, Michael. 1980. "Fictions of the Self: The End of Autobiography." In *Autobiography: Essays Theoretical and Critical*. Edited by James Olney. Princeton: Princeton University Press.

Spurling, Hilary. 1988. "Neither Morbid nor Ordinary." In *The Troubled Face of Biography*. Edited by Eric Homberger and John Charmley. London: Macmillan.

Stacey, Robert. 1991. "The Myth—and Truth—of the True North." In *The True North: Canadian Landscape Painting 1896-1939*. Edited by Michael Tooby. London: Lund Humphries/Barbican Art Gallery.

Stanton, Domna C. 1987. "Autogynography: Is the Subject Different?" In *The Female Autograph: Theory and Practice of Autobiography from the Tenth to the Twentieth Century*. Edited by Domna C. Stanton. Chicago: University of Chicago.

Steedman, Carolyn Kay. 1986. *Landscape for a Good Woman: The Story of Two Lives*. New Brunswick, NJ: Rutgers University Press.

Steinem, Gloria. 1992. *Revolution from Within: A Book of Self-Esteem*. Toronto: Little, Brown.

Steiner, George. 1971. *In Bluebeard's Castle: Some Notes Towards the Redefinition of Culture*. New Haven: Yale University Press.

————. 1989. *Real Presences*. Chicago: University of Chicago Press.

Strachey, Lytton. 1984 [1918]. *Eminent Victorians*. Harmondsworth: Penguin.

Strenski, Ivan. 1987. *Four Theories of Myth in Twentieth-Century History: Cassirer, Eliade, Levi-Strauss and Malinowski*. Iowa City: University of Iowa Press.

Strong-Boag, Veronica. 1988. *The New Day Recalled: Lives of Girls and Women in English Canada, 1919-1939*. Markham, ON: Penguin.

Symons, A. J. A. 1969. "Tradition in Biography." In *Essays and Biographies*. Edited by Julian Symons. London: Cassell.

Taylor, Charles. 1989. *Sources of the Self: The Making of Modern Identity*. Cambridge: Harvard University Press.

Taylor, Mark C. 1984. *Erring: A Postmodern A/theology*. Chicago: University of Chicago Press.

Teitelbaum, Robert. 1991. "Sighting the Single Tree, Sighting the New Found Land." In *Eye of Nature*. Based on exhibitions at the Walter Phillips Gallery, Banff, Alberta.

Thomas, Clara. 1976. "Biography in Canada." In *Literary History of Canada*. Edited by Carl F. Klinck. 2d ed. University of Toronto Press.

Thompson, Dorothy. 1990. *Queen Victoria: Gender & Power*. London: Virago Press.

Tippett, Maria, and Douglas Cole. 1977. *From Desolation to Splendour: Changing Perceptions of the British Columbia Landscape*. Toronto: Clarke, Irwin.

Tippett, Maria. 1990. *Making Culture: English Canadian Institutions and the Arts before the Massey Commission*. Toronto: University of Toronto Press.

Tooby, Michael. 1991. "Orienting the True North." In *The True North: Canadian Landscape Painting 1896-1939*. Edited by Michael Tooby. London: Lund Humphries/Barbican Art Gallery.

Torgovnick, Marianna. 1990. *Gone Primitive: Savage Intellects, Modern Lives*. Chicago: University of Chicago Press.

Tracy, David. 1987. *Plurality and Ambiguity: Hermeneutics, Religion, Hope*. San Francisco: Harper & Row.

Trofimenkoff, Susan Mann. 1985. "Feminist Biography." *Atlantis* 10, 2 (Spring): 1-10.

Tuchman, Maurice, et al. *The Spiritual in Art: Abstract Painting 1890-1950*. Los Angeles County Museum of Art. New York: Abbeville Press.

Turner, James. 1985. *Without God, Without Creed: The Origins of Unbelief in America*. Baltimore: Johns Hopkins University Press.

Turner, Victor. 1974. *Drama, Fields and Metaphors: Symbolic Action in Human Society*. Ithaca and London: Cornell University Press.

Wagner, Roy. 1981. *The Invention of Culture*. Rev. ed. Chicago: University of Chicago Press.

Walker, Doreen Elizabeth. 1969. "The Treatment of Nature in Canadian Art Since the Time of the Group of Seven." M.A. thesis, University of British Columbia, Vancouver.

Walker, Nancy. 1988. "Wider than the Sky: Public Presence and Private Self in Dickinson, James and Woolf." In *The Private Self: Theory and Practice of Women's Autobiographical Writings*. Edited by Shari Benstock. Chapel Hill and London: University of North Carolina Press.

Walker, Stephanie Kirkwood. 1994. "Brigit of Kildare as She Is: A Study of Biographical Image." *biography* 17, 2: 107-20.

Warner, Marina. 1981. *Joan of Arc: The Image of Female Heroism*. Harmondsworth: Penguin.

Watson, Scott. 1990. *Jack Shadbolt*. Vancouver: Douglas & McIntyre.

————. 1991. "Disfigured Nature: The Origins of the Modern Canadian Landscape." In *Eye of Nature*. Based on exhibitions at the Walter Phillips Gallery, Banff, Alberta.

Weedon, Chris. 1987. *Feminist Practice and Poststructuralist Theory*. Oxford: Basil Blackwell.

Wehr, Demaris S. 1989. *Jung & Feminism: Liberating Archetypes*. Boston: Beacon Press.

Welsh, Robert P. 1987. "Introduction." In *The Spiritual Image in Modern Art*. Edited by Kathleen J. Regier. Wheaton, IL: The Theosophical Publishing House.

Westfall, William. 1989. *Two Worlds: The Protestant Culture of Nineteenth-Century Ontario*. Kingston and Montreal: McGill-Queen's University Press.

White, Hayden. 1987. *The Content of the Form: Narrative Discourse and Historical Representation*. Baltimore and London: Johns Hopkins University Press.

Whittemore, Reed. 1988. *Pure Lives: The Early Biographers*. Baltimore and London: Johns Hopkins University Press.

Willbern, David. 1989. *"Filia Oedipi:* Father and Daughter in Freudian Theory." In *Daughters and Fathers.* Edited by Lynda E. Boose and Betty S. Flowers. Baltimore: Johns Hopkins University Press.

Williams, Raymond. 1960. *Culture and Society 1780-1950.* London: Chatto & Windus.

Wilson, Bryan R. 1988. "The Functions of Religion: A Reappraisal." *Religion* 18: 199-216.

Wittkower, Rudolf, and Margot Wittkower. 1963. *Born Under Saturn: The Character and Conduct of Artists.* New York and London: W. W. Norton.

Witzling, Mara. 1991. *"Through the Flower:* Judy Chicago's Conflict Between a Woman-Centered Vision and the Male Artist Hero." In *Writing the Woman Artist: Essays on Poetics, Politics, and Portraiture.* Edited by Suzanne W. Jones. Philadelphia: University of Pennsylvania Press.

Wolff, Janet. 1990. *Feminine Sentences: Essays on Women and Culture.* Berkeley and Los Angeles: University of California Press.

Woodcock, George. 1985. *Strange Bedfellows: The State and the Arts in Canada.* Vancouver: Douglas & McIntyre.

———. 1989. *The Century that Made Us: Canada 1814-1914.* Toronto: Oxford University Press.

Woolf, Virginia. 1961. "The Art of Biography." In *The Death of the Moth and Other Essays.* Harmondsworth: Penguin.

———. 1966. "Mr. Bennett and Mrs. Brown." In *Collected Essays.* Vol. 1. Edited by Leonard Woolf. New York: Harcourt, Brace & World.

———. 1978. *A Writer's Diary: Being Extracts from the Diary of Virginia Woolf.* Edited by Leonard Woolf. London: Triad Grafton.

———. 1979. "Men and Women." In *Books and Portraits.* Edited by Mary Lyon. London: Triad Grafton.

———. 1981. "The New Biography" and "Women and Fiction." In *Granite and Rainbow.* London: The Hogarth Press.

———. 1985. *Moments of Being.* London: Hogarth.

———. 1988. "Romance and the Heart." In *The Essays of Virginia Woolf.* Vol. 3, 1919-1924. Edited by Andrew McNeillie. London: Hogarth.

Wyatt, Jean. 1990. *Reconstructing Desire: The Role of the Unconscious in Women's Reading and Writing.* Chapel Hill: University of North Carolina Press.

Wyschogrod, Edith. 1990. *Saints and Postmodernism: Revisioning Moral Philosophy.* Chicago: University of Chicago Press.

Yorke, Malcolm. 1988. *The Spirit of Place: Nine Neo-Romantic Artists and Their Times.* London: Constable.

Young, Robert. 1990. *White Mythologies: Writing History and the West.* London and New York: Routledge.

Zemans, Joyce, Elizabeth Burrell and Elizabeth Hunter. 1988. *Kathleen Munn and Edna Tacon: New Perspectives on Modernism in Canada.* Toronto: Art Gallery of York University.

Zolberg, Vera L. 1990. *Constructing a Sociology of the Arts.* Cambridge: Cambridge University Press.

INDEX

Aboriginal. *See* Native

Agnosticism, 45, 46, 69, 87

Allen, Paula Gunn, 120, 180 n. 13

Ambiguity: tendency of biography to promote, 1, 6, 27, 41, 46, 49, 74, 80, 147

Anger, 19, 56, 60

Archives, 4, 26-27, 32, 54

Arnold, Matthew, 64

Art Gallery of Ontario, 32

Art historians, feminist. *See* historians, feminist art

Artists: analogous to God, 79; biographies of, 42, 95; modernist, 22

Artists, female, 3-5, 55, 66, 85, 88, 93, 100, 115-16, 158 n. 6; characteristics of, 93; exclusion of, 13, 15, 79, 92-95, 172 n. 3

Artmagazine, 101

Artscanada, 89

Assumptions, tacit, and relation to biography, 1, 30, 42, 92, 123

Auerbach, Nina, 84-85, 88

Authenticity, 175 n. 24

Autobiography: and gender, 18, 22; as discursive forum, 14-15, 20, 22; as self-creation, 17, 20; by Canadian women, 160 n. 18; definition, 159 n. 11; female, 17-19, 22; genre conventions, 14, 18; letters as, 20, 161 n. 22; religious dimensions, 20, 22

Avant-garde: 11, 13, 21, 53, 56, 100, 112, 114, 130, 137, 164 nn. 1, 17

BC Studies, 89, 101

Barbeau, Marius, 58, 90-91

Barthes, Roland, 111

Barton, John, 119-21

Bateson, Mary Catherine, 102, 124-25, 162 n. 8

Battersby, Christine, 110-11

Bell, Clive, 113, 135, 136, 139

Bell, Millicent, 103-104

Bell, Susan Groag, 6, 96

Benjamin, Arthur, 60

Benstock, Shari, 53

Berger, Carl, 129

Berger, Peter, 121-22, 124

Bibby Reginald, 87, 175 n. 25

Bieler, André, 62

Biographer: feminist, 81; gender, 73; role, 49

Biographical image, 14, 28-30, 32, 91, 129, 131, 142, 143, 144; definition, 2; female, 5, 36-37, 82

Biography: in Canada, 62, 65, 124, 162 n. 5, 170 n. 29; as discursive forum, 1, 3, 4, 5, 10, 21, 26, 34, 41, 79, 80, 88, 91, 92, 100, 130, 142-44, 145-48; fictionalization, 30, 32, 116, 164 n. 15; and gender, 5, 6, 47-48, 51, 79-84, 92, 110-11, 115; genre, conventions, 1-4, 25, 29-30, 37, 42, 46, 49, 73-74, 91, 115, 116, 119, 125, 146, 148; genre, criticism of, 29, 34-35, 163 nn. 12, 14; genre, development, 4-5, 25-26, 30, 34, 41-52, 78, 81, 88, 97, 162 n. 3, 168 n. 7, 173 n. 14; and postmodernism, 38, 92, 165 n. 27; religious dimensions, 1, 2, 4, 33-34, 43-44, 103-104, 115, 118, 120

Blanchard, Paula, 31-32, 55-56, 119, 120, 136-37, 158 n. 8

Blavatsky, Helena, 114

Bloomsbury, 45, 50, 62
Boswell, James, 42-44, 48, 70, 78, 97
Braudel, Fernand, 47
Braudy, Leo, 28
British Columbia, 31, 54, 58, 72, 91,
 134, 143, 146, 184 n. 43; Carr's trips
 within, 59
Brown, Eric, 58, 90
Buchanan, Donald W., 57, 59, 60-61
Bucke, Richard Maurice, 87
Burns, Flora, 73, 118
Bynum, Caroline Walker, 102, 110,
 166 n. 27, 179 n. 1

Canada, spiritual climate at mid-century,
 68-70
Canadian Art, 10, 143
Canadian Broadcasting Corporation, 9,
 21, 100, 104
Canadian Federation of University
 Women, 73
Canadian Forum, 57, 59, 113
Canadian West Coast Art: Native and
 Modern, 52, 57, 91
Careless, James M., 65
Carlyle, Thomas, 64, 167 n. 4
Carr, Alice, 55, 84, 104-105
Carr, Clara, 84
Carr, Edith, 84
Carr, Lizzie, 84, 104-105
Carr, Emily: additional interpretations,
 163 n. 10; attitude to natives, 10,
 140-43; childhood (and Small), 19, 66,
 83, 129, 142, 165 n. 22; and cities, 55,
 89, 94-95, 120, 134, 137, 138,
 176 n. 34; education, 11, 54, 55; as a
 female artist, 13, 130; and feminism,
 130-31; health, 22, 32, 55, 58, 95, 130;
 and hyperbole, 13, 55-56, 62, 89;
 landladying (hardship), 19, 56-57, 72,
 73, 74, 84, 118, 121; as a modernist,
 13, 15; native themes in her work, 33,
 54, 59, 60, 66, 71-72, 74, 114, 121,
 131, 138, 139; physicality and sexuality,
 66, 67, 86, 104, 142, 143, 146,
 185 n. 52; publications, 158-59 n. 10;
 religious life and spirituality, 5, 15, 61,
 86-87, 112, 116-21, 129, 140; repeated

themes in her work, 18, 60, 89,
 127-28; stories broadcast, 169 n. 17;
 temperament, 89-90; writing, 3, 13,
 15, 19-20, 55, 58, 83; on writing and
 words, 16, 33, 60
Carr, Emily, biographical image of, 3, 9,
 10, 14, 19, 29, 33, 42, 65, 99, 101-102,
 124, 125, 127, 129, 131, 132, 137-38,
 143; early stage, 59-62; inaccuracies, 31-
 32; at mid-century, 61-62, 66, 67; remi-
 niscences, personal, 61, 66, 70, 71, 91,
 170 n. 30; self-invention, 57, 62, 72, 74
Carr, Emily, individual works: books,
 The Book of Small, 58; Growing Pains,
 18, 54-55, 59, 61, 117; The Heart of a
 Peacock, 59; The House of All Sorts, 57,
 58, 61; Hundreds and Thousands, 16, 19,
 117; Klee Wyck, 16, 58, 59, 60, 90,
 141; Pause, 59; letters, 20, 107, 104;
 painting: Indian Church, 131; stories:
 "D'Sonoqua," 16; "Cowyard," 19,
 "Sunday," 15
Cézanne, Paul, 11, 135
Charmé, Stuart L., 17
Chicago, Judy, 144
Childhood: in biography, 26; in
 autobiography, 19
Christianity, 12, 64, 86, 113, 114, 115,
 126, 179 n. 7
Church, 15, 16, 45, 86, 115, 129
Clapham Sect, 44, 50, 167 n. 3
Clifford, James, 139
Coburn, Kathleen, 57, 61, 66, 171 n. 31
Cockshut, A. O. J., 25-26
Cole, Douglas, 31-32, 100, 121
Coleman, M. E., 61
Comfort, Charles F., 68
Conference of Canadian Artists, 62,
 169 n. 22
Crean, Susan, 10, 128
Creighton, Donald, 65, 80
Cridge, Bishop, 86, 175 n. 23
Crosby, Marcia, 185 n. 53
Cubism, 54, 114
Culpepper, Emily, 126-29, 172 n. 8
Culture, 63-64; definition of, 123-24;
 and gender, 172-73 n. 2. See also
 Religion and culture

Dalhousie Review, 61
Daly, Thomas, 61
Daniells, Roy, 71-73
Darwin, Charles, 44
Davies, Robertson, 59, 60
Davis, Ann, 175 n. 25, 176 n. 31,
 179 n. 7
Dictionary of National Biography, 45, 59
Dilworth, Ira, 56, 59-60
D'Sonoqua, 16, 104, 131

Eccles, William J., 65
Edel, Leon, 81, 165 n. 25
Elder, R. Bruce, 185 n. 50
Eliot, George, 48, 97, 168 n. 8
Eliot, T. S., 11, 157-58 n. 4; on religion
 and culture, 63, 64, 68, 121-22,
 170 n. 25
England, 11, 18, 74, 85, 92, 132,
Enlightenment, 38, 45, 79, 97; post-
 Enlightenment, 46
Epstein, William, 17
Erikson, Erik, 84
Experience: female, 6, 51, 80, 82-83,
 96, 98-99, 111; gendered, 78-79, 102;
 and language, 97; relation to biography,
 2, 5, 17-18, 36, 51, 104; and religion,
 126; and theology, 99

Fact and fiction in biography, 35, 50, 55,
 116, 164 n. 15
Facts, as evidence, 2, 4, 14, 17, 19,
 26-31, 35, 43, 46-47, 56, 74, 116, 142
Fame, 28. *See also* Legend
Felski, Rita, 88, 92, 97, 157-58 n. 4
Feminism, 21, 36-37, 80, 81, 83; and
 individualism, 93; and spirituality, 120,
 123, 126, 127, 128, 146-47, 182 n. 31;
 movement, 89, 99; use in text, 172 n. 7;
Fitzgerald, Zelda, 81
Flâneur, 22, 172 n. 4
Flax, Jane, 38, 97
Forest and wilderness, 13, 16, 21, 60,
 105, 110, 112, 121, 131-35, 137, 138,
 146
Foucault, Michel, 95, 111, 161 n. 1,
 165 n. 24, 167 n. 36; epic and dossier,
 32, 104, 177 n. 38

Fourth dimension in art, 114, 131
Fox-Genovese, Elizabeth, 93
France, 11, 54, 55, 56, 74, 92, 132
Freud, Sigmund, 104, 119; pathography,
 136, 168 n. 9
Froude, James Anthony, 45, 46, 47, 48
Fry, Roger, 52, 168 n. 11, 169 n. 14
Frye, Joanne S., 96-98, 99, 177 n. 39
Frye, Northrop, 52-53
Fulford, Robert, 9-10, 143-44
Fuller, Peter, 132-33, 135-36, 137,
 184 n. 46

Geertz, Clifford, 125, 161 n. 1, 166 n. 29,
 180 n. 12
Genius, 60, 64, 95, 110-11, 179 n. 3
Gibb, Harry, 54-55
Glendinning, Victoria, 27
Globe and Mail, The, 127, 128, 181 n. 15
Goldie, Terry, 139-40, 169 n. 16
Gosse, Edmund, 46, 47, 48
Grant, George P., 68
Greer, Germaine, 94
Group of Seven, 11, 12, 52, 58, 60, 90,
 91, 113, 114, 132, 145

Hagiography, medieval, 42, 43, 46, 102,
 110, 116, 120, 180 n. 14
Harris, Lawren, 12, 21, 52, 57, 59, 60,
 113, 132, 142; and Theosophy, 88, 114
Harrison, Beverly Wildung, 146
Hanscombe, Gillian, 85
Hawkings, Stephen, 147, 148
Heffernan, Thomas, 46-47, 102-103,
 110, 168 n. 6; "empirical biography,"
 46-47
Heilbrun, Carolyn, 6, 19, 81, 88, 97,
 116, 124, 162 n. 8, 172 n. 7; *Writing a
 Woman's Life*, 83-84, 96, 100,
 166 n. 33, 169 n. 18
Hembroff-Schleicher, Edythe, 31, 91,
 119, 140-41; *Emily Carr: The Untold
 Story*, 101, 141; *m.e.: A Portrayal of
 Emily Carr*, 71, 101
Hiatus. *See* Carr, Emily: Landladying
Higonnet, Anne, 95, 165 n. 24, 176 n. 32
Historians, feminist art, 91, 92, 93, 95,
 130

Hoberman, Ruth, 46, 81
Housser, Fred, 52-53
Humphrey, Ruth, 70, 73, 90-92
Hutchison, Bruce, 65, 164 n. 15

Identity, 2, 10, 17, 51, 92, 99-100, 115,
 122, 123, 137, 143, 144
Indian. See Native
Intimacy, 20, 104, 105, 148
Irony, 6, 105

Jacobs, Jane, 137
James, William, 126
Jameson, Frederic, 38, 115
Johnson, Samuel, 43-44, 70
Journal of Canadian Art History, 90

Kahlo, Frida, 6, 88, 116, 142, 144
Kandinsky, Wassily, 69
Kane, Paul, 134
Karl, Frederick R., 168 n. 14
Kelly, Joan, 82
Kempe, Margery, 102, 160 n. 16,
 165 n. 27, 186 n. 2
Kilbourn, Rosemary, 117-18
Kilbourn, William, 65
King, William Lyon Mackenzie, 30,
 164 nn. 15, 16
King, Winston L., 2, 125-26, 144
Kingston Artists' Conference. See
 Conference of Canadian Artists
Klee Wyck (film), 61-62
Kröller, Eva-Marie, 163 n. 10
Kurelek, William, 165 n. 27, 177 n. 37

Landscape, 5, 100; Canadian, 11, 52, 90;
 painting in England, 132, 134-35
Language, gender duality in, 79, 83,
 173 n. 12
Legend, 30-31, 33, 89, 164 n. 16. See also
 Mythicization
Leonard, Ellen, 99, 126
Life writing, 4, 17, 96; use of term,
 157 n. 1
Lionnet, Françoise, 18; métissage, 102,
 130, 167 n. 35
Lipsey, Roger, 17, 112

Lives, female, 47-48, 51, 66, 83-86, 92,
 97, 122-23, 165 n. 26; in hagiography,
 102-103, 124
Livesay, Dorothy, 128, 183 nn. 34, 35
London, 15, 22, 53, 54, 59, 72, 85, 137,
 142, 176 n. 34
Lord, Barry, 101
Lorde, Audre, 146
Lower, Arthur, 69-70
Lyons, John O., 43

MacCannell, Dean, 144
McFague, Sallie, 78-79
McInnes, Graham, 61-62
Mann, Susan. See Trofimenkoff, Susan
 Mann
Marchessault, Jovette, 21, 104-105,
 119-21, 166 n. 31, 178 nn. 43, 47,
 181 n. 20
Marsh, Jan, 176-77 n. 36, 179 n. 6
Massey, Vincent, 63, 80, 88, 129,
 170 n. 27; On Being Canadian, 64-65
Massey Commission, 63-65, 68, 69
Mays, John Bentley, 127-28, 183 n. 34
Memory, 14, 54, 91, 97
Métissage. See Lionnet, Françoise
Middlebrook, Diane Wood, 26-27,
 157 n. 3, 159 n. 13
Milford, Nancy, 81, 166 n. 33
Modernism, 3, 21, 33-34, 43, 47, 53, 56,
 78, 99, 112, 115, 157 n. 3, 157-58 n.4;
 and cities, 94-95; depth as an aspect of,
 12, 15, 52-53, 69, 72, 126; and gender,
 160 nn. 19, 20; religious dimensions,
 11-12, 21. See also Postmodernism
Modernists, female, 85-86; quests of, 69,
 112, 139, 185 n. 49
Moore, George, 93
Moray, Gerta, 57, 58, 143
Morisot, Berthe, 88
Morley, Patricia, 165 n. 27, 177 n. 37
Morrice, James Wilson, 57, 59
Morton, Nelle, 128
Murray, Joan, 185 n. 52
Mythicization of biographical subjects,
 27-28

Narrative, 14, 17, 26, 33-35, 51, 96-97,
 183 n. 37; and change, 98, 100; life
 stories, 96
National Gallery of Canada, 13, 21, 32,
 52, 57, 58, 89, 127, 138
Native culture, 58, 68, 120, 139;
 appropriation issues, 10, 21, 66,
 142-43; indigene in literature, 139-40,
 142. *See also* Carr, Emily, native themes
 in her work
Neatby, Hilda, 63
Neering, Rosemary, 100
Nicolson, Harold, 43
Nochlin, Linda, 94, 128
Novarr, David, 35
National Film Board, 61-62

O'Brien, Lucius, 32, 134, 165 n. 20
Ochs, Carol, 126
Oelschlager, Max, 112
O'Keeffe, Georgia, 6, 88, 114, 116, 142
O'Rourke, Pam, 154
O'Toole, Roger, 122
Otto, Rudolf, 136
Owen, Alex, 87-88

Paris, 53, 54, 55, 59, 85, 93, 137, 142
Parker, Rozsika, 128
Pathography, 136
Patriarchy, as metaphor, 78
Patterson, Nancy-Lou, 57, 117, 153-54,
 181 n. 17
Pearce, Lynne, 165 n. 24
Pearson, Carol, 66, 70
Photography, 31
Picasso, Pablo, 54; and the word
 "sacred," 12, 69, 104, 112; *Demoiselles
 d'Avignon*, 53, 79, 93
Plutarch, 34, 44, 45, 148
Pollock, Griselda, 93-95, 128,
 176 nn. 34, 36
Postmodernism, 10, 34, 38, 81-82,
 165 n. 23; characteristics, 78-79,
 157 n. 3; pastiche and schizophrenia
 in, 38. *See also* Modernism
Primitive, the, 5, 21, 58, 113, 138-39,
 161 n. 26
Psychobiography, 31, 136

Psychoanalysis, 5, 80, 131, 135-36
Psychology and biography, 43, 46,
 48-49, 136; and modernists, 69, 70,
Pugin, A. W. N., 64

Queen's Quarterly, 67, 70

Reiss, Timothy J., 47, 157-58 n. 4
Religion: and art, 5, 11-13, 69, 112-15,
 132-35, 138, 139, 146; and culture,
 44-46, 63-65, 68, 121-24, 125, 127,
 129, 170 n. 25, 175 n. 25; definition, 2,
 125-26, 181 n. 21; function of,
 181 n. 22; and gender, 181 n. 21,
 182 n. 31; implicit, 122-23; and
 spirituality, 112, 127, 183 n. 33
Renaissance, 42, 79, 82-83
Riel, Louis, 30, 116-17, 164 nn. 15, 16,
 181 n. 15
Roper, Richard, 44
Royal Commission on National
 Development in the Arts. *See* Massey
 Commission
Royal Commission on the Status of
 Women, 89, 183 n. 32
Ruskin, John, 64, 132-35, 138
Ryley, Nancy, 100

Sacred, 12-13, 65, 69, 112, 116,
 181 n. 23
San Francisco, 11, 15, 18, 22, 53, 54, 59,
 74
Sanders, Valerie, 19
Sartre, Jean-Paul, 17, 18, 115, 166 n. 29
Saturday Night, 59, 60, 61
Say, Elizabeth A., 96, 98, 99
Sayability, 33-35, 165 n. 21
Scott, Gail, 36-37, 105, 166 nn. 30, 31
Sedgewick, Garnett, 60
Self, 2, 4, 13, 17, 18, 20, 34, 38, 46, 51,
 69, 98, 115, 137, 172 n. 2; autobio-
 graphical, 14, 17; female, 82, 86, 111;
 invention of, 125; self/other, 6, 110-11
Sexton, Anne, 26-27
Shadbolt, Doris, 9, 10, 21, 32, 100, 119,
 120; 1971 article, 89-92; *Art of Emily
 Carr, The*, 101-102; *Emily Carr*, 138-42
Shadbolt, Jack, 61

Showalter, Elaine, 88; George, Eliot, on, 48; unmarried women, 84-85; women and illness, 161 n. 29, 164 n. 18, 183 n. 38

Siddal, Elizabeth, 88, 176-77 n. 36, 179 n. 6

Skidelsky, Robert, 35

Smith, Peter L., 28, 101

Smith, Sidonie, 18

Smyers, Virginia L., 85

Snipes, Wilson, 116

Social Gospel, 57, 87, 97, 129

Sophie, 83

Spacks, Patricia, 82, 169 n. 18

Special Committee on Reconstruction and Re-establishment, 62-63

Sphere, feminist public, 88, 92

Spheres, separate, 20, 48, 50, 83-84, 94, 98, 133, 174 n. 17

Spinsters. *See* Lives, female

Spiritualism, 87-88, 114, 175 nn. 25, 26

Spirituality. *See* Feminism and spirituality; Religion and spirituality

Spurling, Hilary, 27

St. Thérèse of Lisieux, 117, 148

Stacton, Derek, 67-68, 70, 73

Stanton, Domna, 22

Steiner, George, 33-34, 36, 37, 38, 51, 96, 157-58 n. 4, 170 n. 25

Stephen, Leslie, 44-46, 47, 97, 125, 168 n. 5; agnosticism, 45-46, 69, 87; *Dictionary of National Biography* and his style, 45, 59, 74

Strachey, Lytton, 45, 46, 51, 104; *Eminent Victorians*, 26, 43, 48-49, 78, 85, 103-104; and Freud, 168 n. 9

Subjectivity, 2, 3, 10, 38, 97; of the indigene, 140

Sweden, 55

Taylor, Charles (biographer), 100, 118, 119

Taylor, Charles (philosopher), 45

Taylor, Mark C., 34, 36, 37, 167 nn. 34, 36

Theosophy, 11, 21, 88, 113-15, 121, 180 n. 10

Thomas, Clara, 65, 170 n. 29

Thomson, Tom, 52-53

Tippett, Maria, 145, 147; and Douglas Cole, 100, 121; early articles, 89-92; *Emily Carr: A Biography*, 101-102, 178 n. 43; 1991 essay, 119-21, 132

Tracy, David, 78

Trofimenkoff, Susan Mann, 80, 81, 97, 168 n. 10

Turner, J. M. W., 134

Turner, Victor, 102, 170 n. 28

Turpin, Marguerite, 71

University of Toronto Quarterly, 59, 90

Van Gogh, Vincent, 11

Vancouver, 74

Vasari, Giorgio, 42-45, 61, 148

Victoria, BC, 11, 13, 29, 31, 59, 60, 72, 74, 83, 86, 90, 92, 119, 121, 128, 146, 163 n. 11

Wagner, Roy, 124

Walker, Doreen, 20, 104

Watson, Scott, 143

Westfall, William, 123

Westra, Monique Kaufman, 101-102

White, Hayden, 35, 36, 37, 51

Whitfield, Eileen, 104-105, 155, 178 n. 49, 181 n. 18

Whitman, Walt, 11, 61, 87, 114, 180 n. 9

Wilderness. *See* Forest and wilderness

Wilson, Bryan, 122, 181 n. 22

Winnicott, D. W., 135, 142

Wolff, Janet, 128, 137, 171 n. 2

Woman question, 80, 81, 130

Women, health, 161 n. 29, 164 n. 18, 183 n. 38

Woolf, Virginia, 4, 12, 17, 22, 27, 53, 55, 146-47, 168 n. 12, 172 n. 5, 185 n. 53; "Am I a Snob," 164 n. 19; as biographical subject, 27; influence of, 168 n. 13; moments of being, 51, 69, 113; on biographers and biography, 49-52, 165 n. 24; *Orlando*, 50, 163 n. 13; *Roger Fry*, 50, 168 n. 11

Word-object bond, 33, 36, 51, 96

Writers, female, francophone and anglophone in Canada, 36-37, 105

Yallom, Marilyn, 6, 96